ART NOW
VOL 3

Edited by Hans Werner Holzwarth

ART NOW
VOL 3

A cutting-edge selection of today's most exciting artists
Ein aktueller Überblick zu 73 internationalen Künstlern
Une sélection actuelle de 73 artistes de la scène internationale

TASCHEN

Contents — Inhalt — Sommaire

Preface

For more than a decade now, the *ART NOW* series has been closely following all the exciting work produced in studios worldwide every day, to introduce its readers to the latest developments in the diverse areas of contemporary art. Artistic positions shift, new trends emerge: today abstract painting has once again become an open field, many young artists work in the most varied media as if this were a matter of course, and the use of materials drawn from popular culture and models taken from art history is at present extraordinarily innovative. These are frequently the themes that the older artists represented here have been addressing since the 1980s, which is reason enough to show both in this book.

Besides these developments, there are also totally different positions, so we hope that some of our entries will surprise or intrigue. The selection was, of course, a subjective process, in which the editor and the publisher participated along with the many people whom we've had discussions with during preparations. Which is exactly the point of this publication: it is not a list of the 73 "best" artists today, but instead highlights the works that have been at the centre of discussion in recent years – either among insiders or the general public.

We have continued the tried-and-tested formula: 73 of today's most exciting artists are each given four pages for a short introduction and, most importantly, images of their current work.

Our thanks go first to Uta Grosenick and Burkhard Riemschneider, who from the first issue of *Art at the Turn of the Millennium* in 1999 have given this series its special character.

A special thanks to our authors, Cecilia Alemani, Jens Asthoff, Andrew Bonacina, Suzanne Hudson, Christy Lange, Holger Lund, Astrid Mania, Rodrigo Moura, Simon Rees, Vivian Rehberg and Eva Scharrer, and to Kirsty Bell, who has helped to select this team.

Many thanks to all the members of staff in galleries and artists' studios, who quickly and willingly assisted us with images and information whenever we needed them.

However, our sincerest thanks go out to the artists involved, not only because some of them made personal contributions to this project, but, above all, for their art, which is the heart of our book.

Hans Werner Holzwarth

Vorwort

Seit über einem Jahrzehnt verfolgt die Reihe *ART NOW* inzwischen, was täglich an aufregenden Arbeiten in Ateliers auf der ganzen Welt entsteht, um den Lesern die neuesten Entwicklungen auf dem unüberschaubaren Gebiet der zeitgenössischen Kunst vorstellen zu können. Künstlerische Positionen verschieben sich, Trends zeichnen sich ab: Heute ist abstrakte Malerei wieder zu einem offenen Feld geworden, viele junge Künstler arbeiten ganz selbstverständlich in den unterschiedlichsten Medien und auch die Arbeit mit Fundstücken aus der Populärkultur und mit Vorbildern aus der Kunstgeschichte ist derzeit außerordentlich innovativ. Häufig sind das genau die Themen, mit denen sich die älteren der hier vertretenen Künstler seit den 1980er-Jahren beschäftigen. Grund genug beides zu zeigen.

Neben diesen Entwicklungen gibt es auch ganz andere Positionen, und wir hoffen, dass mancher Eintrag überrascht und neugierig macht. Die Auswahl war natürlich ein subjektiver Prozess, an dem Herausgeber und Verleger genauso beteiligt waren wie die vielen Menschen, mit denen wir im Vorfeld diskutiert haben. Und genau um diesen Punkt geht es in diesem Buch: Hier wird keine Liste der „besten" 73 Künstler geschaffen, sondern die Werke gezeigt, die über die letzten Jahre Diskussionsstoff gaben – in der Fachwelt und auch beim Publikum.

Wir haben das bewährte Format beibehalten: 73 der derzeit spannendsten Künstler werden auf je vier Seiten mit einer kurzen Einführung und vor allem mit Abbildungen ihrer aktuellen Arbeiten vorgestellt.

Unser erster Dank geht an Uta Grosenick und Burkhard Riemschneider, die mit der ersten Ausgabe von *Art at the Turn of the Millennium* im Jahr 1999 dieser Reihe ihre besondere Prägung verliehen haben.

Besonderen Dank unseren Autorinnen und Autoren Cecilia Alemani, Jens Asthoff, Andrew Bonacina, Suzanne Hudson, Christy Lange, Holger Lund, Astrid Mania, Rodrigo Moura, Simon Rees, Vivian Rehberg und Eva Scharrer sowie an Kirsty Bell, die bei der Wahl der Autoren beteiligt war.

Vielen Dank den vielen Mitarbeiterinnen und Mitarbeitern in den Galerien und Ateliers, die uns schnell und bereitwillig mit Bildmaterial und Informationen geholfen haben.

Der wichtigste Dank geht aber an alle Künstlerinnen und Künstler, nicht nur weil sich viele von ihnen in dieses Projekt persönlich mit eingebracht haben, sondern vor allem für ihre Kunst, das Herz unseres Buchs.

Hans Werner Holzwarth

Préface

Depuis plus de dix ans, la collection *ART NOW* suit au plus près le travail passionnant produit chaque jour dans les ateliers du monde entier, pour présenter à ses lecteurs les toutes dernières évolutions des différentes disciplines de l'art contemporain. Les positionnements artistiques changent, des tendances se dessinent : aujourd'hui la peinture abstraite est redevenue un champ ouvert aux expérimentations, beaucoup d'artistes travaillent d'instinct avec les médiums les plus divers, mêlant de façon particulièrement novatrice objets trouvés, icônes de la culture populaire et classique de l'histoire de l'art. Ce sont d'ailleurs souvent les thèmes qui, depuis les années 1980, intéressent aussi les artistes un peu plus âgés représentés ici. Cette parenté thématique justifie à elle seule que ce livre présente les deux générations.

En marge de ces évolutions, certains artistes empruntent des chemins tout différents. Nous espérons que plus d'une entrée surprendra et aiguisera la curiosité du lecteur. Comme on peut s'y attendre, la sélection des artistes a résulté d'une démarche subjective conjointe de la part de l'éditeur, du directeur de publication et des nombreuses autres personnes qui ont préparé ce projet en amont. C'est précisément ce dont il est question dans ce livre : nous n'y établissons pas un palmarès des 73 «meilleurs» artistes, nous présentons les œuvres qui ont alimenté le débat artistique ces dernières années – dans le monde professionnel comme parmi le public.

Le format de la série a été conservé : 73 des artistes les plus passionnants du moment sont présentés sur quatre pages chacun, par une brève introduction et surtout à travers des reproductions de leurs œuvres récentes.

Nos remerciements vont d'abord à Uta Grosenick et Burkhard Riemschneider, qui donnent son caractère à cette collection depuis la publication du premier volume, *Art at the turn of the millennium*, en 1999.

Nos remerciements particuliers vont ensuite aux auteurs – Cecilia Alemani, Jens Asthoff, Andrew Bonacina, Suzanne Hudson, Christy Lange, Holger Lund, Astrid Mania, Rodrigo Moura, Simon Rees, Vivian Rehberg et Eva Scharrer, ainsi qu'à Kirsty Bell qui a participé à leur sélection.

Un grand merci également aux nombreux collaboratrices et collaborateurs des galeries et ateliers d'artistes qui nous ont soutenus en nous fournissant aimablement et rapidement illustrations et informations.

Nos remerciements vont enfin et surtout à tous les artistes – pas seulement parce que beaucoup d'entre eux se sont investis personnellement dans ce projet, mais surtout pour leur art, qui est au cœur du présent ouvrage.

Hans Werner Holzwarth

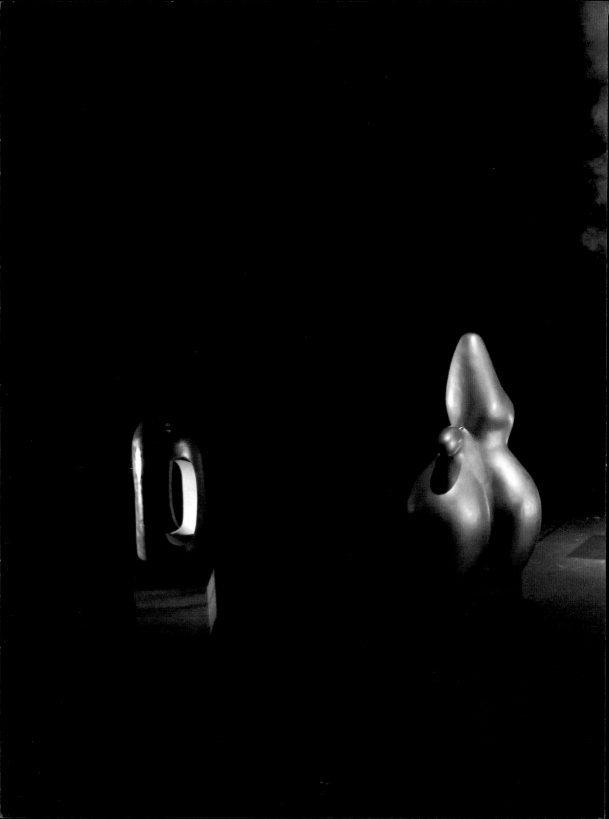

24 GIANT SIZE PKGS.

New!

Brillo®

Brillo

soap pads
WITH RUST RESISTER

SHINES ALUMINUM FAST

ARTISTS

Franz Ackermann

1964 born in Neumarkt St. Veit, lives and works in Berlin and Karlsruhe, Germany

The expansiveness that distinguishes Franz Ackermann's work and its interaction with the exhibition space is the same that determines the artist's continual need to travel the world. Based in Berlin, Ackermann is a tireless globetrotter, and on these travels – from São Paulo to Hong Kong, from Los Angeles to Machu Picchu, from Libya to the confines of Europe – he gathers the feel for urban and natural spaces evinced throughout his oeuvre. Ackermann's psychogeography, a term derived from Guy Debord's situationist theory, is first laid out as watercolours in his "mental maps", in which architectural elements of the city appear in a sort of a quick psychedelic flow. These drawings that the artist produces during flights and in hotel rooms provide the base for large-format canvases that he paints in his studio, often creating site-specific paintings as part of large installations. In *No Direction Home* (2007), Ackermann presented a reflection on his rapport with São Paulo, a metropolis that he has visited since 1998 and refers to as "a master plan of anonymity". The installation comprised rotating paintings, second-hand furniture, and dozens of photographs shot in Tropical Islands, a German resort that glamorizes the stereotype of a tropical environment. The clichéd images conflicted with the chaotic representation of the large city rendered in the paintings, challenging the spectator's longing to still nurture a romantic view of the exotic. Always mediated by an extremely subjective vision, Ackermann's work offers a reflection on the many simultaneities in our contemporary world, its interrelations and superimpositions – in other words, its lack of centre.

Die Ausweitung der Malerei in den Raum, die Franz Ackermanns Werke kennzeichnet, und ihre Interaktion mit dem spezifischen Ausstellungsort entsprechen ganz dem Bedürfnis des Künstlers, ständig auf Reisen zu sein. Ackermann, der sein Atelier in Berlin hat, ist ein unermüdlicher Globetrotter, der von seinen Reisen – von São Paulo nach Hong Kong, von Los Angeles nach Machu Picchu, von Libyen bis an die letzten Grenzen von Europa – ein sein gesamtes Œuvre durchdringendes Faible für urbane und natürliche Räume mitbringt. Ackermanns Psychogeografie – der Ausdruck ist von Guy Debords situationistischer Theorie abgeleitet – entwickelt sich zunächst mit Aquarellfarben in Form so genannter *Mental Maps*, auf denen wie in einem schnellen psychedelischen Flow urbane Architekturansichten erscheinen. Diese Zeichnungen entstehen im Flugzeug oder im Hotelzimmer und dienen dem Künstler später im Atelier als Vorlage für seine großformatigen Gemälde, die er häufig für ortsspezifische Arbeiten als Teil von Rauminstallationen entwirft. In *No Direction Home* (2007) präsentierte Ackermann eine Reflexion über sein Verhältnis zur Metropole São Paulo, die für ihn „eine Art Masterplan der Anonymität" darstellt und die er seit 1998 immer wieder besucht hat. Die Installation umfasste rotierende Gemälde, Secondhand-Mobiliar und dutzende Fotografien aus dem Resort Tropical Islands in Brandenburg, das mit dem Ambiente von tropischen Inseln wirbt. Der scharfe Kontrast dieser klischeehaften Fotos zu den chaotischen Großstadtansichten der Gemälde reibt den Betrachter in seinem Verlangen nach exotisch-verträumter Idylle auf. Gegenstand von Ackermanns Arbeit, die immer eine extrem subjektive Sichtweise zeigt, ist die Reflexion über die vielen Gleichzeitigkeiten unserer heutigen Welt, ihre wechselseitigen Beziehungen und Überlagerungen – oder anders formuliert, den Verlust ihres Zentrums.

Le déploiement qui caractérise le travail de Franz Ackermann et son interaction avec l'espace d'exposition est ce qui le pousse à parcourir le monde sans relâche. Au cours de ses nombreux voyages – de São Paulo à Hong Kong, de Los Angeles au Machu Picchu, de la Libye aux confins de l'Europe – cet infatigable globe-trotter vivant à Berlin rassemble des impressions d'espaces urbains et naturels qui marquent son œuvre. Sa « psychogéographie » (pour emprunter un terme des théories situationnistes de Guy Debord) s'exprime sous forme d'aquarelles, ses *Mental Maps*, où des éléments d'architecture urbaine apparaissent dans un flux psychédélique. Ses dessins, réalisés lors de voyages en avion ou dans des chambres d'hôtel, fournissent la base de toiles grand format qu'il réalise dans son studio, pour une installation conçue spécialement pour un lieu d'exposition. Avec *No Direction Home* (2007), Ackermann propose une réflexion sur son rapport à São Paulo, une métropole où il se rend régulièrement depuis 1998 et qu'il décrit comme « un urbanisme de l'anonymat ». L'installation comprend des tableaux rotatifs, des meubles d'occasion et des dizaines de photos de Tropical Islands, un site de villégiature allemand qui pousse à l'extrême les stéréotypes de l'île tropicale. Les images-clichées entrent en conflit avec la représentation chaotique de la grande ville présentée dans les tableaux, et incitent le spectateur à reconsidérer son attachement à une vision romantique de l'exotisme. A travers son travail et le filtre très subjectif de son regard, Ackermann offre une réflexion sur les nombreuses contemporanéités de notre monde actuel, ses interrelations et superpositions – en d'autres termes, sur son absence de centre.

R. M.

SELECTED EXHIBITIONS →
2008 *Franz Ackermann*, Kunstmuseum St. Gallen. *Die Tropen*, Martin Gropius Bau, Berlin. *Vertrautes Terrain – Aktuelle Kunst in und über Deutschland*, ZKM, Karlsruhe **2007** *Reality Bites*, Opelvillen Rüsselsheim **2006** *Home, home again. 23 Ghosts*, Kestnergesellschaft, Hanover; Domus Artium 2002, Salamanca. *Faster! Bigger! Better!*, ZKM, Karlsruhe. *Berlin-Tokyo/Tokyo-Berlin*, Neue Nationalgalerie, Berlin. **2005** *Franz Ackermann*, Irish Museum of Modern Art, Dublin

SELECTED PUBLICATIONS →
2008 *Die Tropen*, Martin Gropius Bau, Berlin; Kerber Verlag, Bielefeld. *Vertrautes Terrain – Aktuelle Kunst in und über Deutschland*, ZKM, Karlsruhe **2006** *Franz Ackermann: Home, home again. 23 Ghosts*, Kestnergesellschaft, Hanover; Domus Artium 2002, Salamanca; Hatje Cantz, Ostfildern. *Eija-Liisa Ahtila, Franz Ackermann, Dan Graham*, Parkett 68, Zürich. *Faster! Bigger! Better!*, ZKM, Karlsruhe; Verlag der Buchhandlung Walther König, Cologne **2005** *Franz Ackermann*, Irish Museum of Modern Art, Dublin

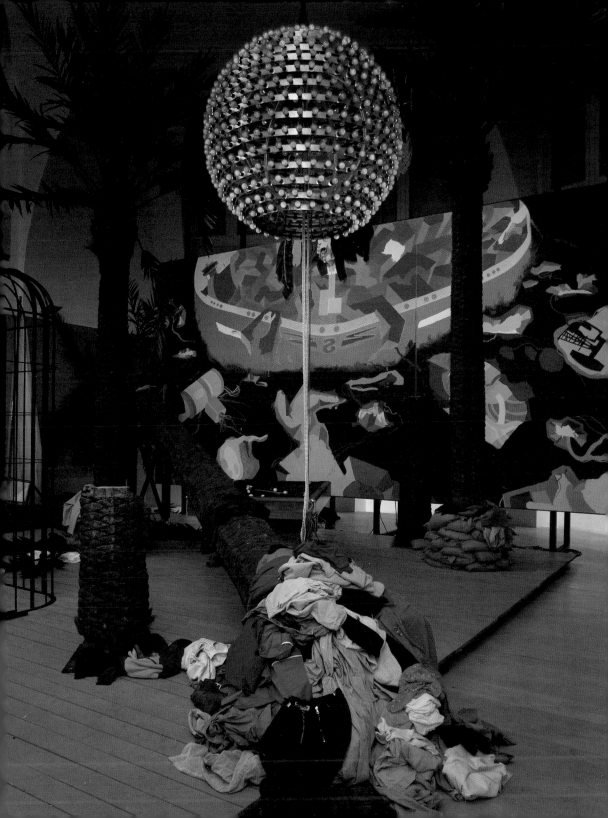

1 **Home, Home Again/23 Gespenster**, 2006. Installation view,
Kestnergesellschaft, Hanover
2 **Little Harbour**, 2007, pencil, gouache on paper on aludibond.
Installation view, neugerriemschneider, Berlin

3 **Home, Home Again**, 2006, mixed media, dimensions variable.
Installation view, Broad Art Foundation, Santa Monica, 2007

„Jene Fremdheit, die gekoppelt ist an Begriffe wie Abenteuer und Exotik,
existiert nicht mehr."

« L'étrangeté, au sens d'aventure et d'exotisme, n'existe plus. »

"Foreignness, in the sense of adventure and exoticism, no longer exists."

2

Ai Weiwei

1957 born in Beijing, lives and works in Beijing, China

Ai Weiwei is best described as the creator of his environment, as this term encompasses both his architectural activities – which have included advising Herzog & De Meuron on designing the national stadium for the 2008 Olympic Games in Beijing – and his art projects. The conceptual artist's contribution to Documenta 2007 consisted of a huge sculptural structure and an equally large-scale social endeavour. *Template* (2007), an eight-winged construction inspired by Chinese temples, was built from the doors and windows of demolished historic Chinese houses, countering the customary attributions of tradition and innovation, familiarity and alienation, preservation and loss. For *Fairytale* (2007), Ai invited 1001 Chinese people to stay at Documenta. This sort of cultural clash is a central and recurrent theme in his work, but here the traditional Western view of China was turned on its head. The 1001 Chinese guests were accompanied to Kassel by the same number of Qing Dynasty chairs, which were reinvented as seating for footsore visitors and later as art objects for sale. Traditional everyday objects from China appear frequently in the artist's oeuvre, always significantly defamiliarized and displaced. A recent series of works revolves around the image of gigantic fallen chandeliers. *Descending Light* (2007) is like a helpless colossus that has collapsed under its own weight and excessive grandeur. With its reference to Vladimir Tatlin's unrealized *Monument to the Third International* (1920), Ai's *Working Progress (Fountain of Light)* (2007) brings to mind utopian undertakings – both of China and of every other place where the chandelier is shown.

Ai Weiwei beschreibt man am besten als Gestalter seiner Umwelt. Denn damit lassen sich seine architektonischen Aktivitäten – er war unter anderem beratend am Bau des Nationalstadions von Herzog & De Meuron für die Olympischen Spiele 2008 in Peking beteiligt – wie auch seine künstlerischen umfassen. So bestand der Beitrag des Konzeptkünstlers zur Documenta 2007 aus einer gewaltigen skulpturalen Struktur sowie aus einer ebenso gewaltigen sozialen Anstrengung. *Template* (2007), ein von chinesischen Tempeln inspirierter Bau aus acht Flügeln, wurde aus den Türen und Fenstern abgerissener historischer Häuser aus China errichtet, sodass die gängigen Zuschreibungen von Tradition und Neuerung, Vertrautem und Fremdem, Bewahren und Verlust die Leere liefen. Für *Fairytale* (2007) lud Ai 1001 Chinesen zu einem Aufenthalt auf der Documenta ein. Damit nimmt er ein zentrales Thema seiner Arbeiten auf, den Zusammenprall von Kulturen, doch wird der übliche westliche Blick auf China hier umgekehrt. Zusammen mit den 1001 Chinesen wurde eine gleiche Anzahl Stühle aus der Quing-Dynastie zur Documenta verfrachtet, um dort eine Umdeutung als Sitzgelegenheit für müde Besucher und später als zu verkaufende Kunstobjekte zu erfahren. Traditionelle Objekte aus dem chinesischen Alltag erscheinen immer wieder stark verschoben und verfremdet im Werk des Künstlers. In jüngster Zeit ist eine Reihe von Arbeiten entstanden, die mit dem Bild gigantischer gestürzter Lüster spielen. *Descending Light* (2007) wirkt wie ein hilfloser Koloss, der unter seinem Gewicht und seiner Pracht zu Boden geht. *Working Progress (Fountain of Light)* (2007) nimmt Bezug auf Wladimir Tatlins nie realisiertes *Monument der Dritten Internationale* (1920) und verweist damit auf die utopischen Vorhaben sowohl Chinas als auch des jeweiligen Aufstellungsorts dieses Leuchters.

Pour aborder l'œuvre d'Ai Weiwei, le mieux est de décrire l'artiste conceptuel comme un créateur de son environnement. Cette approche tient compte en effet de ses activités architecturales – il a notamment participé à la construction du stade national de Herzog & De Meuron pour les Jeux Olympiques de Pékin en 2008 – comme de ses activités artistiques. Ainsi, sa contribution à la Documenta de 2007 a consisté en une gigantesque structure sculpturale accompagnée d'un tout aussi formidable engagement social. *Template* (2007), un bâtiment à huit ailes inspiré de temples chinois, a été construit avec les portes et les fenêtres d'anciennes maisons chinoises démolies, et les définitions habituelles – tradition et renouveau, familiarité et étrangeté, perte et conservation – devenaient dès lors caduques. Pour *Fairytale* (2007), Ai invitait 1001 Chinois à la Documenta. S'il revenait ainsi au thème central de son travail, à savoir le choc des cultures, le regard occidental habituellement porté sur la Chine y était inversé. Avec ces 1001 Chinois, un même nombre de chaises de la dynastie Qing furent transportées à la Documenta pour y subir une réinterprétation comme sièges pour les visiteurs fatigués et être vendues ensuite comme objets d'art. Dans l'œuvre de l'artiste, les objets traditionnels de la vie quotidienne chinoise apparaissent souvent de manière décalée et détournée. Récemment, Ai Weiwei a créé une série d'œuvres réalisées sur la base de gigantesques lustres effondrés. *Descending Light* (2007) ressemble à un colosse maladroit écrasé sous son propre poids et sa splendeur, *Working Progress (Fountain of Light)* (2007), une référence au *Monument à la IIIᵉ Internationale* (1920) de Vladimir Tatline qui ne fut jamais réalisé, renvoie aux projets utopiques tant de la Chine que du lieu d'exposition respectif. A. M.

SELECTED EXHIBITIONS →
2008 *International 08*, Liverpool Biennial, Liverpool. *Ai Weiwei: Under Construction*, Campbelltown Arts Centre, Campbelltown. *Go China! Ai Weiwei*, Groninger Museum, Groningen **2007** *Documenta 12*, Kassel. *China Welcomes You...*, Kunsthaus Graz **2006** *Zones of Contact*, Biennale of Sydney 2006, Sydney. *Serge Spitzer und Ai Weiwei – Eroberung*, MMK, Frankfurt am Main **2005** *Mahjong – Chinesische Gegenwartskunst aus der Sammlung Sigg*, Kunstmuseum Bern

SELECTED PUBLICATIONS →
2008 *Ai Weiwei: Under Construction*, Campbelltown Arts Centre, Campbelltown. *Christian Jankowski, Cosima von Bonin, Ai Weiwei*, Parkett 81, Zürich. *MADE UP International 08 Guide*, Liverpool Biennial, Liverpool **2007** *Documenta 12 Catalogue*, Taschen, Cologne **2006** *Zones of Contact*, Biennale of Sydney, Art Gallery of New South Wales, Sydney **2005** *Mahjong – Chinesische Gegenwartskunst aus der Sammlung Sigg*, Hatje Cantz, Ostfildern

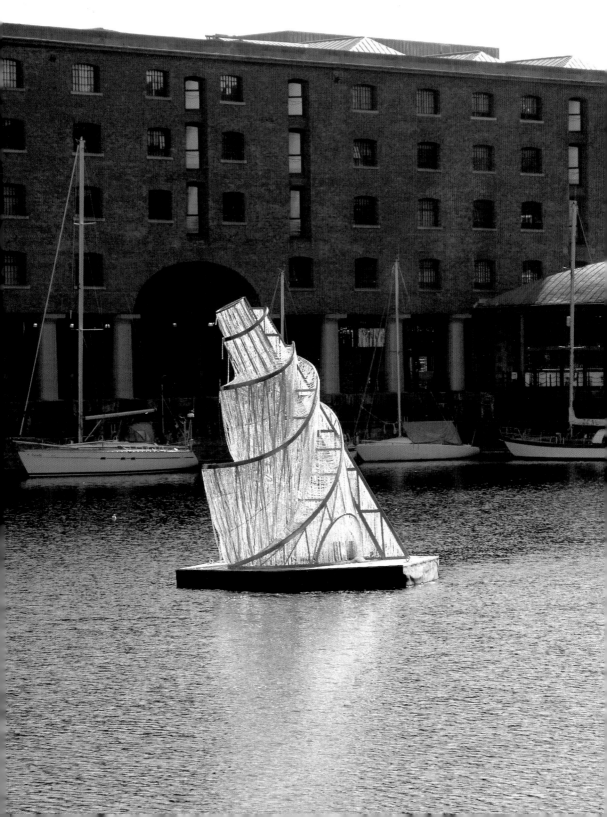

1 **Fountain of Light**, 2007, steel, glass crystals, wooden base,
 700 x 529 x 400 cm. Installation view, Tate Liverpool
2 **Template**, 2007 (after collapsing), wooden doors and windows from
 destroyed Ming and Qing Dynasty houses (1368–1911), wooden base,
 422 x 1106 x 875 cm. Installation view, Documenta 12, Kassel

3 **Fairytale**, 2007, 1001 Qing Dynasty wooden chairs (1644–1911).
 Installation view, Ai Weiwei's studio
4 **Coloured Vases**, 2008, Neolithic vases, industrial paint, dimensions variable
5 **Descending Light**, 2007, glass crystals, stainless brass, electric lights,
 396 x 457 x 681 cm

„Ich stelle nach Möglichkeit alle festen Vorstellungen in Frage und versuche
gerade das umzustoßen, was als selbstverständlich vorausgesetzt wird."

« J'ai tendance à remettre en question tous les concepts figés et à bousculer
certains faits que les gens considèrent toujours comme acquis. »

"I tend to question all fixed concepts and overthrow certain facts that people always take for granted."

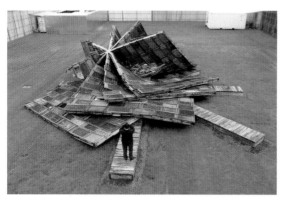

2

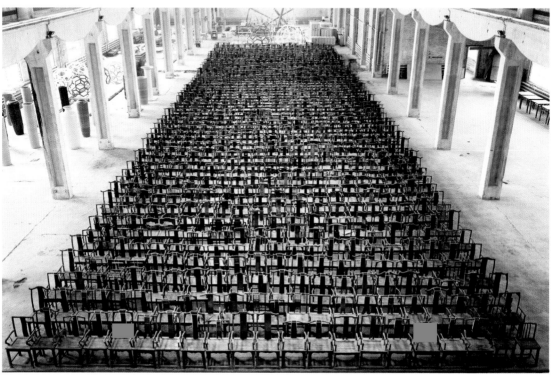

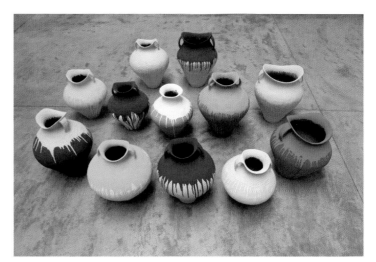

4

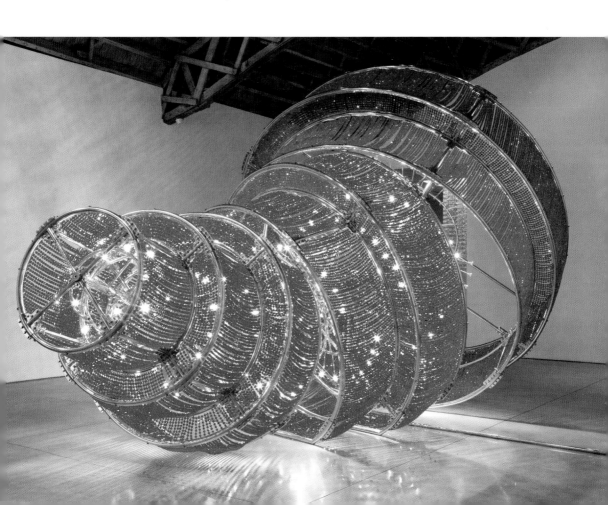

Doug Aitken

1968 born in Redondo Beach (CA), lives and works in Los Angeles (CA), USA

Broken Screen: Expanding the Image, Breaking the Narrative is not just the title of a 2006 book by Doug Aitken; it also sums up his artistic agenda. The screen is broken because Aitken seeks to expand the image using multiple projections, effectively breaking the conventions of cinematic narration. To this end, Aitken leaves the interior of the museum, and projects onto its facades. *sleepwalkers* (2007) is a parallel projection showing the actions of five people, all of whom depart from normality by performing ecstatic movements. In *migration* (2008), four projections show hotel and motel rooms being taken over, not by American people but by American animals. The films operate on a multi-narrative level, insofar as the parallel projections relate to one another and create interfaces and synchronicities. Aitken's artistic references are, on the one hand, the expanded cinema of the 1960s and its use of multiple projections in the attempt to go beyond the visual one-way street of the film theatre, and, on the other, an aesthetic derived from Hollywood productions as well as from music videos, of which he has made several, for artists such as Iggy Pop and Fatboy Slim. What comes as a surprise is the broad range of media in which Aitken realizes his artworks. Although his current focus is on outdoor multiple projections and photography, in *k-n-o-c-k-o-u-t* (2007) he constructed an interactive music table, and in *silent pavilion* (2008) an architectural structure with an exterior that reflects its surroundings and a sound-absorbing interior that can be used as a place of contemplation; here one can escape life's diffuse din – a topic to which Aitken responds in such diverse ways in many of his works.

Broken Screen: Expanding the Image, Breaking the Narrative – so lautet der Titel eines Buches von Doug Aitken (2006), der zugleich sein künstlerisches Programm zusammenfasst. Gebrochen ist die Projektionsfläche, weil Aitken mit Multi-Projektionen eine Erweiterung des Bildes anstrebt, was eine Auflösung der herkömmlichen Kinonarrativität bewirkt. Aitken verlässt dabei das Innere des Museums und projiziert auf die Fassaden. Bei *sleepwalkers* (2007) sind es parallel projizierte Handlungen von fünf Personen, die ihre Normalität verlassen, indem sie ekstatische Bewegungen ausführen. Bei *migration* (2008) zeigen vier Projektionen Räume von Hotels und Motels, in die nicht etwa amerikanische Menschen, sondern amerikanische Tiere eindringen. Die Filme arbeiten mit einer pluralen Narrativität, insofern sich die parallelen Projektionen aufeinander beziehen, Schnittpunkte und Synchronizitäten hergestellt werden. Aitkens künstlerische Bezugspunkte liegen einerseits beim Expanded Cinema der 1960er-Jahre und dessen Versuch, mit Multi-Projektionen die visuelle Einbahnstraße des Kinoraums zu überwinden. Andererseits bezieht er seine Ästhetik von Hollywood-Produktionen, aber auch von Musikvideos, von denen er selbst einige gedreht hat, etwa für Iggy Pop und Fatboy Slim. Überraschend ist die mediale Bandbreite, innerhalb derer sich Aitkens künstlerische Arbeiten manifestieren. Auch wenn Outdoor-Multi-Projektionen und Fotografie die aktuellen Schwerpunkte sind, so konstruierte er mit *k-n-o-c-k-o-u-t* (2007) einen interaktiven Musiktisch und mit *silent pavilion* (2008) eine Architektur, deren Äußeres die Umgebung reflektiert und deren Inneres als schallabsorbierter Kontemplationsort genutzt werden kann. In ihm kann man dem diffusen Rauschen des Lebens entkommen, auf das Aitken mit vielen seiner Arbeiten so facettenreich reagiert.

Broken Screen : Expanding the Image, Breaking the Narrative est le titre d'un livre de Doug Aitken (2006) qui résume en même temps son programme artistique. Ce qui est brisé, c'est la surface de projection – les projections multi-écrans d'Aitken visent en effet à un élargissement de l'image qui produit un éclatement de la narration cinématographique habituelle. En l'occurrence, Aitken quitte l'intérieur du musée pour projeter ses images sur les façades. *sleepwalkers* (2007) projette en parallèle les actions de cinq personnes qui quittent le champ de leur normalité en exécutant des mouvements extatiques. Dans *migration* (2008), quatre projections présentent des espaces d'hôtels et de motels investis non pas par des hommes américains, mais par des animaux américains. Ses films d'Aitken travaillent sur une narration multiple : les projections parallèles se réfèrent les unes aux autres et génèrent des coïncidences et des synchronicités. Les références artistiques relèvent pour une part du cinéma élargi des années 1960 et de sa tentative de dépasser le sens unique visuel de la salle de cinéma. De plus, Aitken emprunte son esthétique aux productions hollywoodiennes, mais aussi au clip vidéo – il en a lui-même tourné quelques-uns, notamment pour Iggy Pop et Fatboy Slim. Les œuvres d'Aitken couvrent une large palette de médiums. Même si les projections multi-écrans en extérieur et la photographie constituent aujourd'hui la part principale de son travail, pour *k-n-o-c-k-o-u-t* (2007), Aitken a aussi mis au point une table musicale interactive, et pour *silent pavilion* (2008) une architecture dont l'extérieur reflète l'environnement et l'intérieur peut servir de lieu de contemplation insonorisé. L'on y échappe au bruit diffus de la vie, à laquelle Aitken réagit si diversement dans chacune de ses œuvres. H. L.

SELECTED EXHIBITIONS →
2008 *Life on Mars – 55th Carnegie International,* Carnegie Museum of Art, Pittsburgh **2007** *sleepwalkers: Doug Aitken,* MoMA, New York. *Mapping the City,* Stedelijk Museum, Amsterdam **2006** *Doug Aitken,* Aspen Art Museum, Aspen. *Doug Aitken,* The Parrish Art Museum, Southampton. *Doug Aitken: Broken Screen, Happenings,* New York and Los Angeles. *Ecotopia: The Second ICP Triennial of Photography and Video,* ICP, New York. **2005** *Doug Aitken,* Musée d'Art moderne de la Ville de Paris

SELECTED PUBLICATIONS →
2008 *Doug Aitken: 99 Cent Dreams,* Aspen Art Museum, Aspen **2007** *Doug Aitken: sleepwalkers,* MoMA, New York **2006** *Doug Aitken: Alpha,* JRP Ringier, Zürich. *Ecotopia: The Second ICP Triennial of Photography and Video,* ICP New York, Steidl, Göttingen, New York **2005** *Doug Aitken: Broken Screen: Expanding the Image, Breaking the Narrative. 26 Conversations with Doug Aitken,* Distributed Art Publishers, New York

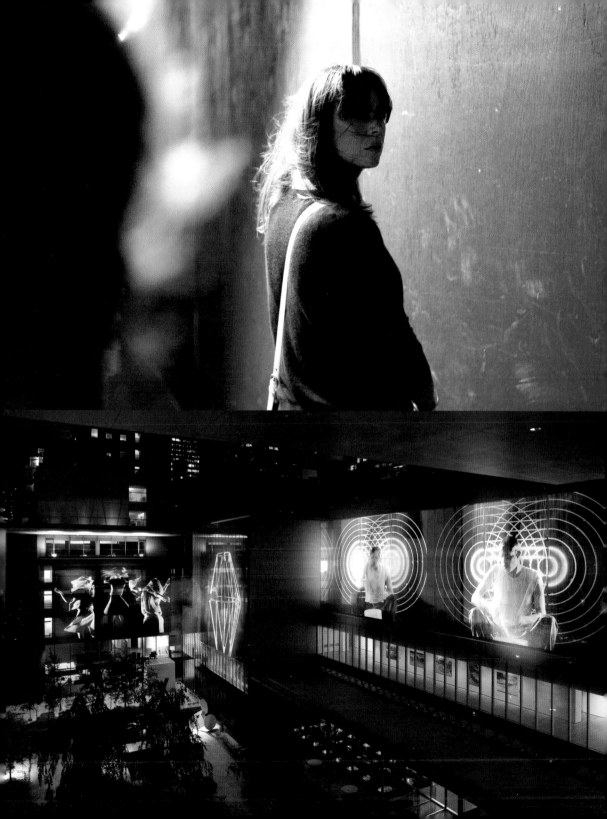

1 **sleepwalkers**, 2007, 6-channel video installation, dimensions variable
2 **sleepwalkers**, 2007, 6-channel video installation, dimensions variable. Installation view, MoMA, New York, 2007
3 **migration**, 2008, single-channel video installation with single or multiple site-specific projections or monitors, 18 min
4 **silent pavilion**, 2008, site-specific installation, dimensions variable, ca 458 x 610 x 1220 cm
5 **target**, 2008, C-print mounted on aluminium, 121.9 x 152.4 cm
6 **sunset stripped**, 2007, nitric acid, phosphoric acid on C-print, 121.9 x 152.4 cm

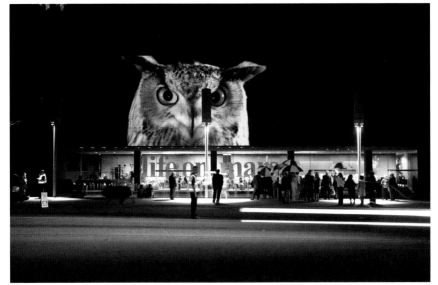

3

4

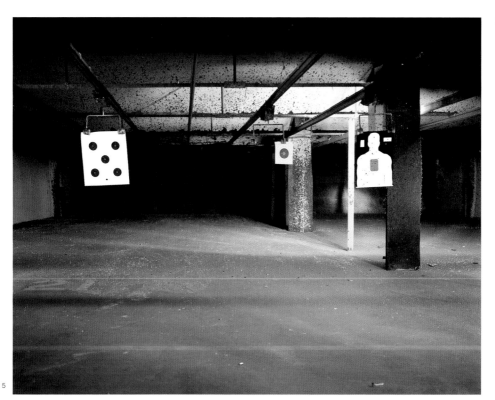

5

6

Darren Almond

1971 born in Wigan, lives and works in London, United Kingdom

Darren Almond's works are evocative explorations of temporal phenomena. Ranging from films devoted to specific periods of time, photographs taken with unusual exposure times and clock sculptures to installations about waiting, they examine different structures and perceptions of time. For the installation *Terminus* (2007), Almond took fourteen Socialist-era bus stops from Oświęcim (formerly Auschwitz), which were located near the memorial and museum at Auschwitz-Birkenau. They constitute a unique kind of waiting room; it is as if the historic experience of collectively waiting – either for freedom or death – had been condensed and preserved within them. Since 1998 Almond has been working on a photographic series entitled *Fifteen Minute Moons*, comprising landscape images shot during full moon nights with an exposure time of fifteen minutes. They have been captured in locations all over the world, with some of the most recent ones taken on the English coast in 2007. The artist's chosen method yields unusual colour and brightness values, making the images seem more like daylight shots. The nocturnal mood can still be felt, however, and lends the photographs a ghostly, otherworldly air. Devoid of people, the depicted landscapes are up to 400–600 million years old – they really are from another temporal world. Almond's interest in time structures has led him to create a number of film pieces dealing with routine working scenarios in extreme situations. The video *Bearing* (2007), for example, shows workers toiling in the dangerous, gruelling conditions of Indonesian sulphur mines. How does the extreme become routine? This is perhaps one of the key questions posed by Almond's diverse oeuvre.

Darren Almonds Arbeiten setzen sich auf unterschiedliche Weise mit Zeitphänomenen auseinander. Seien es Filme, die einer Zeitspanne gewidmet sind, Fotografien mit ungewöhnlicher Belichtungsdauer, Uhrenskulpturen oder Installationen mit Wartesituationen. Meist gehen sie verschiedenen Zeitstrukturen und Zeitwahrnehmungen nach. Für die Installation *Terminus* (2007) hat Almond 14 Bushaltestellen aus Oświęcim, ehemals Auschwitz, verwendet. Die Haltestellen stammen aus der Zeit des Sozialismus und befanden sich in der Nähe der Gedenkstätte und des Museums von Auschwitz-Birkenau. Sie eröffnen einen Warteraum der besonderen Art, als wäre in ihnen das historische, kollektive Warten auf Befreiung oder den Tod komprimiert erhalten geblieben. Seit 1998 beschäftigt sich Almond mit der Fotoserie *Fifteen Minute Moons*. Es handelt sich um Landschaftsbilder, bei denen die Belichtungszeit 15 Minuten bei Vollmond beträgt. Die Aufnahmen dafür erfolgten weltweit, einige der neuesten entstanden 2007 an der englischen Küste. Dabei wurden eigentümliche Farb- und Helligkeitswerte erzielt, welche die Bilder eher wie Tageslichtaufnahmen erscheinen lassen. In den Stimmungen jedoch sticht die Nacht durch, weshalb die Fotografien geisterhaft wirken, wie von einer anderen Welt. Die menschenleer aufgenommenen Landschaften sind bis zu 400–600 Millionen Jahre alt – sie stammen tatsächlich aus einer anderen Zeit-Welt. Almonds Interesse an Zeitstrukturen führt ihn immer wieder zu Arbeitsroutinen in Extremsituationen, die er filmisch erfasst. Zuletzt zeigte die Videoarbeit *Bearing* (2007) indonesische Schwefelminenarbeiter bei ihrer gefährlichen, extrem anstrengenden Arbeit. Wie kann das Extreme Routine werden? Vielleicht eine der wichtigsten Fragen, die Almond mit seinen verschiedenen Arbeiten stellt.

Les œuvres de Darren Almond abordent de différentes manières des phénomènes temporels – par des films portant sur une durée définie, des photographies résultant d'une exposition exceptionnellement longue, des sculptures à base d'horloges ou des installations comportant des situations d'attente – et suivent généralement plusieurs structures et perceptions temporelles. Pour l'installation *Terminus* (2007), Almond a utilisé quatorze abris-bus d'Oświęcim, anciennement Auschwitz. Les abris-bus datent de l'époque socialiste et se trouvaient près du mémorial et du musée d'Auschwitz-Birkenau. Ils instaurent une salle d'attente bien particulière, comme si l'attente historique et collective de la délivrance ou de la mort y était conservée de manière comprimée. Depuis 1998, Almond travaille sur la série photographique *Fifteen Minute Moons*, paysages photographiés les nuits de pleine lune avec une exposition de chaque fois quinze minutes. Les vues ont été prises dans le monde entier. Les plus récentes ont été réalisées en 2007 sur la côte anglaise. Les valeurs chromatiques et lumineuses très particulières résultant du procédé utilisé les font apparaître comme des vues diurnes plutôt que nocturnes, alors que les ambiances distillent des impressions de nuit qui confèrent aux images un aspect fantomatique, comme d'un autre monde. Les paysages déserts ont parfois entre 400 et 600 millions d'années et appartiennent donc réellement à un autre univers temporel. L'intérêt d'Almond pour les structures du temps le conduit régulièrement à des routines de travail en situation extrême qu'il capte cinématographiquement. Sa vidéo *Bearing* (2007) a récemment montré des ouvriers indonésiens travaillant dans des mines de soufre dans des conditions dangereuses et éreintantes. Comment l'extrême peut-il devenir routinier? Peut-être est-ce une des questions les plus importantes posées par les œuvres d'Almond. H. L.

SELECTED EXHIBITIONS →
2008 *Darren Almond: Fire under Snow*, Parasol Unit, London.
The Cinema Effect: Illusion, Reality and the Moving Image, Hirshhorn Museum and Sculpture Garden, Washington. **2007** *Darren Almond: Day Return*, Castle Ujazdowski – Center for Contemporary Art, Warsaw. **2006** *Darren Almond: Day Return*, Museum Folkwang Essen. *Darren Almond: If I Had You*, Domus Artium 2002, Salamanca. **2005** *Darren Almond: Isolation*, K21 Kunstsammlung Nordrhein-Westfalen, Düsseldorf. *Turner Prize 2005*, Tate Britain, London.

SELECTED PUBLICATIONS →
2008 *Darren Almond: Fire under Snow*, Parasol Unit, London. *Darren Almond: Moons of the Iapetus Ocean*, White Cube, London. **2007** *Darren Almond: Day Return*, Folkwang Museum Essen; Steidl, Göttingen. *Darren Almond: Journey Time*, Steidl, Göttingen. *Darren Almond: Terminus*, Galerie Max Hetzler, Berlin; White Cube, London; Holzwarth Publications, Berlin. **2006** *Carbonic Anhydride*, Galerie Max Hetzler, Berlin. **2005** *Darren Almond: 50 moons at a time*, K21 – Kunstsammlung Nordrhein-Westfalen, Düsseldorf.

1 **Infinite Betweens: Life Between, Phase 3**, 2008, C-print, 220 x 176 cm
2 **Sakura Fullmoon**, 2006, C-print mounted on aluminium, 121.2 x 121.2 cm
3 **Terminus**, 2007, 14 bus shelters, aluminium, steel, wood, fibreglass, PVC, 1 salt cast train plate, bus shelters 265 x 600 x 335 cm (each), plaque 25.5 x 179.5 x 2.5 cm. Installation view, Galerie Max Hetzler Temporary, OsramHöfe, Berlin

4 **Tide**, 2008, 600 digital wall clocks, Perspex, electro-mechanics, steel, vinyl, computerised electronic control system and components, 31.2 x 18.2 x 14.2 cm (each)

„Besonders bin ich an Transportmitteln interessiert, sie sind ein Medium, durch das wir Kultur und Erinnerung verstehen können. Fließende und organisierte Systeme wie Zeit und Transport sind Instrumente, um Gedächtnis und Geschichte zu ordnen."

« Je suis très intéressé par le transport comme moyen permettant de comprendre notre culture et notre mémoire. Les systèmes de flux et d'organisation comme le temps et le transport sont des moyens ordonnateurs qui façonnent notre mémoire et notre histoire. »

"I am very interested in transport as a medium through which we can understand culture and memory. Systems of flow and organization, like time and transport, are ordering mediums that shape our memory and history."

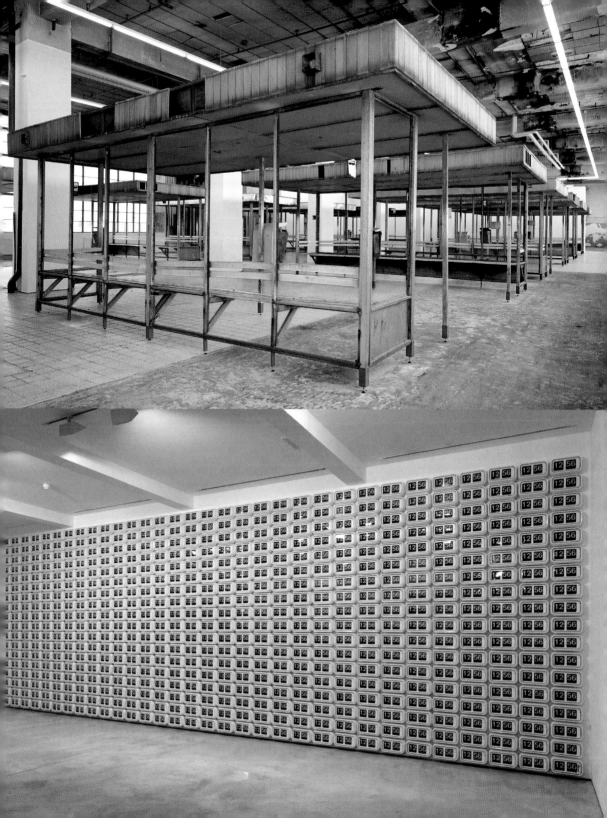

David Altmejd

1974 born in Montreal, Canada, lives and works in New York (NY), USA

David Altmejd is known for sculptures and installations that recall natural history dioramas and surreal cabinets of curiosities. For one of his most recent exhibitions, Altmejd constellated the gallery space with nine larger-than-life figures that resembled mythological creatures from outer space. Altmejd's titans – like most of his sculptures – are handmade and combine different materials such as mirrors, taxidermied animals or furs. Some of them, for example *The Quail* (2008), are covered with reflective surfaces, which turn them into more abstract sculptures. Others, like *The Center* (2008), are decorated with fake plants and organic materials that confer a sense of decay. Highly crafted but roughly finished, Altmejd's mutant colossi inhabit a world of hybrids, where the distance between animal and human is finally blurred. In several works on the werewolf, he adds a darker side to this world, as the werewolf is not only half human half animal but can also be seen as a metaphor for the struggle between good and evil. Decapitated werewolf heads also featured in *The Index* (2007), Altmejd's complex installation for the Canadian pavilion at the 52nd Venice Biennale, which transformed the exhibition space into the laboratory of a mad scientist guarded by *The Giant* (2007), a massive statue of a Goliath-like monster. Tropical plants, stuffed animals, plastic trees, human organs and bird-headed men shaped a nightmarish universe in continuous growth. Altmejd is often associated with a neo-gothic sensibility, although his work is also embedded with references to minimalism, updated by a visionary, at times grotesque sensuality.

David Altmejd ist für Skulpturen und Installationen bekannt, die wie naturhistorische Dioramen und surreale Gruselkabinette anmuten. Anlässlich einer aktuellen Ausstellung stellte Altmejd neun überlebensgroße Figuren in den Raum, die an mythische Wesen aus dem All denken ließen. Altmejds Titanen sind – wie die Mehrheit seiner Skulpturen – handgemacht und kombinieren verschiedene Materialien wie Spiegel, präparierte Tierkörper oder auch Tierfelle. Manche davon, etwa *The Quail* (2008), werden durch ihre verspiegelten Oberflächen eher abstrakte Skulpturen. Andere, wie *The Center* (2008), sind mit künstlichen Pflanzen und organischen Materialien dekoriert, was den Verfall mit ins Spiel bringt. Altmejds kunstvolle, aber grob vollendete Riesenmutanten bevölkern eine Welt voller Mischwesen, in denen die Grenzen zwischen Mensch und Tier verwischt sind. In mehreren Arbeiten über die Figur des Werwolfs fügt er diesem Reich noch eine düstere Komponente hinzu, da der Werwolf, halb Mensch und halb Tier, auch eine Metapher für den Kampf zwischen Gut und Böse ist. Abgehackte Werwolfköpfe waren denn auch im Zentrum von Altmejds vielschichtiger Installation *The Index* (2007) für den kanadischen Pavillon auf der 52. Biennale in Venedig, die den Ausstellungsraum, bewacht von der mächtigen Statue eines Monster-Goliaths, *The Giant* (2007), in das Labor eines irren Wissenschaftlers verwandelte. Tropische Pflanzen, ausgestopfte Tiere, Plastikbäume, menschliche Organe und Vogelkopf-Männer fügten sich zu einem alptraumhaften, wild wuchernden Universum. Altmejd wird häufig eine Tendenz zur Schauerromantik nachgesagt, dennoch enthält sein Œuvre auch Referenzen an den Minimalismus, den er durch eine visionäre, zuweilen groteske Sinnlichkeit aktualisiert hat.

David Altmejd est connu pour ses sculptures et installations qui rappellent les dioramas des musées d'histoire naturelle ou les cabinets de curiosités surréalistes. À l'occasion d'une exposition récente, il a constellé l'espace d'une galerie de neuf figures géantes s'apparentant à des créatures mythologiques extraterrestres. Les titans d'Altmejd, comme la plupart de ses sculptures, sont réalisés à la main à partir de matériaux aussi divers que des miroirs, des animaux empaillés ou de la fourrure. Certaines pièces, comme *The Quail* (2008), sont recouvertes de surfaces réfléchissantes qui les rapprochent de sculptures abstraites. D'autres, comme *The Center* (2008), sont décorées de plantes artificielles et de matériaux organiques qui les font paraître en état de décomposition. De fabrication complexe malgré leur finition grossière, les colosses mutants d'Altmejd habitent un monde d'êtres hybrides, où la distinction entre l'homme et l'animal est brouillée. Dans plusieurs travaux sur le loup-garou, cet univers révèle une face plus sombre : le loup-garou n'est pas seulement mi-homme, mi-animal, mais également une métaphore de la lutte entre le bien et le mal. Des têtes de loups-garous décapités figurent également dans *The Index* (2007), l'installation complexe d'Altmejd pour le pavillon canadien de la 52ᵉ Biennale de Venise ; l'espace d'exposition y devenait le laboratoire d'un savant fou, sous la surveillance de *The Giant* (2007), une immense statue d'un monstre aux allures de Goliath. Plantes tropicales, animaux empaillés, arbres en plastique, organes humains et hommes à tête d'oiseau créaient un univers en perpétuelle évolution. Si l'on attribue souvent à Altmejd une sensibilité néo-gothique, son œuvre est également truffée de références au minimalisme – mais un minimalisme associé à une sensualité visionnaire et parfois grotesque.

C. A.

SELECTED EXHIBITIONS →
2008 *David Altmejd*, Museum De Pont, Tilburg. *Freeway Balconies*, Deutsche Guggenheim, Berlin **2007** *David Altmejd*, Canadian Pavilion, 52nd Venice Biennial, Venice. *David Altmejd*, Illingworth Kerr Gallery, Alberta College of Art & Design, Calgary. *David Altmejd: Stages*, Fundació La Caixa, Barcelona. *David Altmejd: Métamorphose Metamorphosis*, Oakville Galleries, Ontario; Galerie de l'Uqam, Montreal **2006** *Six Feet Under*, Kunstmuseum Bern **2005** *Wunschwelten*, Schirn Kunsthalle, Frankfurt am Main

SELECTED PUBLICATIONS →
2008 *Collier Schorr: Freeway Balconies*, Deutsche Guggenheim, Berlin **2007** *David Altmejd: The Index*, The National Gallery of Canada, Ottawa. *David Altmejd*, Galerie de l'Uqam, Montreal **2006** *Six Feet Under*, Kunstmuseum Bern, Bern **2005** *Wunschwelten / Ideal Worlds*, Schirn Kunsthalle, Frankfurt am Main; Hatje Cantz, Ostfildern

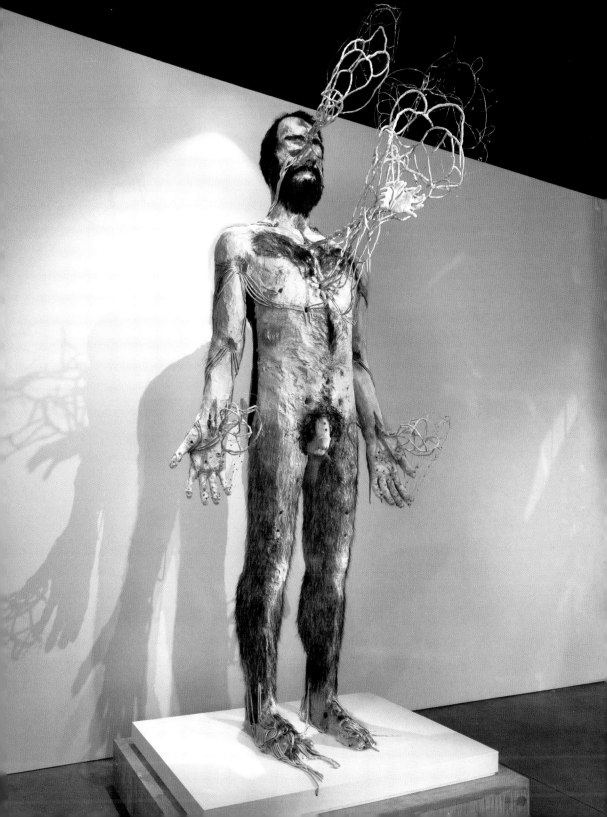

1 **The Spiderman**, 2008, wood, foam, epoxy clay, epoxy resin, horse hair, paint, metal wire, glass beads, plaster, glass, glitter, 389 x 183 x 173 cm
2 **The Center**, 2008, wood, foam, epoxy clay, resin, horsehair, metal wire, paint, mirror, glass beads, plaster, glue, feathers, glass eyes, 358 x 183 x 122 cm
3 **The Quail**, 2008, wood, mirror, glue, quail eggs, 354 x 104 x 64 cm
4 **The Index**, 2007 (detail), mixed media, 333 x 1297 x 923 cm. Installation view, Canadian Pavilion, 52. Biennale di Venezia, Venice

„Meine Arbeit soll hoffnungsfroh und verführerisch sein. Die Geschöpfe in meinem Werk verwesen nicht, sie kristallisieren. So stehen die Geschichten, die meine Werke erzählen, dem Leben näher als dem Tod."

« Ce que je fais doit être positif et séduisant. Dans mon œuvre, les personnages ne pourrissent pas : ils cristallisent. Les histoires racontées ont pour horizon la vie, non la mort. »

"What I make has to be positive and seductive. Instead of rotting, the characters in my work are crystallizing. This makes the narratives of the pieces move towards life rather than death."

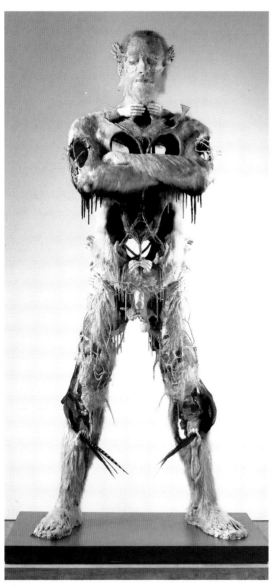

2

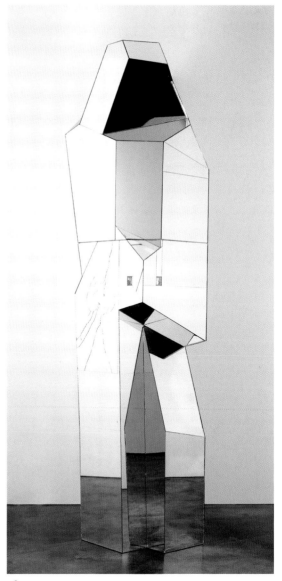

3

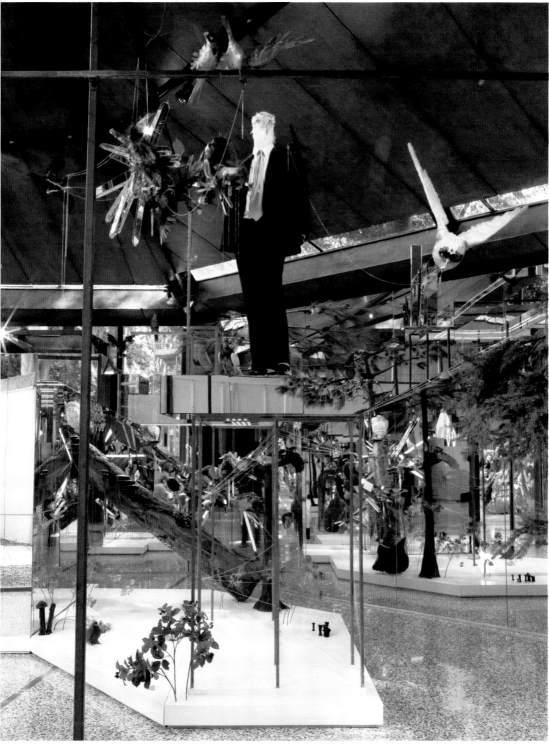

Banksy

While Banksy's identity remains a mystery, his irreverent interventions in the public sphere are anything but anonymous and have been vigorously embraced by the contemporary art world, media and general public alike. Following a trajectory previously carved out by artists such as Jean-Michel Basquiat and Keith Haring in the 1980s, Banksy brings the languages of traditional graffiti writing into the rarefied environs of art discourse and the auction house where his works have sold for staggering sums. Using a characteristic stencil technique which allows him to execute his graffiti works quickly and accurately, his subjects – from a pair of kissing policemen and armed rats to iconic moments taken from film and art history – are often paired with humorous slogans and pose wry critiques of capitalism, war and the establishment. In recent years Banksy has developed his graffiti works with large-scale sculptural interventions that play with images of urban decay and obsolescence as well as toying with traditional notions of public sculpture with comically altered versions of well-known works: Rodin's The Thinker with a traffic cone for a hat or a raunchy re-invention of the figure of "Justice" hitching her skirt to reveal a thong, garter stuffed with a dollar bill and PVC boots. While the guerrilla hanging of his own parody-ridden works in London's British Museum or New York's Metropolitan Museum of Art reflect on the antagonism between sanctioned institutions of art and the unlawful nature of his practice in the public sphere, these headline-grabbing interventions reveal the media itself, not the street or gallery, to be Banksy's primary context.

Bisher hat Banksy das Geheimnis um seine Person wahren können, doch seine respektlosen Interventionen im öffentlichen Raum bleiben beileibe nicht anonym und finden in der zeitgenössischen Kunst- und Medienwelt und vor allem in der Öffentlichkeit sehr lebhaftes Interesse. Banksy folgt den in den 1980ern von Künstlern wie Jean-Michel Basquiat und Keith Haring gelegten Spuren und bringt die Ausdrucksformen des traditionellen Graffiti-Writing in den exklusiven Bereich des Kunstbetriebs und der Auktionshäuser, wo seine Werke für Unsummen verkauft werden. Seine charakteristische Schablonentechnik ermöglicht ihm eine rasche, präzise Ausführung seiner Graffiti; seine Sujets – zwei sich küssende Polizisten, bewaffnete Ratten oder Höhepunkte aus der Film- und Kunstgeschichte – stellen, oft mit witzigen Sprüchen gepaart, eine sarkastische Kritik an Kapitalismus, Krieg und Establishment dar. In den letzten Jahren hat Banksy seine Graffitikunst in großen skulpturalen Aktionen weiterentwickelt und spielt mit Erscheinungsformen des Verfalls und der Überalterung der Städte oder macht sich über traditionelle Vorstellungen von öffentlicher Skulptur lustig, indem er bekannte Werke persifliert: Rodins Denker bekommt einen Verkehrskegel als Hut, und eine provokante Neuinterpretation der Justitia trägt Plastikboots, hebt ihren Rock und enthüllt ein Strumpfband mit einer Dollarnote darunter. Während seine Guerilla-Aktionen, bei denen er parodistische Werke ins British Museum in London und das Metropolitan Museum of Art in New York hängte, den Widerspruch zwischen sanktionierten Kunstinstitutionen und den eigenen illegalen Aktionen im öffentlichen Raum reflektieren, zeigen seine provozierenden, schlagzeilenträchtigen Interventionen, dass Banksy nicht nur auf der Straße oder in der Galerie, sondern mehr noch im medialen Kontext existiert.

Si l'identité de Banksy demeure un mystère, ses interventions impertinentes dans la sphère publique n'ont rien d'anonyme et reçoivent un accueil enthousiaste aussi bien de la part du monde de l'art contemporain que des médias ou du grand public. Suivant un parcours dessiné dans les années 1980 par des artistes comme Jean-Michel Basquiat ou Keith Haring, Banksy importe le langage traditionnel du graffiti dans les hautes sphères du discours artistique et de la vente aux enchères, où le prix de ses œuvres atteint des sommes colossales. Usant d'une technique classique au pochoir, qui lui permet d'exécuter ses graffitis avec autant de rapidité que de précision, il enrichit souvent ses sujets – tels que policiers en train de s'embrasser, rats bardés d'armes à feu, scènes clés tirées du cinéma ou de l'histoire de l'art – de slogans critiquant avec un humour noir le capitalisme, la guerre ou l'ordre établi. Depuis quelques années, Banksy associe son travail sur le graffiti à des interventions sculpturales à grande échelle, dans lesquelles il met en scène le déclin et l'obsolescence des villes en jouant avec la conception traditionnelle de la sculpture publique – des œuvres célèbres sont ainsi détournées avec humour, tel Le Penseur de Rodin coiffé d'un cône de balisage orange, ou une allégorie de la Justice soulevant sa robe pour exhiber un string, une jarretière dont dépasse un billet d'un dollar et des bottes en caoutchouc. Si l'accrochage sauvage de ses œuvres parodiques, au British Museum de Londres ou au Metropolitan Museum of Art de New York, reflète l'antagonisme entre les institutions artistiques officielles et la nature illicite de sa propre pratique dans la sphère publique, de telles interventions – systématiquement relayées par la presse – révèlent que les médias, plus encore que la rue ou la galerie d'art, constituent désormais le cadre primordial de son œuvre. A. B.

SELECTED EXHIBITIONS →
2008 Call it what you like! Collection Rik Reinking, Art Centre Silkeborg Bad. Radical Advertising, NRW-Forum, Düsseldorf **2007** Warhol vs. Banksy, Pollock Fine Art, London **2006** In the darkest hour there may be light, Serpentine Gallery, London. Spank the Monkey, BALTIC Centre for Contemporary Art, Gateshead. Minimal Illusions – Arbeiten mit der Sammlung Rik Reinking, Galerien der Stadt Esslingen

SELECTED PUBLICATIONS →
2007 Steve Wright: Banksy's Bristol: Home Sweet Home, Tangent Books, Bristol. Christian Hundertmark: The Art of Rebellion 2 The World of Urban Art Activism, Publikat, Mainaschaff **2006** Martin R. Bull: Banksy Locations and Tours: A Collection of Graffiti Locations and Photographs in London, Shell Shock Publishing, London. In the darkest hour there may be light, Serpentine Gallery; Other Criteria, London **2005** Banksy: Wall and Piece, Century, London

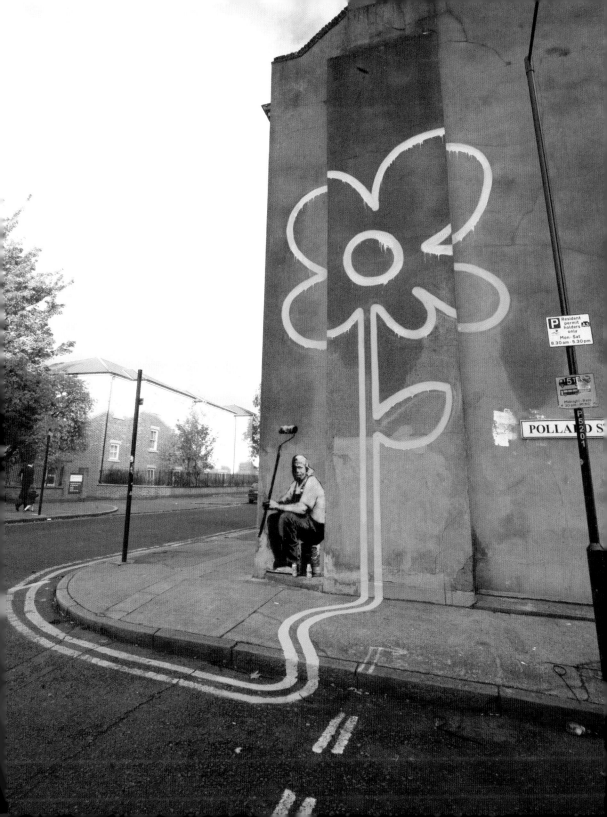

1 **Flower**, 2007, Pollar Street, London
2 **Artiste**, 2007, London

„Mir wird beim Gedanken an das Geld, das meine Arbeiten inzwischen erbringen, schon ein bisschen unbehaglich, aber das Problem lässt sich einfach lösen – nicht meckern sondern alles verschenken. Es ist nicht möglich, Kunst über Armut zu machen und dann all das Geld einzustecken, das wäre sogar mir zu ironisch. Ich mag es, wie der Kapitalismus sogar für seine Feinde noch ein Plätzchen findet."

« L'argent que mon œuvre rapporte en ce moment me met un peu mal à l'aise, mais c'est un problème qui se résout facilement – on arrête de geindre et on le distribue. Je ne pense pas qu'on puisse faire de l'art à propos de la pauvreté tout en empochant les billets, c'est pousser un peu loin l'ironie, même pour moi. J'adore la manière dont le capitalisme trouve une place, même pour ses ennemis. »

"The money that my work fetches these days makes me a bit uncomfortable, but that's an easy problem to solve – you just stop whingeing and give it all away. I don't think it's possible to make art about world poverty and then trouser all the cash, that's an irony too far, even for me. I love the way capitalism finds a place even for its enemies."

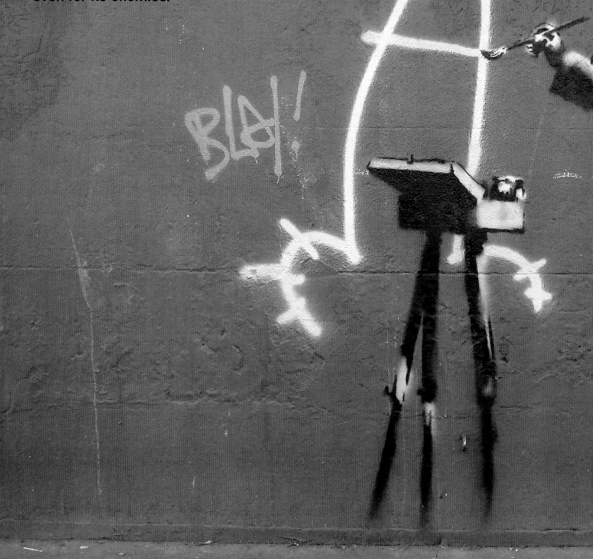

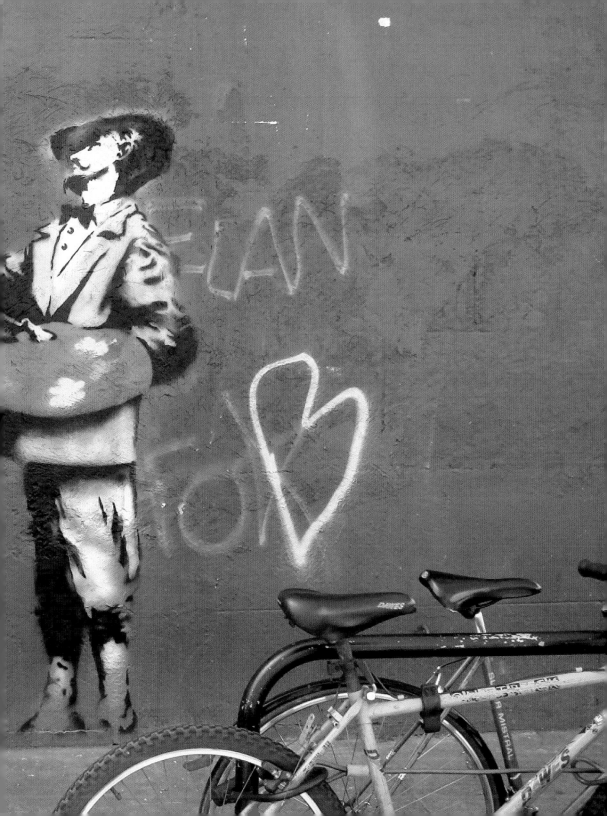

Matthew Barney

1967 born in San Francisco (CA), lives and works in New York (NY), USA

Matthew Barney didn't rest on his laurels after wrapping up the five films of his *Cremaster Cycle* (1994–2002) and an eponymous travelling exhibition. Instead, he came up with another intricately crafted, multi-sensory feature-length film. *Drawing Restraint 9* (2005) takes up the themes of resistance, physicality and mark-making that Barney has been exploring in his *Drawing Restraint* series of performances and works since 1998. The film stars Barney and pop musician Björk (who also composed the score) as "Occidental Guests" on a Japanese whaling ship whose cargo includes vast quantities of liquid petroleum jelly poured into a mould shaped like the artist's emblem: an oval field with a horizontal bar through it. As the vessel glides into colder waters and the petroleum jelly solidifies, the bar is removed, indicating the elimination of restraint, and the individuals, united during an elaborate Japanese tea ceremony, undergo a stunning physical and metaphorical sea change. Parallel to the *Drawing Restraint* series, Barney's provocative stage performance *Guardian of the Veil* (2007) – a collaboration with Jonathan Bepler that incorporates a live bull, a urinating contortionist, balaclava-wearing pall bearers and an automobile – draws on the *Cremaster Cycle* and meditates on the after-life. With astonishing formal originality and conceptual rigor, Barney's work at once tethers and liberates sexual energy and physical discipline, drawing inspiration from horror movies and video art as well as from the dance films of Busby Berkeley. This constant movement between restraint and release enables him to harness those elements as forces of sheer creative potential.

Anstatt sich auf seinen Lorbeeren auszuruhen, präsentierte Matthew Barney nach seinem fünfteiligen Filmzyklus *The Cremaster Cycle* (1994–2002) und einer gleichnamigen Wanderausstellung einen weiteren abendfüllenden, dicht gewebten, multisensorischen Film. *Drawing Restraint 9* (2005) greift die Themen von Widerstand, Körperlichkeit und Zeichen-Setzung auf, die Barney in den Performances und anderen Arbeiten seiner Serie *Drawing Restraint* seit 1998 untersucht hat. Der Film zeigt ihn mit der Popsängerin Björk (sie komponierte auch den Soundtrack) als „Gäste aus dem Okzident" auf einem japanischen Walfangschiff, das eine riesige Ladung flüssiger Vaseline an Deck hat, wobei der Containerform dem Emblem des Künstlers nachempfunden ist (ein von einem Querbalken gekreuztes Oval). Während das Schiff durch kältere Gewässer gleitet, geht die Vaseline in festen Aggregatzustand über; der horizontale Balken wird entfernt und alle Beschränkung ist aufgehoben: Die in einer kunstvollen japanischen Teezeremonie vereinten Gäste unterziehen sich einer wundersamen körperlichen und metaphorischen Verwandlung. Parallel zu der Serie *Drawing Restraint* entwickelte Barney Motive aus dem *Cremaster* Zyklus für seine gemeinsam mit Jonathan Bepler geschaffene, provozierende Bühnenperformance *Guardian of the Veil* (2007) weiter – eine Meditation über das Leben nach dem Tod, die einen lebenden Bullen, einen urinierenden Schlangenmenschen, Leichenträger mit Sturmhauben und ein Automobil kombiniert. Mit hoher formalstilistischer Originalität und konzeptueller Strenge erzeugt Barney ein Kraftfeld aus sexueller Energie und Körperdisziplin, inspiriert von Horrorfilmen, Videokunst und Busby Berkeleys Tanzfilmen. Durch den ständigen Fluss von An- und Entspannung werden diese Elemente als reines Kreativitätspotenzial genutzt.

Après avoir achevé les cinq films de son *Cremaster Cycle* (1994–2002) et l'exposition itinérante du même nom, Matthew Barney ne s'est pas reposé sur ses lauriers. Bien au contraire, il a imaginé un nouveau long métrage multisensoriel, d'une grande complexité. *Drawing Restraint 9* (2005) reprend les thèmes de la résistance, de la corporalité et de l'empreinte que Barney explore depuis 1998 dans la série de performances et d'œuvres regroupées sous le titre *Drawing Restraint*. Barney joue le rôle principal du film aux côtés de la musicienne pop Björk (qui en a composé la bande originale). Ils sont les « passagers occidentaux » d'un baleinier japonais dont la cargaison comporte de vastes quantités de vaseline liquide déposées dans un moule dont la forme reprend l'emblème de l'artiste : un ovale traversé d'une barre horizontale. Lorsque le vaisseau s'avance dans des eaux plus froides et que la vaseline se solidifie, la barre horizontale est retirée, symbolisant l'élimination de la contrainte. Les invités, unis au cours d'une cérémonie japonaise du thé, subissent alors une transformation physique et métaphorique radicale. En parallèle à la série *Drawing Restraint*, la performance théâtrale intitulée *Guardian of the Veil* (2007) – une collaboration avec Jonathan Bepler comprenant entre autres un taureau vivant, un contortioniste incontinent, des porteurs de cerceuils encagoulés et une automobile – s'inspire du *Cremaster Cycle* et développe une méditation sur l'au-delà. Alliant rigueur conceptuelle et originalité formelle étonnante, le travail de Barney dompte et déchaîne tout à la fois les pulsions sexuelles et la discipline du corps, en s'inspirant de sources aussi diverses que les films d'horreur, l'art vidéo et les films de danse de Busby Berkeley. Le mouvement constant entre retenue et défoulement permet à l'artiste de maîtriser et d'exploiter ces éléments telles des forces de pure potentialité créatrice. C. Es.

SELECTED EXHIBITIONS →
2008 *Matthew Barney: Drawing Restraint*, Kunsthalle Wien, Vienna **2007** *Matthew Barney*, Sammlung Goetz, Munich. *Matthew Barney – Kaiserringträger der Stadt Goslar 2007*, Mönchehaus-Museum, Goslar. *Matthew Barney*, Serpentine Gallery, London. *Mythos: Joseph Beuys, Matthew Barney, Douglas Gordon, Cy Twombly*, Kunsthaus Bregenz **2006** *Barney Beuys*, Deutsche Guggenheim, Berlin **2005** *Matthew Barney: Drawing Restraint*, 21st Century Museum of Contemporary Art, Kanazawa

SELECTED PUBLICATIONS →
2008 *Matthew Barney: Drawing Restraint Vol. 5*, Verlag der Buchhandlung Walther König, Cologne. *Matthew Barney*, Sammlung Goetz, Munich **2007** *Matthew Barney*, Mondadori, Milan. *Matthew Barney: Träger des Goslarer Kaiserrings 2007*, Mönchehaus-Museum, Goslar. *Mythos: Joseph Beuys, Matthew Barney, Douglas Gordon, Cy Twombly*, Kunsthaus Bregenz, Bregenz **2006** *Barney Beuys: All in the Present Must Be Transformed*. Deutsche Guggenheim, Berlin; Hatje Cantz, Ostfildern

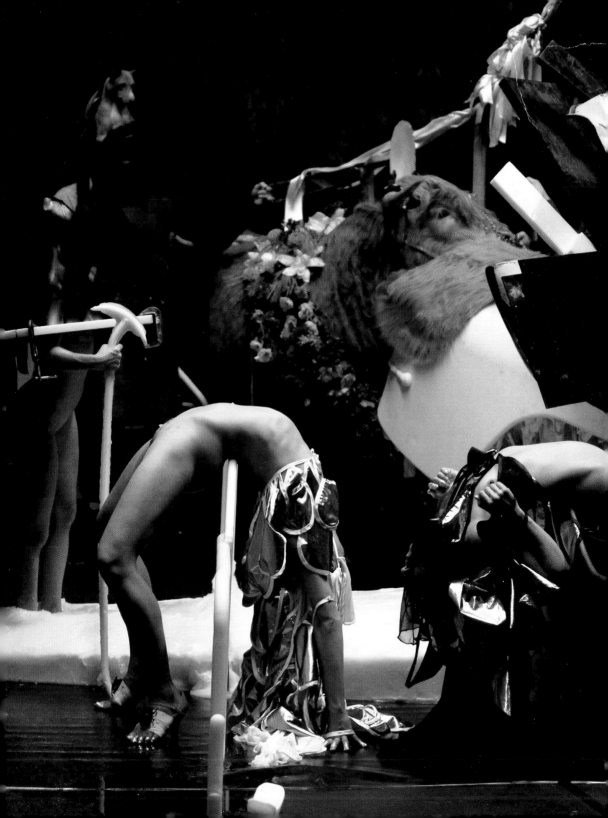

1 **Guardian of the Veil**, 2007, in collaboration with Jonathan Bepler
2–4 **Drawing Restraint 9**, 2005, production stills

„Ich glaube, bei vielen Entscheidungen in Bezug auf Dauer und Gewichtung geht es darum, einen Organismus darzustellen, der seinen eigenen Puls und sein eigenes Verhalten hat. Und das ist es, was mich immer wieder zum Medium Film zurückbringt."

« Je pense qu'un grand nombre de décisions prises sur le plan de la durée et de l'équilibre participent d'un effort de décrire un organisme ayant son propre pouls et son propre comportement. C'est ce qui me fait sans cesse revenir au procédé cinématographique. »

"I think a lot of the decisions that are made in regards to duration and balance are about trying to describe an organism that has its own pulse and that has its own behaviour. It's something that keeps me coming back to the filmmaking process."

2

3

Cosima von Bonin

1962 born in Mombasa, Kenya, lives and works in Cologne, Germany

Cosima von Bonin is a "prominent representative of conceptual art who works with textiles, films, installations and social relations, among other media," according to wikipedia.de. This may sound rather vague and arbitrary, but in its very openness it hits the nail on the head. Von Bonin combines different genres, materials and social networks to produce striking imagery. Throughout her career she has used collaboration with other artists as a creative process, even going so far as to cede exhibitions to them (*Ingeborg Gabriel*, 1992) – but still, it must be noted, as her own work. Social coding is thus an integral part of her oeuvre. In recent works, the exploration of textile processes, sculpture and the aesthetics of architecture and design has become increasingly central to her practice. Her use of materials entails the displacement and association of diverse cultural codes: combining patterned fabrics by Laura Ashley or Hermès into a soft tableau, or turning plain grey or black cloth into plump sculptures of dogs. Hers is a patchwork minimalism that crosses modernist gestures with fashionable expressions to create its own ironic idiom. Lately this has included cartoon-like animal figures and reduced plots, as in *Deprionen, A Voyage to the Sea* (2006). The combination of formalism and pop is characterized by an expressive diversity of material. Von Bonin also incorporates her works into installations such as *Relax – It's Only a Ghost* (2006), last shown at Documenta 12, or *Roger and Out* (2007). Providing diverse outlooks and insights, her displays include obstacles or enclosures – hurdles that have to be overcome before the viewer can enjoy the experience.

Cosima von Bonin ist „eine prominente Vertreterin der Konzeptkunst und arbeitet u.a. mit Textilien, Filmen, Installationen und sozialen Beziehungen", weiß wikipedia.de. Das klingt vage zusammengewürfelt, trifft in dieser Offenheit aber durchaus zu. Denn indem von Bonin ganz unterschiedliche Gattungen, Materialien sowie soziale Netzwerke verknüpft, schafft sie eine markante Bildwelt. Von Beginn an nutzte von Bonin die Zusammenarbeit mit Künstlern als Verfahren und ging dabei sogar so weit, ihnen den Auftritt gleich komplett zu überlassen (*Ingeborg Gabriel*, 1992). Als eigene Arbeit, wohlgemerkt. Soziale Codierung wird so zum Werkbestandteil. In ihren neueren Arbeiten steht die Auseinandersetzung mit textilen Verfahren, Skulptur sowie Design- und Architekturästhetik im Zentrum. Ihr Umgang mit Material setzt dabei auf Verschiebung und Verknüpfung diverser kultureller Codes. Da werden etwa gemusterte Stoffe von Laura Ashley oder Hermès zum soften Tafelbild oder schlichtes Grau und Schwarz zu pummeligen Hundeskulpturen (2006) vernäht: Ein Patchwork-Minimalismus, der Attitüden der Moderne karikierend mit Modismen kreuzt und daraus ein eigenes ironisches Idiom gewinnt. Darin tauchen neuerdings verstärkt comichafte Tierfiguren und ein reduzierter Plot auf, etwa in *Deprionen, A Voyage to the Sea* (2006). Die Kombination von Formalismus und Pop ist gekennzeichnet von effektvoller Materialvielfalt, wobei von Bonin ihre Arbeiten in Displays einbindet, etwa bei der zuletzt auf der Documenta 12 gezeigten Installation *Relax – It's Only a Ghost* (2006) oder bei *Roger and Out* (2007). Die Displays vermitteln Aus- und Einsichten, nehmen die Form von Hindernissen und Gattern an und erzeugen somit Ausstellungsbedingungen, die sich der Betrachter erst erobern muss.

Cosima von Bonin, « représentante majeure de l'art conceptuel, travaille notamment avec des tissus, des films, des installations et des contextes sociaux », nous apprend wikipedia.de. Si cette description plutôt vague s'apparente à un pêle-mêle, elle n'en est pas moins pertinente par son ouverture. En combinant médiums, matériaux et réseaux sociaux hétéroclites, von Bonin construit des univers visuels marquants. Dès ses débuts, l'artiste a exploité la collaboration avec d'autres comme un procédé créatif, poussant même la démarche jusqu'à leur laisser toute la place (*Ingeborg Gabriel*, 1992) – comme un travail personnel, s'entend. Le codage social devient ainsi une composante de l'œuvre. Dans son travail récent, l'accent porte plutôt sur la confrontation avec des procédés textiles, des sculptures, l'esthétique du design et de l'architecture. Le maniement des matériaux mise sur le décalage et le mélange des codes culturels : des tissus de grands couturiers deviennent des tableaux mous, un simple tissu gris ou noir devient une sculpture canine potelée (2006), patchwork minimaliste qui croise caricaturalement les modes et les positions de la modernité pour en tirer un idiome personnel ironique. Récemment apparaissent de plus en plus souvent des figures animales proches de la BD et des intrigues embryonnaires comme dans *Deprionen, A Voyage to the Sea* (2006). La combinaison entre formalisme et pop est caractérisée par une efficiente diversité de matériaux, sachant que von Bonin confine ses œuvres dans des présentoirs, comme on l'a vu à la Documenta 12 avec l'installation *Relax – It's Only a Ghost* (2006) ou avec *Roger and Out* (2007). Les présentoirs créent des vues extérieures et intérieures, prennent la forme d'obstacles ou de clôtures et créent des conditions d'exposition que le spectateur doit d'abord s'approprier.

J. A.

SELECTED EXHIBITIONS →
2008 *Betwixt*, Magasin 3 Stockholm Konsthall, Stockholm. *Vertrautes Terrain – Aktuelle Kunst in und über Deutschland*, ZKM, Karlsruhe **2007** *Cosima von Bonin: Roger and Out*, MOCA, Los Angeles. *Documenta 12*, Kassel **2006** *Make Your Own Life: Artists in and out of Cologne*, ICA, Philadelphia; The Power Plant, Toronto; Henry Art Gallery, Seattle; MOCA, North Miami **2005** *It takes some time to open an oyster*, Centro Cultural Andratx **2004** *Cosima von Bonin*, Kölnischer Kunstverein, Cologne

SELECTED PUBLICATIONS →
2008 Christian Jankowski, Cosima von Bonin, Ai Weiwei, *Parkett 81*, Zürich. *Vertrautes Terrain – Aktuelle Kunst in und über Deutschland*, ZKM, Karlsruhe **2007** *Cosima von Bonin: Roger and Out*, MOCA, Los Angeles; Verlag der Buchhandlung Walther König, Cologne. *Documenta 12 Catalogue*, Taschen, Cologne **2006** *Make Your Own Life: Artists in and out of Cologne*, ICA, Philadelphia

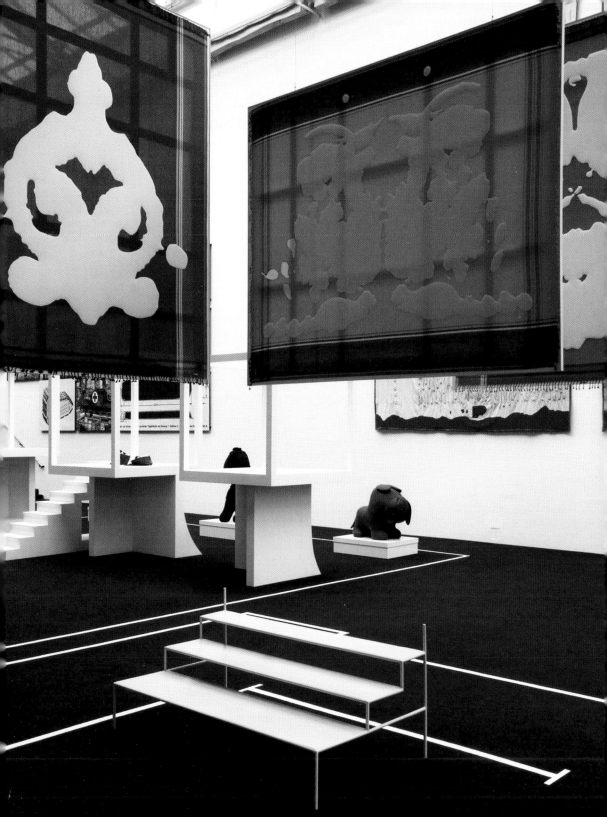

1 Installation view, Documenta 12, Kassel, 2007
2 **Deprionen, A Voyage to the Sea**, 2006, cotton, linen, 319 x 357 cm
3 **Reference Hell #2 (Mighty Mouse)**, 2007, powdercoated steel, soft toy,
 170 x 150 x 90 cm

4 **Decoy (Der Krake #3)**, 2007, mixed media, 65 x 235 x 330 cm
5 **England (Hut #1)**, 2007, lacquered wood panels, roofing cardboard,
 196 x 162 x 162 cm. Installation view, *Cosima von Bonin: Roger and Out*,
 MOCA, Los Angeles, 2007/08

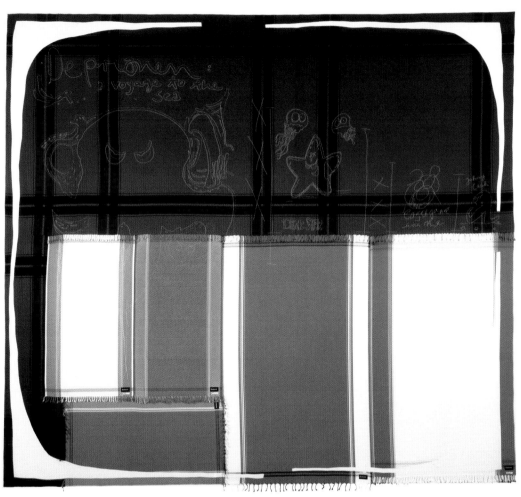

2

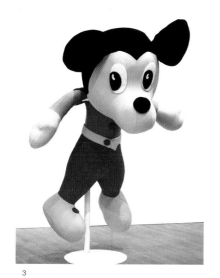

3

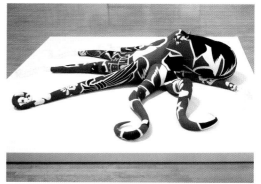

4

Cecily Brown

1969 born in London, United Kingdom, lives and works in New York (NY), USA

Cecily Brown's paintings slip almost imperceptibly between paint and depicted form, figuration and utter abstraction. The artist conjures bodily tempests that owe as much to Willem de Kooning (who, after all, lasciviously maintained that "flesh was the reason oil paint was invented") as to other strange bedfellows – Goya and Velázquez, Poussin and Cézanne, Francis Bacon and John Currin. Despite the startlingly precocious degree to which Brown has assimilated these historical and contemporary references, her distinctly irony-free approach is neither subtended by Oedipal fantasies nor subdued by an anxiety of influence. If anything, Brown has painted as she sees fit, transmuting paint into viscous bodily matter wherever she can: teeth and abject thighs, glimpses of lovers in various stages of copulation, orgies and climaxes exist alongside winged phalluses, supine nudes, pastoral landscapes, sylvan bacchanals and even a feverish celebration of a woman's new shoes, the aptly titled *New Louboutin Pumps* (2005). As this painting makes clear, the cheap thrills of the bad girl sex scenes for which she gained notoriety (following quickly on the heels of her 1997 exhibition of "bunny gang rape" paintings) have not gone away. But they are interspersed with other themes; beacons of mortality and intimations of the passage of time have crept in, and many recent paintings are altogether ambiguous in their subject. *The Picnic* (2006) nods to Manet's *Le Déjeuner sur l'herbe* (1862/63), but this triptych displays the meal's – and by extension modernism's – aftermath, platters and bowls askew. We might have come too late to the party, but there is still something to savour.

Cecily Browns Bilder changieren beinahe unmerklich zwischen Farbe und dargestellter Form, Figuration und völliger Abstraktion. Die Künstlerin zeigt uns körperliche Stürme, die Willem de Kooning (der doch lüstern behauptete, dass Fleisch der einzige Grund sei, warum die Ölfarbe erfunden wurde) ebenso viel verdanken wie anderen seltsamen Bettgenossen – Goya und Velázquez, Poussin und Cézanne, Francis Bacon und John Currin. Obwohl Brown sich verblüffend frühreif diese geschichtlichen und zeitgenössischen Bezüge aneignete, ist ihr bewusst ironiefreier Ansatz weder von ödipalen Fantasien begleitet noch von Einflussängsten gedämpft. Eindeutig malt Brown ganz wie es ihr gefällt und verwandelt Farbe in zähflüssige Körpermaterie, wo immer sie kann: Zähne und unterwürfige Schenkel, Blicke auf Liebende in verschiedenen Phasen des Geschlechtsverkehrs, Orgien und Orgasmen neben geflügelten Phalli, auf dem Rücken liegenden Nackten, pastoralen Landschaften, Waldbacchanalen und sogar einer fiebrigen Hommage an ein Paar neuer Frauenschuhe, die entsprechend *New Louboutin Pumps* (2005) betitelt ist. Wie dieses Bild zeigt, gehören die billigen Kicks der Böse-Mädchen-Sexszenen, mit denen sie (kurz nach der Ausstellung ihrer *bunny gang rape*-Bilder 1997) berühmt wurde, noch nicht der Vergangenheit an. Aber sie werden jetzt mit anderen Themen durchsetzt; Signale der Sterblichkeit und Andeutungen einer schnell vergehenden Zeit sind eingedrungen, und viele von Browns jüngsten Bildern sind in ihrem Gegenstand völlig uneindeutig. *The Picnic* (2006) verneigt sich vor Manets *Le Déjeuner sur l'herbe* (1862/63), aber dieses Triptychon zeigt im Durcheinander der Platten und Schüsseln die Nachwirkungen des Essens – und gleichzeitig des Modernismus. Aber obwohl wir zu spät zur Party gekommen sind, gibt es noch immer etwas zu genießen.

Les toiles de Cecily Brown oscillent imperceptiblement entre peinture et forme peinte, entre figuration et pure abstraction. L'artiste fait surgir des tempêtes charnelles qui doivent autant à Willem de Kooning (qui, après tout, affirmait lascivement que « la peinture a été inventée pour peindre la chair ») qu'à d'autres compagnons inattendus – Goya et Velázquez, Poussin et Cézanne, Francis Bacon et John Currin. Malgré l'étonnante précocité qui a permis à Brown d'assimiler ces références historiques et contemporaines, son approche originale, résolument dénuée d'ironie, n'est nullement sous-tendue par des fantasmes œdipiens ni écrasée par l'angoisse d'une telle filiation. En réalité, Brown peint comme elle l'entend, transmue la peinture en une matière corporelle visqueuse à la moindre occasion : dents et cuisses abjectes, amants saisis dans différentes positions de copulation, orgies et orgasmes, coexistent avec des phallus ailés, des nus alanguis, des paysages de pastorale, des bacchanales sylvestres, ou même un vibrant hommage à des escarpins neufs dans *New Louboutin Pumps* (2005). Comme le prouve cette toile, le côté aguicheur de son travail avec ses scènes figurant des filles délurées qui a fait sa notoriété (depuis l'exposition en 1997 de toiles représentant filles provocantes et viols collectifs) n'a pas tout à fait disparu. Mais d'autres thèmes sont venus s'y ajouter : la mort et le passage du temps ont fait leur apparition dans son œuvre, et de nombreuses toiles récentes manifestent une ambiguïté thématique croissante. *The Picnic* (2006) est un clin d'œil au *Déjeuner sur l'herbe* de Manet (1862/63), mais ce triptyque s'attache à montrer ce qui reste après le déjeuner (assiettes et bols renversés), et par extension après le modernisme. Nous sommes peut-être arrivés une fois la fête terminée, mais on peut quand même encore en profiter.

S. H.

SELECTED EXHIBITIONS →
2008 *Garten Eden*, Städtische Galerie Bietigheim-Bissingen; Kunsthalle Emden **2007** *INSIGHT?*, Gagosian Gallery/Red October Chocolate Factory, Moscow. *True Romance*, Kunsthalle Wien, Vienna **2006** *Cecily Brown*, Museum of Fine Arts, Boston. *Cecily Brown*, Des Moines Art Center, Des Moines. *The Triumph of Painting 5*, Saatchi Gallery, London. *Full House*, Kunsthalle Mannheim **2005** *Cecily Brown*, Kunsthalle Mannheim. *Cecily Brown: Paintings*, Museum of Modern Art, Oxford.

SELECTED PUBLICATIONS →
2008 *Cecily Brown*, Rizzoli, New York **2007** *Extremes & In-Betweens*, Dorsky Gallery, New York. *INSIGHT?*, Gagosian Gallery, New York **2006** *Cecily Brown: Paintings 2003–2006*, Gagosian Gallery, New York. *Cecily Brown*, Des Moines Art Center, Des Moines; Museum of Fine Arts, Boston **2005** *Cecily Brown*, Museum of Modern Art, Oxford

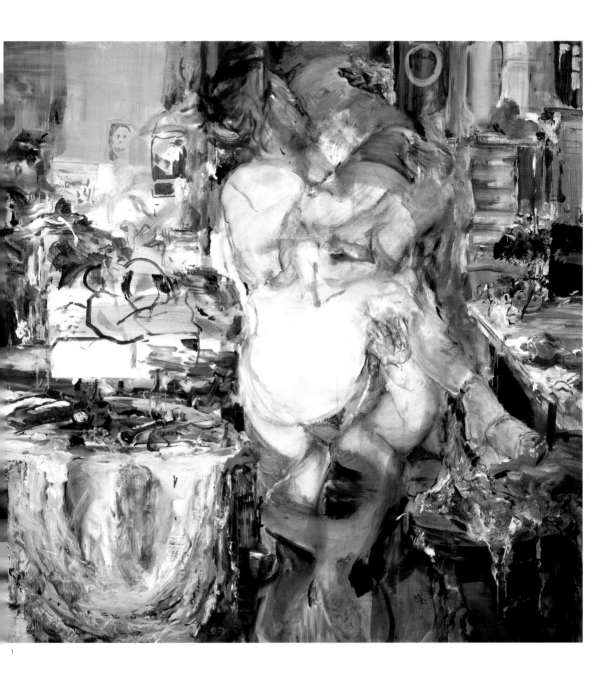

1 **New Louboutin Pumps**, 2005, oil on linen, 205.7 x 204.5 cm 3 **The Adoration of the Maid**, 2006, oil on linen, 198.1 x 198.1 cm
2 **The Picnic**, 2006, oil on linen, 246.4 x 312.4 cm

„Für mich ist die Kunst der Vergangenheit nichts Fernliegendes. Wenn man in ein Museum geht, ist sie heute da. Ich liebe die Freiheit, all diese Künstler nebeneinander in meinem Kopf zu haben: In einem Moment denkt man vielleicht an Jeff Koons und im nächsten dann an Giotto."

« Pour moi l'art du passé n'est pas si éloigné. Ce qui est exposé dans un musée est bien là, aujourd'hui. C'est une merveilleuse liberté que d'avoir tous ces artistes côte à côte dans la tête ; on est en train de penser à Jeff Koons, et une minute après on pense à Giotto. »

"I don't really think of the art of the past as distant. If you go into a museum, it's there today. One of the things I love is the freedom of having all these artists in your head side by side; you might find yourself thinking of Jeff Koons one minute and Giotto the next."

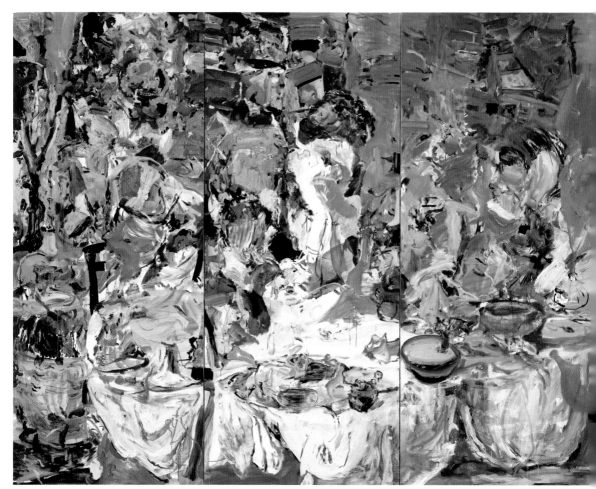

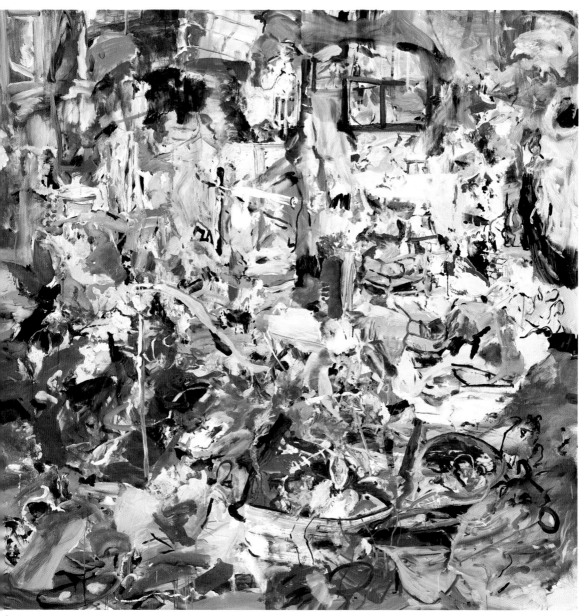

Glenn Brown

1966 born in Hexham, lives and works in London, United Kingdom

In Glenn Brown's paintings, the beautiful and the ugly, the familiar and the visionary are inextricably interwoven, creating associations that exude an almost magical fascination. Brown borrows motifs from the Old Masters such as Rembrandt, Fragonard or El Greco, but also from more recent painters like Auerbach and Dalí, as well as from science fiction illustrators. But Brown doesn't just quote, he comments and travesties: using anamorphosis, inversion and combination, he turns his source material into the stuff of dreams – and nightmares. Brown adds another twist to the postmodern game in that he borrows titles as well as source images from art history. *The Great Masturbator* (2006), for example, owes its title to a work by Dalí, although the image is based on Murillo's *Laughing Boy with a Feather-Adorned Headdress* (1655). The Spanish baroque painter's motif is steered sharply towards the burlesque by Brown: the laughing youth acquires a greenish complexion, streaky skin, blue eyeballs and black pupils, giving him a sickly gruesome look. But Brown paints his subject with such virtuosity that the beauty of the painting and the morbidity of its appearance challenge and surpass one another. His typically rich, impasto painting style is in fact elaborate *trompe l'oeil* – the clearly discernible and apparently virtuoso swirls of paint are actually created with fine brushstrokes that are barely visible under the smooth surface, recalling Dalí's expert command of Old Master painting techniques. The dramatic handling of colour and paint conveys extreme artificiality and carnal deterioration, deliberately bestowing, for example, the impression of bloated, rotting viscosity upon a bare skeleton. Brown's expertise aims at radical ambivalence, at disillusioning by means of illusion.

In Glenn Browns Malerei sind das Schöne und das Hässliche, das Bekannte und das Visionäre untrennbar verflochten, wobei ihre Verknüpfung eine fast magische Faszination erzeugt. Dafür greift Brown Motive alter Meister auf, etwa von Rembrandt, Fragonard oder El Greco, aber auch neuerer Maler wie Auerbach, Dalí sowie von Science-Fiction-Illustratoren. Doch Brown zitiert nicht nur, er kommentiert und travestiert, indem er Bildvorlagen durch Anamorphose, Inversion und Vermischung ins (Alp-)Traumhafte überführt. Brown treibt das postmoderne Spiel eine Ebene weiter, denn er greift nicht allein auf Bildzitate zurück, sondern verschränkt diese mit Zitaten von Titeln. *The Great Masturbator* (2006) etwa entlehnt seinen Titel einem Werk von Dalí, auf dem Bild hingegen erkennt man Murillos *Lachenden Jungen mit federgeschmücktem Kopfputz* (1655). Das Genremotiv des spanischen Barockmalers lenkt Brown sehr drastisch ins Burleske: Grüner Teint, schlierige Haut, blaue Augäpfel und schwarze Pupillen geben dem lachenden Kerl einen krankhaft-grausigen Zug. Dabei malt Brown das Entstellende so virtuos, dass die Schönheit der Malerei und das Morbide der Erscheinung einander herausfordern und wechselseitig übertrumpfen. Seine typische, scheinbar satte und pastose Malweise ist dabei raffiniertes Trompe-l'œil: die virtuosen, gut sichtbaren Pinselgesten entstehen tatsächlich aus feinen, unter der glatten Oberfläche kaum sichtbaren Pinselstrichen, die den glatten, altmeisterlichen Bildoberflächen Dalís nahe stehen. Der inszenatorische Umgang mit Farbe vermittelt größte Künstlichkeit und fleischlichen Verfall, der etwa ausgerechnet einem blanken Skelett den Eindruck körpersatt verrottender Viskosität verleiht: Browns Raffinement zielt auf radikale Ambivalenz, auf Desillusionierung durch die Illusion.

Dans la peinture de Glenn Brown, le beau et le laid, le connu et le visionnaire sont intimement imbriqués, et de leur mélange émane une fascination presque magique. Brown s'appuie pour cela sur les motifs de maîtres anciens comme Rembrandt, Fragonard ou El Greco, mais s'inspire aussi de peintres plus récents comme Auerbach, Dalí, ou encore d'illustrateurs de science-fiction. Toutefois, Brown ne se contente pas de citer, mais commente et travestit en transposant ses modèles dans la sphère du rêve ou du cauchemar par des procédés relevant de l'anamorphose, de l'inversion ou du mélange. Le jeu post-moderne passe sur un autre plan quand les citations visuelles sont mêlées à des citations de titres. *The Great Masturbator* (2006) tire son titre d'une œuvre de Dalí, alors que le tableau lui-même évoque le *Garçon riant coiffé d'un chapeau à plume* (1655) de Murillo. Le motif de genre du peintre espagnol y est drastiquement détourné vers le burlesque: teint glauque, peau glaireuse, prunelles bleues et pupilles noires confèrent au jeune homme riant un aspect maladif et monstrueux. Par même temps, Brown peint cette dénaturation avec une telle virtuosité que la beauté de la peinture et la morbidité de l'aspect rivalisent et ne cessent de se surclasser l'une l'autre. La facture fortement saturée et pâteuse est un trompe-l'œil raffiné: les traits de pinceau virtuoses et nettement visibles sont réalisés à partir de traits fins à peine visibles sous une surface lisse et proches de la facture des maîtres anciens qui caractérise également Dalí. La mise en scène de la couleur communique un sentiment de grande artificialité et de décomposition charnelle qui confère comme par hasard à un squelette décharné une apparence de viscosité charnelle putréfiée: le raffinement de Brown vise à une ambivalence radicale, au désillusionnement par l'illusion.

J. A.

SELECTED EXHIBITIONS →
2008 *Glenn Brown*, Kunsthistorisches Museum, Vienna. *Photopeintries*, FRAC Limousin, Limoges **2007** *INSIGHT?*, Gagosian Gallery / Red October Chocolate Factory, Moscow. *Der Symbolismus und die Kunst der Gegenwart*, Von der Heydt Museum, Wuppertal **2006** *Zurück zur Figur*, Kunsthalle der Hypo-Kulturstiftung, Munich; Museum Franz Gertsch, Burgdorf. *Infinite Painting*, Villa Manin, Codroipo **2005** *Rückkehr ins All*, Hamburger Kunsthalle, Hamburg. *Ecstasy: In and about Altered States*, MOCA, Los Angeles.

SELECTED PUBLICATIONS →
2008 *Painting Now*, Veenman Publishers, Rotterdam **2007** *Glenn Brown*, Gagosian Gallery, New York. *INSIGHT?*, Gagosian Gallery, New York **2006** *Glenn Brown*, Galerie Max Hetzler, Holzwarth Publications, Berlin. *Kai Althoff, Glenn Brown, Dana Schutz*, Parkett 75, Zürich. *Zurück zur Figur: Malerei der Gegenwart*, Kunsthalle der Hypo-Kulturstiftung; Prestel, Munich **2005** *Ecstasy: In and about Altered States*, MOCA, Los Angeles. *Rückkehr ins All*, Hamburger Kunsthalle, Hamburg; Hatje Cantz, Ostfildern

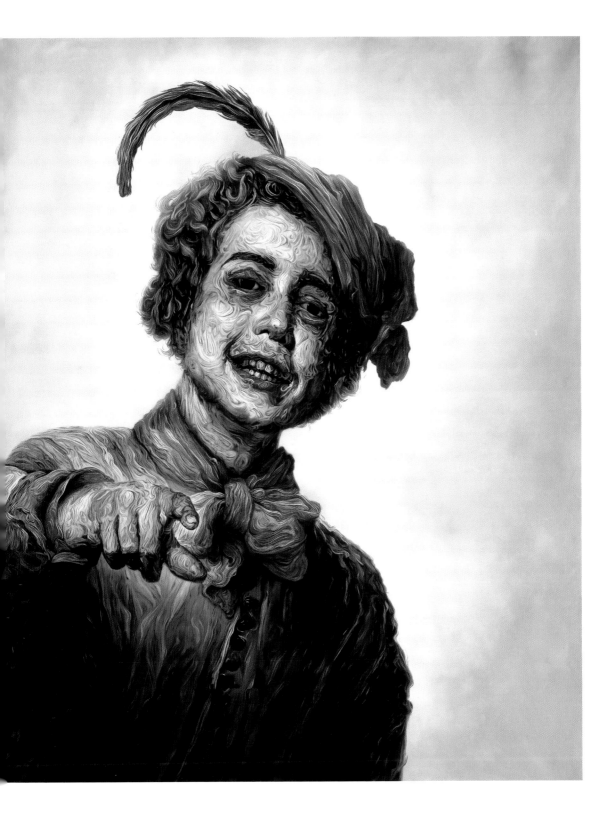

1 **The Great Masturbator**, 2006, oil on panel, 110 x 87.5 cm
2 **Youth, Beautiful Youth**, 2008, oil on panel, 153 x 121 cm

3 **Asylums of Mars**, 2006, oil on panel, 156 x 122.5 cm
4 **The Hinterland**, 2006, oil on panel, 148 x 122.5 cm

„Ich bin ein bisschen wie Dr. Frankenstein, denn ich baue meine Bilder mit Überresten oder toten Teilen von Arbeiten anderer Künstler."

« Je suis un peu comme le docteur Frankenstein, car je crée mes tableaux à partir des restes ou des parties mortes des œuvres d'autres artistes. »

"I'm rather like Dr. Frankenstein, constructing paintings out of the residue or dead parts of other artist's work."

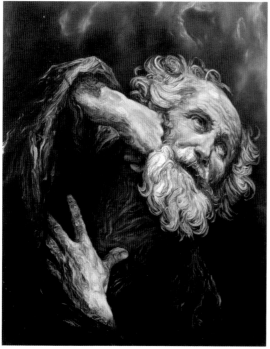

2

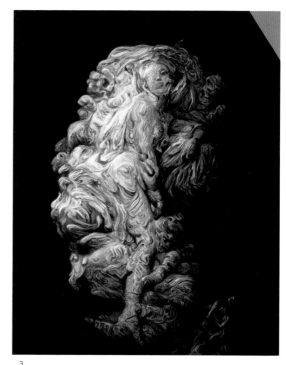

3

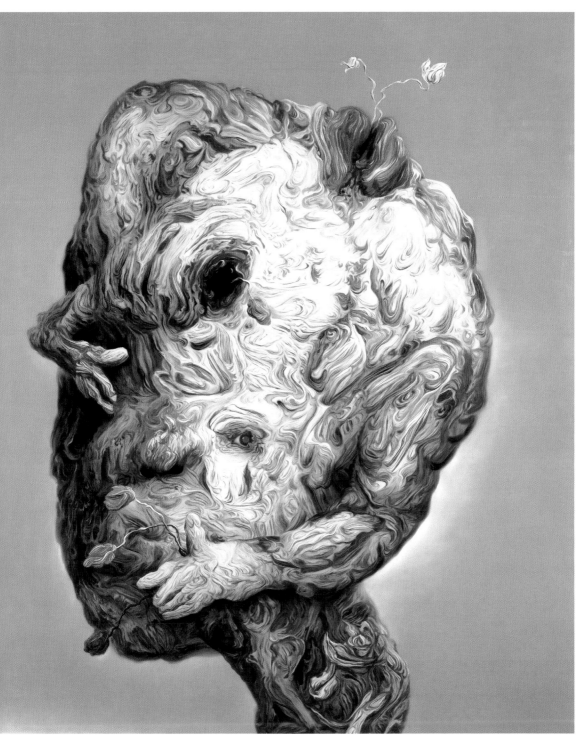

André Butzer

1973 born in Stuttgart, lives and works in Berlin, Germany

André Butzer – who grew up in the 1980s in "American-occupied West Germany", as he calls it rather playfully in one of his interviews – describes his experience of seeing American soldiers having barbeques at army headquarters as he peered through the fence. Butzer's colourful, chaotic landscapes mirror this distanced but intense gaze upon the collision of these two cultures. In his paintings' imaginary worlds and in his cast of comically ghoulish characters, we glimpse a witty satire of the American Dream. The figures have Butzer's signature maniacal smiles, hollowed-out death mask eyes and puffy Mickey Mouse hands. Sometimes they stand beside a suburban house ominously marked with the letter N, which stands for "Nasaheim" – a conglomeration of NASA (the embodiment of American progress) and Anaheim (the location of Disneyland) – just one of the end-of-the-world science-fictional domains that the artist has invented. Lately, Butzer has also curated "Kommando exhibitions" (2004–), inspired by and named after his heroes – among them Henry Ford, Calvin Cohn and Friedrich Hölderlin – a motley crew comprised of misunderstood visionaries. Butzer's painterly inspirations are easier to discern: his gestural application and raw primitive renderings revive Jean Dubuffet's Art Brut. More recently, his paintings have incorporated jumbles of what look like cables or crossed wires, recalling the meandering lines of Joan Miró. These kaleidoscopically colourful canvases, chock-a-block with finger-painted scribbles and globs of pigment, can look like the work of a child with a box of multi-coloured crayons or Butzer's own apocalyptic view of the future his heroes have helped create.

André Butzer, der in den 1980ern im „amerikanisch besetzten Westdeutschland" aufwuchs, wie er einmal in einem Interview witzelte, beschrieb dann ein Barbecue von Soldaten auf einem US-amerikanischen Militärgelände, das er durch die Umzäunung beobachtet hatte. Butzers bunte, chaotische Bildlandschaften reflektieren seinen distanzierten, aber intensiven Blick auf das Zusammentreffen dieser beiden Kulturen. Seine imaginären Welten mit comicartig makabren Figuren sind satirische Anspielungen auf den Amerikanischen Traum. Die Figuren zeigen ein irres Lächeln, Butzers Markenzeichen, die ausgehöhlten Augen von Totenschädeln und die plumpen Hände von Mickey Mouse. Manchmal stehen sie neben einem mit einem ominösen N markierten Einfamilienhaus. Das N steht für „Nasaheim" – NASA (ein Wahrzeichen des amerikanischen Fortschritts) und Anaheim (der Standort von Disneyland) –, nur eine Unterkunft in den Science-Fiction-Welten, die sich der Künstler ausgedacht hat. Inspiriert von seinen Helden – wie Henry Ford, Calvin Cohn und Friedrich Hölderlin –, organisierte Butzer im Verlauf seiner Karriere „Kommando-Ausstellungen" (seit 2004), die er nach dieser bunt gescheckten Truppe missverstandener Visionäre benannte. Butzers malerische Inspirationen sind leichter zu erkennen: Sein malerischer Gestus und seine grob vereinfachte Malweise knüpfen an Jean Dubuffets Art Brut, während seine neueren Gemälde in Anlehnung an die mäandernden Linien Joan Mirós aus Kabeln und ineinander verknäuelten Drähten bestehen könnte. Diese kaleidoskopartig bunten Bilder mit Kritzeleien und Farbklecksen können wie kindliche Buntstiftmalereien aussehen oder wie Butzers apokalyptische Visionen einer Zukunft, die von seinen Helden mitgestaltet wurde.

André Butzer, qui a grandi dans ce qu'il nomme avec humour « une Allemagne de l'Ouest occupée par les Américains », évoque un souvenir des années 1980 : à travers la palissade bordant le quartier général américain, il lui arrivait d'apercevoir des soldats réunis autour d'un barbecue. Les paysages colorés et chaotiques de Butzer reflètent ce regard, à la fois intense et distancié, sur la collision de ces deux cultures. Ses mondes imaginaires, peuplés d'une galerie de personnages morbides jusqu'au comique, font une subtile satire du rêve américain, comme ce couple grotesque devant un pavillon de banlieue sinistrement orné de la lettre N. Leurs traits sont déformés par un sourire halluciné et des yeux caverneux de masque mortuaire ; leurs mains sont démesurément gonflées comme celles de Mickey. Le N représente « Nasaheim », contraction de NASA (le progrès à l'américaine) et d'Anaheim (le site de Disneyland) : il s'agit d'un des lieux fictifs inventés par l'artiste, un lieu où semble se jouer la fin de notre monde. Tout au long de sa carrière, Butzer a organisé des « expositions Kommando » (2004–) inspirées par et baptisées d'après ses héros personnels – tels Henry Ford, Calvin Cohn ou Friedrich Hölderlin – évoquant un panthéon hétéroclite de visionnaires incompris. Ses sources d'inspiration picturale sont plus faciles à repérer, son application gestuelle et son interprétation primitiviste le situant dans la lignée de l'Art brut de Dubuffet. Plus récemment, il a incorporé dans sa peinture un agrégat de câbles et de barbelés qui rappellent les lignes d'un Joan Miró. Ces toiles, parées de couleurs kaléidoscopiques, barbouillées de traces de peinture ou de grumeaux de pigment et qui semblent parfois dues à un enfant à qui l'on aurait offert une boîte de crayons, figurent la vision apocalyptique de l'avenir que les héros de Butzer ont contribué à créer.

CH. L.

SELECTED EXHIBITIONS →
2008 Son of... Guillaume Bruere, André Butzer..., Musée des Beaux-Arts, Tourcoing; Bad Painting – Good Art, MUMOK, Vienna; Kommando Tilmann Riemenschneider. Europa 2008, Hospitalhof, Stuttgart **2007** Kommando Calvin Cohn New York, Salon 94, New York; Kommando Friedrich Hölderlin Berlin, Galerie Max Hetzler Temporary, Berlin **2006** Imagination Becomes Reality, Sammlung Goetz, Munich **2005** La Peinture Allemande, Carré d'Art, Nîmes **2004** André Butzer, Kunstverein Heilbronn

SELECTED PUBLICATIONS →
2008 Kommando Tilmann Riemenschneider. Europa 2008, Hospitalhof, Stuttgart; Bad Painting – Good Art, MUMOK, Vienna; DuMont, Cologne **2007** André Butzer, Galerie Guido W. Baudach Berlin; Kommando Friedrich Hölderlin Berlin, Galerie Max Hetzler, Berlin **2006** Carbonic Anhydride, Galerie Max Hetzler, Berlin **2005** Haselnuß, Galerie Guido W. Baudach, Berlin **2004** André Butzer: Das Ende vom Friedens-Siemens Menschentraum, Kunstverein Heilbronn; Snoeck Verlag, Cologne

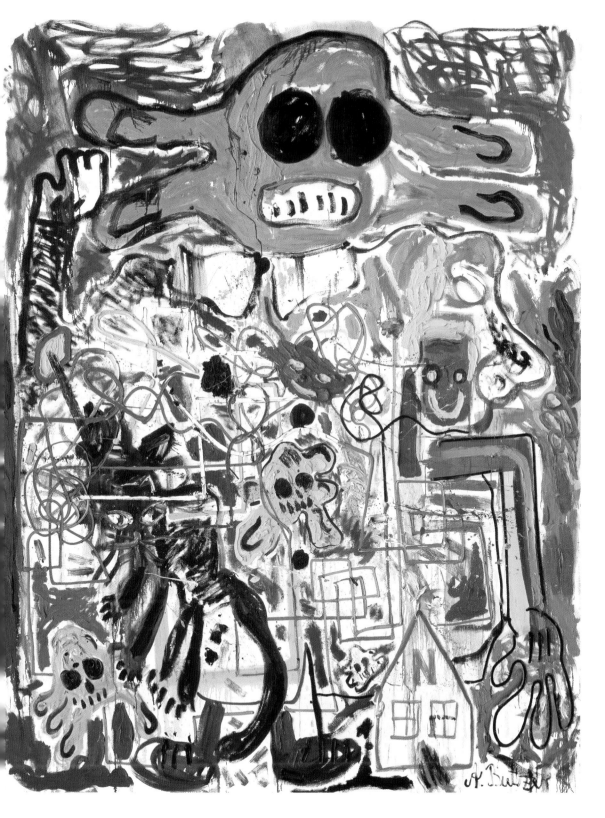

1 **Portrait H.H.**, 2006, oil on canvas, 340 x 260 cm
2 **Untitled (8)**, 2007, oil on canvas, 200 x 160 cm

3 **Kommando Friedrich Hölderlin**, 2006, oil on canvas, 280 x 460 cm
4 **Gehirnzentrum von A.B.**, 2006, oil on canvas, 280 x 460 cm

„Ich mache einfach unbehelligt weiter, vermische alle Formen und Inhalte, vergesse alles ständig mit Absicht wieder, ich bin wie ein Fabrikant, der damit rechnet, dass seine Produkte dann von selber ernst drauf kommen."

« C'est tout simple, je continue sans me soucier de rien, je mélange toutes les formes et tous les contenus, j'oublie volontairement tout à chaque instant, je suis comme un fabricant qui s'attend à ce que ses produits se prennent au sérieux. »

"I simply carry on regardless, constantly mixing form and content and then intentionally forgetting them all again. I'm like a manufacturer who figures his products will hit on something serious by themselves."

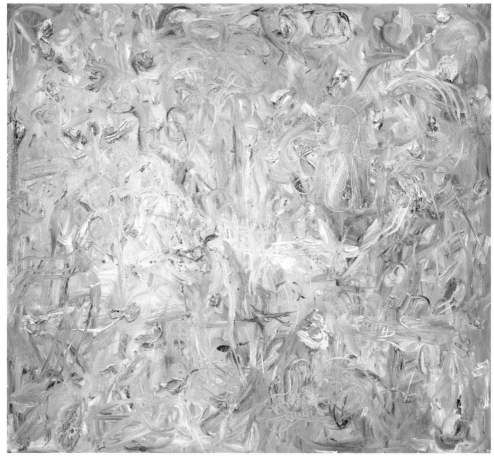

2

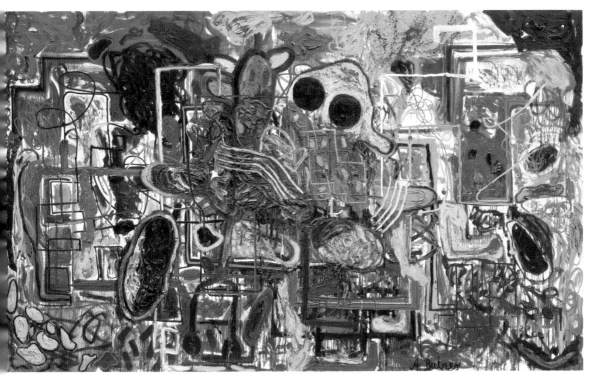

Cai Guo-Qiang

1957 born in Quanzhou, China, lives and works in New York (NY), USA

Cai Guo-Qiang's practice spans from gunpowder drawings to ephemeral sculptures and monumental installations, all of which are rich with references to Chinese history, Taoist cosmology and current political events. Cai deals with the latter in a spectacular installation for *I Want to Believe*, his 2008 retrospective in New York: from the centre of the Guggenheim rotunda the artist – a learned set designer, by the way – suspended *Inopportune: Stage One* (2004), consisting of a series of nine cars hovering in mid air to represent in cinematic progression the effects of a car bomb. Since the 1980s, Cai has been working on drawings realized by igniting explosive powder on large sheets of paper. These works possess an aura that evokes both the vivid gestures of abstract expressionism and the quieter surfaces of Chinese traditional painting. Gunpowder is also at the centre of a series of environmental works, begun in 1989, which combine the tradition of Land Art with that of Chinese fireworks. For his explosion events, Cai stages pyrotechnical choreographies that sketch temporary drawings in the sky. These events are also meant to act as social, festive collective experiences that the artist – not without irony – believes could be perceived even from outer space. Cai participated in many international events, imposing himself as one of the strongest artists to emerge from China. At the Venice Biennale 1999 he was awarded the Golden Lion for *Venice's Rent Collection Courtyard* (1999), a series of unfired clay sculptures depicting icons of the Cultural Revolution. Cai also organized the opening ceremony for the 2008 Olympic Games in Beijing.

Cai Guo-Qiangs Werk umfasst Zeichnungen mit Schießpulver, vergängliche Skulpturen und monumentale Installationen, die alle reich an Anspielungen auf chinesische Geschichte, taoistische Kosmologie und aktuelle politische Ereignisse sind. Mit Letzteren beschäftigt Cai sich in einer spektakulären Installation für *I Want to Believe*, seine Retrospektive 2008 in New York: In das Innere der Rotunde des Guggenheim Museums hängte der Künstler – übrigens gelernter Setdesigner – *Inopportune: Stage One* (2004), das aus einer Reihe von neun in der Luft schwebenden Autos bestand, die in quasi filmischer Abfolge die Auswirkungen einer Autobombe darstellten. Seit den 1980er-Jahren arbeitet Cai an Zeichnungen, die durch das Entzünden von Schießpulver auf großen Papierbögen entstanden. Diese Arbeiten haben eine Aura, die sowohl die heftigen Gesten des Abstrakten Expressionismus als auch die ruhigeren Oberflächen der traditionellen chinesischen Malerei evozieren. Schießpulver steht auch im Mittelpunkt einer Reihe von Arbeiten (ab 1989), die die Tradition der Land Art mit der des chinesischen Feuerwerks verbinden. Für seine Explosionsevents inszeniert Cai pyrotechnische Choreografien, die flüchtige Zeichnungen an den Himmel werfen. Diese Events wollen auch soziale, festliche Gemeinschaftserfahrungen ermöglichen, von denen der Künstler – nicht ohne Ironie – glaubt, sie könnten sogar im Weltall wahrgenommen werden. Cai hat an vielen internationalen Veranstaltungen teilgenommen und etablierte sich dabei als einer der stärksten Künstler aus China. Bei der Biennale in Venedig 1999 bekam er den Goldenen Löwen für *Venice's Rent Collection Courtyard* (1999), einer Serie von ungebrannten Tonskulpturen, die Ikonen der Kulturrevolution darstellten. Cai organisierte auch die Eröffnungszeremonie der Olympischen Spiele 2008 in Peking.

Qu'il choisisse pour support le dessin à la poudre à canon, la sculpture éphémère ou l'installation monumentale, Cai Guo-Qiang se réfère constamment à l'histoire de la Chine, à la cosmologie taoïste et aux événements politiques contemporains. Ces derniers sont notamment abordés dans l'installation spectaculaire réalisée à l'occasion de la rétrospective *I Want to Believe* organisée en 2008 à New York : au centre de la rotonde du Guggenheim, l'artiste a suspendu dans les airs neuf véhicules figurant, comme dans un ralenti cinématographique, l'explosion d'une voiture piégée. Depuis les années 1980, Cai réalise des dessins en mettant le feu à de la poudre explosive sur de grandes feuilles de papier. Ces œuvres dégagent une aura évoquant aussi bien les gestes violents de l'expressionisme abstrait que les surfaces paisibles de la peinture chinoise traditionnelle. La poudre à canon est également au cœur d'une série d'œuvres environnementales, entamée en 1989, qui associe la tradition du Land Art à celle des feux d'artifice chinois. Pour ses œuvres événementielles, Cai organise des chorégraphies pyrotechniques qui créent dans le ciel des dessins éphémères. Ces événements sont conçus comme des expériences sociales et festives que l'artiste – non sans ironie – entend rendre visibles y compris depuis l'espace. Cai a pris part à de nombreuses manifestations internationales et s'est imposé comme l'un des plus grands artistes chinois de sa génération. En 1999, à la Biennale de Venise, il a reçu le Lion d'Or pour sa *Venice's Rent Collection Courtyard* (1999), série de sculptures d'argile désamorcées figurant les icônes de la Révolution culturelle. Cai a également organisé la cérémonie d'ouverture des Jeux Olympiques de Pékin en 2008.

C. A.

SELECTED EXHIBITIONS →
2008 *Cai Guo-Qiang*, Hiroshima City Museum of Contemporary Art, Hiroshima. *Cai Guo-Qiang: I Want to Believe*, Solomon R. Guggenheim Museum, New York **2007** *Cai Guo-Qiang: Inopportune: Stage One*, Seattle Art Museum, Seattle **2006** *Cai Guo-Qiang: Head On*, Deutsche Guggenheim, Berlin. *Cai Guo-Qiang: Transparent Monument*, The Metropolitan Museum of Art, New York **2005** *Cai Guo-Qiang: Paradise*, Zacheta National Gallery of Art, Warsaw. *Cai Guo-Qiang: On Black Fireworks*, IVAM, Valencia

SELECTED PUBLICATIONS →
2008 *Cai Guo-Qiang: I Want to Believe*, Solomon R. Guggenheim Museum, New York **2006** *Cai Guo-Qiang: Head On*, Deutsche Guggenheim, Berlin, Hatje Cantz, Ostfildern. *Cai Guo-Qiang: Transparent Monument*, Charta, Milan. *Cai Guo-Qiang: Long Scroll*, National Gallery of Canada, Ottawa **2005** *Cai Guo-Qiang: On Black Fireworks*, IVAM, Valencia. *Where Heaven & Earth Meet: The Art of Xu Bing and Cai Guo-Qiang*, Timezone 8 Ltd, Beijing.

1 **Inopportune: Stage One**, 2004, 9 cars, sequenced multichannel light tubes, dimensions variable. Installation view, Solomon R. Guggenheim Museum, New York, 2008

2 **Light Passage – Autumn**, 2007, gunpowder on paper, 400 x 600 cm

3 **Head On**, 2006, 99 life-sized replicas of wolves (gauze, resin, painted hide), glass wall, dimensions variable. Installation view, Deutsche Guggenheim, Berlin

4 **Same Word, Same Seed, Same Root**, 2006, gunpowder on paper, LED screens, 1800 x 900 cm. Installation view, Min Tai Yuan Museum, Quanzhou

„Meine Installationen versuchen immer, den Zeitfluss darzustellen, ganz gleich, welche stilistische Freiheit ich mir erlaube. Jedenfalls haben meine Arbeiten im Kern diese Merkmale: die Einladung zur Teilnahme und das Fließen der Zeit."

« Mes installations s'efforcent toujours d'obtenir une fluidité temporelle, qui contraste avec la liberté de style que je m'autorise. Cependant mes œuvres se caractérisent essentiellement par leur nature participative et par le passage du temps. »

"My installations have consistently pursued a temporal fluidity, in contrast to the stylistic freedom I allow myself. However, my works in essence contain these characteristics: a participatory nature and a flow of time."

2

Maurizio Cattelan

1960 born in Padua, Italy, lives and works in New York (NY), USA

Some might say that Maurizio Cattelan's works resemble jokes, but they are more like political cartoons. Each of his pieces amounts to an iconic, provocative image with a darkly humorous twist: the Pope stricken by a meteorite, Hitler on his knees in prayer, a horse with its head buried in a wall. But the impact of his mischievous works doesn't dissipate after the punchline hits you; rather, the impression that remains after you've seen JFK lying barefoot in his coffin or a suicidal squirrel slumped over a miniature kitchen table is still haunting or befuddling long after the initial urge to laugh has worn off. Cattelan provokes public reaction mainly by satirizing authority – politicians, the Church, the police force, the art world. His disobedient gestures have drawn their fair share of controversy – most recently, his vision of a female crucifixion installed at a synagogue in Pulheim, Germany, in 2008 elicited public debate. Cattelan has no studio and no traces of his own hand appear in his work (though his face sometimes does, in the form of frequent caricatures of himself). He claims he spends most of his time on the phone. Working from a single idea, Cattelan employs fabricators to create taxidermied animals and extremely lifelike wax figures. He relishes playing the role of the mysterious producer behind the artwork – the burglar who sneaks in and out of the gallery unnoticed, the host who slinks away from his own party. Though he is frequently labelled a court jester, it's not Cattelan himself who is entertaining the masses – he is an escape artist, setting a spectacle in our midst and then fleeing the scene.

Manche betrachten Maurizio Cattelans Werke als reinen Schabernack, obwohl sie eigentlich politische Karikaturen sind. Jede seiner bildmächtigen, provozierenden Inszenierungen ist mit schwarzem Humor gewürzt: der durch einen Meteoriten zu Fall gebrachte Papst, der kniende Hitler im Gebet, das Pferd mit in die Wand gerammtem Kopf. Aber diese überspitzten Bilder leben nicht nur von ihrer Pointe; wenn der Lachreiz vergangen ist, haben sich die Ansichten des barfüßigen JFK in seinem Sarg oder eines am Küchentisch in den Selbstmord geschickten Eichhörnchens tief in die Erinnerung eingegraben. Öffentlichen Ärger ruft Cattelan vor allem deshalb hervor, weil er die Systeme der Macht der Lächerlichkeit preisgibt – Politik, Kirche, Polizei, den Kunstbetrieb. Seinen unbotmäßigen Handlungen folgen stets reichlich kontroverse Debatten – erst dieses Jahr, 2008, hat er mit einer ans Kreuz geschlagenen Frauenfigur an der Synagoge Stommeln in Pulheim eine öffentliche Diskussion entfacht. Cattelan hat kein Atelier, und keines seiner Werke lässt Spuren seiner eigenen Hand erkennen (umso häufiger seine Gesichtszüge, da er sich oft selbst karikiert). Nach eigenen Angaben verbringt er die meiste Zeit am Telefon. Ausgehend von einer Idee beschäftigt Cattelan Leute, die ihm Tiere ausstopfen und ungemein lebensechte Wachsfiguren herstellen. Er gefällt sich in der Rolle des geheimnisvollen Machers hinter dem Kunstwerk – wie ein Dieb, der sich unbemerkt in die Galerien hinein und wieder hinaus schleicht, oder ein Gastgeber, der sich von der eigenen Party stiehlt. Obwohl Cattelan oft als Hofnarr betitelt wird, unterhält er das Volk nicht selbst – er ist ein Entfesselungskünstler, der ein Schauspiel inmitten der Menge inszeniert und anschließend den Schauplatz verlässt.

Si, pour certains, les œuvres de Maurizio Cattelan pourraient se résumer à des plaisanteries, il s'agit plutôt, en fait, de dessins satiriques. Chacune de ses pièces représente une image iconique provocatrice teintée d'humour noir : le Pape frappé par une météorite, Hitler enfant priant à genoux, un cheval dont la tête est encastrée dans un mur. Mais l'impact de ces œuvres facétieuses ne se dissipe pas immédiatement ; au contraire, l'image de JFK pieds nus étendu dans son cercueil, ou celle d'un écureuil suicidaire, effondré sur une table de cuisine miniature, continue à hanter les esprits bien après que la première envie de rire ne se soit dissipée. C'est en faisant la satire de l'autorité sous toutes ses formes – hommes politiques, Église, forces de police, monde de l'art – que Cattelan provoque la réaction du public. Ses gestes frondeurs ont suscité bien des controverses – en 2008, son installation d'une crucifixion d'une femme dans une synagogue de Pulheim en Allemagne a provoqué la polémique. Cattelan n'a pas d'atelier et nulle trace de sa main n'apparaît dans son travail (même si on y aperçoit parfois son visage, sous la forme de caricature de lui-même). Il affirme passer le plus clair de son temps au téléphone. Cattelan génère des idées, des exécutants réalisent les animaux empaillés ou figurines de cire extrêmement ressemblantes. Il adore jouer le rôle du mystérieux producteur derrière l'œuvre d'art – le cambrioleur qui entre et sort de la galerie sans se faire voir, l'hôte quittant furtivement sa propre fête. Même si on lui colle souvent l'étiquette de bouffon de la cour, Catellan ne divertit pas lui-même les foules – c'est un artiste de l'échappée qui installe le spectacle parmi nous, puis fuit la scène.

CH. L.

SELECTED EXHIBITIONS →
2008 *Maurizio Cattelan*, Kunsthaus Bregenz. *Maurizio Cattelan*, Synagoge Stommeln, Pulheim. *Traces du Sacré*, Centre Georges Pompidou, Paris. *theanyspacewhatever*, Guggenheim Museum, New York **2007** *Maurizio Cattelan*, MMK, Frankfurt am Main. *Maurizio Cattelan*, Portikus, Frankfurt am Main **2006** *Of Mice and Men*, 4th Berlin Biennial for Contemporary Art, Berlin **2005** *Dionysiac*, Centre Georges Pompidou, Paris **2004** *Maurizio Cattelan*, Musée du Louvre, Paris

SELECTED PUBLICATIONS →
2008 *Maurizio Cattelan: Die / Die More / Die Better / Die Again*, Kunsthaus Bregenz; Three Star Books, Paris **2007** Maurizio Cattelan, Massimiliano Gioni, Ali Subotnick: *Charley 05*, Les Presses du Réel, Dijon **2006** Maurizio Cattelan, Massimiliano Gioni, Ali Subotnick: *Of Mice and Men*, 4th Berlin Biennial for Contemporary Art, Berlin; Hatje Cantz, Ostfildern. *Maurizio Cattelan*, Mondadori, Milan. *Maurizio Cattelan*, Trans-Atlantic Publications, Philadelphia **2005** *Dionysiac*, Centre Georges Pompidou, Paris

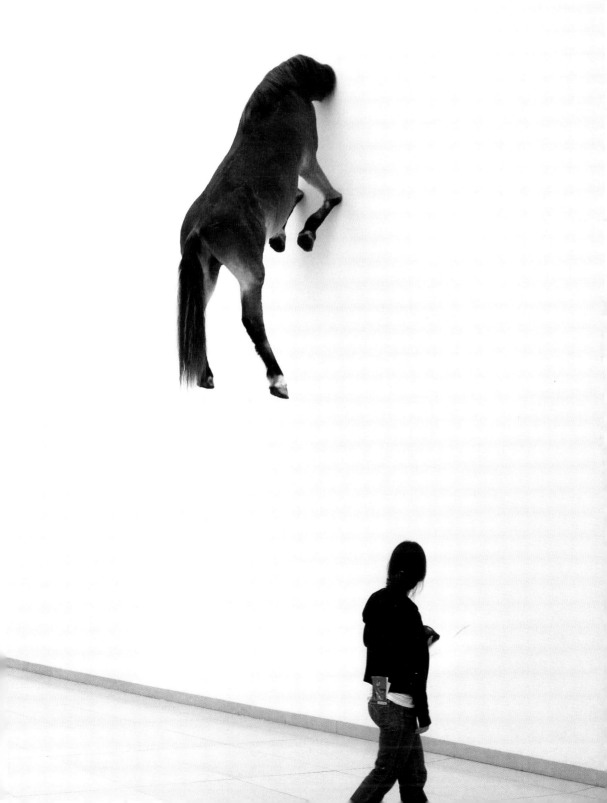

1 **Untitled**, 2007, stuffed horse, natural dimensions. Installation view, Museum für Moderne Kunst, Frankfurt am Main

2 **Untitled**, 2007, polyurethane, metal, clothes, paint. Installation view, Portikus, Frankfurt am Main

3 **Untitled**, 2007, silicon resin, real hair, steel, wood door, 216 x 130 x 70 cm. Installation view, Synagoge Stommeln, Pulheim, 2008

„Man versucht, die Grenzen ein wenig auszudehnen, und dann muss man erkennen, mit welcher Leichtigkeit die Kunstwelt alle Schläge verkraften kann. Aber das ist okay, das gehört zum Spiel."

« On essaie de repousser les frontières un peu plus loin, et puis on se rend compte avec quelle facilité le monde de l'art peut absorber tous les coups. Mais ce n'est pas grave, je suppose que ça fait partie du jeu. »

"You try to move the borders a little bit further, and then you realize how easily the art world can absorb any blow. But that's OK, I guess that's part of the game."

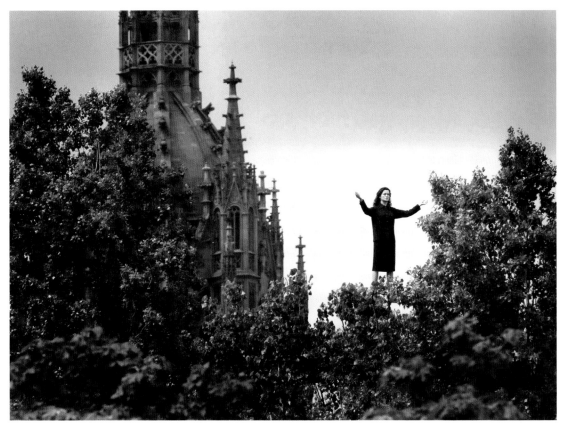

2

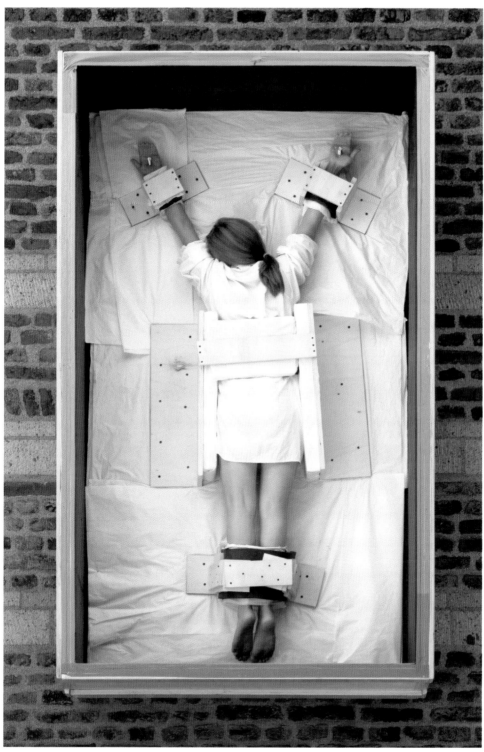

Tacita Dean

1965 born in Canterbury, United Kingdom, lives and works in Berlin, Germany

In her films, photographs, drawings and collections of found objects Tacita Dean reveals a deep-rooted fascination with the act of obser-vation, particularly of subjects which may quickly disappear or become invisible. Her 16mm films lend space and light a palpable materiality and counter the frenetic speed of modern life with a gaze characterized by static camera positions and long takes that create a certain stillness in the moving images. Whether of events, people or places, her films might for the most part be classified as portraits, revealing the innate quali-ties of her various subjects. Dean's recent *Darmstädter Werkblock* (2007) is filmed in the suite of rooms devoted to and installed by Joseph Beuys in Darmstadt's Hessisches Landesmuseum. Rather than focusing on the works themselves, Dean trains her camera on the rooms' dilapi-dated jute walls carpet which are soon to be replaced, emphasising the entropic nature of Beuys' work and creating an enigmatic portrait of the artist. Many of Dean's films and drawings explore elusive natural phenomena, from solar eclipses to the green flash of light that accompa-nies the setting of the sun. Often they appear together with architectural elements, symbols for outmoded or bankrupt beliefs. *Palast* (2004) for example – an elegiac portrait of the now destroyed Palast der Republik in Berlin, an iconic building of the GDR era – shows reflections of light on the mirror-like surface of the building. As much as Dean's films are recordings of the visual beauty of these spectacular moments, their focus on the passing of time casts each of Dean's films as an elegiac and reflexive musing on the obsolescence of the medium of film itself.

In ihren Filmen, Fotografien, Zeichnungen und Sammlungen gefundener Objekte beschäftigt sich Tacita Dean gerne mit dem Akt der Beobachtung, vor allem jener Sujets, die bald verschwinden oder unsichtbar werden können. Ihre 16-mm-Filme verleihen Licht und Raum eine fühlbare Materialität. Dem rasenden Tempo des modernen Lebens begegnen sie durch statische Kamerapositionen und lange Einstellungen, die ein Element der Stille in die bewegten Bilder bringen. Ganz gleich, ob sie Situationen, Menschen oder Orte zeigen, lassen sich die Filme zumeist als Porträts bezeichnen, da sie die verborgenen Eigenschaften ihrer jeweiligen Sujets enthüllen. In ihrer neuen Arbeit *Darmstädter Werkblock* (2007) filmt Dean in den nach Beuys benannten und von ihm installierten Räumen des Hessischen Landesmuseums in Darmstadt. Anstatt auf die Werke selbst richtet die Künstlerin ihre Kamera auf die marode Jutebespannung an den Wänden, die bald ersetzt werden soll, wobei unter Hervorhebung des entropischen Charakters von Beuys' Arbeit ein enigmatisches Künstlerporträt entsteht. Dean untersucht in ihren Filmen und Zeichnungen oft schwer fassbare Naturerscheinungen, wie Sonnenfinsternisse oder das grüne aufblitzende Licht, das einen Son-nenuntergang begleitet. Häufig tauchen sie in Verbindung mit Architektur auf, die veraltete oder gescheiterte Ideologie symbolisiert. *Palast* (2004) z.B. – ein melancholisches Porträt des nunmehr abgerissenen Palasts der Republik in Berlin, eines Symbols der DDR-Zeit – zeigt Licht-reflexe auf der spiegelglatten Oberfläche des Gebäudes. Wenn Dean in ihren Filmen einerseits die visuelle Schönheit solch besonderer Momente festhält, sind ihre Arbeiten, die das Verstreichen der Zeit fokussieren, andererseits ein wehmütiges Reflektieren über das Veralten des Mediums Film an sich.

Dans ses films, ses photographies, ses images et ses collections d'objets trouvés, Tacita Dean révèle une profonde fascination pour l'acte d'observer – notamment des sujets dont la disparition peut les faire se perdre ou les rendre invisibles. Ses films en 16 mm donnent à l'espace et à la lumière une matérialité palpable, opposant à la frénésie de la vie moderne un regard que caractérisent un cadre fixe et de longues prises dotant ces images mouvantes d'un certain statisme. Qu'ils portent sur des événements, des gens ou des lieux, ses films apparaissent pour la plupart comme des portraits révélant les qualités intrinsèques de leurs divers sujets. Le récent *Darmstädter Werkblock* (2007) est filmé dans les pièces consacrées à Joseph Beuys et installées par ce dernier au Hessisches Landesmuseum de Darmstadt. Au lieu de filmer les œuvres elles-mêmes, Dean a braqué sa caméra sur la vieille tapisserie de jute qui, en attente de remplacement, recouvre les murs de la pièce – soulignant ainsi la nature entropique de l'œuvre de Beuys et offrant de l'artiste un portrait énigmatique. De nombreux films et dessins de Dean explorent des phénomènes naturels éphémères, de l'éclipse solaire au rayon vert qui parfois accompagne le coucher ou le lever du soleil. Ces phénomènes sont souvent présentés en relation avec des éléments d'architecture, symboles de croyances désuètes ou déçues. *Palast* (2004), par exemple – portrait mélancolique d'une icône de l'ancienne RDA, le Palast der Republik de Berlin aujourd'hui détruit –, saisit des reflets de lumière sur la surface en miroir du bâtiment. Si les films de Dean enregistrent la beauté visuelle de ces moments spectaculaires, leur fascination obsessionnelle pour le passage du temps fait de chacun d'eux une méditation élégiaque sur l'obsolescence de la pellicule cinématographique comme support artistique.

A. B.

SELECTED EXHIBITIONS →
2008 *Tacita Dean*, Dia: Beacon, New York. *Real*, Städel Museum, Frankfurt am Main **2007** *Tacita Dean: The Hugo Boss Prize 2006*, Solomon R. Guggenheim Museum, New York. *Tacita Dean: Film Works*, Miami Art Central, Miami **2006** *Tacita Dean: Human Treasure*, Center for Contemporary Art, Kitakyushu. *Tacita Dean*, The National Gallery, Oslo. *Tacita Dean & Francis Alÿs*, Schaulager, Münchenstein/Basle **2005** *Tacita Dean*, Tate St. Ives. *Tacita Dean: The Russian Ending, 2001*, Berlinische Galerie, Berlin

SELECTED PUBLICATIONS →
2008 *Tacita Dean: Film Works*, Miami Art Central, Miami, Charta, Milan **2006** *Tacita Dean*, Phaidon Press, London. *Tacita Dean: Analogue. Drawings 1991–2006*, Schaulager, Münchenstein/Basle, Steidl, Göttingen **2005** *Tacita Dean: An Aside*, Hayward Gallery, London; Steidl, Göttingen. *Tacita Dean: Die Regimentstochter*, Steidl, Göttingen

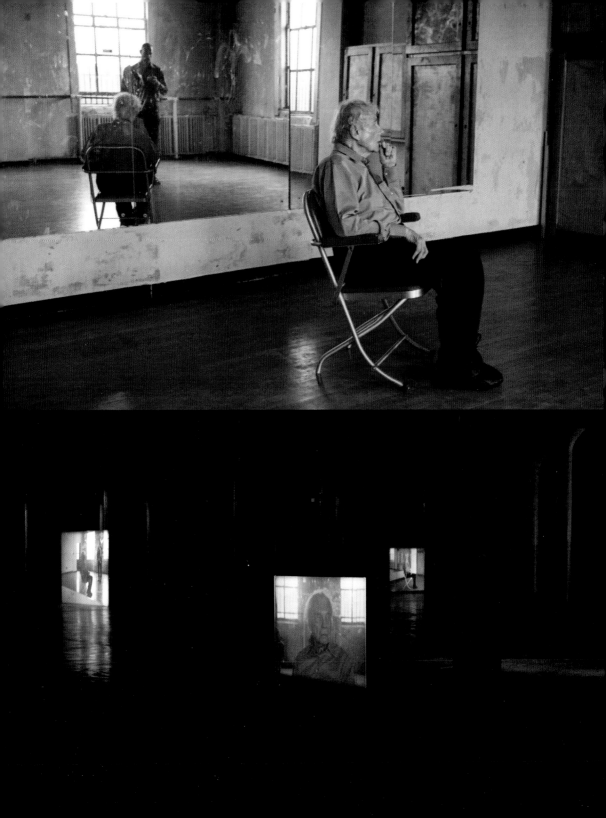

1 **Merce Cunningham Performs** *Stillness (in Three Movements)* **to John Cage's Composition** *4'33"* **with Trevor Carlson, New York City, 28 April 2007 (Six Performances, Six Films)**, 2008, production still, 16mm colour film, optical sound
2 **Merce Cunningham Performs** *Stillness (in Three Movements)* **to John Cage's Composition** *4'33"* **with Trevor Carlson, New York City, 28 April 2007 (Six Performances, Six Films)**, 2008, 16mm colour film, optical sound. Installation view, Dia:Beacon, New York

3 **Crowhurst II**, 2007, gouache on fibre-based photograph, mounted on paper, 300 x 380 cm
4 **Darmstädter Werkblock**, 2007, production still, 16mm colour film, optical sound, 18 min, continuous loop
5 **Darmstädter Werkblock**, 2007, 16mm colour film, optical sound, 18 min, continuous loop. Installation view, Frith Street Gallery, London

„Es wird gesagt, dass es in meinen Filmen oft um Erinnerung geht, aber Erinnerung ist etwas sehr Subjektives."

« On dit que la mémoire constitue souvent le sujet de mes films – mais la mémoire est une chose bien subjective. »

"People say that my films are often about memory, but memory is such a subjective thing."

3

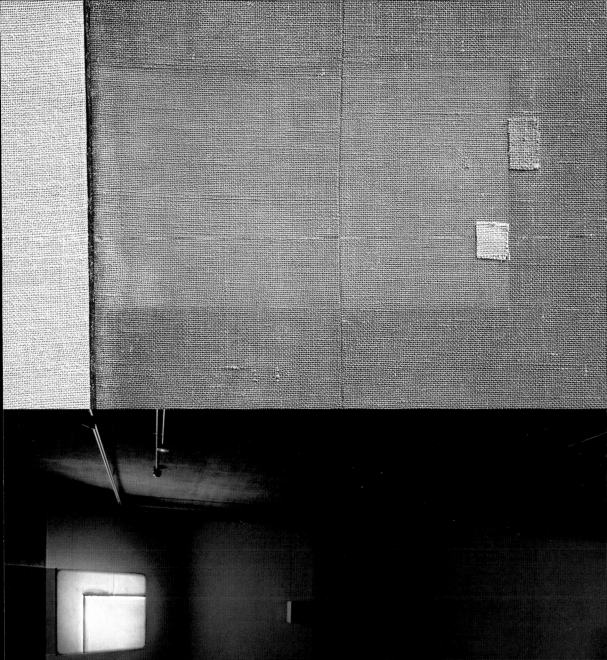

Rineke Dijkstra

1959 born in Sittard, lives and works in Amsterdam, The Netherlands

Rineke Dijkstra's photographic series prove that the relationship between a photographer and her subject does not have to be a glancing exchange between strangers, in which one is armed with a camera and the other without any defence. Dijkstra's portraits bear witness to the development of young men and women experiencing rites of passage such as adolescence or childbirth, but to ensure that she doesn't merely steal single images of these moments, Dijkstra stays in contact with her subjects and chronicles their growth over time. Every two years, for instance, she has photographed Almerisa, a young Bosnian girl she met in an asylum seekers' centre in the Netherlands in 1994. Almerisa appears first as a slouching teenager with black painted fingernails, then a defiant young woman and, most recently, as a softened young mother holding her baby. By photographing her subjects in minimal surroundings and providing few clues about their environments or upbringings, Dijkstra directs her viewers toward subtler clues. We can just barely glimpse her subjects' imminent adulthood in their elongated limbs or oversize feet, the way they hold their heads, apply their makeup or the way their hair falls over their shoulders. Dijkstra says her interest in photography arose as an extension of her passive observation of people she found interesting or special: "I was interested in photographing people at moments when they had dropped all pretence of a pose." By forging enduring relationships out of these brief encounters, Dijkstra's act of photographing is less like distant or detached observation and more akin to the sensitivity and intimacy of friendship or motherhood.

Wie Rineke Dijkstra in ihren fotografischen Porträtserien beweist, muss die Beziehung zwischen der Fotografin und ihrem Sujet nicht wie ein Blickwechsel zwischen Fremden aussehen – die eine Seite mit einer Kamera bewaffnet, die andere dem wehrlos ausgesetzt. Dijkstras Porträtfotografien dokumentieren Veränderungen von jungen Männern und Frauen in einer Übergangsphase, etwa in der Pubertät oder nach einer Entbindung. Doch anstatt sich Einzelbilder dieser Momente anzueignen, hält Dijkstra den Kontakt weiter aufrecht, um spätere Entwicklungen immer wieder festzuhalten. So fotografierte sie im Zweijahres-Turnus ein junges bosnisches Mädchen namens Almerisa, das sie 1994 in einem niederländischen Asylbewerberheim kennengelernt hatte. Erst erscheint Almerisa als durchhängender Teenager mit schwarz lackierten Fingernägeln, dann als herausfordernde junge Frau und zuletzt besänftigt als Mutter mit ihrem Baby. Durch das minimalistische Dekor, das kaum einen Hinweis auf Umfeld oder Herkunft liefert, lenkt Dijkstra den Blick des Betrachters auf subtilere Details. Die Schwelle zum Erwachsensein angedeutet in den überlangen Gliedmaßen oder den großen Füßen, in der Kopfhaltung, im Make-up, in der Art, wie die Haare über die Schulter fallen. Dijkstras fotografisches Interesse entwickelte sich, wie sie sagt, ursprünglich aus rein passiver Beobachtung von Menschen, die sie interessant oder bemerkenswert fand: „Mein Anliegen war, die Leute in dem Moment zu fotografieren, wo sie ihre Posen abwerfen." Dadurch, dass sie diese Kurzbegegnungen zu dauerhaften Beziehungen weiterzuentwickeln vermag, ist Dijkstras fotografischer Akt weniger eine distanzierte oder unparteiische Betrachtung, als vielmehr dem Feingefühl und der Intimität von Freundschaft oder Mütterlichkeit verwandt.

Les séries photographiques de Rineke Dijkstra démontrent que la relation entre un photographe et son sujet ne se réduit pas nécessairement à un échange de regards entre étrangers, où l'un est armé d'un appareil et l'autre laissé sans défense. Les portraits de Dijkstra témoignent du développement de jeunes hommes et de jeunes femmes qui vivent des rites de passages comme l'adolescence ou la naissance d'un enfant. Pour s'assurer qu'elle ne se contente pas de ravir à ces moments des images isolées, Dijkstra reste en contact avec ses sujets et rend compte de leur évolution dans le temps. Un an sur deux, par exemple, elle revient photographier Almerisa, une jeune Bosniaque rencontrée en 1994 aux Pays-Bas dans un centre d'hébergement pour demandeurs d'asile. Almerisa apparaît d'abord comme une adolescente avachie aux ongles vernis de noir, puis comme une jeune femme rebelle et plus récemment en jeune mère adoucie tenant son bébé dans ses bras. En photographiant ses sujets dans des décors minimalistes et en ne donnant que de rares indications sur leur milieu d'origine, Dijkstra suggère au spectateur des indices plus subtils. Nous entrapercevons la maturité à venir de ses sujets à leurs membres étirés, leurs pieds surdimensionnés, la façon dont ils tiennent leur tête, se maquillent ou se coiffent. Dijkstra explique que son intérêt pour la photographie est apparu comme une extension de son observation passive des gens qu'elle trouvait intéressants ou spéciaux : « Ce qui m'intéressait, c'était de photographier les gens à des moments où ils abandonnent toute prétention de pose. » En créant des relations durables à partir de ces brèves rencontres, le *modus operandi* photographique de Dijkstra renvoie moins à une observation distanciée qu'à la sensibilité et l'intimité qui fondent une amitié ou un rapport maternel.

CH. L.

SELECTED EXHIBITIONS →
2008 *Puberty*, Haugar Vestfold Kunstmuseum, Tonsberg. *Presumed Innnocence: Photographic Perspectives of Children*, DeCordova Museum, Lincoln **2007** *Schmerz*, Hamburger Bahnhof, Berlin **2006** *Faster! Bigger! Better!*, ZKM, Karlsruhe. **2003** *Rineke Dijkstra*, The Buzzclub, Liverpool; Mysteryworld, Zaandam; Kunstverein für die Rheinlande und Westfalen, Düsseldorf **2001** *Israel Portraits*, The Herzliya Museum of Art, Herzliya: *Focus: Rineke Dijkstra*, The Art Institute of Chicago. *Rineke Dijkstra: Portraits*, ICA, Boston

SELECTED PUBLICATIONS →
2007 *Schmerz*, Hamburger Bahnhof, Berlin; DuMont, Cologne **2006** *Faster! Bigger! Better!*, ZKM, Karlsruhe; Verlag der Buchhandlung Walther König, Cologne **2004** *Rineke Dijkstra: Portraits*, Schirmer/Mosel, Munich **2002** *Rineke Dijkstra: Beach Portraits*, LaSalle Bank, Chicago **2001** *Israel Portraits: Rineke Dijkstra*, The Herzliya Museum of Art, Herzliya; Sommer Contemporary Art, Tel Aviv. *Rineke Dijkstra: Portaits*, ICA, Boston; Hatje Cantz, Ostfildern

1 **Almerisa, Zoetermeer, The Netherlands, June 19**, 2008, C-print, 94 x 75 cm
2 **Vondelpark, Amsterdam, June 10**, 2005, C-print, 112.5 x 140 cm
3 **Almerisa, Asylumcenter Leiden, The Netherlands, March 14**, 1994, C-print, 94 x 75 cm

4 **Almerisa, Wormer, The Netherlands, June 23**, 1996, C-print, 94 x 75 cm
5 **Almerisa, Leidschendam, The Netherlands, December 9**, 2000, C-print, 94 x 75 cm
6 **Almerisa, Leidschendam, The Netherlands, June 25**, 2003, C-print, 94 x 75 cm

„Für mich ist es wichtig, eine Beziehung zum Modell aufzubauen. Es muss da ein Wechselspiel geben. Ich denke, es geht darum, einander auf einer emotionalen Ebene zu erkennen. Ich gebe nicht gern viele Anweisungen."

« Il est important pour moi de pouvoir me relier au sujet. Il faut qu'il y ait une interaction. Je pense qu'il s'agit essentiellement de reconnaissance à un niveau émotionnel. Je n'aime pas donner beaucoup de directives. »

"For me it is important that I can relate to my subject. There needs to be an interaction. I think it's all about recognition on an emotional level. I don't like to direct too much."

2

Nathalie Djurberg

1978 born in Lysekil, Sweden, lives and works in Berlin, Germany

Nathalie Djurberg's video animations picture a world populated by vicious girls, tortured men, mutilated bodies and grotesque animals. Adopting the old-fashioned technique of stop-motion, Djurberg portrays small handmade clay figures and marionettes that move in dreamlike sets. She explores bestial human instincts and primordial desires, which appear even more perverse as they contrast with the child-like simplicity of the medium of animation. Deviant sexuality, sadistic violence, monstrous incest and brutal death are weaved together in a theatre of cruelty that combines juvenile innocence with adult guilt. Female figures abound and are often accompanied by animals, as in *Tiger Licking Girl's Butt* (2004), in which, as the title implies, a tiger compulsively licks a girl's behind. Along with the modelling clay animations she began in 1999, Djurberg has also been making charcoal animations, like *My Name Is Mud* (2003), the story of a personified blob of mud that swallows animals and houses. Djurberg's short narratives play around themes such as male-female relationships, parental love and domestic abuse, mixing childhood memories with fairytale archetypes and a generous share of dark humour. All her works, which usually lack dialogue, are accompanied by vibrant musical scores composed by Hans Berg: at times joyful or dramatic, the electronic soundtracks give a baroque grandiosity to the scenarios of Djurberg's videos. Recently, Djurberg has also started experimenting with sculpture: for her exhibition *Turn into Me* (2008), she created several sculptural environments: a forest, a giant potato, a female body – pavilion-like structures which viewers can enter to watch the videos, as though immersed in the terrifying setting of a contemporary fable.

Nathalie Djurbergs Animationsfilme zeigen eine von bösartigen Frauen, gequälten Männern, verstümmelten Körpern und grotesken Tieren bevölkerte Welt. Mit der altmodischen Stop-Motion-Technik porträtiert Djurberg kleine, handgefertigte Plastilinfiguren und Marionetten vor traumartigen Kulissen. Sie interessiert sich für menschliche Bestialität und Urbegierden, wobei die Perversion durch die Harmlosigkeit des Kindertrickfilms betont wird. Sexuelle Abartigkeit, sadistische Gewalt, inzestuöse Monstrosität und tödliche Brutalität verbinden sich zu einem Theater des Grauens, in einem Spiel mit unschuldigen Kindern und schuldigen Erwachsenen. Die überwiegend weiblichen Figuren treten oft zusammen mit Tieren auf, wie in *Tiger Licking Girl's Butt* (2004), wo ein Tiger gierig am Hinterteil eines kleinen Mädchens leckt. Außer ihren 1999 begonnenen Trickfilmen mit Plastilin machte Djurberg auch animierte Kohlezeichnungen: *My Name Is Mud* (2003) handelt von einem belebten Stück Mist, das Tiere und Häuser verschlingt. Djurbergs kurze narrative Filme thematisieren Mann-Frau-Beziehungen, Elternliebe und häusliche Gewalt, wobei sie Kindheitserinnerungen und Archetypen der Märchenwelt mit einem kräftigen Schuss makabrem Humor verknüpfen. Die Filme haben keinen Dialog, sondern werden von Hans Bergs kraftvoller Musik untermalt. Die teils heiteren, teils dramatischen elektronischen Soundtracks verdichten Djurbergs Videofilme zu einer grandios barocken Fülle. Neuerdings experimentiert Djurberg auch mit Skulptur: Für ihre Ausstellung *Turn into Me* (2008) schuf sie skulpturale Environments – einen Wald, eine Riesenkartoffel, einen Frauenkörper –, pavillonartige Strukturen, die der Zuschauer betritt, um in der beklemmenden Kulisse einer zeitgenössischen Fabel die Videos zu betrachten.

Les animations vidéo de Nathalie Djurberg dépeignent un monde peuplé de filles sadiques, d'hommes torturés, de corps mutilés et d'animaux grotesques. Adoptant la vieille technique de l'animation image par image, Djurberg manipule des figurines d'argile réalisées à la main et des marionnettes qui évoluent dans des décors oniriques. Elle explore les instincts bestiaux et les désirs primaux de l'homme, qui apparaissent d'autant plus pervers qu'ils contrastent chez elle avec la simplicité enfantine de son médium. Sexualité déviante, violence sadique, incestes monstrueux et morts brutales s'entremêlent dans un théâtre de la cruauté associant innocence juvénile et culpabilité adulte. Les personnages féminins, très nombreux, sont souvent accompagnés d'animaux comme dans *Tiger Licking Girl's Butt* (2004), où l'on voit un tigre lécher avec ferveur les fesses d'une jeune fille. Outre ses animations employant des figurines d'argile, entamées en 1999, Djurberg réalise des dessins animés au fusain, tel *My Name Is Mud* (2003), qui raconte l'histoire d'un petit tas de boue qui engloutit des animaux et des maisons. Les courts récits de Djurberg mettent en scène les rapports homme-femme, l'amour parental et les violences conjugales, mêlant des souvenirs d'enfance aux archétypes du conte de fées, avec une bonne dose d'humour noir. Ses œuvres, presque toujours dépourvues de dialogue, s'appuient toujours sur une ardente partition musicale de Hans Berg – joyeuse ou dramatique, cette musique donne une ampleur baroque à ses scénarios. Depuis peu, Djurberg pratique également la sculpture : pour son exposition *Turn into Me* (2008), elle a créé différents environnements sculpturaux – une forêt, une pomme de terre géante, un corps de femme –, structures gigantesques que le visiteur est invité à pénétrer pour regarder les vidéos, comme immergé dans le décor terrifiant d'une fable contemporaine.

C. A.

SELECTED EXHIBITIONS →
2008 *Nathalie Djurberg: Turn into Me*, Fondazione Prada, Milan. *Nathalie Djurberg*, Sammlung Goetz, Munich **2007** *Nathalie Djurberg: Denn es ist schön zu leben*, Kunsthalle Wien, Vienna. *Nathalie Djurberg*, Kunsthalle Winterthur. *Traum und Trauma*, MUMOK, Vienna **2006** *Into Me/Out Of Me*, P.S.1 Contemporary Art Center, Long Island City; KW Institute for Contemporary Art, Berlin. *Of Mice and Men*, 4th Berlin Biennial for Contemporary Art, Berlin **2005** *Tirana Biennale*, Tirana.

SELECTED PUBLICATIONS →
2007 *Nathalie Djurberg: Denn es ist schön zu leben*, Kunsthalle Wien, Vienna; Verlag für moderne Kunst, Nuremberg. *Traum und Trauma*, MUMOK, Vienna; Hatje Cantz, Ostfildern. *Into Me/Out Of Me*, P.S.1 Contemporary Art Center, Long Island City; KW Institute for Contemporary Art, Berlin; Hatje Cantz, Ostfildern **2006** *Of Mice and Men*, 4th Berlin Biennial for Contemporary Art, Berlin, Hatje Cantz, Ostfildern

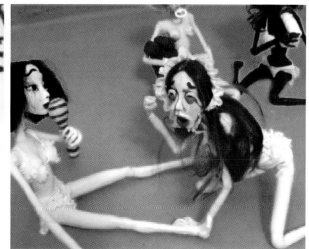
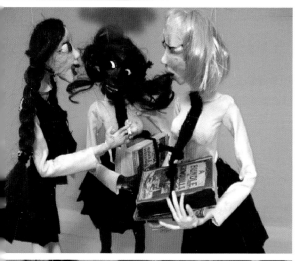
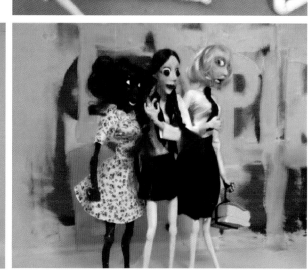

74

1 **New Movements in Fashion**, 2006, clay animation, video, music by Hans Berg, 9 min 24 sec
2 **It's the Mother**, 2008, clay animation, video, music by Hans Berg, 6 min

3 **The Natural Selection**, 2006, clay animation, video, music by Hans Berg, 11 min 42 sec
4 **Turn into Me**, 2008, clay animation, video, music by Hans Berg, 7 min 10 sec

„Ich spiele alle Rollen in meinen Filmen, ich bringe meine weiblichen und männlichen Anteile ein. Als ich mit den Trickfilmen anfing, identifizierte ich mich mit dem Opfer, aber dann erkannte ich, dass ich genauso als Peiniger auftrat. Ich bin Opfer und Täter."

« Dans mes films, je joue tous les rôles ; j'y suis à la fois homme et femme. Quand j'ai commencé l'animation, je me voyais toujours comme la victime, avant de comprendre que j'étais aussi le tortionnaire. Je suis la victime et le bourreau. »

"I play all the parts in my films, so I am both male and female in them. When I started animating, I always saw myself as the victim, but then I realized that I was just as much the torturer. I am the victim and the perpetrator."

2

Peter Doig

1959 born in Edinburgh, United Kingdom, lives and works in Port of Spain, Trinidad and Tobago

Peter Doig is a phenomenon. His paintings break price records, are lauded by critics, influence other artists and, to this day, remain seductive for imitators. Doig spearheaded a renaissance of figurative painting that began in the mid-1990s and has continued almost uninterrupted since then. As a result, it is not easy to view his paintings without the distortions of hype and mythmaking. That it is nevertheless worth the effort was demonstrated most recently by Doig's retrospective exhibition at Tate Britain (2008), which proved that terms such as "magical realism" or "Gauguin exoticism" do not suffice to describe his work. One of Doig's qualities is that he has not fallen victim to a stylistic standstill. Over the course of time he has considerably altered his approach to the figure and to landscape, and has even modified painting itself while testing the boundaries of figuration. "I don't like repetition in progress. I want to avoid that way of working," he says. This is particularly evident in motifs which Doig has employed on a number of occasions and repeatedly transformed: for example in *Red Boat (Imaginary Boys)*, 2004, and *Figures in Red Boat* (2005–07), or in *Man Dressed as Bat* (2004 and 2007). The archaic *Untitled (Jungle Painting)*, 2007, obviously an echo of the no less sombre *Untitled (Paramin)*, 2004, also shows that such differentiations are not merely about variations or sketches. What is expressed here is a power of invention, sometimes tentative, sometimes erratic, whose "contents" are derived from painting. Doig thus succeeds, above all in his more recent paintings, in opening up figuration for broader contexts: "Painting should evolve into a type of abstraction; it should slowly dissipate into something else through time, through working, seeing things through."

Peter Doig ist ein Phänomen. Seine Bilder stellen Preisrekorde auf, werden von Kritikern gefeiert, waren für Künstler richtungweisend und sind bis heute verführerisch für Epigonen. Doig wurde zur Gallionsfigur der Wiederentdeckung einer figurativen Malerei, die Mitte der 1990er-Jahre in Gang kam und seither beinah ungebrochen ist, sodass es einige Mühe kostet, die Bilder unverstellt von Hype und Mythenbildung zu sehen. Dass so etwas durchaus lohnt, erwies sich zuletzt bei Doigs Retrospektive in der Tate Britain (2008), die zeigte, dass das Werk in Schlagworten von „Magischer Realismus" bis „Gauguin-Exotik" nicht aufgeht. Zu Doigs Qualität gehört, dass er keinem stilistischen Stillstand verfällt. Seinen Zugang zu Figur und Landschaft hat er im Laufe der Jahre stark verändert und im Ausloten der Grenzen von Figuration auch die Malerei selbst immer wieder neu justiert. „Ich mag keine Wiederholungen und versuche, solche Arbeitsweisen zu vermeiden", sagt er. Besonders deutlich wird das an Motiven, die Doig mehrfach aufgegriffen und dabei immer wieder verändert hat: etwa in *Red Boat (Imaginary Boys)* (2004) und *Figures in Red Boat* (2005–07) oder bei *Man Dressed as Bat* (2004 und 2007). Auch das archaische *Untitled (Jungle Painting)* (2007), offenbar ein Echo des nicht weniger düsteren *Untitled (Paramin)* (2004), zeigt: Bei solchen Differenzierungen geht es nicht bloß um Varianten oder Skizzen. Hier drückt sich eine mal tastend, mal sprunghaft vollzogene Erfindungskraft aus, die ihre „Inhalte" vom Malerischen her bestimmt. So gelingt es Doig vor allem in neueren Bildern, die Figuration auch für weitere Kontexte zu öffnen: „Malerei sollte sich zu einer Art von Abstraktion entwickeln", sagte er einmal, „und sich langsam in etwas anderes verwandeln – durch Zeit, durch Arbeit, indem man Dinge durchschaut."

Peter Doig est un phénomène. Ses tableaux battent des records en termes de prix, sont célébrés par la critique, influencent d'autres artistes et tentent les épigones. Doig est une des figures de proue d'une redécouverte de la peinture figurative qui s'est amorcée au milieu des années 1990 et s'est développée presque sans discontinuer, de telle manière qu'il est aujourd'hui difficile de regarder ses tableaux en laissant de côté la frénésie et le mythe. Le fait que son œuvre mérite un tel regard s'est à nouveau vérifié lors de la rétrospective présentée en 2008 à la Tate Britain et qui a montré qu'il ne pouvait être réduit à des clichés comme « réalisme magique » ou « exotisme à la Gauguin ». Une de ses qualités est qu'il ne s'enferme dans aucune forme de stagnation stylistique. Son approche de la figure et du paysage a fortement évolué au fil des ans, et Doig n'a cessé de renouveler aussi sa peinture en sondant les limites de la figuration. « Je n'aime pas les répétitions. Je préfère éviter cette manière de travailler », explique-t-il. Ceci ressort clairement des motifs que Doig a repris plusieurs fois de façon toujours différente, par exemple dans *Red Boat (Imaginary Boys)* (2004) et *Figures in Red Boat* (2005–07) ou *Man Dressed as Bat* (2004 et 2007). L'archaïque *Untitled (Jungle Painting)* de 2007, qui fait manifestement écho au non moins sombre *Untitled (Paramin)* de 2004, montre que ces distinctions ne sont pas seulement des variantes ou des études. Une puissance d'invention y procède tantôt par tâtonnements, tantôt par bonds, mais détermine surtout ses « contenus » à partir du fait pictural. Dans ses tableaux récents, Doig parvient ainsi à ouvrir la figuration à d'autres contextes : « La peinture devrait évoluer vers une sorte d'abstraction », a-t-il pu dire, « et se transformer lentement en quelque chose d'autre – par le temps, le travail, en perçant les choses à jour. »

J. A.

SELECTED EXHIBITIONS →
2008 *Peter Doig*, Tate Britain, London, Musée d'Art moderne de la Ville de Paris; Schirn Kunsthalle, Frankfurt am Main **2007** *Von Abts bis Zmijewski*, Pinakothek der Moderne, Munich. *The Secret Public*, ICA, London **2006** *Peter Doig: Go West Young Man*, Museum der bildenden Künste, Leipzig. *Peter Doig. Ballroom Marfa. Eye on Europe*, MoMA, New York **2005** *Peter Doig: Studiofilmclub*, Museum Ludwig, Cologne **2004** *Peter Doig: Metropolitain*, Kestnergesellschaft, Hanover

SELECTED PUBLICATIONS →
2008 *Peter Doig*, Tate Publishing, London; DuMont, Cologne **2006** *Peter Doig: Works on Paper*, Rizzoli, New York **2007** *Peter Doig*, Phaidon Press, London **2005** *Peter Doig: Studiofilmclub*, Museum Ludwig, Cologne, Kunsthalle Zürich, Zürich **2004** *Peter Doig: Metropolitain*, Pinakothek der Moderne, Munich, Kestnergesellschaft, Hanover; Verlag der Buchhandlung Walther König, Cologne

1 **Figures in Red Boat**, 2005–07, oil on linen, 250 x 200 cm
2 **Man Dressed as Bat**, 2007, oil on linen, 300 x 350 cm

3 **Untitled (Jungle Painting)**, 2007, oil on linen, 275 x 200 cm

„Häufig versuche ich, eine Art von ‚Sprachlosigkeit' zu schaffen. Ich versuche etwas zu machen, das fragwürdig bleibt, etwas, das sich schwer oder unmöglich in Worte fassen lässt."

« Souvent j'essaie de provoquer une "stupeur". J'essaie de créer le doute, de créer quelque chose de difficile voir d'impossible à définir. »

"Often I am trying to create a 'numbness'. I am trying to create something that is questionable, something that is difficult, if not impossible, to put into words."

2

Marlene Dumas

1953 born in Cape Town, South Africa, lives and works in Amsterdam, The Netherlands

Known for her oil, watercolour and ink portraits and renderings of the human figure, Marlene Dumas has made the personal political for the past twenty-five years, effectively throwing a grenade into an art-historical field where sexuality – and sexual politics as they intersect with race – too often remains untroubled. So perhaps it comes as little surprise that, in the aftermath of September 11 and in the midst of the atrocities perpetrated at Abu Ghraib, she would return to representations of death, a leitmotif in her work, alongside violence, religion and motherhood. *Measuring Your Own Grave* (2003), also the title of her recent retrospective, evinces a woman, arms spread like wings or maybe a cross, peering down into a monochrome void. Other works like *Dead Marilyn* (2008) shift from the anticipatory to the already gone. Based on a post-mortem shot of Marilyn Monroe, it makes use of photographic source material, as do most of Dumas' past images, some of which originate in the artist's own personal Polaroids, while others appropriate pornographic sources or frames from media archives. But lest the transcription from photograph to painting seem too direct, Dumas' close cropping decontextualizes its subjects, cleaving them from broader narrative and the signposts of background detail; their frontality might suggest an unsavory mugshot. Often as grisly in content as they are gorgeous in execution, the violence Dumas' wrestles into expressionistic pictorial form in fact remains at the level of implication, the better to psychologically unquiet and otherwise – ethically and ideologically – provoke.

Die für ihre Porträts und Darstellungen der menschlichen Gestalt in Öl, Aquarell und Tusche bekannte Künstlerin Marlene Dumas hat seit 25 Jahren das Persönliche zum Politischen erhoben. In einer Kunstgeschichte, in der die Sexualität – und Sexualpolitik, die sich mit Rassenfragen überschneidet – allzu oft unbeachtet bleibt, schlug ihre Arbeit wie eine Bombe ein. So gesehen überrascht es nicht, dass sie nach dem 11. September und inmitten des Folterskandals von Abu Ghraib erneut an die Todesdarstellungen knüpft, die neben Gewalt, Religion und Mutterschaft ein Leitmotiv ihres Kunstschaffens sind. Das Bild *Measuring Your Own Grave* (2003), nach dem die aktuelle Retrospektive benannt wurde, zeigt eine Frau mit ausgebreiteten Armen, die an Flügel oder ein Kreuz erinnern, den Blick in eine monochrome Leere gerichtet. Andere Arbeiten wie *Dead Marilyn* (2008) werden vom Antizipatorischen weg zum bereits Geschehenen verlagert. Das auf einer Aufnahme der toten Marilyn Monroe basierende Bild benutzt eine fotografische Quelle – wie die meisten von Dumas Arbeiten, die teils auf eigene Polaroidaufnahmen, teils auf pornografische Quellen oder Material aus Medienarchiven zurückgehen. Um zu vermeiden, dass die Übertragung von der Fotografie zur Malerei zu unmittelbar erscheint, reißt Dumas durch Beschneiden der Fotos die Sujets aus ihrem ursprünglichen Kontext und trennt sie von ihren narrativen Zusammenhängen und Hintergrundinformationen; ihre direkte Frontalität könnte auf ein hässliches Fahndungsfoto verweisen. Oft inhaltlich abschreckend, sind die Werke doch schön ausgeführt. Die in Dumas' expressionistischen Bildern verdichtete Gewalt bleibt auf der Bedeutungsebene erhalten, um dadurch die Psyche stärker zu beunruhigen und sowohl ethisch wie auch ideologisch zu provozieren.

Connue pour ses représentations du corps humain et ses portraits à l'huile, à l'aquarelle ou à l'encre, Marlene Dumas, fait du personnel un sujet politique en dynamitant efficacement depuis un quart de siècle une histoire de l'art où la sexualité – tout comme la politique sexuelle dans son rapport à la politique raciale – est trop rarement mise à mal. On ne saurait donc s'étonner de ce que, au lendemain du 11 Septembre et des atrocités commises à Abu Ghraib, elle revienne à des représentations de la mort – motif récurrent de son œuvre au même titre que la violence, la religion et la maternité. *Measuring Your Own Grave* (2003), dont le titre est également celui d'une rétrospective récente, montre une femme aux bras ouverts comme deux ailes ou en croix, qui observe à ses pieds un néant monochrome. Ailleurs – comme dans *Dead Marilyn* (2008), d'après une photographie *post mortem* de Marylin –, la disparition remplace l'anticipation. Par le passé, Dumas a souvent utilisé pour ses peintures des sources photographiques : polaroids personnels, photos de presse, images pornographiques. Pour que ce passage de la photographie à la peinture ne soit pas trop direct, elle décontextualise ses sujets par un recadrage serré qui les prive de leur environnement narratif et les dépouille de tout détail d'arrière-plan. Leur caractère frontal peut alors évoquer un sinistre cliché d'anthropométrie judiciaire. Contenu macabre, exécution somptueuse : la violence de Dumas, exprimée sous une forme quasi expressionniste, demeure toujours implicite – comme pour mieux nous déstabiliser psychologiquement et mieux nous interroger sur le plan éthique, et idéologique. S. H.

SELECTED EXHIBITIONS →
2008 *Marlene Dumas: Measuring Your Own Grave*, MOCA, Los Angeles; MoMA, New York. *Order. Desire. Light*, Irish Museum of Modern Art, Dublin. *The Painting of Modern Life*, Castello di Rivoli, Turin **2007** *Marlene Dumas: Broken White*, Museum of Contemporary Art, Tokyo **2006** *The 80's: A Topology*, Museo Serralves, Porto. *The Present*, Stedelijk Museum, Amsterdam **2005** *Marlene Dumas: Female*, Taidehalli Helsinki; Staatliche Kunsthalle Baden-Baden. *Eros*, Fondation Beyeler, Riehen / Basle

SELECTED PUBLICATIONS →
2008 *Marlene Dumas*, Phaidon Press, London. *Marlene Dumas: Measuring Your Own Grave*, MOCA, Los Angeles **2007** *Marlene Dumas: Broken White*, Museum of Contemporary Art, Tokyo **2006** *Marlene Dumas*, Mondadori, Milan. *Marlene Dumas: Broken White*, Museum of Contemporary Art, Tokyo **2005** *Marlene Dumas: Female*, Taidehalli Helsinki; Staatliche Kunsthalle Baden-Baden; Snoeck Verlag, Cologne

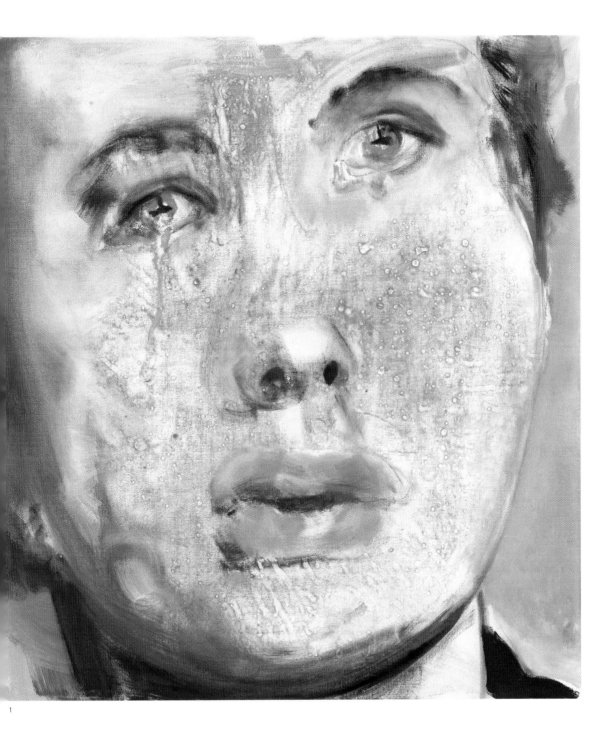

1

1 **For Whom the Bell Tolls**, 2008, oil on canvas, 100 x 90 cm
2 **Dead Marilyn**, 2008, oil on canvas, 40 x 50 cm

3 **Glass Tears**, 2008, oil on canvas, 40 x 50 cm
4 **Blue Movie**, 2008, oil on canvas, 40 x 50 cm

„Meine besten Arbeiten sind erotische Zurschaustellungen mentaler Verwirrungen (mit eingestreuten belanglosen Informationen)."

« Mes meilleures œuvres sont l'expression érotique d'une confusion mentale (où viennent s'ajouter des informations dépourvues de toute pertinence). »

"My best works are erotic displays of mental confusions (with intrusions of irrelevant information)."

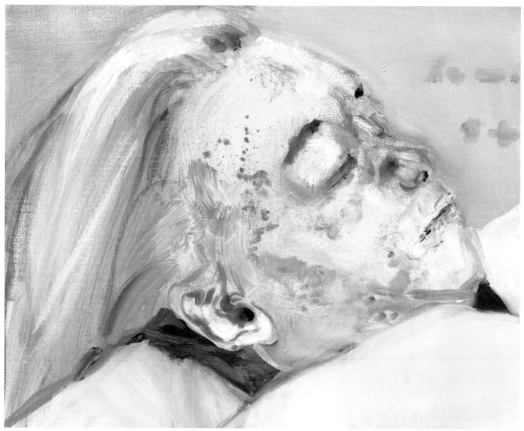

2

3

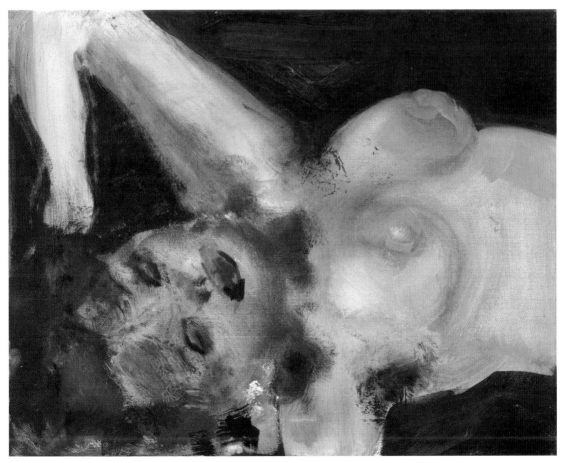

Marcel Dzama

1974 born in Winnipeg, Canada, lives and works in Brooklyn (NY), USA

Marcel Dzama's works depict a fairytale world in which people, animals, anthropomorphic plants and hybrid creatures interact, but where familiar dimensions and natural laws no longer apply. Dzama chooses to explore the threatening side of fairytales in his drawings, collages, films and sculptures, as they rarely promise a happy ending. In his recent dioramas he alludes to diverse cultural references: on the one hand to the forms of display found in natural history museums, on the other to religious shrines, which he became interested in during a stay in Mexico. At the same time, references to dada and surrealism abound, for example to Joseph Cornell. A work shown in his New York exhibition *Even the Ghost of the Past* (2008) reveals what might have preceded Marcel Duchamp's *Etant donnés* (1946–66): through a hole in a door a fox can be spied that seems to have knocked the couple out – in Duchamp's work, only the naked woman would be visible. Staged groups of figures such as *Welcome to the Land of the Bat* (2008) portray nightmarish scenes, for example when a sleeping bear is harried by a swarm of bats that could have flown straight out of Goya's *The Sleep of Reason*. In *On the Banks of the Red River* (2008), Dzama translates the catalogue cover of one of his own previous exhibitions into a surreal hunt and visitation scene consisting of almost 300 ceramic figures, including aristocratic hunters, bats and oversize heads. In contrast to his earlier works, today Dzama also includes commentary on contemporary US politics, as in *The Underground* (2008), a diorama that uses puppet-like sculptures to evoke images of the Iraq war.

Marcel Dzamas Arbeiten zeigen eine märchenhafte Welt, in der Menschen, Tiere, beseelte Pflanzen und hybride Kreaturen interagieren, wobei vertraute Größenverhältnisse und Naturgesetze keine Geltung mehr haben. Es ist eher die bedrohliche Seite von Märchen, die Dzama in seinen Zeichnungen, Collagen, Filmen und Skulpturen aufnimmt, denn sie verheißen selten ein gutes Ende. In neueren Arbeiten spielt er mit der Form des Dioramas auf verschiedene kulturelle Bezüge an: zum einen auf die Präsentationsform naturhistorischer Museen, zum anderen auf religiöse Schreine, wie er sie bei einem Mexiko-Aufenthalt kennengelernt hat. Zugleich enthalten sie immer wieder Bezüge zu Dada und Surrealismus, etwa zu Joseph Cornell. In seiner Ausstellung *Even the Ghost of the Past* (2008) in New York enthüllt eine Arbeit, was Marcel Duchamps *Etant donnés* (1946–66) zeitlich vorausgegangen sein könnte: Durch ein Loch in einer Tür lässt sich ein Fuchs erspähen, der vielleicht das Liebespaar – bei Duchamp wäre dann nur die nackte Frau zu sehen – in den Ruhezustand versetzt hat. Inszenierte Figurengruppen wie *Welcome to the Land of the Bat* (2008) schildern alptraumartige Szenen, wenn etwa ein schlafender Bär von einer Schar Fledermäuse bedrängt wird, die aus Goyas *Der Schlaf der Vernunft gebiert Ungeheuer* stammen könnten. In *On the Banks of the Red River* (2008) überträgt Dzama sein eigenes Cover für den Katalog einer früheren Ausstellung in eine aus fast 300 Keramikfiguren bestehende surreale Jagd- und Heimsuchungsszene mit aristokratischen Jägern, Fledermäusen und überdimensionalen Köpfen. Anders als in früheren Werken finden sich bei Dzama heute auch Kommentare zur aktuellen US-Politik. So in *The Underground* (2008), einem Schaukasten, der mit puppenartigen Skulpturen Bilder aus dem Irakkrieg heraufbeschwört.

Les œuvres de Marcel Dzama montrent un monde féerique où interagissent des hommes, des animaux, des plantes animées et des créatures hybrides, et où les rapports de proportions et les lois de la nature habituels n'ont plus cours. C'est plutôt la face inquiétante des contes que Dzama fait entrer dans ses dessins, collages, films, sculptures, qui présagent rarement un dénouement heureux. Récemment, Dzama exploite les possibilités du diorama pour évoquer différentes références culturelles : d'un côté, la forme de présentation des musées d'histoire naturelle, de l'autre, les châsses religieuses découvertes lors d'un séjour au Mexique. En même temps, on y trouve régulièrement des références au dadaïsme et au surréalisme, notamment à Joseph Cornell. Dans son exposition *Even the Ghost of the Past* (New York, 2008), une des œuvres dévoilait aux spectateurs l'évènement qui aurait pu précéder *Étant donnés* (1946–66) de Marcel Duchamp : par un trou de serrure ménagé dans une porte, on aperçoit un renard qui a peut-être mis le couple d'amants à la retraite – chez Duchamp, seule la femme nue apparaîtrait à cet endroit. Les groupes de figures comme *Welcome to the Land of the Bat* (2008) décrivent des scènes cauchemardesques, par exemple quand un ours ensommeillé est assailli par une nuée de chauves-souris qui pourraient être sorties du *Sommeil de la raison* de Goya. Dans *On the Banks of the Red River* (2008), Dzama transforme la couverture de catalogue d'une précédente exposition en scène de chasse et d'affliction surréaliste composée de plus de 300 figures en terre cuite – avec chasseurs aristocrates, chauves-souris, têtes surdimensionnées. Contrairement aux œuvres plus anciennes, on trouve aussi aujourd'hui chez Dzama des commentaires sur l'actualité politique américaine : *The Underground* (2008) est une vitrine dans laquelle les sculptures apparentées à des poupées évoquent des scènes de la guerre d'Irak. A. M.

SELECTED EXHIBITIONS →
2007 *Marcel Dzama*, Oficina para Proyectos de Arte (OPA), Guadalajara. *Comix*, Kunsthallen Brandts, Odense **2006** *Marcel Dzama*, Ikon Gallery, Birmingham. *Marcel Dzama*, Centre for Contemporary Art, Glasgow. *Into Me / Out Of Me*, P.S.1 Contemporary Art Center, Long Island City; KW Institute for Contemporary Art, Berlin. *Day for Night*, Whitney Biennial 2006, Whitney Museum, New York **2005** *Marcel Dzama*, Le Magasin, Grenoble. *XII. Rohkunstbau: Child's Play*, Wasserschloss Groß Leuthen. *IBCA 2005*, IBCA Biennale Prague

SELECTED PUBLICATIONS →
2008 *Marcel Dzama: Even the Ghost of the Past*, David Zwirner, New York; Steidl, Göttingen. *Marcel Dzama: The Berlin Years*, Perseus Distribution, Jackson **2006** *Marcel Dzama: Tree with Roots*, Ikon Gallery, Birmingham. *Marcel Dzama: The Course of Human History Personified*, David Zwirner, New York. *Whitney Biennial: Day for Night*, Whitney Museum of American Art, New York **2005** *Marcel Dzama: Paintings & Drawings*, Verlag der Buchhandlung Walther König, Cologne

1 **The Banks of the Red River / A Veritable Army of Underdogs**, 2008, ink, watercolour, graphite on paper, 4 parts, 34.9 x 27 cm (each)
2 **Even the Ghost of the Past**, 2008, diorama, brick, door, wood, taxidermic fox, glazed ceramic sculptures, acrylic on blackboard, dimensions variable
3 **Welcome to the Land of the Bat**, 2008, diorama, wood, glazed ceramic sculptures, metal, fabric, outer dimensions 84 x 71 x 102 cm, window 58 x 71 cm, display height 202 cm
4 **On the Banks of the Red River**, 2008, diorama, wood, glazed ceramic sculptures, metal, fabric, outer dimensions 643 x 246 x 218 cm, window 179 x 635 cm, display height 285 cm
5 **The Underground**, 2008, diorama, wood, glazed ceramic sculptures, fibreglass, resin, sand, metal, fabric, outer dimensions 132 x 74 x 211 cm, window 165 x 119 cm, display height 236 cm

„Wenn es um Zeichnungen und Collagen geht bin ich eher Perfektionist. In der Malerei bin ich etwas lockerer. Aber aus irgendeinem Grund habe ich in·der Skulptur das Gefühl, dass alles erlaubt ist. Da ist mehr Freiheit, und·ich lasse mir ganz andere Dinge durchgehen."

« Je suis un peu un perfectionniste quand il s'agit de dessins et de collages. Je suis plus décontracté en peinture. Mais avec la sculpture, je ne sais pas pourquoi, je sens que tout est possible. J'ai plus de liberté, je sens que je peux donner davantage. »

"I'm a little bit of a perfectionist when it comes to drawings and collages. I'm kind of looser in paintings. But with sculpture for some reason I feel that anything goes. There's more freedom, I feel that I can get away with more."

2

3

4

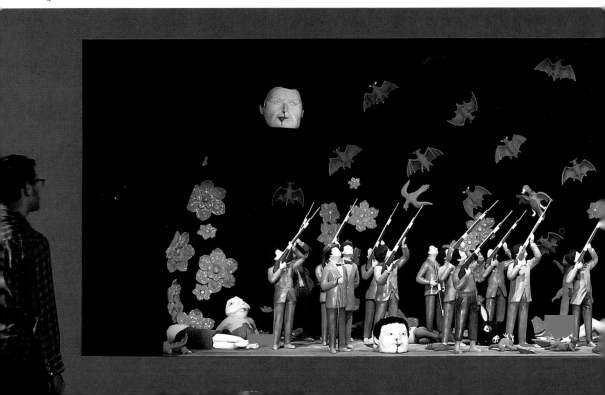

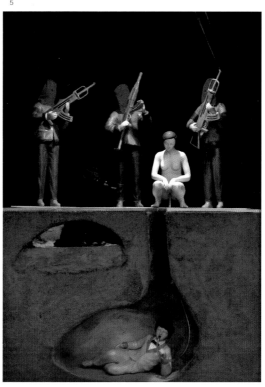

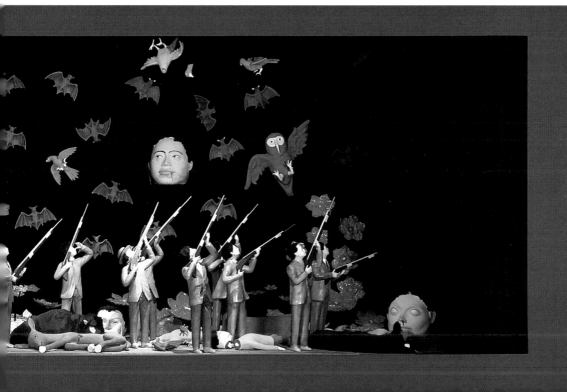

Olafur Eliasson

1967 born in Copenhagen, Denmark, lives and works in Berlin, Germany

Research is an integral part of Olafur Eliasson's art, his practice is informed by a laboratory spirit. Based in his Berlin studio since the mid-1990s, he has built a network of collaborators working there: architects, scientists and technicians who play a major role in the creation of his projects. It takes many a blueprint and model before one of Eliasson's large-scale dramatic works can be realized to challenge the viewer's perception of how to deal, in phenomenological terms, with space, vision, light, colour and, at the same time, with his expectations of art in an everyday experience. *The New York City Waterfalls* (2008) bring a new dimension to art in public space: four giant artificial waterfalls were installed at different places in Manhattan's East River, where they introduced a man-made "natural" component into the complex and socially dense context of the hyper-coded vista of the New York skyline. Nature in a man-made world is a central topic of Eliasson's art: for a gallery exhibition in Berlin, he hauled six metric tons of 15,000 year-old glacier ice from Iceland and created a refrigeration system to keep it frozen in the neutral atmosphere of the showroom throughout the duration of the exhibition (2006). Whether it be in architectural projects such as his temporary pavilion at Serpentine Gallery in London (2007), or in his works with light projections of abstract forms, whose afterimages blend on the viewer's retina into a new and individual image (*the inside of outside*, 2008): Eliasson's oeuvre elicits both individual and collective reactions and extracts truth and power from the contradictions between the two.

Forschung ist ein integraler Bestandteil von Olafur Eliassons Kunst, seine Arbeitsweise folgt dem Prinzip eines Labors. Seit er sich Mitte der 1990er-Jahre in einem Studio in Berlin niederließ, hat er sich ein Netzwerk aus Mitarbeitern aufgebaut: Architekten, Wissenschaftler und Techniker, die eine wichtige Rolle bei der Realisierung seiner Projekte spielen. Es braucht viele Entwürfe und Modelle, bis eine von Eliassons groß angelegten Arbeiten verwirklicht werden kann – Arbeiten, die die Wahrnehmung der Betrachter herausfordern, ihren phänomenologischen Umgang mit Raum, Sehen, Licht und Farbe und gleichzeitig ihre Erwartung an Kunst in der alltäglichen Erfahrung verändern. *The New York City Waterfalls* (2008) fügt der Kunst im öffentlichen Raum eine neue Dimension hinzu: Vier riesige, künstliche Wasserfälle wurden an verschiedenen Orten im East River in Manhattan errichtet und fügen dort ein „natürliches" Element aus menschlicher Hand in den komplexen und sozial dichten Kontext der hypercodierten New Yorker Skyline ein. Natur in einer menschengemachten Welt ist ein zentrales Thema von Eliassons Kunst: Für eine Ausstellung in einer Berliner Galerie ließ er sechs Tonnen von 15.000 Jahre altem Gletschereis aus Island holen und konstruierte ein Kühlsystem, um das Eis während der gesamten Dauer der Ausstellung im neutralen Galerieraum gefroren zu halten (2006). Ob in einem Architekturprojekt wie seinem temporären Pavillon für die Londoner Serpentine Gallery (2007) oder bei seinen Arbeiten mit abstrakten Lichtprojektionen, deren Nachbilder sich auf der Netzhaut des Betrachters zu ganz neuen individuellen Eindrücken vermischen (*the inside of outside*, 2008): Eliassons Werk provoziert sowohl individuelle als auch kollektive Reaktionen und gewinnt Wahrheit und Macht aus den Widersprüchen zwischen beiden.

La recherche fait partie intégrante du travail d'Olafur Eliasson et l'esprit de laboratoire nourrit sa démarche artistique. Depuis qu'il s'est installé dans son studio berlinois au milieu des années 1990, il y a créé un réseau de collaborateurs (architectes, scientifiques, techniciens), qui jouent un rôle crucial dans la réalisation de ses projets. Nombre de plans, prototypes et maquettes précèdent la réalisation de ses spectaculaires œuvres monumentales qui – en termes de phénoménologie – défient la perception sensorielle de l'espace, de la vision, de la lumière, de la couleur ainsi que les attentes du spectateur en matière d'expérience d'art au quotidien. *The New York City Waterfalls* (2008) redéfinissent l'art dans l'espace public. Quatre cascades artificielles géantes, érigées à divers endroits le long d'East River à Manhattan, introduisent un élément « naturel » façonné par la main de l'homme, dans le contexte complexe et socialement dense de la vue hypercodée de la *skyline* new-yorkaise. La nature dans un monde modelé par l'homme est au cœur de l'art d'Eliasson. Pour une exposition dans une galerie berlinoise, il a fait venir six tonnes de glace vieille de 15 000 ans provenant d'un glacier islandais et créé un système de réfrigération pour assurer sa conservation pendant toute la durée de l'exposition. Qu'il s'agisse de projets architecturaux, tel son pavillon temporaire pour la Serpentine Gallery à Londres (2007), ou de ses projections lumineuses de formes abstraites, dont les images projetées sur la rétine du spectateur produisent de nouvelles formes individuelles (*the inside of outside*, 2008) : l'œuvre d'Eliasson provoque des réactions individuelles et collectives parfois contradictoires dont elle tire sa force et sa vérité.

R. M.

SELECTED EXHIBITIONS →
2008 *Olafur Eliasson: The Nature of Things*, Fundació Caixa, Girona and Fundació Joan Miró, Barcelona. *Olafur Eliasson: Your mobile expectations – BMW H2R project*, Pinakothek der Moderne, Munich **2007** *Olafur Eliasson: Take Your Time*, SFMOMA, San Francisco; MoMA, New York and P.S.1 Contemporary Art Center, Long Island City **2006** *Olafur Eliasson: The collectivity project*, The National Museum of Art, Architecture and Design, Oslo **2005** *Olafur Eliasson: Notion motion*, Museum Boijmans van Beuningen, Rotterdam

SELECTED PUBLICATIONS →
2008 *Studio Olafur Eliasson: An Encyclopedia*, Taschen, Cologne. *Olafur Eliasson: The Nature of Things*, Fundacio Joan Miro, Barcelona. Hans Ulrich Obrist: *Olafur Eliasson*, Verlag der Buchhandlung Walther König, Cologne **2007** *Olafur Eliasson: Take Your Time*, SFMOMA, San Francisco; Thames & Hudson, London. *Olafur Eliasson, David Adjaye: Your Black Horizon*, Thyssen-Bornemisza Art Contemporary, Vienna; Verlag der Buchhandlung Walther König, Cologne **2006** *Olafur Eliasson: Remagine*, Kunstmuseum Bonn, Bonn

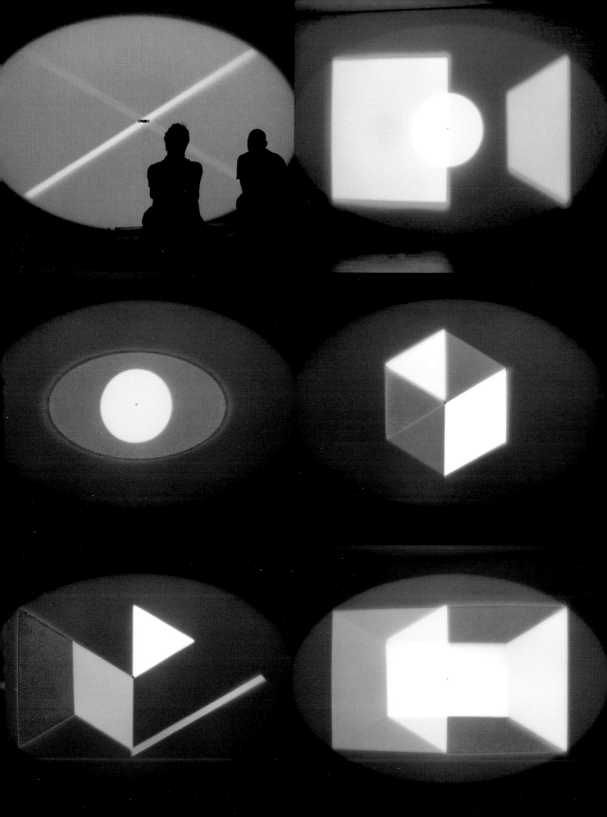

1 **the inside of outside**, 2008, 24 source-four spotlights, dimmers, filter foil, control unit, spherical stainless steel wall fixture, 3 wooden benches, metronome (54 beats/min), 5 min projection sequences, spherical stainless steel wall fixture: ø 4 cm, 3 benches: 46,5 x 300 x 42 cm (each), overall installation size variable

2 **Timetable**, 2007, elm wood, stainless steel, 84 x 387 x 110 cm

3 **Temporal Pavilion Lamps**, 2007, set of 4 lamps, dimensions variable, 2 lamps ø 150 cm, height up to 450 cm, 2 lamps ø 120 cm, stainless steel, height adjustable tripod, fluorescent lamp, energy saving lamp, dimmer cable

4/5 **Serpentine Gallery Pavilion**, 2007, in collaboration with Kjetil Thorsens. Installation view, Serpentine Gallery, Kensington Gardens, London

„Körperliche Erfahrung macht einen viel tieferen Eindruck als eine rein intellektuelle Begegnung. Ich kann Ihnen erklären, wie es sich anfühlt, wenn Ihnen kalt ist, aber ich kann Sie auch durch meine Kunst frieren lassen. Mein Ziel ist es, Menschen für hochkomplexe Fragen zu sensibilisieren."

« L'expérience physique produit une impression beaucoup plus profonde que la rencontre purement intellectuelle. Je peux vous expliquer ce que l'on ressent quand on a froid, mais je peux aussi vous faire éprouver le froid par le truchement de mon art. Mon but est de sensibiliser les gens à des questions hautement complexes. »

"Physical experience makes a much deeper impression than a purely intellectual encounter. I can explain to you what it's like to feel cold, but I can also have you feel the cold yourself through my art. My goal is to sensitize people to highly complex questions."

2

3

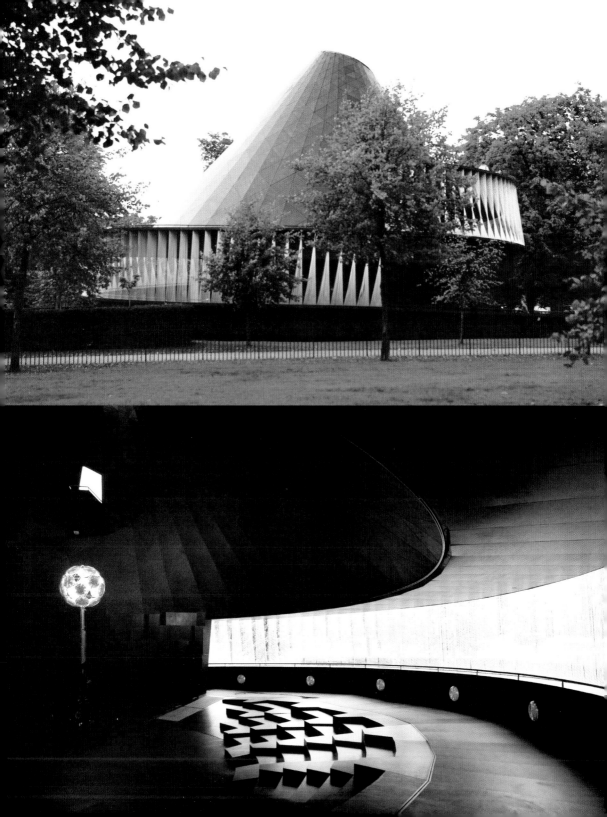

Urs Fischer

1973, born in Zürich, lives and works in Zürich, Switzerland, and New York (NY), USA

Known for his almost obsessive use and transformation of the humble chair (*How to Tell a Joke*, 2007; *Addict*, 2006; *Chair for a Ghost*, 2003), Urs Fischer creates playful and poignant sculptures and installations that can change the shape of a room, both literally and figuratively. Spectacular gestures accompany simpler ones; some are additive, some subtractive. Fischer has breached walls in galleries and art fairs, opening up unexpected vistas, has cast an open grave in aluminium (*Untitled (Hole)*, 2007), plunging its craggy relief into the floor below, and reduced an art gallery to an earthen crater (*You*, 2007). He occupied the former prison and boarding school of Cockatoo Island, off the coast of Sydney, Australia, with skeleton sculptures and the pale branches of crooked horizontal lines that wander through the space of the outer courtyard, like fat strings shot from a slowly spinning cannon and frozen in mid-air. Other works include life-size candles shaped like nude women that melt over the duration of an exhibition (*What If the Phone Rings?*, 2003), masses of coral tear drops raining down from the ceiling of the Palazzo Grassi in Venice (*Vintage Violence*, 2004/05), a chalet built out of bread left to the birds (*Bread House*, 2004/05) and a massive tree made of framed drawings and lights (*Jet Set Lady*, 2005). Though Fischer studied photography, he prefers to work in a wide range of media, including painting and drawing. Across materials and processes, Fischer's visual and visceral work subverts the habitual approaches we take to spaces and the uses we make of objects, reminding us of their contingency and transience, as well as our own.

Der durch die beinahe obsessive Verwendung und Verwandlung von einfachen Stühlen (*How to Tell a Joke*, 2007; *Addict*, 2006; *Chair for a Ghost*, 2003) bekannt gewordene Urs Fischer erschafft spielerische und eindrucksvolle Skulpturen und Installationen, die die Form eines Raumes sowohl im wörtlichen als auch im übertragenen Sinn verändern können. Spektakuläre Gesten treffen auf einfache Formen, einige fügen etwas hinzu, andere nehmen etwas weg. Fischer hat Wände in Galerien und auf Kunstmessen durchbrochen und so unerwartete Durchblicke ermöglicht, hat ein offenes Grab mit Aluminium ausgegossen und dessen schroffes Relief in den Boden versenkt (*Untitled (Hole)*, 2007) und hat eine Kunstgalerie auf einen Krater aus Erde reduziert (*You*, 2007). Er besetzte das ehemalige Gefängnis und Internat Cockatoo Island vor der Küste Australiens mit Skelettskulpturen und den bleichen Zweigen gebogener horizontaler Linien, die durch den Raum des Innenhofs wanderten wie fette Linien, die aus einer sich langsam drehenden Kanone geschossen in der Luft gefrieren. Andere Arbeiten sind zum Beispiel lebens-große Kerzen in Form von nackten Frauen, die während der Dauer einer Ausstellung herunterbrennen (*What If the Phone Rings?*, 2003), Unmengen von korallenen Tränen, die von der Decke des Palazzo Grassi in Venedig hängen (*Vintage Violence*, 2004/05), eine Hütte aus Brot, die den Vögeln überlassen wird (*Bread House*, 2004/05) und ein riesiger Baum aus gerahmten Zeichnungen und Lichtern (*Jet Set Lady*, 2005). Obwohl Fischer gelernter Fotograf ist, arbeitet er lieber in verschiedenen Medien, darunter auch Malerei und Zeichnung. Ganz gleich in welchem Material und mit welcher Strategie, Fischers visuelles und emotionales Werk untergräbt unseren vertrauten Umgang mit Räumen und Gegen-ständen und erinnert uns an ihre Zufälligkeit und Vergänglichkeit – und ebenso an unsere eigene.

Connu pour son obsession à utiliser et transformer des chaises ordinaires (*How to Tell a Joke*, 2007 ; *Addict*, 2006 ; *Chair for a Ghost*, 2003), Urs Fischer crée des sculptures amusantes et poignantes, des installations modifiant la forme d'une pièce, au propre comme au figuré. Des gestes spectaculaires s'accompagnent des plus anodins, certains ajoutent, d'autres retranchent. Fischer a ouvert des murs dans des galeries ou des foires et dévoilé ainsi des perspectives inattendues ; il a réalisé le moule en aluminium d'une fosse (*Untitled (Hole)*, 2007), laissant apparaître le relief terreux à l'étage inférieur ; il a fait d'une galerie un gigantesque cratère (*You*, 2007). Fischer a rempli l'ancienne prison et pensionnat de Cockatoo Island, au large de Sydney (Australie) de sculptures de squelettes et de branches sinueuses et blanchâtres qui jaillissaient dans l'espace de la cour extérieure comme s'il s'agissait de gros rubans projetés par un canon mobile et figés en plein vol. Parmi ses autres œuvres, on compte des bougies représentant des femmes nues grandeur nature qui se consument le temps de l'exposition (*What If the Phone Rings?*, 2003) ; une pluie de gouttes de corail tombant du plafond du Palazzo Grassi à Venise (*Vintage Violence*, 2004/05) ; un chalet en pain livré à l'appétit des oiseaux (*Bread House*, 2004/05) ; ou encore un arbre immense fait de lumières et de dessins encadrés (*Jet Set Lady*, 2005). Bien que photographe de formation, il travaille aussi avec la peinture et le dessin. Circulant entre des matériaux et des procédés hété-rogènes, l'œuvre de Fischer subvertit nos approches habituelles de l'espace et nos utilisations quotidiennes des objets, pointant leur caractère éphémère et contingent si semblable au nôtre.

V. R.

SELECTED EXHIBITIONS →
2008 *Archeology of Mind*, Malmö Konstmuseum, Malmö **2007** *Urs Fischer*, Switzerland Pavilion, 52nd Venice Biennale, Venice. *Unmonu-mental: The Object in the 21st Century*, New Museum, New York **2006** *Urs Fischer: Oh, Sad, I see*, The Modern Institute, Glasgow. *Urs Fischer*, Museum Boijmans van Beuningen, Rotterdam. *Day for Night*, Whitney Biennial 2006, Whitney Museum, New York **2005** *Urs Fischer*, Camden Arts Centre, London. *Urs Fischer*, Hamburger Bahnhof, Berlin **2004** *Urs Fischer: Kir Royal*, Kunsthaus Zürich

SELECTED PUBLICATIONS →
2007 *Album: On/around the works of Urs Fischer, Yves Netz-hammer, Ugo Rondinone, and Christine Streuli*, Swiss Federal Office of Culture, Bern; JRP Ringier, Zürich. *Urs Fischer: Paris 1919*, JRP Ringier, Zürich **2006** *Strange I've Seen That Face Before*, DuMont, Cologne. *Whitney Biennial: Day for Night*, Whitney Museum of American Art, New York **2005** *Monica Bonvicini, Richard Prince, Urs Fischer*, Parkett 72, Zürich **2004** *Urs Fischer: Kir Royal*, Kunsthaus Zürich; JRP Ringier, Zürich

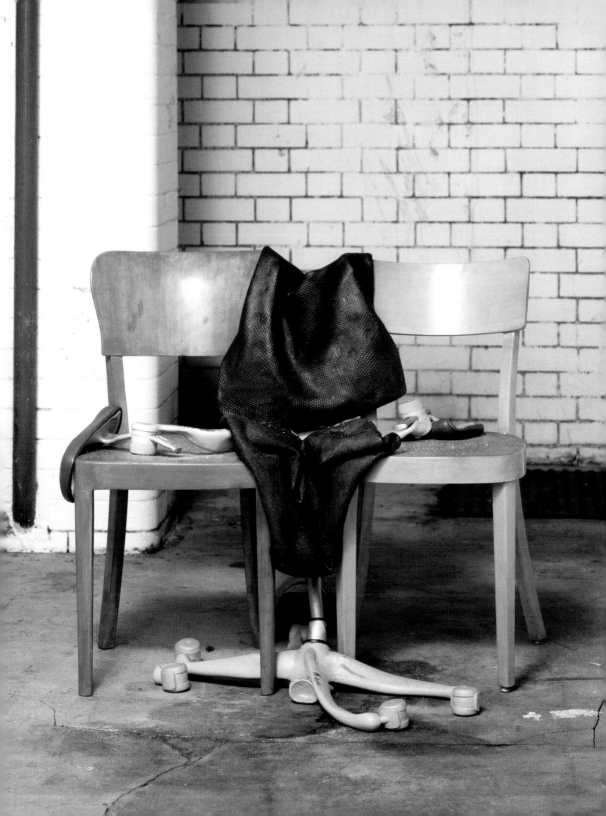

1 **How to Tell a Joke**, 2007, polyurethane cast resin, acrystal, pigments, 95 x 100 x 100 cm
2 **Ohne Titel (Brothaus)**, 2004/05, bread, wood, silicon, screws, polyurethane foam, 500 x 400 x 500 cm. Installation view, Museum Boijmans van Beuningen, Rotterdam, 2006

3 **Ohne Titel (Loch)**, 2007, cast aluminium, 540 x 340 x 270 cm. Installation view, Sadie Coles HQ, London
4 **Jet Set Lady**, 2000–05, iron, 2000 framed drawings (colour prints), 24 fluorescent tubes, 900 x 700 x 700 cm. Installation view, Fondazione Nicola Trussardi, Instituto dei Ciechi, Milan, 2005

„Jedes Werk beginnt mit einer raschen Zeichnung, aber sobald ich mit dem Material arbeite, geht etwas schief. Zum Beispiel bleibt das Ding nicht stehen, und mein Ärger darüber führt dann zu etwas anderem. Meine Arbeit sieht am Ende nie so aus, wie sie geplant war."

« Chaque œuvre commence par un rapide croquis, mais dès que je commence à travailler avec les matériaux, ça tourne mal. Par exemple, le truc ne tient pas debout et mon agacement me mène ensuite vers autre chose. Le résultat ne ressemble jamais à ce que j'avais l'intention de faire au départ. »

"Each work begins with a quick sketch, but as soon as I start to work with materials, something goes wrong. For example, the thing won't stand up and my irritation about that then leads to something else. My work never ends up looking the way I had intended."

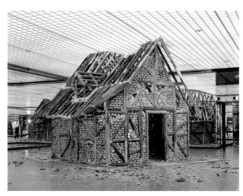

2

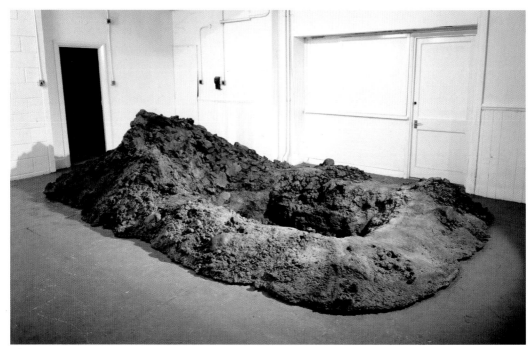

Walton Ford

1960 born in Larchmont (NY), lives and works in Great Barrington (MA), USA

Walton Ford's works are technically brilliant and visually spectacular. His detailed, life-size depictions of animals in watercolour and gouache are fascinatingly reminiscent of natural history drawings from past centuries. Indeed Ford himself has named the ornithologist John J. Audubon, creator of the legendary *Birds of America* series (1827–38) as one of his inspirations. Ford's interest in this visual language is not motivated by simple admiration, however; his aim is to subvert its humanizing approach to animals by creating complex allegories imbued with absurd humour à la John Tenniel. His images are full of surprises and fractures; the depicted scenes often appear brutal or comical – and thus utterly disconcerting. In *Falling Bough* (2002), a large flock of pigeons perch on a branch that hangs in the air somewhere between freefall and surreal suspension. In its detail, the ostensibly naturalistic rendering of the feathered colony is as chaotic as a Brueghelian apocalypse. Ford draws attention to his often very specific and allegorical narrative threads in handwritten commentaries – Dürer plays a role in *Loss of the Lisbon Rhinoceros* (2008), for example, and Hemingway is involved in *Lost Trophy* (2005). A series of paintings that includes *Jack on his Death-bed* (2005) form a cartoon homage to Richard Burton, a spectacular 19th-century adventurer and naturalist who shared his home with forty apes and even compiled a Simian dictionary. Here, the animals represent the colonial master: as civilized apes, they look down upon the viewer with an air of superiority or even contempt. In this comedy of exchanged roles, Ford's actors are protagonists of an unnatural nature, and the satirical alienation is always aimed at human characteristics.

Walton Fords Arbeiten sind technisch virtuos und visuell spektakulär. Die detaillierten, lebensgroßen Tierdarstellungen in Aquarell und Gouache faszinieren durch die Ästhetik naturhistorischer Zeichnungen der letzten Jahrhunderte. Ford selbst nennt den Ornithologen John J. Audubon, Verfasser des legendären *Birds of America* (1827–38), als Vorbild. Doch Ford nutzt diese Bildsprache nicht aus realistischem Interesse, sondern um ihre vermenschlichende Auffassung des Tiers in komplexen Allegorien gegen den Strich zu bürsten – stets mit einem Schuss absurden Humors à la John Tenniel. Die Bilder stecken voller Überraschungen und Brüche, oft wirken Szenen brutal, auch komisch – und darin insgesamt befremdend. In *Falling Bough* (2002) etwa sieht man das Gewimmel eines Taubenschwarms auf einem Ast, der zwischen freiem Fall und surrealem Schweben in der Luft hängt. Die vermeintlich naturalistisch dargestellte Vogelkolonie wirkt im Detail so chaotisch wie ein Brue-ghelscher Weltuntergang. Ford bringt Hinweise auf die oft sehr speziellen allegorischen Erzählstränge durch handschriftliche Bildkommentare ein – in *Loss of the Lisbon Rhinoceros* (2008) spielt etwa Dürer, in *Lost Trophy* (2005) Hemingway eine Rolle. Eine Reihe von Bildern, zu denen *Jack on his Deathbed* (2005) gehört, sind eine karikierende Hommage an Richard Burton, spektakulärer Abenteurer und Naturforscher des 19. Jahrhunderts, der mit vierzig Affen im eigenen Haus zusammenlebte und ein Wörterbuch der Affensprache verfasst hat. Die Tiere repräsentie-ren hier den Kolonialherrn, als zivilisierte Affen blicken sie erhaben oder leicht verächtlich auf den Betrachter herab. In der Komik der vertausch-ten Rollen sind Fords Darsteller Protagonisten einer unnatürlichen Natur, und die satirische Verfremdung zielt immer auf Züge des Humanen.

Les œuvres de Walton Ford sont techniquement virtuoses et visuellement spectaculaires. Réalisées à l'aquarelle et à la gouache, ses représentations animalières détaillées, peintes en grandeur nature, fascinent par leur esthétique proche du dessin d'histoire naturelle des derniers siècles. Ford cite lui-même comme modèle l'ornithologue John J. Audubon, auteur du légendaire *Birds of America* (1827–38). Cela dit, ce langage iconique ne sert pas un propos réaliste, mais Ford prend son anthropomorphisme implicite à rebrousse-poil par des allégories complexes – toujours avec une pointe d'humour absurde à la John Tenniel. Les images sont pleines de surprises et de ruptures, les scènes souvent d'un effet brutal, parfois comique et donc globalement étrange. *Falling Bough* (2002) montre une nuée de pigeons agglomérés autour d'une branche suspendue entre chute libre et indétermination surréaliste ; représentée sur un mode prétendument réaliste, dans le détail, la colonie d'oiseaux est aussi chaotique qu'une Apocalypse de Bruegel. Avec ses inscriptions, Ford renvoie à des fils narratifs allégoriques souvent très particuliers – Dürer est présent dans *Loss of the Lisbon Rhinoceros* (2008), dans *Lost Trophy* (2005), il s'agit d'Hemingway. Une série de tableaux parmi lesquels on trouve *Jack on his Deathbed* (2005), constitue un hommage caricatural à Richard Burton, spectaculaire aventurier et explorateur du XIXᵉ siècle qui vécut dans sa maison avec une quarantaine de singes et fut l'auteur d'un dictionnaire de la langue des singes. Les animaux incarnent ici le seigneur colonial ; singes civilisés, ils jettent sur le spectateur un regard supérieur ou légèrement méprisant. Par le comique de l'inversion des rôles, les personnages de Ford sont les protagonistes d'une nature artificielle, alors que le détournement satirique vise toujours des traits de l'humain.

J. A.

Chimpanzee Pan troglodytes

1 **A Monster from Guiny**, 2007, watercolour, gouache, pencil, ink on paper, 151.8 x 104.1 cm
2 **Tur**, 2007, watercolour, gouache, pencil, ink on paper, 3 panels, 1st and 3rd panel 248.9 x 97.8 cm (framed), 2nd panel 248.9 x 158.8 cm (framed)
3 Installation view, Paul Kasmin Gallery, New York, 2008

4 **Scipio and the Bear**, 2007, watercolour, gouache, pencil, ink on paper, 151.1 x 303.5 cm
5 **Loss of the Lisbon Rhinoceros**, 2008, watercolour, gouache, pencil, ink on paper, 1st panel 249.6 x 108.6 cm, 2nd panel 249.6 x 159.4 cm, 3rd panel 249.6 x 108.6 cm

„Die wirklich große Sache, die ich in meiner Arbeit immer verfolge, ist diese Spannung zwischen Anziehung und Abstoßung. Zu Beginn scheint alles wunderschön, bis man plötzlich merkt, dass gleich eine schreckliche Gewalttat passieren wird, oder sogar schon begonnen hat.“

« La chose la plus importante que je cherche toujours dans mon travail a quelque chose à voir avec l'attraction-répulsion : dans un premier temps, les choses sont belles, puis l'on remarque une horrible violence latente, qui pourrait surgir à tout instant. »

"The big, big thing I'm always looking for in my work is a sort of attraction-repulsion thing, where the stuff is beautiful to begin with until you notice that some sort of horrible violence is about to happen or is in the middle of happening."

2

3

4

Tom Friedman

1965 born in St. Louis (MO), lives and works in Northampton (MA), USA

Those who believe that art is simply handicraft taken to the extreme might find confirmation upon first glance at the artist Tom Friedman's sculptures and installations. Friedman creates sculptures and drawings with obsessive attention to detail and handiwork, and then combines them to make installations. His materials can be picked up at any supermarket: paper, wire, cardboard, foam, foil and marker pens. Friedman is influenced by 1960s conceptual art and minimalism. The Fluxus movement is worthy of special mention here, as it inspired humorous, reflexive works such as *1000 Hours of Staring* (1992–97), an empty sheet of paper that – as the title suggests – the artist stared at for 1000 hours. In his latest collages and sculptures, shown in his exhibition *Monsters and Stuff* (2008), Friedman has stayed true to his choice of materials and painstakingly elaborate production process, but the gulf between the banality of the material and the spectacular forms that emerge from it has widened, for example in the sculpture *Green Demon* (2008). The field of reference is also considerably broader here, with Frankenstein and voodoo associations slotting in easily next to African sculpture, Miró and Picasso. However, the question remains as to whether the harmless material removes the horror aspect or whether the artist has drawn hidden horror out of the material. And thus the question of art as handicraft comes full circle. As soon as handicraft is supported by a conceptual approach and – in the true spirit of the surrealist idea of the miraculous – mundane everyday material is transformed to something astounding, then you have art.

Wer zu der Ansicht neigt, dass Kunst nur exzessives Basteln sei, könnte auf den ersten Blick von den Arbeiten des Bildhauers und Installationskünstlers Tom Friedman bestätigt werden. In geradezu obsessiver Klein- und Handarbeit erstellt Friedman Skulpturen und Grafiken, die er dann zu Installationen zusammenfasst. Das Material, das er verwendet, ist allenthalben in Supermärkten zu bekommen: Papier, Draht, Pappe, Schaumstoff, Folie und Stifte. Friedmans Schulung basiert auf der Konzeptkunst und Minimal Art der 1960er-Jahre. Insbesondere die Fluxus-Bewegung ist zu erwähnen, deren humorvolle, kunstreflexive Werke ihn zu Arbeiten wie *1000 Hours of Staring* (1992–97) angeregt haben, einem leeren Blatt Papier, das der Künstler 1000 Stunden lang angestarrt hat. Bei seinen neueren Collagen und Skulpturen, wie sie die Ausstellung *Monsters and Stuff* (2008) zeigt, ist Friedman der Materialwahl wie auch dem aufwändigen und kleinteiligen Produktionsprozess treu geblieben. Allerdings vergrößert er die Spanne zwischen der Nichtigkeit des Materials und dem Spektakulären des daraus Geformten. Ein Beispiel dafür liefert die Skulptur *Green Demon* (2008). Hier ist das Bezugsfeld dann auch wesentlich breiter, neben afrikanischer Plastik, Miró und Picasso stellen sich auch unschwer Frankenstein- und Voodoo-Assoziationen ein. Fraglich bleibt jedoch, ob das harmlose Material den Schrecken auflöst oder ob der Künstler den verborgenen Schrecken aus dem Material geholt hat. Und da schließt sich der Kreis zur Frage von Kunst als Basteln. Sobald das Basteln einem konzeptuellen Ansatz unterworfen wird und das banale Alltagsmaterial, ganz im Geiste der surrealistischen Idee des Wunderbaren, zu etwas Verblüffendem transformiert wird, entsteht Kunst.

Ceux qui tendent à penser que l'art n'est rien d'autre qu'une débauche de bricolage pourraient bien se sentir confortés de prime abord par les œuvres du sculpteur et installationniste Tom Friedman. Par un travail manuel minutieux jusqu'à l'obsession, Friedman crée des sculptures et des dessins qu'il regroupe ensuite en installations. Le matériau utilisé peut être trouvé dans le premier supermarché venu : papier, carton, fil de fer, mousse synthétique, film plastique et crayons. La formation de Friedman remonte à l'art conceptuel et au minimalisme des années 1960. Dans ce contexte, il convient de citer plus particulièrement le mouvement Fluxus, dont les œuvres pleines d'humour et la réflexion sur l'art ont notamment inspiré *1000 Hours of Staring* (1992–97), une feuille de papier blanc que l'artiste a regardée pendant 1000 heures. Dans ses collages et sculptures récents, comme les présente l'exposition *Monsters and Stuff* (2008), Friedman est resté fidèle au choix des matériaux et à un mode de production infiniment minutieux, tout en augmentant encore l'écart entre la futilité du matériau et l'aspect spectaculaire de ce qu'il en fait, comme l'illustre très bien *Green Demon* (2008). Ici, le champ référentiel est lui aussi nettement plus vaste : à côté de la sculpture africaine, de Picasso et de Miró, s'instaurent également aisément des associations avec Frankenstein et le vaudou. Reste la question de savoir si l'épouvante est résorbée par la banalité du matériau ou si l'artiste a fait surgir l'épouvante cachée dans le matériau. C'est ici que nous revenons à la question initiale de l'art comme bricolage : l'art apparaît dès que le bricolage est soumis à une approche conceptuelle et qu'un matériau quotidien est transformé en quelque chose de surprenant – en l'occurrence dans l'esprit du merveilleux surréaliste. H. L.

SELECTED EXHIBITIONS →
2008 *About Us*, Boulder Museum of Contemporary Art, Boulder. *Styrofoam*, RISD Museum, Providence **2007** *Mapping the Self*, Museum of Contemporary Art, Chicago. *INSIGHT?*, Gagosian Gallery/Red October Chocolate Factory, Moscow. *Into Me/Out Of Me*, P.S.1 Contemporary Art Center, Long Island City; KW Institute for Contemporary Art, Berlin. *The Shapes of Space*, Solomon R. Guggenheim Museum, New York **2006** *Tom Friedman: Pure Invention*, Mildred Lane Kemper Art Museum, St. Louis.

SELECTED PUBLICATIONS →
2008 *Tom Friedman*, Yale University Press, New Haven. *Tom Friedman*, Gagosian Gallery, New York **2007** *INSIGHT?*, Gagosian Gallery/Red October Chocolate Factory, Moscow. *Pop Art Is*, Gagosian Gallery, London. *Into Me/Out Of Me*, P.S.1 Contemporary Art Center, Long Island City; KW Institute for Contemporary Art, Berlin; Hatje Cantz, Ostfildern **2006** *Tom Friedman*, Gagosian Gallery, New York **2005** *Ecstasy: In and about Altered States*, MOCA, Los Angeles

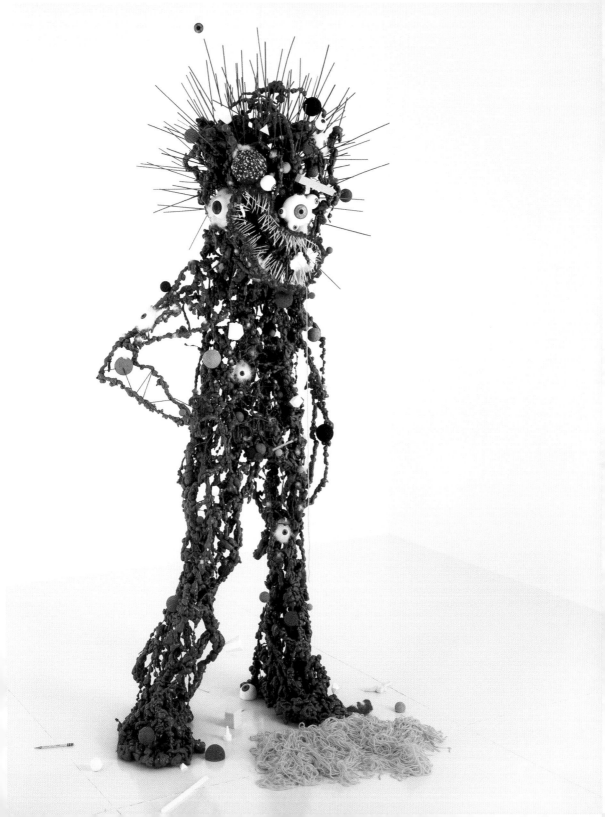

1 **Green Demon**, 2008, expanding insulation foam, mixed media, 231 x 109 x 91 cm

2 **Care Package (Manipulated)**, 2008, inkjet photos, 57 x 56 x 56 cm
3 **Monster Collage**, 2007, collage with artist's hair, 345.4 x 304.8 cm

„Mich interessiert, dass ich gar nicht in der Lage bin, alles zu verarbeiten womit ich konfrontiert werde, eine Idee vom Ganzen zu bekommen ... Was mein Werk zusammenhält ist, dass ich etwas nehme, das mir sonnenklar erscheint, das ich zu kennen glaube, nur um festzustellen, dass, je näher ich komme und je genauer ich es untersuche, alles umso unklarer wird."

« Ce qui m'intéresse avant tout, c'est l'incapacité de transformer tout ce à quoi je suis confronté et l'idée de globalité... le dénominateur commun de mon travail, c'est de prendre une chose qui était pour moi claire comme de l'eau de roche, une chose que je croyais connaître, et de découvrir que plus je m'en rapproche en l'examinant méticuleusement, moins cette chose est claire. »

"What interests me is my inability to process everything that I am confronted with and the idea of the whole... what unifies what I do is taking something that is crystal clear to me, something that I seem to know, and finding that the closer I get and the more carefully I inspect it, the less clear it becomes."

2

Ellen Gallagher

1965 born in Providence (RI), lives and works in New York (NY), USA

With different techniques from painting to 16mm films, Ellen Gallagher opens up windows onto a universe in which narratives of black history and identity are at once pulled apart and re-imagined. Gallagher's work is affected through its subtle straddling of the aesthetic, social and political, in the collision of historical realism with science fiction fantasy, or the austere structures of minimalism with mass-media representation. In her ongoing series *Watery Ecstatic* (2001–), Gallagher submerges her exploration of racial stereotypes in an underwater realm of aquatic plant and animal life. She focuses on the "middle passage" in which millions of slaves lost their lives on the journey from Africa to America by creating her version of a "black Atlantis", the mythical Drexciya populated by slaves who jumped from the ships during the passage and who now emerge like ghosts in this world of translucent watercolours. Gallagher is particularly interested in the way in which images of black culture have been mediated. In *IGBT* (2008) she has mounted two stereotyped black male silhouettes on a gilded PCB thus creating a sort of modern icon. The PCB and the insulated gate bipolar transistor (IGBT) to which the title alludes are elements of an electronized and computerized time, whereas the silhouettes are characterized by their clothes as belonging to the 19th century. By interweaving these different elements, Gallagher opens up a wide field of associations such as the metaphor of the "black gold" on which the modern US society is, at least partly, built. A memory that is still engraved in the society's structure, even if contemporary gold takes a different – an electronical – form.

Mit verschiedenen Techniken vom Gemälde bis zum 16mm-Film öffnet Ellen Gallagher Fenster auf eine Welt, in der Erzählungen von schwarzer Geschichte und Identität gleichzeitig auseinandergenommen und neu geschildert werden. Gallaghers Arbeit vereint in sehr subtiler Weise Ästhetik, Soziales und Politik, geschichtsbewusster Realismus prallt auf Science-Fiction-Fantasien oder strenge, minimalistische Strukturen auf Bilder aus den Massenmedien. In der laufenden Serie *Watery Ecstatic* (2001–) verlegt Gallagher ihre Untersuchung von Rassenvorurteilen in ein Unterwasserreich mit Pflanzen und Tieren. Sie konzentriert sich auf die „Middle Passage", die Überfahrt zwischen Afrika und Amerika, auf der Millionen von Sklaven ihr Leben verloren haben, und sie erschafft ihre Version eines „schwarzen Atlantis", dem mythischen Drexciya, das von Sklaven bewohnt wird, die während der Fahrt von den Schiffen gesprungen sind und nun wie Geister in dieser Welt durchsichtiger Wasserfarben schweben. Gallagher interessiert besonders, wie die Bilder der schwarzen Kultur vermittelt werden. Für *IGBT* (2008) hat sie zwei männliche Silhouetten auf einer vergoldeten Platine befestigt und so eine Art moderne Ikone geschaffen. Die Platine und der Insulated Gate Bipolar Transistor (IGBT), auf den der Titel anspielt, sind Teile einer elektronisierten und computerisierten Zeit, während die Scherenschnitte durch ihre Kleidung dem 19. Jahrhundert zuzuordnen sind. Indem sie diese verschiedenen Elemente verbindet, macht Gallagher eine Vielzahl von Assoziationen möglich, wie etwa die Metapher des „schwarzen Goldes", auf dem die Gesellschaft der USA zumindest teilweise erschaffen wurde. Eine Erinnerung, die noch immer in die Struktur dieser Gesellschaft eingeschrieben ist, auch wenn das moderne Gold eine andere – elektronische – Form annimmt.

En utilisant différentes techniques, de la peinture au film 16 mm, Ellen Gallagher nous ouvre des portes donnant sur un univers qui démonte le récit historique et identitaire noir pour mieux le ré-imaginer. Se plaçant de manière subtile à la croisée de l'esthétique, du social et du politique, son travail est influencé par l'opposition entre réalisme historique et science-fiction, entre austères structures du minimalisme et représentation médiatique. Dans la série *Watery Ecstatic*, initiée en 2001, l'artiste immerge son étude des stéréotypes raciaux dans un royaume de flore et faune sous-marines. Elle cible le « Passage du milieu » où des millions d'esclaves périrent pendant leur transfert d'Afrique en Amérique, et crée sa version de « l'Atlantide noire », la mythique Drexciya peuplée par les esclaves qui se sont jetés à la mer durant le voyage et qui émergent à présent, fantomatiques, dans ce monde d'aquarelles diaphanes. Gallagher s'intéresse particulièrement à la transmission des images de la culture noire. Dans *IGBT* (2008), elle a collé deux silhouettes stéréotypées d'hommes noirs sur l'image d'une plaquette de circuit intégré, créant ainsi une sorte d'icône moderne. Si la plaquette et le transistor bipolaire à grille isolée du titre (IGBT en anglais) participent d'une ère électronique et informatique, les vêtements des personnages les ancrent dans le XIXᵉ siècle. En entrelaçant ces différents éléments, Gallagher ouvre un vaste champ d'associations, telle la métaphore de « l'or noir », fondement – partiel – de la société américaine moderne. Un souvenir toujours gravé dans sa structure, même si aujourd'hui, l'or prend une forme différente – électronique. A. B.

SELECTED EXHIBITIONS →
2008 *Eclipse – Art in a Dark Age*, Moderna Museet, Stockholm
2007 *Ellen Gallagher*, Tate Liverpool; Dublin City Gallery, The Hugh Lane, Dublin. *Comic Abstraction*, MoMA, New York **2006** *Heart of Darkness*, Walker Art Center, Minneapolis. *Black Alphabet*, Zacheta National Gallery, Warsaw. *Having New Eyes*, Aspen Art Museum, Aspen. *Skin Is a Language*, Whitney Museum of American Art, New York **2005** *Ellen Gallagher: Murmur and DeLuxe*, MOCA, North Miami. *Ellen Gallagher: DeLuxe*, Whitney Museum of American Art, New York

SELECTED PUBLICATIONS →
2007 *Ellen Gallagher: Coral Cities*, Tate Publishing, London **2006** *Ellen Gallagher: Heart of Darkness*, Walker Art Center, Minneapolis. *Alien Nation*, ICA, London et al.; Hatje Cantz, Ostfildern **2005** *Ellen Gallagher: Exelento*, Gagosian Gallery, New York. *Paul McCarthy, Ellen Gallagher, Anri Sala*, Parkett 73, Zurich

1

1 **IGBT**, 2008, gesso, gold leaf, ink, varnish, cut paper on canvas,
 201.9 x 188 cm
2 **Dirty O's**, 2006, pencil, ink, watercolour, plasticine, cut paper on paper,
 60.5 x 80.5 cm
3 **Bird in Hand**, 2006, oil, ink, cut paper, polymer medium, salt, gold leaf
 on canvas, 238 x 307 cm
4 **An Experiment of Unusual Opportunity**, 2008, ink, graphite, oil, varnish,
 cut paper on canvas, 202 x 188 cm

„In vielen meiner Arbeiten gibt es diese Idee des Gigantischen, aber in
miniaturisierter Form. Bezogen auf den Gegenstand kann dies eine
sehr kleine Beobachtung sein, etwa eine bestimmte Geste oder eine
bestimmte Geschichte."

« Le gigantesque est présent dans mon travail mais sous forme miniature.
Le sujet peut être quelque chose d'effroyable réduit à une observation
microscopique : un geste ou un récit spécifiques. »

"In much of my work there is this idea of the gigantic, but in a miniaturized form. In terms of the subject matter, it can be something sort of awful that's then reduced to a very minute observation, maybe a specific gesture or specific narrative."

2

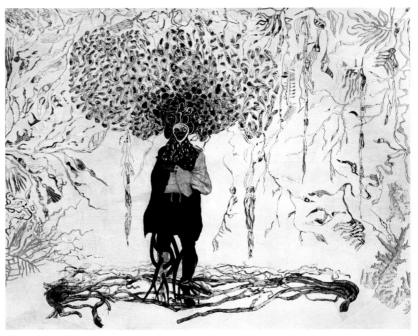

3

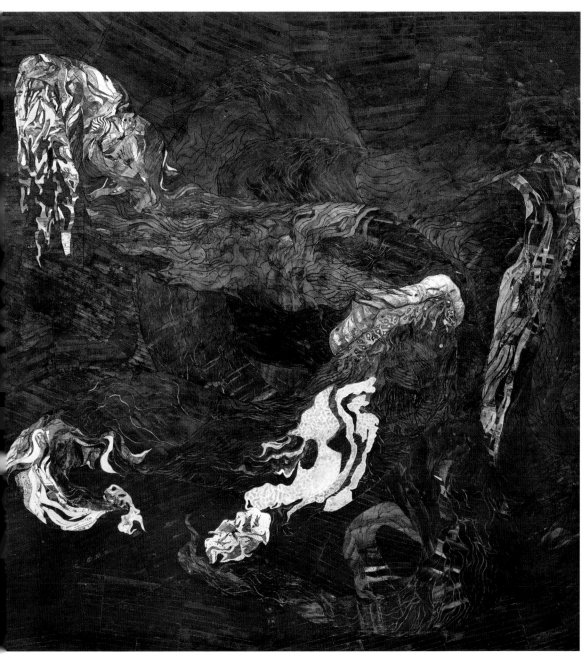

Luis Gispert

1972 born in Jersey City (NJ), lives and works in Brooklyn (NY), USA

In his large-scale photographs, interactive sound sculptures and installations, Luis Gispert filters what is frequently described as "urban youth culture" through screens as diverse as science fiction films, music videos and baroque art. An artist who has wryly admitted to learning English from watching television, Gispert made use of this training in the quixotic *Smother* (2006/07), a 24-minute video set in the 1980s Miami of the artist's childhood, with references to the film *Scarface*. Co-written with Orly Genger, the narrative centers on Waylon, an eleven-year old bed-wetter, and Nora, his pill-popping, castration-obsessed mother; they live in a "narco-nouveau-riche" house – in the artist's inimitable words – of art deco flourishes and candy-coloured pastels, furnished by Waylon's absent, drug dealing father. In the film's course, the family's German shepherd gets deep fried by Nora's suitor (a butcher), and other misadventures ensue, the sum total of which suggest a boy's odyssey through a fallen world riddled by intractable signs of class. It is also the subject of related photos (a particularly arresting one frames Waylon floating, like a partially submerged Ophelia, in a pool of his own urine, clutching stereo equipment to his chest), as well as a sculptural installation extending the film's settings into space via heart shaped speakers and a neon-framed mirror. Like his earlier projects that enlist a personal if not strictly autobiographical iconography – e.g., his photographs of Latina cheerleaders or his images that make use of friends' or relatives' dwellings – Gispert's new work plumbs social identities, revealing cultural codes that are no less odd for being ubiquitous.

Luis Gisperts großformatige Fotografien, interaktive Klangskulpturen und Installationen filtern die so genannte urbane Jugendkultur durch verschiedene Genres wie Science-Fiction-Filme, Musikvideos und barocke Kunst. Gispert, der erzählt, dass er Englisch vor dem Fernseher gelernt hat, nutzte dieses Training für seinen 24-minütigen Videofilm *Smother* (2006/07), der in den 1980ern in Miami spielt, wo Gispert aufwuchs, und darüber hinaus Referenzen an den Film *Scarface* enthält. Das mit Orly Genger erarbeitete Drehbuch handelt von dem elfjährigen Bettnässer Waylon und von Nora, seiner drogensüchtigen, kastrationswütigen Mutter. In den Worten des Künstlers wohnen sie in einem „narco-neureichen" Haus, das Waylons nie anwesender Vater, ein Drogenhändler, in schwülstigem Art-Deco mit bonbonfarbenen Pastellbildern ausgestattet hat. Im Verlauf der Handlung wird der Deutsche Schäferhund der Familie von Noras Freier (einem Metzger) in schwimmendem Fett ausgebraten. Weitere Katastrophen folgen in der Odyssee eines Jungen durch eine vom sozialen Zerfall gezeichnete Welt. Das Sujet ist auch Thema der begleitenden Fotografien (eine besonders interessante Aufnahme zeigt Waylon, seine Stereoanlage fest an sich gedrückt, wie Ophelia halb untergetaucht in einer Pfütze seines eigenen Urins) und einer skulpturalen Installation, die den Schauplatz der Handlung durch herzförmige Lautsprecher und einen neongerahmten Spiegel in den realen Raum hinein erweitert. Wie in früheren Projekten, die persönliche, wenn nicht strikt autobiografische Bilder enthielten – so auch eigene Fotos lateinamerikanischer Cheerleader oder Abbildungen der Wohnungen von Freunden oder Verwandten –, lotet Gispert in seiner neuen Arbeit gesellschaftliche Identitäten aus und enthüllt dabei kulturelle Codes, die nicht weniger seltsam werden, nur weil sie allgegenwärtig sind.

Dans ses photographies grand format, ses sculptures sonores interactives ou ses installations, Luis Gispert explore la « culture de la jeunesse urbaine » par le biais de « filtres » aussi divers que les films de science-fiction, les clips vidéo ou l'art baroque. Gispert, qui admet avec humour qu'il a appris l'anglais en regardant la télévision, a mis cette formation à profit avec *Smother* (2006/07), une vidéo picaresque de 24 minutes dont l'action se déroule – comme l'enfance de l'artiste – dans un Miami des années 1980 émaillé de références au film *Scarface*. Co-écrite avec Orly Genger, l'histoire tourne autour de Waylon, garçonnet de 11 ans qui fait encore pipi au lit, et de Nora, mère castratrice et dévoreuse de cachets. Ils habitent, selon la formule de l'artiste, une maison de « narco-nouveau-riche » ornée de bibelots Art déco aux couleurs pastels et acidulées, décorée par un père absent et narcotrafiquant. Le film se présente comme une succession de péripéties (un prétendant de Nora, boucher de son état, finira ainsi par cuire à la casserole le berger allemand de la famille) retraçant l'épopée d'un jeune garçon dans un monde encombré de symboles d'appartenance sociale. L'histoire se décline aussi sous la forme de photographies – l'une d'elles montre un Waylon aux allures d'Ophélie flottant dans une mare de sa propre urine, son matériel hi-fi serré sur la poitrine – ou encore d'une installation sculpturale qui prolonge dans l'espace les décors du film (enceintes audio en forme de cœur, miroir au cadre en néon). À l'instar de ses œuvres plus anciennes, qui convoquent une iconographie personnelle sinon strictement autobiographique – photographies de *pom-pom girls* portoricaines ou d'intérieurs habités par ses proches –, l'œuvre récente de Gispert sonde les identités sociales, révélant des codes culturels aussi excentriques que courants.

S. H.

SELECTED EXHIBITIONS →
2007 *Rock'n'Roll Fantasy*, White Box, New York. *The State*, Hermitage Museum, St. Petersburg. *Zwischen zwei Toden / Between Two Deaths*, ZKM, Karlsruhe. *Art in America. Now*, MOCA Shanghai. *MOCA's Tenth Anniversary Collection*, MOCA, North Miami. *Not for Sale*, PS1 Contemporary Art Center, Long Island City **2006** *USA Today*, Royal Academy of Arts, London. *Die Jugend von heute*, Schirn Kunsthalle, Frankfurt am Main **2005** *Will Boys Be Boys?*, Museum of Contemporary Art, Denver

SELECTED PUBLICATIONS →
2008 *Lacanian Ink 31 – Sacrosanct Depression*, The Wooster Press, New York **2004** *Luis Gispert: Loud Image*, Hood Museum of Art, Hanover

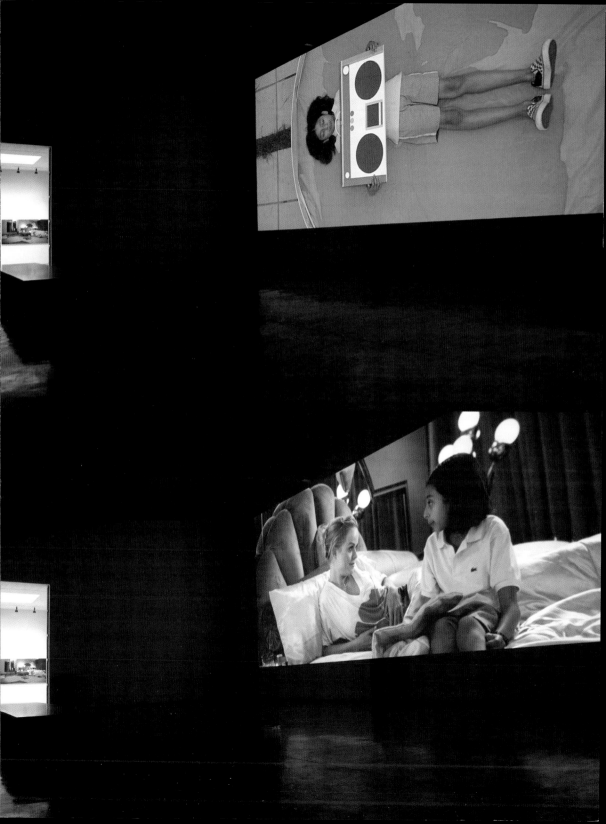

1/2 Installation views, *Luis Gispert: The World Is Yours*, Mary Boone Gallery, New York, 2008
3 **Photograph from *Smother* (Air Hockey)**, 2006/07, C-print, 101.6 x 152.4 cm
4 **Photograph from *Smother* (Little Brownie)**, 2006/07, C-print, 101.6 x 188 cm
5 **Untitled (Escalades)**, 2007, C-print, 106.7 x 152.4 cm
6 **Untitled (Gerilla)**, 2007, C-print, 106.7 x 162.6 cm

„Was mich an der Popkultur am meisten anspricht ist, dass sie uns daran erinnert, wie absolut wichtig Veränderung ist."

« Ce qui m'attire le plus dans la culture pop, c'est sa façon de suggérer que le changement est absolument essentiel. »

"The part of pop culture that most appeals to me is the part that suggests that change is absolutely essential."

3

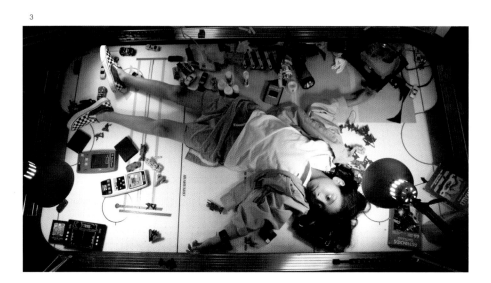

4

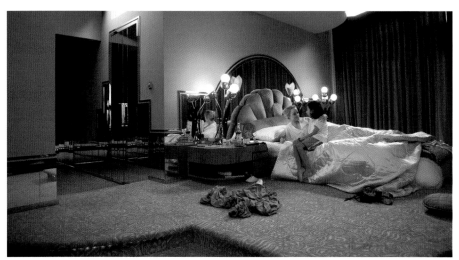

Robert Gober

1954 born in Wallingford (CT), lives and works in New York (NY), USA

Prolonged scrutiny of even the most quotidian objects can render them strange or mysterious. A similar transformation is enacted in Robert Gober's sculptures, drawings and installations, where alternative narratives and associations are drawn out of painstaking recreations and juxtapositions of everyday objects. In elusive sculptures such as *Melted Rifle* (2006), in which a limp Winchester rifle is draped over a milk crate filled with gleaming green apples, surrealist games of chance encounter and narrative association are played out. The rifle appears again in a piece from an untitled series of wall-mounted compositions (2007/08), in this case stuck through a stool on which two breasts are growing. But even where the objects appear to be real on first sight, up close they divulge the secrets of their careful fabrication from common materials, lending an uncanny air to Gober's works. His early series of sink sculptures already followed that principle, conjuring references to Duchamp's ready-made pissoir, but fabricated from plaster and other materials. The latent human presence that resides in these inanimate representations took on more recognizable figurative form in Gober's work from the 1990s onwards: dismembered limbs began to populate his ever more complex installations, growing out of walls or human torsos, interspersing references to childhood and religion with architectural metaphors for both imprisonment and escape. Gober's work interrogates the shadowy space between surface and subtext; his is an ever-growing lexicon of objects taken from everyday life that questions what we readily take for granted.

Lange Beschäftigung selbst mit den alltäglichsten Gegenständen kann diese in etwas Fremdes und Rätselhaftes verwandeln. Eine ähnliche Verwandlung findet in Robert Gobers Skulpturen, Zeichnungen und Installationen statt, wo neue, überraschende Geschichten und Assoziationen durch die sorgfältige Neuschöpfung und Gegenüberstellung von alltäglichen Gegenständen entstehen. In einer schwer fassbaren Skulptur wie *Melted Rifle* (2006) – ein schlaffes Winchester-Gewehr, das über einer mit glänzenden grünen Äpfeln gefüllten Plastikkiste hängt – finden zufällige Begegnungen im surrealistischen Sinne statt und werden narrative Assoziationen durchgespielt. Das Gewehr taucht auch bei einer Arbeit aus einer titellosen Serie von an der Wand hängenden Kompositionen auf, wo es durch einen Stuhl gesteckt ist, auf dem zwei Brüste wachsen. Aber auch da, wo Gegenstände auf den ersten Blick echt zu sein scheinen, enthüllen sie, genau besehen, die Geheimnisse einer sorgfältigen Produktion aus ungewöhnlichen Materialien – und genau das macht Gobers Arbeiten etwas unheimlich. Seine frühe Serie von Waschbecken funktionierte schon nach diesem Prinzip, rief Erinnerungen an Duchamps Pissoir und das Readymade wach, bestand tatsächlich aber aus Gips und anderen Materialien. Die versteckte Gegenwart des Menschlichen in diesen leblosen Darstellungen wurde in Gobers Werk seit den 1990ern erkennbar figurativ: Losgelöste Gliedmaßen begannen seine immer komplexeren Installationen zu bevölkern, wuchsen aus den Wänden oder aus menschlichen Torsos, durchsetzten Bezüge zu Kindheit und Religion mit architektonischen Metaphern für Gefangenschaft und Freiheit. Gobers Arbeiten befragen den grauen Bereich zwischen Oberfläche und Subtext; sie sind ein stetig wachsendes Inventar von Objekten unseres alltäglichen Lebens, das in Frage stellt, was wir bereitwillig für selbstverständlich halten.

L'examen approfondi d'un objet, même le plus ordinaire, peut le rendre étrange et mystérieux. Une transformation de ce type est mise en œuvre dans les sculptures, les dessins et les installations de Robert Gober, où des associations et des récits nouveaux surgissent de la re-création méticuleuse d'objets familiers et de leur juxtaposition. Des sculptures au sens élusif telles que *Melted Rifle* (2006) – une carabine Winchester molle posée sur un cageot rempli de pommes d'un vert éclatant – convoquent des jeux surréalistes de rencontres fortuites et d'associations d'idées. Le fusil apparaît à nouveau dans une série sans titre de pièces murales (2007/08) : il est ici passé à travers un tabouret sur lequel pousse une paire de seins. Même lorsque les objets semblent a priori réels, un second examen révèle leurs secrets de fabrication, à partir de matériaux ordinaires, ce qui leur donne un air troublant. Les premières séries de sculptures d'éviers suivaient déjà ce principe : ils faisaient référence à l'urinoir ready-made de Duchamp mais étaient faits de plâtre et d'autres matériaux. La présence humaine latente qui habite ces représentations inanimées prit une forme plus figurative à partir des années 1990 : des membres séparés de leurs corps commencèrent à peupler ses installations à la complexité grandissante. Ils jaillissent des murs ou de torses humains et mêlent métaphores architecturales de l'emprisonnement et de l'évasion avec des références à l'enfance et à la religion. L'œuvre de Gober interroge l'interstice entre surface et sous-texte ; sous-texte qui, dans son cas, est un vocabulaire sans cesse grossissant d'objets arrachés à la vie quotidienne et mettant en question ce que nous considérons comme allant de soi.

A. B.

SELECTED EXHIBITIONS →
2008 *The Shape of Time*, Walker Art Center, Minneapolis. *Wunderkammer: A Century of Curiosities*, MoMA, New York **2007** *Robert Gober*, Schaulager, Münchenstein/Basle. *More than the World – Works from the Astrup Fearnley Collection*, Astrup Fearnley Museet for Moderne Kunst, Oslo. *Out of Time – A Contemporary View*, MoMA, New York. **2006** *Quartet – Barney, Gober, Levine, Schütte*, Walker Art Center, Minneapolis. *Day for Night*, Whitney Biennial 2006, Whitney Museum, New York

SELECTED PUBLICATIONS →
2007 *Robert Gober: Sculptures 1979–2007*, Schaulager, Münchenstein/Basle; Steidl, Göttingen **2006** *Robert Gober: The Meat Wagon*, The Menil Foundation, Houston **2005** *A Robert Gober Lexicon*, Matthew Marks Gallery, New York, Steidl, Göttingen **2004** *Robert Gober*, Phaidon Press, London

1 **Untitled**, 2007/08, beeswax, pigment, cotton, leather, aluminium pull tabs,
 human hair, cast gypsum polymer, paint, 70 x 43 x 45 cm
2 **Untitled**, 2006/07, plaster, pewter, watercolour, oil paint, ceramic, acrylic
 paints, twigs, grass, 89 x 86 x 57 cm

3 **Melted Rifle**, 2006, plaster, paint, cast plastic, beeswax, walnut, lead,
 69 x 58 x 40 cm

„Was ich zu sagen habe, ist in meinen Werken und nicht in meinen Worten." « Ce que j'ai à dire est dans l'œuvre, pas dans les mots. »

"My communication is the work and not the word."

2

Douglas Gordon

1966 born in Glasgow, United Kingdom, lives and works in New York (NY), USA

In 2007 Douglas Gordon produced the performative-photographic work *Psycho Hitchhiker (Coming or Going)* for a retrospective in Wolfsburg; it is a self-ironic reference to his famous work *24 Hour Psycho* (1993). Gordon stood next to a street in Wolfsburg holding up a sign with the word "Psycho" written on it. This gesture reveals an ambiguity that is symptomatic of his work across the media of film, text, photography and installation. In addition to temporality, his works always deal with duality: light/dark, good/bad, reality/image. The exhibition *Douglas Gordon's The Vanity of Allegory* (2005) exemplified the relationship between self-presentation and mortality by examining the veiled self-portrait as a topos in art history, a literary device and a filmic strategy. Gordon explores the theme of reflection and copy in a variety of ways in his works: in *Plato's Cave* (2006) he confronted viewers in Edinburgh with their own shadow in a deconstruction of Plato's cave allegory. In the series *Self-Portrait of You and Me*, he availed himself of pop iconography and mounted partially destroyed photographs of Bond girls on mirrors (2006). In the second part of this series, the stars were presented in the already iconic form of Warholian silkscreen prints (2007). The viewers then see themselves in the holes of these star portraits, so that their image blends with that of the star, taking the place of the object of desire and projections. Through his collaboration with the band Chicks on Speed (*Art Rules*, 2006–), which takes the form of a record and various stage performances, Gordon himself has become a pop star, as it were, and has thus gone behind the mirror.

Für seine Retrospektive in Wolfsburg schuf Douglas Gordon die performativ-fotografische Arbeit *Psycho Hitchhiker (Coming or Going)* (2007), mit der er sich selbstironisch auf seine berühmte Arbeit *24 Hour Psycho* (1993) bezieht. Gordon stellte sich an eine Straße in Wolfsburg und hielt ein Schild mit der Aufschrift „Psycho" empor. In dieser Geste offenbart sich eine Ambiguität, die symptomatisch für Gordons Arbeit in den Medien Film, Text, Fotografie und Installation ist. In ihnen geht es, neben Zeitlichkeit, immer auch um Dualität: Hell/Dunkel, Gut/Böse, Realität/Abbild. Das Verhältnis von Selbstpräsentation und Sterblichkeit exemplifizierte Gordon in der Ausstellung *Douglas Gordon's The Vanity of Allegory* (2005) anhand einer Untersuchung des verschleierten Selbstporträts als kunsthistorischem Topos, literarischem Kunstgriff und filmischer Strategie. Spiegelung und Abbild sind Themen, die Gordon in seinen Arbeiten auf unterschiedliche Weise untersucht: In *Plato's Cave* (2006) in Edinburgh konfrontierte er den Betrachter in einer Dekonstruktion von Platons Höhlengleichnis mit seinem eigenen Schatten. In der Serie *Self-Portrait of You and Me* greift Gordon auf Popikonografie zurück und montiert teilweise zerstörte Fotografien von Bond Girls auf Spiegel (2006). In einem zweiten Teil der Serie erscheinen die Stars in der bereits schon ikonischen Form von Warholschen Siebdrucken (2007). In den Löchern der Starporträts erblickt der Betrachter dann sich selbst, sein Abbild vermischt sich so mit demjenigen des Stars, schiebt sich an den Platz des Objekts der Bewunderung und Projektionen. In der Zusammenarbeit mit Chicks on Speed (*Art Rules*, 2006–), die sich in einer Schallplatte und verschiedenen Bühnenauftritten äußert, ist Gordon gleichsam selbst zum Popstar geworden und begibt sich damit hinter den Spiegel.

Pour sa rétrospective à Wolfsburg, Douglas Gordon devait créer son œuvre performative-photographique *Psycho Hitchhiker (Coming or Going)* (2007), avec laquelle il se référait à sa célèbre œuvre *24 Hour Psycho* (1993) – non sans porter sur lui-même un regard ironique. Gordon se plaça au bord d'une rue de Wolfsburg en brandissant un écriteau marqué «Psycho». Cette posture révèle une ambiguïté symptomatique du travail que Gordon réalise dans les médiums du cinéma, du texte, de la photographie et de l'installation. À côté de la qualité temporelle, ceux-ci traitent toujours et notamment de dualité : clair/obscur, bien/mal, réalité/représentation. Dans son exposition *Douglas Gordon's The Vanity of Allegory* (2005), Gordon a illustré le rapport entre représentation de soi et mortalité à l'appui d'une étude de l'autoportrait voilé, lieu commun de l'histoire de l'art, tour de main littéraire et stratégie cinématographique. Le reflet et l'image sont des thèmes que ses œuvres abordent de manière très diverse : dans *Plato's Cave* (2006) qu'on a pu voir à Édimbourg, Gordon confrontait le spectateur à sa propre ombre par le truchement d'une déconstruction du mythe de la caverne de Platon. Dans la série *Self-Portrait of You and Me*, il revient à l'iconographie pop en montant sur des miroirs des photographies partiellement détruites de James Bond Girls. Dans une seconde partie de la série, les stars apparaissent sous la forme déjà iconique des sérigraphies de Warhol (2007). Dans les épargnes des portraits de stars, le spectateur se voit ensuite lui-même ; son image se mêle ainsi à celle de la star et prend la place de l'objet d'admiration et de projection. Par le biais de sa collaboration avec Chicks on Speed (*Art Rules*, 2006–), qui a débouché sur un disque et différentes apparitions sur scène, Gordon est en quelque sorte devenu lui-même une pop star et passe ainsi de l'autre côté du miroir.

E. S.

SELECTED EXHIBITIONS →
2008 *Douglas Gordon*, Collection Lambert, Avignon **2007** *Douglas Gordon*, SFMOMA, San Francisco. *Douglas Gordon: Between Darkness and Light*, Kunstmuseum Wolfsburg **2006** *Douglas Gordon: Superhumanatural*, National Gallery of Scotland, Edinburgh. *Douglas Gordon: Timeline*, MoMA, New York **2005** *Douglas Gordon's The Vanity of Allegory*, Deutsche Guggenheim, Berlin

SELECTED PUBLICATIONS →
2007 *Douglas Gordon: Self-Portrait of You and Me, after the Factory*, Gagosian Gallery, New York. *Douglas Gordon: Between Darkness and Light*, Kunstmuseum Wolfsburg, Wolfsburg; Hatje Cantz, Ostfildern. *Douglas Gordon: Superhumanatural*, National Galleries of Scotland, Edinburgh **2006** Douglas Gordon, Philippe Parreno: *Zinédine Zidane*, DVD, 90 min., Walther Koenig Books Ltd., London. *Douglas Gordon: Timeline*, MoMA, New York **2005** *Douglas Gordon's The Vanity of Allegory*, Deutsche Guggenheim, Berlin

1 **Bloom**, 2006, C-print, dimensions variable
2 **Plato's Cave**, 2006, room, fire, dimensions variable

3 **Psycho Hitchhiker (Coming or Going)**, 2007, lambda-print, 46 x 59,6 cm
4 **Self-Portrait of You and Me (Elvis)**, 2007, smoke, mirror, 139.1 x 99.1 x 7.6 cm

„Wir brauchen Stars, um uns selbst in ihnen zu spiegeln."

« Nous avons besoin de stars pour pouvoir nous refléter en elles. »

"We need stars so as to mirror ourselves in them."

3

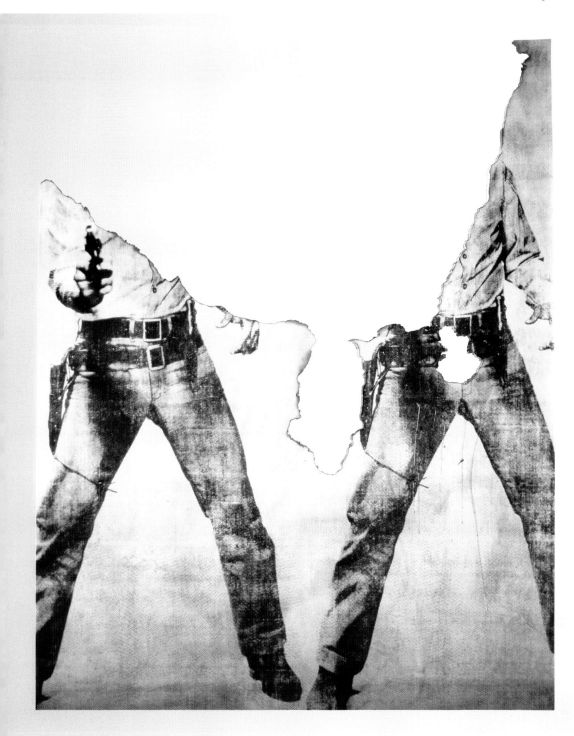

Mark Grotjahn

1968 born in Pasadena (CA), lives and works in Los Angeles (CA), USA

In January 2007, Mark Grotjahn surprised the New York art scene with an exhibition of eleven dark-blue canvases that only unfold their composition when carefully contemplated. Part of the artist's ongoing series of "butterfly paintings" since 2001, these monochromatic abstractions are geometric compositions of thick strips of colour expanding centrifugally – although slightly out of symmetry – from two vanishing points. This structure recurs in both monochromatic and joyfully colourful paintings, in which the artist applies the paint in dense layers, allowing for an illusion of depth. The series *Blue Painting Light to Dark* (2006) consists of dark blue canvases in which various tonalities of blue radiate on the canvas creating a kaleidoscopic composition which references modernist abstraction and colourfield painting as well as Beat Generation aesthetics. At times, at the centre of the canvas, one can barely perceive a refraction of a very different colour, which actually belongs to a preliminary primer featuring cartoonish faces or expressionistic explosions of colour that Grotjahn conceals underneath the final coats of paint. Almost completely invisible in the final work, these traces of the hidden life of the painting do seem to agitate the pictorial surface, suggesting the ominous presence of a secret world. Although he is best known for his abstract paintings, Grotjahn has also been exhibiting figurative works, such as the recent *Untitled (Angry Flower Guga the Architect 727)* (2008), in which the artist finally reveals the grotesque caricature style that he has often hidden behind his more sombre pictures.

Im Januar 2007 überraschte Mark Grotjahn die New Yorker Kunstszene mit einer Ausstellung von elf dunkelblauen Leinwänden, die ihre Komposition erst nach gründlicher Betrachtung enthüllten. Als Teil einer seit 2001 fortlaufenden Serie von „Butterfly Paintings" sind diese monochromen Abstraktionen geometrische Kompositionen von dicken Farbstreifen, die sich – wenn auch leicht asymmetrisch – von zwei Fluchtpunkten aus zentrifugal ausdehnen. Diese Struktur wiederholt sich sowohl in monochromen als auch in farbenfröhlichen Bildern, bei denen der Künstler die Farbe in dichten Schichten aufträgt, um eine Illusion von Tiefe zu erzeugen. Die Serie *Blue Painting Light to Dark* (2006) besteht aus dunkelblauen Leinwänden, auf denen verschiedene Blautöne Strahlen aussenden und eine kaleidoskopartige Form entstehen lassen, die an modernistische Abstraktion und Farbfeldmalerei ebenso erinnert wie an die Ästhetik der Beat Generation. Manchmal kann man im Mittelpunkt der Leinwand ganz schwach die Lichtbrechung einer anderen Farbe erkennen, die tatsächlich zur vorigen Grundierung gehört, bei der Grotjahn cartoonartige Gesichter oder expressionistische Farbexplosionen malt, bevor er sie unter den endgültigen Farbschichten verbirgt. Beinahe völlig unsichtbar im fertigen Werk, scheinen diese Spuren eines verborgenen Lebens unter dem Bild die gemalte Oberfläche aufzurühren, die ahnungsvolle Existenz einer geheimen Welt andeutend. Obwohl seine abstrakten Gemälde am bekanntesten sind, hat Grotjahn auch figurative Arbeiten ausgestellt, wie jüngst *Untitled (Angry Flower Guga the Architect 727)* (2008), mit dem der Künstler endlich den grotesken karikaturhaften Stil offenbart, den er oft unter seinen düstereren Bildern verbirgt.

En janvier 2007, Mark Grotjahn surprit le monde de l'art new-yorkais avec une exposition de onze toiles bleu foncé dont la composition ne se révélait qu'après un examen attentif. Ces abstractions monochromes, qui font partie de sa série des «butterfly paintings» en cours depuis 2001, sont des compositions géométriques où de larges bandes de couleur s'élargissent à partir de deux points de fuite, de façon centrifuge mais pas tout à fait symétrique. Cette même structure réapparaît dans des toiles, certaines monochromes, d'autres joyeusement multicolores, dans lesquelles l'artiste applique la peinture en couches denses, créant ainsi une illusion de profondeur. La série *Blue Painting Light to Dark* (2006) se compose d'œuvres bleu foncé où différentes teintes de bleu rayonnent sur la toile, rappelant les compositions kaléidoscopiques de l'abstraction moderniste et du colourfield painting, ainsi que l'esthétique de la *beat generation*. Parfois, au centre de la toile, on peut voir, à peine, la réfraction d'une toute autre couleur : celle-ci appartient à une couche de préparation où figurent des visages caricaturaux ou bien des explosions expressionnistes de couleur que Grotjahn dissimule ensuite sous les dernières couches de peinture. Bien qu'elles soient presque invisibles une fois la toile terminée, ces traces d'une vie cachée de l'œuvre semblent en agiter la surface picturale, suggérant la présence inquiétante d'un univers secret. Même si Grotjahn est surtout connu pour ses peintures abstraites, il a aussi exposé des travaux figuratifs, comme le récent *Untitled (Angry Flower Guga the Architect 727)* (2008), dans lequel il divulgue enfin le style grotesque et caricatural qu'il a si souvent caché dans ses peintures plus sombres.

C. A.

SELECTED EXHIBITIONS →
2008 *Oranges and Sardines: Conversations on Abstract Painting with Mark Grotjahn, Wade Guyton, Mary Heilmann, Amy Sillman, Charline von Heyl, and Christopher Wool*, Hammer Museum, Los Angeles **2007** *Mark Grotjahn*, Kunstmuseum Thun. *Like Color in Pictures*, Aspen Art Museum, Aspen **2006** *Mark Grotjahn*, Whitney Museum of American Art, New York. *Painting in Tongues*, MOCA, Los Angeles **2005** *Mark Grotjahn: Drawings*, Hammer Museum, Los Angeles

SELECTED PUBLICATIONS →
2008 Dominique Gonzalez-Foerster, *Mark Grotjahn, Allora & Calzadilla*, Parkett 80, Zürich **2007** *Mark Grotjahn*, Kunstmuseum Thun, Thun. *Like Color in Pictures*, Aspen Art Press, Aspen **2006** *Whitney Biennial: Day For Night*, Whitney Museum of American Art, New York **2005** *Mark Grotjahn: Drawings*, Blum & Poe, Los Angeles, Anton Kern, New York

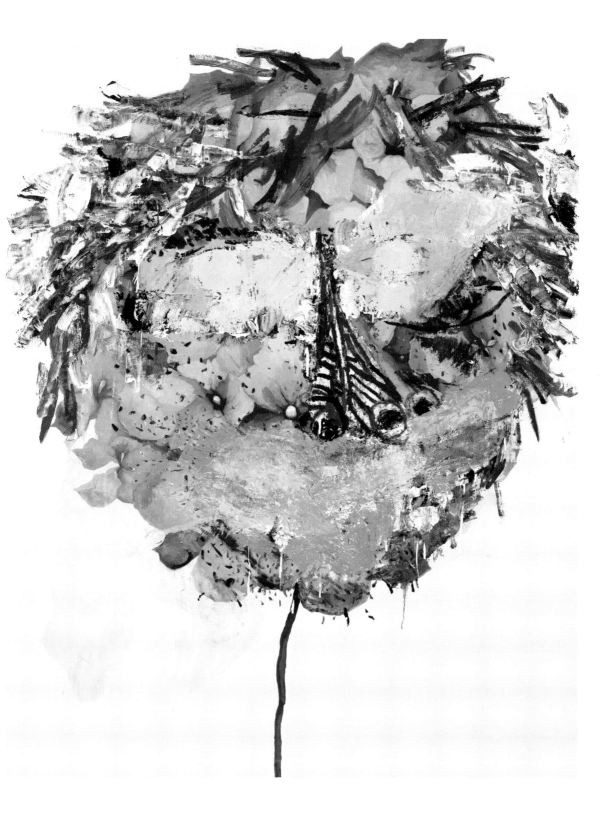

1 Untitled (Angry Flower Guga the Architect 727), 2008, oil,
 enamel paint on linen, 152.4 x 121.9 cm
2 Untitled (Angry Flower Female Big Nose Baby Moose #3), 2006, sock,
 oil on cardboard, mounted on canvas, 183 x 137 x 15.2 cm

3 Untitled (Creamsicle 681), 2007, colour pencil on paper,
 163.8 x 121.3 cm
4 Untitled (Blue Butterfly Dark to Light IV #654), 2006, oil on linen,
 182.9 x 137.2 cm

„Ich habe eine Vorstellung davon, was für eine Art von Gesicht es werden
wird, wenn ich ein ‚Face Painting' male, aber ich weiß nicht genau, was für
eine Farbe oder wie viele Augen es haben wird, wohingegen die ‚Butterflies'
recht streng geplant sind."

« Lorsque je fais un "face painting", j'ai une idée du type de visage qui va
émerger, mais je ne sais pas exactement quelle couleur il aura, ni combien
d'yeux, alors qu'avec les "butterfly paintings" tout est plus ou moins planifié
d'avance. »

"I have an idea as to what sort of face is going to happen when I do a 'face painting', but I don't exactly know what color it will take, or how many eyes it's going to have, whereas the 'butterflies' are fairly planned out."

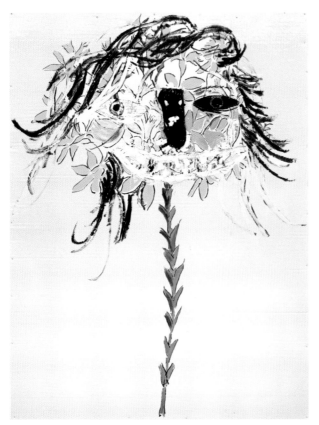

2

3

Subodh Gupta

1964 born in Khagaul, lives and works in New Delhi, India

Subodh Gupta subjects his artworks – mainly installations, sculptures or paintings – to a strategic process of multiple encoding. While his source materials are emblematic objects of everyday life in India, they may be interpreted differently in other geographical contexts and are also given new meaning when filtered through the system of Western aesthetics. *Spill* (2007), for example, has lots of small stainless steel pots and bowls spilling out of a large, shiny bucket. It is in fact a larger-than-life milk pail and the other objects are cooking or eating utensils; as such they form part of India's gastronomic culture with its sacred and ritual connotations, but they could also be regarded as representative of Indian culture as a whole. In the form of an artwork they become a sculpture with strong references to pop art and the readymade. For Gupta, however, it is not about the gesture of elevating utilitarian objects to the level of artworks, but about the multiple meanings such objects have. In the installation *Silk Road* (2007), for instance, countless pots and pans have been piled up into shiny silvery towers, which together evoke a futuristic urban landscape, while in Gupta's recent paintings, entitled *Still Steal Steel* (2007–) or left untitled, utensils are depicted in a virtuoso, hyperrealist style of painting reminiscent of American photorealism. By combining themes from his Indian homeland with stylistic references to recent US art history and by harnessing the tension that arises when country and city, tradition and change, specifically local and standardized global interests collide, Gupta's work convincingly reflects the complex nature of contemporary Indian society.

Subodh Gupta unterwirft seine Arbeiten – meist Installationen, Skulpturen oder Gemälde – einer Strategie der Mehrfachcodierung: Sein Ausgangsmaterial sind emblematische Objekte aus der Alltagswelt Indiens, die allerdings in wechselnden geografischen Kontexten jeweils andere Lesarten erfahren können, und die zudem durch das System der westlichen Ästhetik gefiltert und umgedeutet werden. *Spill* (2007) etwa besteht aus einem glänzenden Eimer, aus dem kleinere Edelstahlgefäße und -schalen quellen. Es handelt sich um einen Milcheimer und Essgeschirr; beides entstammt der indischen Esskultur mit ihren sakralen und rituellen Konnotationen, könnte aber andernorts stereotypisch für die indische Kultur einstehen, und wird in Form eines Kunstwerks zu einer Skulptur, die starke Bezüge zur Pop Art oder auch zum Readymade aufweist. Doch geht es bei Gupta nicht um die Geste, mit der Gebrauchsgegenstände in den Rang eines Kunstwerks erhoben werden, sondern um deren vielfältige Bedeutungen. So finden sich in der Installation *Silk Road* (2007) unzählige Töpfe und Schalen zu silbrig glänzenden Türmen aufgestapelt, die in ihrer Gesamtheit eine futuristische Stadtlandschaft evozieren. Auf Guptas neueren, unbetitelten oder *Still Steal Steel* genannten Gemälden (2007–) wird Geschirr zum Vorwand für eine virtuose hyperrealistische Malerei, die an die amerikanischen Fotorealisten denken lässt. Indem Gupta Motive aus seiner indischen Heimat mit vorwiegend stilistischen Referenzen an die neuere US-amerikanische Kunstgeschichte verquickt, gelingt es ihm in seinen Arbeiten, im Aufeinandertreffen von Land und Stadt, Tradition und Umbruch, Lokal-Spezifischem und Global-Standardisiertem die Komplexität der zeitgenössischen indischen Gesellschaft zu reflektieren.

Subodh Gupta soumet ses œuvres – le plus souvent des installations, des sculptures ou des peintures – à une stratégie du codage multiple : son matériau de base est constitué d'objets emblématiques de la vie quotidienne indienne qui peuvent néanmoins subir des lectures diverses en fonction des contextes géographiques et qui sont de surcroît filtrés et réinterprétés par le système esthétique occidental. *Spill* (2007) consiste en un seau rutilant d'où débordent toutes sortes de récipients en inox de moindre taille. Il s'agit d'un seau d'un lait et d'éléments de vaisselle qui font partie de la culture de table indienne avec ses connotations sacrées et rituelles. Dans d'autres zones, ces objets peuvent toutefois apparaître comme les représentants stéréotypés de la culture indienne ; en tant qu'œuvre d'art, ils deviennent une sculpture avec de fortes références au Pop Art ou au ready-made. Cela dit, le propos de Gupta n'est pas d'incarner une position artistique par laquelle des objets utilitaires sont élevés au rang d'œuvre d'art, mais de mettre en évidence leur polysémie. Dans l'installation *Silk Road* (2007) sont empilés d'innombrables pots et coupes qui forment des tours brillantes et argentées évoque un paysage urbain futuriste. Dans les œuvres récentes laissées sans titre ou intitulées *Still Steal Steel* (2007–), la vaisselle devient le prétexte d'une peinture hyperréaliste virtuose qui rappelle le photoréalisme américain. En associant des motifs de sa patrie indienne et des aspects stylistiques se référant essentiellement à l'histoire de l'art américain récent, Gupta parvient à traduire la complexité de la société indienne d'aujourd'hui, avec le télescopage de la ville et de la campagne, de la tradition et du changement, de la spécificité régionale et d'une standardisation globalisée. A. M.

SELECTED EXHIBITIONS →
2008 *Chalo! India: A New Era of Indian*, Art Mori Art Museum, Tokyo. *God & Goods. Spirituality and Mass Confusion*, Villa Manin, Codroipo. *Freedom – Sixty Years after Indian Independence*, CIMA, Calcutta **2007** *Subodh Gupta: Silk Route*, BALTIC Centre for Contemporary Art, Gateshead. *Hungry God: Indian Contemporary Art*, Busan Museum of Modern Art, Busan; Art Gallery of Ontario, Toronto. *Edge of Desire*, National Gallery of Modern Art, Bombay **2006** *Dirty Yoga*, Taipei Biennial 2006, Taipei

SELECTED PUBLICATIONS →
2008 *God & Goods. Spirituality and Mass Confusion*, Villa Manin, Codroipo **2007** *Hungry God: Indian Contemporary Art*, Busan Museum of Modern Art, Busan **2005** *Edge of Desire: Recent Art in India*, Philip Wilson Publishers, London

1 **Spill**, 2007, stainless steel, stainless steel utensils, 170 x 145 x 95 cm
2 **Curry**, 2005, stainless steel, stainless steel utensils, 5 cabinets,
 360 x 279 cm (each). Installation view, Nerman Museum of Contemporary
 Art, Kansas, 2008

3 **Gandhi's Three Monkeys**, 2007/08, antique utensils, bronze, steel,
 1st head 184 x 140 x 256 cm, 2nd head 200 x 131 x 155 cm, 3rd
 head 175 x 125 x 150 cm. Installation view, Jack Shainman Gallery,
 New York, 2008

„Ich stehle Idole. Ich stehle aus dem Drama im Leben der Hindus. Und aus der Küche – diese Töpfe sind wie gestohlene Götter, die aus dem Land geschmuggelt wurden."

« Je suis le voleur d'idoles. Je me sers dans le drame de la vie hindoue. Et dans la cuisine – ces bols sont comme des dieux volés, sortis du pays en contrebande. »

"I am the idol thief. I steal from the drama of Hindu life. And from the kitchen – these pots, they are like stolen gods, smuggled out of the country."

2

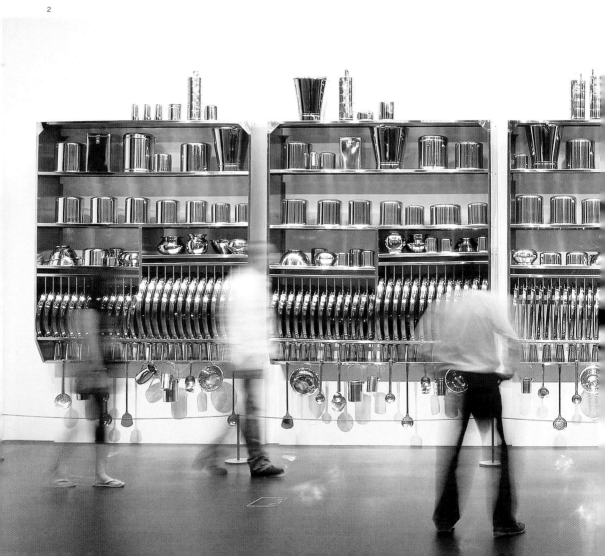

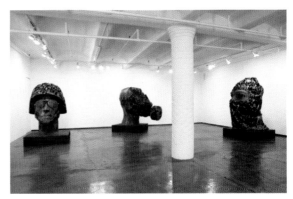

3

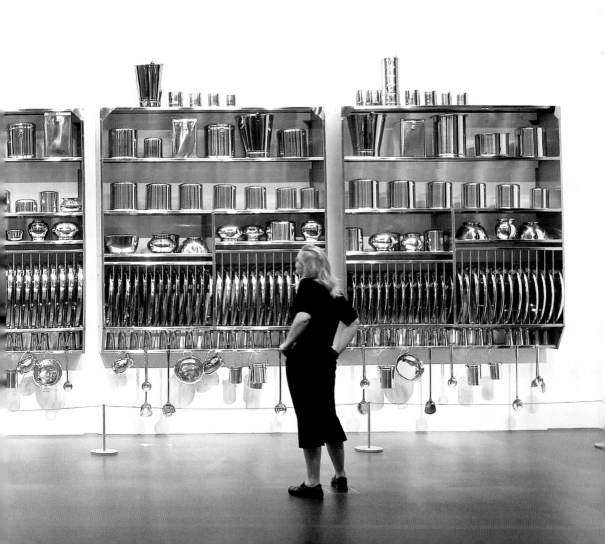

Andreas Gursky

1955 born in Leipzig, lives and works in Düsseldorf, Germany

Andreas Gursky is known for his large-scale panoramic overviews of mass events, architecture, landscapes as well as commercial and leisure sites, capturing the human conditions in modern life. He extends the documentary approach of his teachers Bernd and Hilla Becher by making slight digital changes to the photographs, thus reinforcing their perceptual illogic, produced by the oscillation between the almost ornamental structure of the whole and a surfeit of detail. No wonder he has encountered ideal subjects in the North Korean Mass Games, where colourful pictures are performed by thousands of people (*Pyongyang*, 2007) and on the *Kuwait Stock Exchange* (2007), where hundreds of brokers move across the floor in white garments. By contrast, there is no human presence in *Kamiokande* (2007), Gursky's photograph of a subterranean detector of neutrinos, elementary particles of matter that have almost no mass and zip around at a speed nearly as fast as light: two tiny boats floating on a dark pool of water are dwarfed by the curved, shimmering interior of the cylindrical detector, which is lined with parallel rows of huge gold spheres creating an image like Böcklin's *Toteninsel* boats in a huge disco. Sometimes Gursky's perspective engenders an indeterminacy that veers sharply from the real toward abstraction, like in *Bahrain I* (2007) where a racetrack meanders through the desert like a serpent. The stands and a settlement in the background appear in sharply focused realism but the tarmac is folded and knotted in ribbons until it appears like an M.C. Escher perspective absurdity viewed through a funhouse mirror.

Andreas Gursky ist bekannt für großformatige Panoramabilder von Massenevents, Architektur, Landschaften sowie Szenen aus Beruf und Freizeit, in denen er die modernen Lebensbedingungen erfasst. Er erweitert den dokumentarischen Ansatz seiner Lehrer Bernd und Hilla Becher, indem er die Fotografien leichten digitalen Veränderungen unterzieht. Dadurch verstärkt er die Verunsicherung der Wahrnehmung, die durch das Oszillieren der Motive zwischen dem nahezu ornamentalen Gesamtaufbau und einer Überfülle an Details ausgelöst wird. Kein Wunder, dass er in den nordkoreanischen Massenaufführungen, die Abertausende von Menschen zu farbenprächtigen Bildern vereinen (*Pyongyang*, 2007), und mit dem *Kuwait Stock Exchange* (2007), in dem sich hunderte von Brokern in weißen Gewändern über den Floor bewegen, ideale Sujets gefunden hat. Dem stellt Gursky das fast menschenleere *Kamiokande* (2007) gegenüber, seine Fotografie eines unterirdischen Detektors für Neutrinos, nahezu masselose, quasi mit Lichtgeschwindigkeit herumwirbelnde Elementarteilchen: Zwei kleine Boote treiben auf der dunklen Wasserfläche und erscheinen noch winziger unter den gekrümmten Innenwänden des zylindrischen Detektors, dessen parallel zueinander angeordnete goldene Lichtkugeln die Szenerie wie Böcklins *Toteninsel* in einer riesigen Disko wirken lassen. Gurskys verunsichernde Perspektive kann ein Umschwenken vom Realen zur Abstraktion bewirken, so in *Bahrain I* (2007), wo sich eine Rennstrecke durch die Sandwüste schlängelt. Die Tribüne und eine Siedlung in der Ferne erscheinen in gestochen scharfem Realismus, während die schwarze Strecke selbst sich faltet und Schleifen wirft, bis sie aussieht wie eine von einem Zerrspiegel zurückgeworfene absurde Perspektiv-Konstruktion von M.C. Escher.

Andreas Gursky est célèbre pour ses immenses vues panoramiques d'évènements de masse, de bâtiments, paysages, sites commerciaux ou de loisirs, dans lesquelles il saisit la condition humaine à l'ère moderne. Il prolonge l'approche documentaire de ses maîtres Bernd et Hilla Becher en apportant de légères modifications numériques à ses images, dont il renforce ainsi l'illogisme de la perception produit par l'aller-retour entre la structure quasi ornementale de l'ensemble et la profusion de détails. On ne s'étonnera pas qu'il ait trouvé un sujet idéal dans les rassemblements de masse en Corée du Nord, lors desquels des milliers d'individus dessinent une image colorée (*Pyongyang* 2007) ou avec les courtiers en bourse habillé de blanc dans *Kuwait Stock Exchange* (2007). À l'inverse, on ne décèle nulle présence humaine dans *Kamiokande* (2007), photographie d'un observatoire souterrain de neutrinos – ces particules élémentaires, de masse infinitésimale, qui se déplacent presque à la vitesse de la lumière. Deux petits bateaux, flottant sur un bassin d'eau sombre, paraissent minuscules à côté de l'intérieur incurvé et étincelant du détecteur cylindrique que bordent des rangées parallèles d'énormes sphères dorées : c'est un peu comme si les navires de l'*Île des Morts* de Böcklin se retrouvaient dans une immense discothèque. La perspective indéterminée de Gursky le mène parfois du réel à l'abstraction, comme dans *Bahrain I* (2007), où les méandres d'un circuit automobile serpentent dans le désert. La tribune et la cité à l'arrière-plan apparaissent avec un réalisme acéré alors que le circuit se déploie tel un ruban jusqu'à ressembler à une perspective absurde de M.C. Escher vue à travers un miroir déformant.

C. Es.

SELECTED EXHIBITIONS →
2008 *Andreas Gursky*, Kunstmuseum Krefeld, Haus Lange and Haus Ester, Krefeld. *Andreas Gursky: Cocoon/Frankfurt...*, MMK, Frankfurt. *Andreas Gursky: Architektur*, Institut Mathildenhöhe, Darmstadt. **2007** *Andreas Gursky. Retrospective 1984–2007*, Haus der Kunst, Munich. *Andreas Gursky*, Kunstmuseum Basel, Basle. *Andreas Gursky*, Istanbul Museum of Modern Art, Istanbul

SELECTED PUBLICATIONS →
2008 *Andreas Gursky, Werke 80–08*, Kunstmuseum Krefeld, Krefeld, Hatje Cantz, Ostfildern. *Andreas Gursky: Architecture*, Hatje Cantz, Ostfildern. **2007** *Andreas Gursky*, Kunstmuseum Basel, Basle, Hatje Cantz, Ostfildern. *Andreas Gursky*, Haus der Kunst, Munich, Snoeck Verlag, Cologne. **2001** *Andreas Gursky*, MoMA, New York, Hatje Cantz, Ostfildern

1 **Bahrain I**, 2005, C-print, 302.2 x 219.6 x 6.2 cm 3 **Kuwait Stock Exchange**, 2007, C-print, 295.1 x 222 x 6.2 cm
2 **Kamiokande**, 2007, C-print, 228.2 x 367.2 x 6.2 cm

„Im Prinzip bin ich sehr nahe am Geschehen und bin doch mit den Bildern « En principe, je suis tout près de l'évènement tout en n'étant plus dans le
nicht mehr in der realen Welt." monde réel avec mes images. »

"In principle, I'm very close to the event and at the same time my pictures are no longer in the real world."

2

Rachel Harrison

1966 born in New York (NY), lives and works in New York (NY), USA

Rachel Harrison's Technicolor-surfaced sculptures are amorphous in contour and wryly ambiguous in meaning, often crossing threads of celebrity pulp, mythology, current events and politics. Deploying the language and history of sculpture – its materials, structures and conditions of display – while contaminating notions of its autonomous purity, Harrison renders her assemblages simultaneously artwork and impromptu pedestal for a quixotic exhibition of ready-made objects (air fresheners, canned food, fake food, Barbie dolls, wigs and mannequins), of house plants and taxidermied animals. Her recent New York exhibition, tauntingly called *If I Did It* (2007) after O.J. Simpson's ill-advised hypothetical tell-all of the same name, pressed Harrison's juxtaposition-based logic to its furthest conclusions yet. Indeed, it even warranted her supplying a booklet of photocopies and printouts for reference – a secret decoder ring for the works on view were it not for the fact that Harrison refuses interpretive fixity. Instead, her assembly of nine mixed-media sculptures titled after famous men (amongst them Alexander the Great, Johnny Depp, Fats Domino, Rainer Werner Fassbinder, Claude Lévi-Strauss, Amerigo Vespucci and Tiger Woods) and a series of portrait photographs inspired by Charles Darwin's expedition journal, *Voyage of the Beagle* (2007), obliquely mirror their subjects and offer a critique of the cultural conditions in which they came to fame or power. This decidedly un-heroic memorializing is the crux of Harrison's feminism. It also furthers her earlier play with the status of the monument, denuding those to whom it pays tribute.

Rachel Harrisons bunt bemalte Skulpturen sind amorphe, mit ironischer Mehrdeutigkeit aufgeladene Gebilde, die oft auf Promi-Kitsch, mythologische Themen, aktuelle und politische Ereignisse referieren. Indem Harrison die Sprache und Geschichte der Skulptur aufruft – ihrer Materialien, Strukturen und Ausstellungsbedingungen – und gleichzeitig die Wahrnehmung von Skulptur als eigenständiger Kunstform zerstört, lässt sie ihre Arrangements als Kunstwerke wie auch als Sockelimprovisation für die donquichotteske Präsentation von Readymades (Luftbefeuchter, Konserven, Lebensmittelattrappen, Barbiepuppen, Perücken und Schaufensterpuppen), Zimmerpflanzen und ausgestopften Tieren erscheinen. In ihrer letzten Ausstellung in New York, deren Titel *If I Did It* (2007) auf das gleichnamige Buch mit O.J. Simpsons problematisch-hypothetischem Mordgeständnis anspielte, trieb Harrison diese Logik des Nebeneinanders verschiedenster Dinge auf die Spitze. So gab sie sogar eine Broschüre mit dazugehörigen Fotokopien und Laserdrucken heraus – wie eine Art Geheimcode zu den Exponaten, wenn Harrison sich auf eine Interpretation festlegen ließe. Eher spiegelten ihre neun Skulpturen aus verschiedenen Materialien, die sie mit den Namen berühmter Männer versah (wie Alexander der Große, Johnny Depp, Fats Domino, Rainer Werner Fassbinder, Claude Lévi-Strauss, Amerigo Vespucci, Tiger Woods), in Verbindung mit einer von den Reisenotizen aus Charles Darwins Reisetagebuch *Voyage of the Beagle* (2007) inspirierten fotografischen Porträtserie indirekt ihre Sujets und hinterfragten dadurch den kulturellen Kontext, der ihnen zu Ruhm und Macht verhalf. Diese dezidiert entheroisierende Erinnerungsarbeit bildet die Krux in Harrisons Feminismus. Und sie ist eine Weiterentwicklung ihres früheren Spiels mit dem Status des Denkmals, dessen Ehrenträger sie in voller Blöße zeigt.

Les sculptures en technicolor de Rachel Harrison, aux formes organiques, aux significations équivoques et pleines d'humour, mêlent magazines people, mythologie, actualité et politique. Se référant au langage et à l'histoire de la sculpture – à travers les matériaux, les structures et les conditions d'exposition – tout en altérant l'idée de sa pureté indépendante, Harrison fait de ses assemblages tout à la fois une œuvre d'art et un support improvisé pour une exposition donquichottesque de ready-made (désodorisants d'atmosphère, boîtes de conserve, aliments factices, poupées Barbie, perruques et mannequins), de plantes d'intérieur ou d'animaux empaillés. Sa récente exposition new-yorkaise, ironiquement intitulée d'après le livre de pseudo-confessions de O.J. Simpson, *If I Did It* (Si je l'avais fait) (2007), a poussé la logique de juxtaposition d'Harrison dans ses derniers retranchements. Elle a même fourni une brochure photocopiée et des imprimés – apparemment un décodeur secret pour les pièces exposées, si Harrison ne refusait pas toute fixité interprétative. Au lieu de cela, son assemblage de neuf sculptures de technique mixte, intitulée d'après le nom a'homme célèbre (Alexandre le Grand, Johnny Depp, Fats Domino, Rainer Werner Fassbinder, Claude Lévi-Strauss, Amerigo Vespucci ou Tiger Woods), et sa série de portraits photo inspirés du journal d'expédition de Charles Darwin, *Voyage of the Beagle* (2007), reflètent indirectement leurs sujets et proposent une critique des conditions culturelles dans lesquelles ils sont devenus célèbres ou arrivés au pouvoir. Cette immortalisation résolument non-héroïque est au centre du féminisme d'Harrison. Elle fait également avancer le jeu qu'elle menait précédemment avec le statut du monument, en dénudant ceux à qui il rend hommage. S. H.

SELECTED EXHIBITIONS →
2008 *Lay of the Land*, Le Consortium, Dijon. *The Hamsterwheel*, Malmö Konsthall, Malmö. *Whitney Biennial 2008*, Whitney Museum of American Art, New York **2007** *Rachel Harrison*, Kunsthalle Nürnberg, Nuremberg. *Rachel Harrison*, Migros Museum für Gegenwartskunst, Zürich **2006** *The Uncertainty of Objects and Ideas*, Hirshhorn Museum and Sculpture Garden, Washington. *Of Mice and Men*, 4th Berlin Biennial for Contemporary Art, Berlin. *DARK*, Museum Boijmans van Beuningen, Rotterdam

SELECTED PUBLICATIONS →
2008 *Rachel Harrison: If I Did It*, Kunsthalle Nürnberg, Nuremberg; JRP Ringier, Zürich. *Pawel Althamer, Louise Bourgeois, Rachel Harrison*, Parkett 82, Zürich. *Whitney Biennial 2008*, Whitney Museum of American Art, New York; Yale University Press, New Haven **2006** *Of Mice and Men*, 4th Berlin Biennial for Contemporary Art, Berlin; Hatje Cantz, Ostfildern **2004** *Rachel Harrison: Currents 30*, Milwaukee Art Museum, Milwaukee

1 **I'm with Stupid**, 2007 (detail), wood, polystyrene, cement, Parex, acrylic, child mannequin, papier-mâché skull, green wig, festive hat, Spongebob Squarepants sneakers, Pokemon t-shirt, wheels, canned fruits and vegetables, artificial carrot, artificial feathers, artificial grass, Batman and Cat mask, necktie, scarf, plastic beads, 165 x 79 x 61 cm

2 **Rainer Werner Fassbinder**, 2007, mannequin, latex Dick Cheney mask, cornstarch bio-degradable peanuts, Flo-pak regular and heavy duty peanuts, eyeglasses, athletic wear, 170 x 228 x 84 cm. Installation view, Greene Naftali, New York

3 **Alexander the Great**, 2007, wood, chicken wire, polystyrene, cement, Parex, acrylic, mannequin, Jeff Gordon waste basket, plastic Abraham Lincoln mask, sunglasses, fabric, necklace, 2 unidentified items, 221 x 231 x 102 cm

4 **Tiger Woods**, 2006, wood, chicken wire, polystyrene, cement, Parex, acrylic, spray paint, video monitor, DVD player, NYC marathon video, artificial apple, sewing pins, lottery tickets, Arnold Palmer Arizona Lite Half & Half green tea lemonade can, 201 x 122 x 109 cm

5 **Al Gore**, 2007, wood, chicken wire, polystyrene, cement, Parex, acrylic, Honeywell T87 thermostat, 216 x 86 x 43 cm

6 **Sphinx**, 2002, wood, polystyrene, cement, Parex, acrylic, sheetrock, wheels, C-print, 244 x 122 x 165 cm

„Wenn du die Hunde hörst, bleib nicht stehen."

« Si vous entendez les chiens, ne vous arrêtez pas. »

"If you hear the dogs, keep going."

2

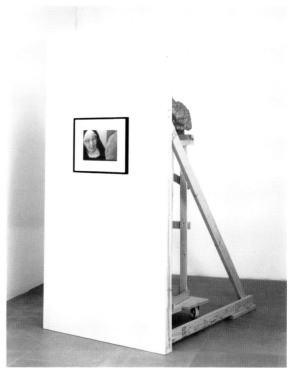

Mona Hatoum

1952 born in Beirut, Lebanon, lives and works in London, United Kingdom, and Berlin, Germany

An oversize kitchen grater as a *Daybed* (2008) whose sharp surface would strip the goose pimples from your flesh; a folding cheese grater as a metal room divider with nastily jagged openings (*Paravent*, 2008) – Mona Hatoum subjects commonplace objects to a transformation that lends them an unsettling or threatening air. The same applies to her series of "cut-outs", small fold-and-cut works reminiscent of children's handcrafts. In *Untitled (Cut-Out 7, 2008)* for example, the repeating ornament turns out to be soldiers aiming at one another. War, exile and living conditions in crisis areas are recurrent themes in Hatoum's oeuvre, which may not be wholly unconnected to her own biography. She never addresses these topics in a simplistically concrete way, however; they always appear in a subliminal and menacing way. In *Nature morte aux grenades* (2006/07) there is an uncanny tension between the seductive material aesthetic of the coloured glass objects and the implicit danger they harbour: similar to organic shapes such as lemons or pomegranates, here the glass has been blown into the form of hand grenades. The installation *Hanging Garden* (2008) consists not only of sandbags – recalling barricades used in military conflicts – but also of grass, which grows over the course of the exhibition. As such it alludes to the discussion that has been ongoing since the 1960s about the permanence and variability of artworks and artistic actions. A sculpture like *Cube* (2008) can also be linked with the debate surrounding art-historical references: although the geometrical grid structure recalls works of minimal art, closer scrutiny reveals that the rods of the cage are fitted with the hooks of barbed wire.

Eine überdimensionale Küchenreibe als Ruhebett (*Daybed*, 2008), dessen scharfkantige Oberfläche die Gänsehaut vom Fleisch nimmt, eine aufklappbare Käsereibe als metallischer Raumteiler mit ungemütlich gezackten Öffnungen (*Paravent*, 2008) – Mona Hatoum unterwirft alltägliche Gegenstände einer Wandlung, der ihnen etwas Beunruhigendes oder Bedrohliches verleiht. So auch in der Serie der „Cut-Outs", kleiner Faltschnitte, die an Kinderbasteleien erinnern. In *Untitled (Cut-Out 7, 2008)* etwa entpuppt sich der ornamentale Rapport als Muster aus Soldaten, die aufeinander zielen. Krieg, Zustände in Krisengebieten und Exil sind Themen, die immer wieder in Hatoums Arbeiten auftauchen – sicherlich nicht ganz ohne Bezug zu ihrer eigenen Biografie. Allerdings behandelt Hatoum diese Themen nie vordergründig-konkret, sie erscheinen stets unterschwellig und bedrohlich. So entsteht in *Nature morte aux grenades* (2006/07) eine eigentümliche Spannung zwischen der verführerischen Materialästhetik der bunten Glasobjekte und der impliziten Gefahr, die sie bergen: Es handelt sich um Handgranaten, die nach organischen Vorbildern wie Zitronen oder Granatäpfeln geblasen wurden. Die Installation *Hanging Garden* (2008) besteht aus Sandsäcken, die an Verschanzungen bei kriegerischen Konflikten gemahnen, doch auch aus Gras, das während der Ausstellungszeit wuchs. So nimmt *Hanging Garden* Bezug auf die seit den 1960er-Jahren geführte Diskussion um Fragen der Beständigkeit und Veränderlichkeit eines Kunstwerks oder einer künstlerischen Aktion. Eine Skulptur wie *Cube* (2008) steht ebenfalls in diesem Spannungsfeld der Auseinandersetzung mit kunsthistorischen Bezügen: Die geometrische Gitterstruktur erinnert an Werke der Minimal Art, doch bei näherem Hinsehen zeigt sich, dass die Stäbe mit den Widerhaken von Stacheldraht versehen sind.

Une râpe de cuisine surdimensionnée en guise de lit (*Daybed*, 2008) dont la surface déchiquetée vous donne la chair de poule, une râpe dépliable en guise de cloison métallique aux fâcheuses ouvertures dentelées (*Paravent*, 2008) – Mona Hatoum soumet des objets quotidiens à une transformation qui leur confère un caractère inquiétant ou menaçant. Il en va de même pour la série des « cut-outs », petits découpages qui rappellent des travaux d'enfants. Dans *Untitled (Cut-Out 7)* (2008), le découpage ornemental s'avère être un motif de soldats se visant les uns les autres. La guerre, les conditions des zones de crise et l'exil sont des thèmes récurrents dans l'œuvre de Hatoum – ce qui n'est pas sans lien avec sa propre biographie. Il est vrai qu'Hatoum n'aborde pas ces thèmes de manière concrète et directe, ils apparaissent toujours sous la forme d'une menace sous-jacente. Ainsi, dans *Nature morte aux grenades* (2006/07), la menace naît de la tension entre l'esthétique matérielle attrayante des objets en verre teinté et le danger implicite qu'ils recèlent : il s'agit de grenades en verre soufflé présentant les formes de modèles naturels comme des citrons ou des grenades. L'installation *Hanging Garden* (2008) est constituée d'herbe qui poussait durant l'exposition et de sacs de sable qui évoquent un retranchement militaire. *Hanging Garden* se réfère ainsi au débat qui, depuis les années 1960, tourne autour de la pérennité et de la fugacité de l'œuvre d'art ou de l'action artistique. Une sculpture comme *Cube* (2008) s'inscrit également dans le champ de tension de la confrontation avec des questions d'histoire de l'art : sa structure géométrique tramée rappelle les œuvres du Minimal Art, mais en y regardant de plus près, on s'aperçoit que les tiges sont garnies de pointes de fil de fer barbelé. A. M.

SELECTED EXHIBITIONS →
2008 *Mona Hatoum: Present Tense*, Parasol Unit, London. *Mona Hatoum: Undercurrents*, XIII Biennale Donna, Palazzo Massari, Ferrara. *Genesis – Die Kunst der Schöpfung*, Zentrum Paul Klee, Bern **2007** *Neue Heimat*, Berlinische Galerie, Berlin. *Capricci: Possibilités d'autres mondes*, Casino Luxemburg – Forum d'art contemporain, Luxembourg **2005** *Mona Hatoum: Over My Dead Body*, Museum of Contemporary Art, Sydney **2004** *Mona Hatoum*, Hamburger Kunsthalle, Hamburg; Magasin 3 Stockholm Konsthall, Stockholm

SELECTED PUBLICATIONS →
2008 *Mona Hatoum: Undercurrents*, XIII Biennale Donna, Palazzo Massari, Ferrara. *Mona Hatoum: Unhomely*, Galerie Max Hetzler, Holzwarth Publications, Berlin **2006** *Mona Hatoum*, White Cube, London. *Carbonic Anhydride*, Galerie Max Hetzler, Berlin **2005** *Mona Hatoum*, The Reed Institute, Portland **2004** *Mona Hatoum*, Hamburger Kunsthalle, Hamburg, Hatje Cantz, Ostfildern

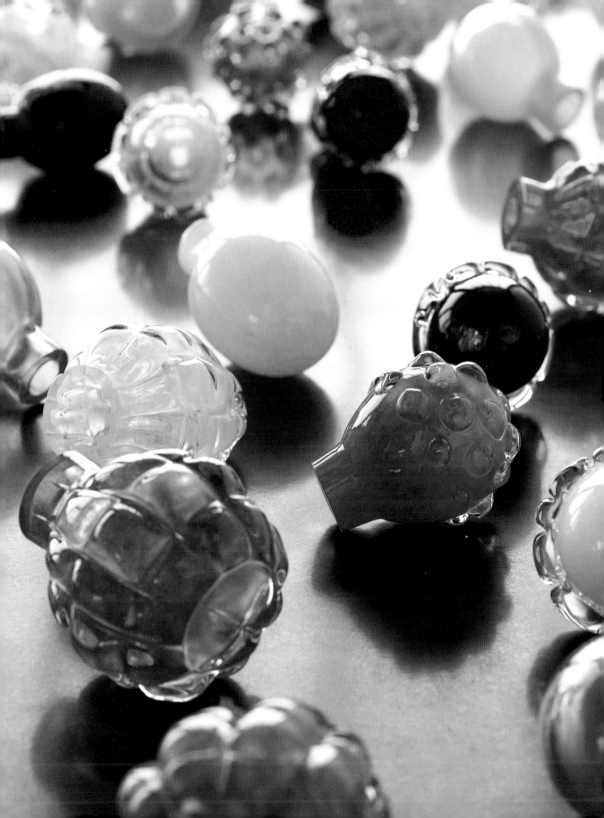

1 **Nature morte aux grenades**, 2006/07 (detail), crystal, mild steel, rubber, 95 x 208 x 70 cm
2 **Round and Round**, 2007, bronze, 61 x 33 x 33 cm

3 **Daybed**, 2008, black finished steel, 32 x 219 x 98 cm
4 **Home**, 1999, wood, stainless steel, electric cable, light bulbs, dimmer device, amplifier, 2 speakers, dimensions variable, table 77 x 198 x 74 cm

„Ich halte meine Arbeiten gern offen, so dass sie auf verschiedenen Ebenen interpretiert werden können. Mit Kunst kann man nicht konkrete Fragen erörtern, Kunst ist kein Jourrnalismus."

« J'aime que mon travail conserve une indétermination qui permette de l'interpréter à différents niveaux. L'art ne peut être comparé au journalisme ; il ne peut débattre de sujets concrets. »

"I like keeping my work so open that it can be interpreted on different levels. Art can't be compared with journalism; it can't discuss concrete issues."

2

Eberhard Havekost

1967, born in Dresden, lives and works in Dresden and Berlin, Germany

Using the devices of photographic representation, Eberhard Havekost investigates the processes by which images are constructed and interrelated. Taking as his starting point photographs shot or found, he employs digital technologies to enhance or alter the source image and inkjet printing as steps on the road to the final canvas. Havekost tinkers with his images, but the original always lurks in his mind's eye. He once said: "Because I always see the precise photographic basis while I paint, I sense how the image forever oscillates between two levels of meaning." In his recent series grouped under the title *Zensur* (Censorship), he has started redacting whole regions of his pictures with unrelenting grey or black rectangles (*Keller 1*, *B07*, 2007), as if working against these inevitable pictorial recollections. Yet, Havekost is not just concerned with how information is or is not conveyed; the placement of these censoring patches enables him to explore how painterly space functions in general. Works incorporating architectural elements, like *L.A. Grau* (2005) or *Superstar* (2005) demonstrate how Havekost's circuitous approach leads to a curiously straightforward-looking result. Too muted in tone and gesture to be considered in the historical vein of socialist realism or photo-realist painting, yet undeniably based on photographs, his swaths of drab colour hug the picture plane with hyper-awareness, yet the effect is never fully abstract. Disturbing portraits of masked figures (*Geist* and *Universal Soldier*, 2006) seem almost uncannily displaced from these vacant interiors, land and cityscapes (*Dunkle Modellwelt*, 2007), lending them a menacing quality after the fact.

Indem er das Medium Fotografie einbezieht, untersucht Eberhard Havekost in seinen Gemälden die Prozesse, die der Konstruktion von Bildern und deren wechselseitigen Beziehungen zugrunde liegen. Ausgehend von eigenen Aufnahmen oder auch gefundenen Fotografien korrigiert und verändert er diese am Computer und bedient sich außerdem des Inkjet-Prints, beides Schritte auf dem Weg bis zum vollendeten Gemälde. Havekost arbeitet die Bilder um, aber er behält das Original im Blick: „Da ich die fotografische Vorlage beim Malen immer genau vor mir sehe, nehme ich das Bild als Übergang zwischen zwei Bedeutungsebenen wahr." In seiner neueren Serie *Zensur* hat er ganze Bereiche seiner Bilder mit unerbittlichen grauen oder schwarzen Rechtecken überarbeitet (*Keller 1*, *B07*, 2007), als wollte er zwanghaften bildlichen Erinnerungen etwas entgegensetzen. Havekost will hier nicht nur wissen, wie Information übertragen wird oder eben nicht. Durch die Platzierung dieser zensierenden Balken erhält er vielmehr Einblick in den malerischen Bildraum überhaupt. Arbeiten mit architektonischen Elementen, wie *L.A. Grau* (2005) oder *Superstar* (2005), demonstrieren, wie Havekosts Umweg über ein anderes Medium zu erstaunlich unkompliziert wirkenden Ergebnissen findet. Zu verhalten in Ton und Gestus, um im historischen Kontext der Malerei des sozialistischen Realismus oder des Fotorealismus gesehen zu werden, und doch auf Fotografien basierend, liegt der Farbauftrag sehr gezielt dicht auf der Bildoberfläche, aber der Effekt ist nie völlig abstrakt. Beunruhigende Porträts von Vermummten (*Geist* und *Universal Soldier*, 2006) wirken fast unheimlich entrückt in diesen leeren Innenräumen, Landschaften und Stadtbildern (*Dunkle Modellwelt*, 2007), denen sie eine bedrohliche Atmosphäre verleihen.

Eberhard Havekost utilise les stratégies de la représentation photographique afin d'explorer en peinture la manière dont les images se construisent et se font écho. À partir de photographies trouvées ou qu'il réalise lui-même, il utilise la technologie numérique pour renforcer ou modifier l'image source et l'impression au jet d'encre comme autant d'étapes vers la toile finale. Havekost altère certes ses images, mais sans jamais perdre de vue l'original : « Comme j'ai toujours une base photographique précise sous les yeux quand je peins, je vois l'image osciller sans cesse entre deux niveaux de sens. » Dans une série récente baptisée *Zensur*, des rectangles gris ou noirs occultent impitoyablement des parties entières de ses toiles (*Keller 1*, *B07*, 2007), comme si son travail s'effectuait contre ces inévitables souvenirs picturaux. Mais la manière dont l'information se transmet (ou non) n'est pas ici sa seule préoccupation ; la répartition de ces aplats venant « censurer » le motif sur la toile lui permet de révéler le fonctionnement général de la surface peinte. Des œuvres comportant des éléments d'architecture, comme *L.A. Grau* (2005) ou *Superstar* (2005), montrent bien comment Havekost parvient par ce détour à un résultat étonnamment direct. D'une tonalité et d'une expressivité trop retenues pour s'inscrire dans la veine du réalisme social ou de la peinture hyperréaliste, mais indéniablement inspirées par la photographie, ses toiles sont comme enserrées par des bandes grisâtres qui font de la censure une forme de lucidité suraiguë, sans que le résultat soit jamais purement abstrait. Des portraits inquiétants de personnages masqués (*Geist* et *Universal Soldier*, 2006) ne semblent pas trouver leur place dans ces intérieurs vides, ces paysages naturels ou urbains désertés (*Dunkle Modellwelt*, 2007) et ils finissent par en devenir menaçants.

V. R.

SELECTED EXHIBITIONS →
2008 *Living Landscapes: A Journey through German Art*, NAMOC – National Art Museum of China, Beijing; *Comme des bêtes: ours, chat, cochon & Cie*, Musée cantonal des Beaux Arts, Lausanne **2007** *Eberhard Havekost – Paintings from the Rubell Family Collection*, Tampa Museum of Art, Tampa; *Imagination Becomes Reality*, ZKM, Karlsruhe **2006** *Havekost, Kahrs, Plessen, Sasnal*, Museu Serralves, Porto **2005** *Eberhard Havekost: Harmonie*, Kunstmuseum Wolfsburg; Stedelijk Museum, Amsterdam

SELECTED PUBLICATIONS →
2007 *Eberhard Havekost: Benutzeroberfläche / User Interface*, Schirmer/Mosel, Munich; *Havekost: Background*, White Cube; Walther Koenig Books Ltd., London; **2006** *Eberhard Havekost 1996–2006*, Rubell Family Collection, Miami; *Imagination Becomes Reality: Part II*, Sammlung Goetz, Munich; *Landschafts-Paraphrasen: Dring, Drühl, Havekost, Jensen*, Museum Baden, Solingen; Salon Verlag, Cologne **2005** *Eberhard Havekost: Harmonie*, Kunstmuseum Wolfsburg; Hatje Cantz, Ostfildern

1 **Idee 1, B08**, 2008, oil on canvas, 170 x 110 cm
2 **Unendlichkeit 1/2, B08**, 2008, oil on canvas, 120 x 80 cm
3 **Unendlichkeit 2/2, B08**, 2008, oil on canvas, 120 x 80 cm

4 **Überzüchtung, B07**, 2007, oil on canvas, 140 x 78 cm
5 **Erscheinung, B07**, 2007, oil on canvas, 170 x 250 cm

„So etwas wie Ganzheit existiert weder in der Realität noch in der Fotografie. Die Fotografie ist ein Medium, das die Realität reduziert, und sie ist ein ‚Gastmedium' für das Bild, wie die Malerei. So gesehen gibt es für mich keinen Unterschied zwischen Fotografie und Malerei."

« L' "intégrité" n'existe ni dans la réalité, ni dans la photographie. La photographie est un support qui restreint le réel, c'est un "support hôte" de l'image, au même titre que la peinture. En ce sens, je ne vois aucune différence entre photographie et peinture. »

"There is no such thing as 'entirety' either in reality or in photography. Photography is a medium that restricts reality and it is a 'guest medium' for the image, as is painting. In this respect, I see no difference between photography and painting."

2

3

4

Arturo Herrera

1959 born in Caracas, Venezuela, lives and works in Berlin, Germany

Arturo Herrera is interested in advancing to transitional areas: were his multi-faceted oeuvre to be reduced to a simple formula, it might be that it always contains both sides of an idea. His current works, made from dark grey felt, take the guise of non-representational forms that evoke something organic or vegetable. But while Herrera's felt works are quite literally material, they speak to both the visual and the tactile, and thus stand on the threshold of the sculptural. His paintings and collages also oscillate between representation and abstraction. The extensive series of collages entitled *Boy and Dwarf* (2006) is based on two characters from a painting book – a boy who plays the accordion and a dwarf – and on twenty abstract drawings by the artist. Herrera had "back views" made of the figures, modifying the resulting four prototypes every fifth time, before overlaying them with the twenty drawings. These basic images were then projected onto surfaces that had already been worked on – painted or collaged – and their silhouettes were cut out, sometimes with elements left blank, doubled or upturned. Seventy-five works were created in this way. Their titles indicate their place in the series as well as the figures they are based on – B for boy, D for dwarf, B for back and F for front. The process of transformation leaves the source images barely discernible in the interplay of fine colourful lines, grainy painterly fields and patterned materials. In this way, Herrera plays two traditional poles of art off against each other – he loads abstraction with a concrete legibility, which he simultaneously works hard to dismantle.

Wenn man das vielfältige Œuvre von Arturo Herrera auf eine Formel reduzieren wollte, dann vielleicht darauf, dass es bei ihm um das Vordringen in Zwischenbereiche geht, um Werke, die ein „sowohl – als auch" in sich tragen. Seine aktuellen Arbeiten aus tiefgrauem Filz haben die Gestalt ungegenständlicher Formen, die Organisches oder Pflanzliches evozieren. Doch sind Herreras Filzarbeiten im wahrsten Sinne des Wortes stofflich, sprechen nicht allein den Seh-, sondern auch den Tastsinn an und stehen damit auf der Schwelle zum Skulpturalen. Seine Gemälde und Collagen wiederum oszillieren zwischen Gegenständlichkeit und Abstraktion. Die umfangreiche Collagenserie *Boy and Dwarf* aus dem Jahre 2006 fußt auf zwei Figuren aus einem Malbuch – einem Akkordeon spielenden Jungen und einem Zwerg, und auf 20 abstrakten Zeichnungen des Künstlers. Herrera ließ Rückenansichten von beiden Figuren anfertigen und variierte die vier Muster je fünf Mal, dann überlagerte er sie mit den 20 Zeichnungen. Diese Grundbilder wurden auf ihrerseits schon bearbeitete – bemalte oder collagierte – Flächen projiziert und ausgeschnitten, manchmal mit ausgesparten, verdoppelten oder umgedrehten Elementen. Aus diesem Prozess entstanden 75 Arbeiten, deren Titel ihren Platz in der Serie sowie die Figurenansichten bezeichnen – B für boy, D für dwarf, B für back und F für front. Durch den Transformationsprozess ist das bildhafte Ausgangsmaterial meist kaum noch auszumachen im Zusammenspiel feiner farbiger Linien, gemaserter malerischer Felder und gemusterten Materials. So spielt Herrera hier zwei traditionelle Pole der Kunst gegeneinander aus – er lädt die Abstraktion mit einer konkreten Lesbarkeit auf, die er jedoch zugleich mit allen Mitteln wieder auflöst.

Si l'on voulait réduire le travail très diversifié d'Arturo Herrera à une formule, on pourrait dire que son propos est d'entrer dans les domaines interstitiels avec des œuvres qui portent en elles un aspect « ceci-et-son-contraire ». Ses œuvres actuelles réalisées en feutre gris foncé se présentent comme des formes non-figuratives qui évoquent l'organique ou le végétal. Mais les œuvres en feutre d'Herrera sont tangibles au sens littéral : elles ne s'adressent pas seulement au sens visuel mais aussi au toucher et se situent donc au seuil du sculptural. Ses peintures et ses collages oscillent quant à eux entre figuration et abstraction. La série de collages *Boy and Dwarf*, réalisée en 2006, repose sur deux figures d'un album de coloriages – un jeune accordéoniste et un nain – et vingt dessins abstraits de l'artiste. Herrera a fait réaliser des vues postérieures des deux figures et a varié cinq fois chacun des quatre motifs avant d'y superposer les vingt dessins. Ces images de base ont été projetées à leur tour sur des surfaces déjà traitées – peintes ou recouvertes de collages –, puis découpées, parfois avec des parties épargnées, redoublées ou renversées. Soixante-quinze œuvres ont vu le jour selon ce procédé, dont les titres désignent la place dans la série et les figures représentées – B pour boy, D pour dwarf, B pour back, F pour front. Après avoir subi cette transformation, le matériau visuel de départ est généralement devenu méconnaissable du fait de l'interaction entre fines lignes colorées, parties picturales veinées et matériaux à motifs. Herrera joue ainsi sur deux polarités traditionnelles – il charge l'abstraction d'une lisibilité concrète tout en dissolvant cette lisibilité par tous les moyens.

A. M.

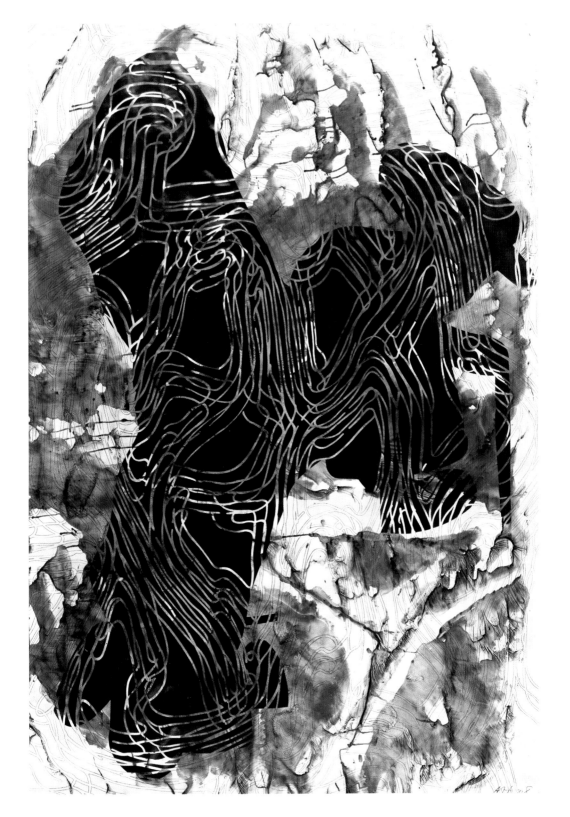

1 **Waiting for Siegfried #2**, 2008, graphite, acrylic on paper, 224.5 x 150 cm
2 **Catch**, 2008, felt, 161 x 153 cm

3 **# 57 BF2**, 2006, cut-out collage, mixed media on paper, 250 x 123 cm
4 **# 69 DB1**, 2006, cut-out collage, mixed media on paper, 250 x 123 cm

„All unsere visuellen Interaktionen werden durch Fragmentierung und Sehnsucht, durch Erinnerungen und Vorstellungen gefiltert."

« Toutes nos interactions visuelles sont relayées par la fragmentation et le désir, la mémoire et l'association. »

"All of our visual interactions are mediated by fragmentation and desire, memory and association."

2

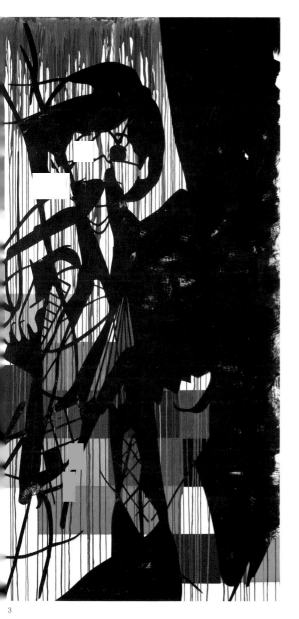

Charline von Heyl

1960 born in Mainz, Germany, lives and works in New York (NY), USA

Painting, reworking, seizing the right point, emphasizing the imponderable: Charline von Heyl forges paintings through process, thereby overcoming the greatest challenge, that of repetition. Her exhibitions are often emphatically uneven, and this itself is a direct consequence of her artistic approach. Von Heyl works through the broad spectrum of gestural-abstract formal languages in order to open up each painting to surprising new possibilities. Her works combine different idioms, attitudes and speeds, bringing diverse representational forms together within the same space. Von Heyl smuggles representational subtexts into her inclination toward opulence and extensive allover painting. *Yellow Rose* (2007), for example, can be seen as an abstract painting, but strangely alarming, zig-zagging lines and skull-like faces seem to threaten the blossom. And one look at the title makes *Woman* (2005) a violated shape, all patched and stitched up. While the former stylistically might recall Basquiat, the other de Kooning, von Heyl never stops at mere allusion, but instead takes stylistic formulae in unexpected directions. The crucial thing is what remains undecidable. *Tathata* (2007), for example, visually embodies the openness of its title (a Buddhist term for the "true state of things"), *Foul* (2005) sumptuously celebrates the unfinished state. The New York critic Jerry Saltz once described von Heyl's work somewhat smugly: "Much of her art takes me to a wonderful snake pit where styles I thought were outmoded turn dangerous again." But more and more it looks like the true danger of these paintings lies in their content.

Malen, umarbeiten, den richtigen Punkt erwischen, Unwägbarkeit zuspitzen. Charline von Heyl erfindet das Bild nah am Prozess und dabei gelingt wiederholt das Schwerste: sich nicht zu reproduzieren. Ihre Ausstellungen sind oft entschieden unausgewogen und gerade darin zeigt sich die Konsequenz der künstlerischen Haltung. Von Heyl arbeitet sich durchs weite Spektrum gestisch-abstrakter Formensprachen, um das jeweils nächste Bild für überraschend neue Möglichkeiten zu öffnen. Ihre Malerei verknüpft ganz unterschiedliche Idiome, Attitüden und Geschwindigkeiten, bringt verschiedene Repräsentationsformen nebeneinander zu stehen. In die Tendenz zu Üppigkeit und flächigem Allover schleust von Heyl auch gegenständliche Subtexte ein: *Yellow Rose* (2007) etwa kann man als abstraktes Gemälde betrachten, aber seltsam unheimliche Zickzack-Linien und schädelartige Gesichtsformen scheinen die Blüte zu bedrohen. Und wenn man den Titel gelesen hat, wird aus *Woman* (2005) eine verletzte Form, die verbunden und zusammengenäht wurde. Lässt der Stil des einen Bildes vielleicht an Basquiat und des anderen an de Kooning denken, bleibt von Heyl jedoch nie bei Anspielungen stehen, sondern wendet Stilformeln ins Unerwartete: Entscheidend ist, was unentscheidbar bleibt. *Tathata* (2007) etwa verkörpert bildhaft und im Titel (ein buddhistischer Terminus für die Form fundamentaler Wirklichkeit) solche Offenheit, *Foul* (2005) zelebriert auf großartige Weise das Unfertige. Der New Yorker Kritiker Jerry Saltz bezeichnete von Heyls Werk einmal ein wenig süffisant als „herrliche Schlangengrube, in der Stile, die man längst für ausrangiert gehalten hatte, plötzlich wieder Biss bekommen." Aber immer deutlicher wird, dass der wahre Biss dieser Gemälde in ihrem Gegenstand liegt.

Peindre, transformer, capter le juste équilibre, exacerber l'impondérable. Charline von Heyl invente le tableau au plus près du processus et réussit de manière récurrente le plus difficile : éviter la redite. Ses expositions sont souvent résolument mal équilibrées et c'est précisément ce qui fait la cohérence de sa démarche artistique. Elle se fraye un chemin à travers le vaste éventail du vocabulaire gestuel-abstrait pour ouvrir chaque tableau à des possibilités étonnamment nouvelles. Sa peinture relie des idiomes, des attitudes et des vitesses totalement différents et fait coexister des modes de représentation divergents. Dans sa tendance à l'exubérance et à l'all-over, elle intègre également des sous-textes figuratifs : *Yellow Rose* (2007) peut être lu de manière abstraite ou figurative, mais les étranges zigzags et figures en forme de crâne semblent menacer la floraison. Après lecture du titre, le tableau *Woman* (2007) devient une forme blessée. Si le style du premier tableau peut rappeler Basquiat et le second de Kooning, von Heyl ne se cantonne jamais à l'allusion, mais retourne inopinément les formules stylistiques : l'aspect décisif est ce qui reste indécis. *Tathata* (2007) incarne ce genre d'ouverture de manière imagée et par son titre (un terme bouddhiste désignant un état suprême de vérité). *Foul* (2005) est une célébration grandiose de l'inachevé. Non sans suffisance, le critique new-yorkais Jerry Saltz a décrit l'œuvre de von Heyl comme « une magnifique fosse aux serpents dans laquelle les styles qu'on croyait depuis longtemps dépassés retrouvent tout à coup du mordant. » Il devient cependant de plus en plus évident que le danger de ces peintures provient de leur contenu.

J. A.

SELECTED EXHIBITIONS →
2008 *Charline von Heyl*, Westlondonprojects, London. *Oranges and Sardines: Conversations on Abstract Painting with Mark Grotjahn, Wade Guyton, Mary Heilmann, Amy Sillman, Charline von Heyl, and Christopher Wool*, Hammer Museum, Los Angeles **2006** *Make Your Own Life: Artists in and out of Cologne*, ICA, Philadelphia; The Power Plant, Toronto; Henry Art Gallery, Seattle; MOCA, North Miami **2005** *Concentrations 48: Charline von Heyl*, Dallas Museum of Art, Dallas **2004** *Charline von Heyl*, Secession, Vienna

SELECTED PUBLICATIONS →
2008 Jörg Heiser, *All of a Sudden: Things that Matter in Contemporary Art*, Sternberg Press, Berlin. Kim Seung-duk, Franck Gautherot, *The Alliance*, doArt Co., Seoul **2006** *Make Your Own Life: Artists in and out of Cologne*, ICA, Philadelphia **2005** Richer, Francesca and Matthew Rosenzweig, *No. 1: First Works by 362 Artists*, DAP, New York. *CAP Collection*, CAP Art Limited, Dublin **2004** *Charline von Heyl*, Secession, Vienna

1 **Yellow Rose**, 2007, oil on canvas, 208 x 198 cm
2 **Tathata**, 2007, oil on canvas, 208 x 198 cm

3 **Foul**, 2005, acrylic, oil on canvas, 228.6 x 215.9 cm
4 **Woman**, 2005, charcoal, acrylic, oil on canvas, 208.3 x 198.1 cm

„Jedes Gemälde schafft auf seine ganz individuelle Weise einen völlig abstrakten Raum der Stille im Kopf, eine Ruhe, die Bewegung einschließt, die Gegenwart einer Abwesenheit und etwas, an dem die Augen zu nagen haben."

« Chacune des peintures crée de manière totalement différente un espace radicalement abstrait de silence dans la tête, avec une quiétude pleine de mouvement, avec la présence d'une absence, avec de quoi ronger pour les yeux. »

"Each one of the paintings in a completely different way creates a radically abstract space of silence in the head, with a stillness that contains movement, with the presence of an absence, with something for the eyes to chew on."

2

3

Damien Hirst

1965 born in Bristol, lives and works in Devon, United Kingdom

Death – a fact of life that is systematically repressed despite its crushing relevance to us all – is one of the great themes of art, and one that Damien Hirst returns to repeatedly. It underlies not only his sculptures of animals in vitrines, such as *Saint Sebastian* (2007), but also his spectacular diamond-covered skull *For the Love of God* (2007) and his recent series of *Biopsy Paintings* (2007), which depict different types of cancer. These find their counterpart in a series featuring the birth of the artist's son by Caesarean section: *Birth Paintings* (2007). Exploring the span of life and death – the intersections of religion, science and art – often through Christian iconography, constitutes one side of Hirst's work. However, he devotes just as much passion and energy to playing the art market. Besides being an artist and producer, he is also curator and collector of art. In this last role he also exhibited works from his collection under the ironic title *In the darkest hour there may be light* (2007). The circularity of art embodied within a single person is also found in Hirst's diamond skull. With what initially appears to be consummate deca-dence, he covered the platinum cast of a real human skull with 8601 flawless diamonds. It was bought for around 100 million dollars by a group of investors, among them – to the subsequent amazement of the public – Hirst himself. His public image thus remains divided: for some people he is the guy who deals in dead animals; others think he explores existential issues in extraordinary ways; others again consider him a manipula-tor of the art market, or even its emblem. Perhaps there are more facets to those diamonds than we first thought?

Der Tod, meist verdrängt und dennoch von zwingender Relevanz für jeden, ist eines jener großen Themen der Kunst, denen sich auch Damien Hirst immer wieder zuwendet. Dies gilt für seine Tier-Skulpturen in Vitrinen, wie *Saint Sebastian* (2007), seinen spektakulären Diaman-tenschädel *For the Love of God* (2007), aber auch seine neuere Gemäldeserie der *Biopsy Paintings* (2007). Diese zeigt verschiedene Formen von Krebserkrankungen. Ihr gegenüber steht die Serie der *Birth Paintings* (2007), auf der die Geburt des Sohns des Künstlers durch Kaiser-schnitt das Thema ist. Die Spanne von Leben und Tod an den Schnittpunkten von Religion, Wissenschaft und Kunst auszuloten, oft unter Nutzung christlicher Ikonografie, prägt eine Seite der Arbeiten von Hirst. Mit genauso großer Leidenschaft wie diesen Themen widmet er sich auch dem Spiel mit dem Kunstmarkt. Denn Hirst ist nicht nur Künstler und Produzent, sondern auch Kurator und Kunstsammler. Als solcher stellte er seine selbst gesammelte Kunst unter dem ironischen Titel *In the darkest hour there may be light* (2007) aus. Die Zirkularität von Kunst in einer Person betrifft dann auch Hirsts Diamantenschädel. Was zunächst wie perfekte Dekadenz wirkt – den Platinabguss eines echten Toten-schädels mit 8601 lupenreinen Diamanten zu bedecken –, wurde für ca. 100 Millionen Dollar an eine Investorengruppe verkauft. Der wiederum gehört, zur nachträglichen Verblüffung der Öffentlichkeit, Hirst selbst an. Und so bleibt Hirsts Wahrnehmung in der Öffentlichkeit gespalten: für die einen ein Händler mit toten Tieren, für die anderen jemand, der auf außergewöhnliche Weise existenziellen Fragen nachgeht, und für manche ein Voltendreher des Kunstmarktes, wenn nicht gar dessen Emblem. Vielleicht stecken in den Reflexionen der Diamanten doch mehr Reflexionen als gedacht?

La mort, le plus souvent refoulée, mais néanmoins une réalité cruciale pour chacun, est un des grands thèmes de l'art auquel Damien Hirst revient lui aussi de manière récurrente. Ceci vaut pour ses sculptures animales exposées dans des aquariums (*Saint Sebastian*, 2007), son spectaculaire crâne couvert de diamants *For the Love of God* (2007), mais aussi pour sa nouvelle série de peintures, les *Biopsy Paintings* (2007), qui montre différentes formes de cancers. À cette série s'oppose celle des *Birth Paintings* (2007) illustrant la naissance de son fils par césa-rienne. Sonder la frange de temps entre la naissance et la mort à la croisée de la religion, des sciences et de l'art, souvent en faisant appel à l'iconographie chrétienne, est une facette de l'œuvre de Hirst. Mais l'artiste se consacre tout aussi passionnément au jeu avec le marché de l'art. Car Hirst n'est pas seulement artiste et producteur, mais aussi commissaire d'exposition et collectionneur. Le commissaire exposa l'art qu'il a lui-même collectionné et le présenta sous le titre ironique *In the darkest hour there may be light* (2007). La boucle artistique à l'intérieur d'une seule et même personne engage dès lors aussi le crâne diamanté de Hirst. Ce qui fait d'abord l'effet d'une parfaite décadence – couvrir de 8601 diamants parfaitement purs le moulage en platine d'un crâne du XVIIIe siècle – a été vendu pour quelque 100 millions de dollars à un groupe d'investisseurs dont Hirst – à la surprise ultérieure du public – fait lui-même partie. La réception publique de l'artiste reste de ce fait partagée : marchand d'animaux morts pour les uns, artiste qui se pose des questions existentielles d'une manière inhabituelle pour les autres, ou encore voltigeur du marché de l'art, voire son emblème. Malgré tout, les réflexions des diamants révèlent peut-être plus de facettes qu'on ne le pense ?

H. L.

SELECTED EXHIBITIONS →
2008 *Damien Hirst: Beautiful Inside My Head Forever*, Sotheby's Auction, London. *Focus: Damien Hirst*, Kemper Museum of Contemporary Art, Kansas City **2007** *Damien Hirst*, Lever House, New York. *Damien Hirst: Beyond Belief*, White Cube, London. *Damien Hirst/David Bailey: The Stations of the Cross*, Sammlung Essl, Klosterneuburg **2006** *Damien Hirst: New Religion*, Rogaland Museum of Fine Arts, Stavanger **2005** *Damien Hirst*, Astrup Fearnly Museet for Moderne Kunst, Oslo

SELECTED PUBLICATIONS →
2008 *Damien Hirst: Beyond Belief*, White Cube, Other Criteria, London **2007** *Damien Hirst: For the Love of God. The Making of the Diamond Skull*, White Cube, London. *Damien Hirst: Superstition*, Gagosian Gallery, Los Angeles, Other Criteria, London **2006** *Damien Hirst: Corpus, Drawings 1981–2006*, Gagosian Gallery, Other Criteria, London. *Hirst, Damien: The Death of God: Towards a Better Understanding of a Life Without God Aboard the Ship of Fools*, Galeria Hilario Galguera, Mexico City; Other Criteria, London

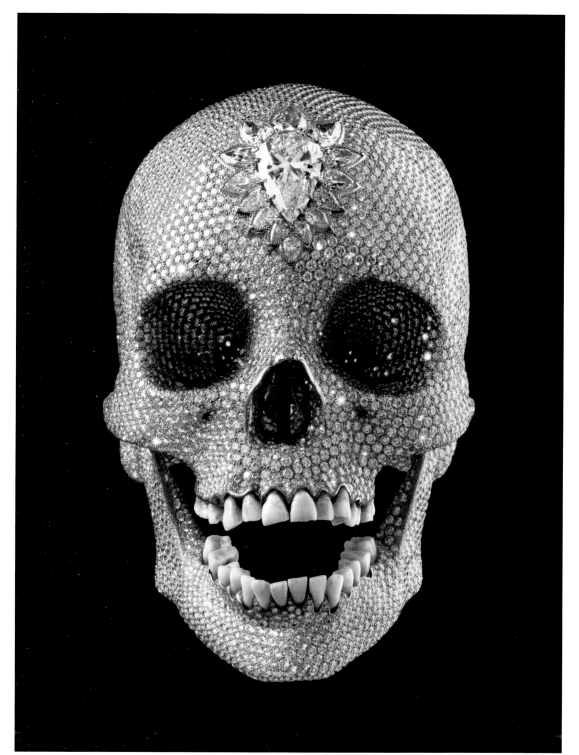

1 **For the Love of God**, 2007, platinum, diamonds, human teeth, 17 x 13 x 19 cm
2 **Baby Born by Caesarean Section (Cyrus)**, 2007, oil on canvas, 81.3 x 61 cm

3 **Saint Sebastian, Exquisite Pain**, 2007 (detail), glass, steel, bullock, arrows, crossbow bolts, formaldehyde solution, 322 x 156 x 156 cm

„Über die Kunst kommt man der Unsterblichkeit so nahe wie nur möglich, aber sie ist ein dürftiger Ersatz – du arbeitest für Menschen, die noch nicht geboren sind – und die Leute wollen die Sachen, weil sie genial sind. Am Ende landet sowieso alles in Museen; die Reichen müssen es dem Volk zurückgeben. Sie haben keine Wahl, ein Leichentuch hat keine Taschen."

« L'art est la meilleure façon d'approcher l'immortalité, bien que ce soit un piètre substitut – on travaille pour des gens qui ne sont pas encore nés – et les gens veulent de l'art parce qu'il est génial. De toutes façons il finit dans les musées, les riches doivent le rendre au peuple. Ils n'ont pas le choix, un linceul n'a pas de poches. »

"Art is the closest you can get to immortality, though it's a poor substitute – you're working for people not yet born – and people want it because it is brilliant. It ends up in museums anyway; the rich have to give it back to the people, it's their only option. There are no pockets in a shroud."

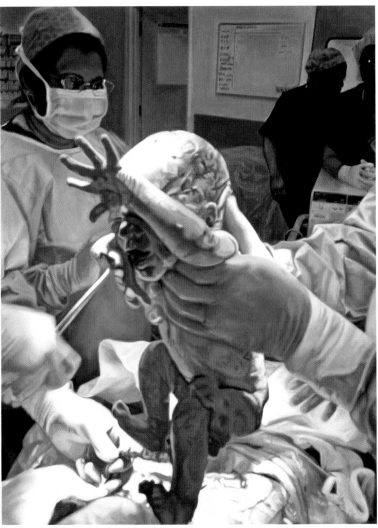

2

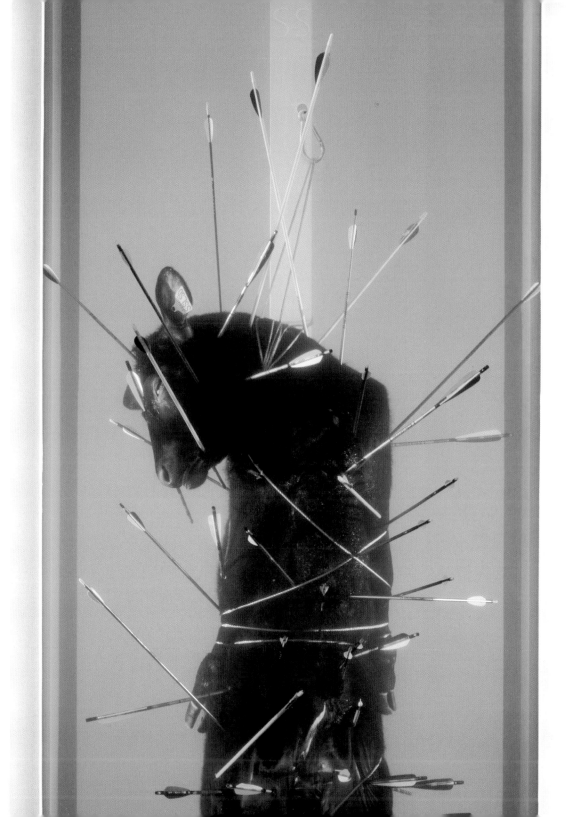

Thomas Houseago

1972 born in Leeds, United Kingdom, lives and works in Los Angeles (CA), USA

Archaic and contemporary, monumental yet fragile, commanding respect but also broken – Thomas Houseago's sculptures of human figures, heads and individual body parts unite qualities that at first seem completely incompatible. His larger than life *Striding Giant* (2008), for example, looms over the viewer with balled fist and sunken head tipped forward. The figure looks as if it could be part of a theatre backdrop – if you walk around it, its two-dimensionality is revealed, along with the way in which it was built. The giant figure is made of disparate elements that are all forms of construction material. The wooden head is shaped like an oval and bears an abstract relief that recalls cubist experiments with form. The body consists of a cut-out piece of plasterboard, on the front of which anatomic details have been roughly sketched. One arm is attached in an oddly awkward position and the feet are weighted with plaster, as if the artist wanted to slow the giant's steps in nightmarish fashion. But the nightmare, the uncanny, is only one facet of these predominantly white sculptures; there is also something comical about these bodies with their strange limbs and bent shapes. Houseago's sculptures are characterized by their engagement with art history. The art-historical influences in his oeuvre are numerous, but both thematically and formally his works are already almost a fusion of the various strands of modernism, which segmented the conventional image, integrated everyday materials into art and borrowed from art forms as disparate as Greek classicism or non-Western cult images.

Archaisch und zeitgenössisch, monumental und doch fragil, respekteinflößend und gebrochen zugleich – Thomas Houseagos Skulpturen von vorwiegend menschlichen Figuren, Köpfen und einzelnen Körperteilen vereinen Eigenschaften in sich, die zunächst vollkommen unvereinbar scheinen. Sein überlebensgroßer *Striding Giant* (2008) etwa schreitet dem Betrachter schwerfällig entgegen, eine Faust geballt, der Kopf gesenkt, nach vorn gebeugt. Es ist eine Gestalt, die etwas Kulissenhaftes hat, denn geht man um sie herum, offenbart sich ihre Flächigkeit, stellt sie ihre Konstruktion zur Schau. Die Figur ist aus disparaten Elementen, sämtlich Baumaterialien, zusammengesetzt: Der hölzerne Kopf beruht auf einem Oval, auf das ein Relief aus abstrakten Formen gesetzt ist, das an kubistische Formenexperimente denken lässt. Der Körper besteht aus einer ausgeschnittenen Gipsplatte, auf deren Vorderseite mit wenigen Strichen anatomische Details angedeutet sind, ein Arm ist seltsam ungelenk angesetzt, die Füße sind mit Gips beschwert, als wollte der Künstler dem Riesen seine Schritte alptraumhaft verlangsamen. Doch ist der Alptraum, das Unheimliche nur eine Facette von Houseagos meist weißen Skulpturen, oft haftet den Körpern mit den seltsamen Gliedmaßen und der verbogenen Körperhaltung auch etwas Komisches an. Houseagos Skulpturen sind dabei geprägt von seiner Auseinandersetzung mit der Kunstgeschichte: Die kunsthistorischen Einflüsse auf sein Œuvre sind vielfältig, doch geraten seine Werke thematisch wie formal fast schon zu einer Fusion der verschiedenen Ausprägungen der Moderne, die das konventionelle Bild zergliederte, Alltagsmaterialien in die Kunst integrierte und bei so disparaten Kunstformen wie der griechischen Klassik oder außereuropäischen Kultbildern Anleihen machte.

Archaïques et contemporaines, monumentales et pourtant fragiles, inspirant le respect et en même temps brisées – les sculptures de Thomas Houseago, essentiellement des figures humaines, des têtes et des parties corporelles, réunissent en elles des propriétés qui semblent a priori s'exclure. Son *Striding Giant* (2008) plus grand que nature marche lourdement à la rencontre du spectateur, poing serré, tête baissée, penché en avant. Cette figure tient du décor de théâtre : quand on la contourne, elle révèle sa superficialité et expose sa conformation. Elle est composée de matériaux disparates appartenant au domaine du bâtiment : la tête de bois est un ovale sur lequel l'artiste a monté des formes abstraites rappelant les expériences cubistes, le corps est fait d'une plaque de plâtre découpée sur laquelle quelques traits indiquent des parties anatomiques, l'attache d'un bras est singulièrement maladroite, les pieds sont lestés de plâtre comme si l'artiste voulait ralentir les pas du géant à la manière d'un cauchemar. Mais le cauchemar et l'étrange ne sont qu'une facette des sculptures le plus souvent blanches de Houseago : avec leurs membres étranges et leurs attitudes tordues, les corps ont aussi quelque chose de comique. En même temps, les œuvres de Houseago sont marquées par un travail sur l'histoire de l'art : les influences de l'histoire de l'art sur son propre travail sont de diverses natures, mais du point de vue thématique autant que formel, ses œuvres se présentent presque comme une fusion des différents développements de la modernité, qui a démembré le tableau traditionnel, fait entré dans l'art des matériaux ordinaires et puisé à des sources aussi disparates que le classicisme grec et les figures cultuelles extra-européennes.

A. M.

SELECTED EXHIBITIONS →
2008 *Thomas Houseago*, Xavier Huffkens, Brussels. *Thomas Houseago*, David Kordansky Gallery, Los Angeles. *Thomas Houseago*, Herald St, London. *Academia: Qui es-tu?*, Chapelle de l'Ecole Nationale Supérieure des Beaux-Arts, Paris **2007** *Thomas Houseago: A Million Miles Away*, The Modern Institute, Glasgow. *Strange things permit themselves the luxury of occurring*, Camden Arts Center, London **2006** *Red Eye: Los Angeles Artists from the Rubell Family Collection*, Rubell Family Collection, Miami

SELECTED PUBLICATIONS →
2008 *Sonsbeek 2008: Grandeur*, Sonsbeek International Foundation, Arnhem **2007** *Red Eye: Los Angeles Artists from the Rubell Family Collection*, Rubell Family Collection, Miami **2005** *Both Ends Burning*, David Kordansky Gallery, Los Angeles

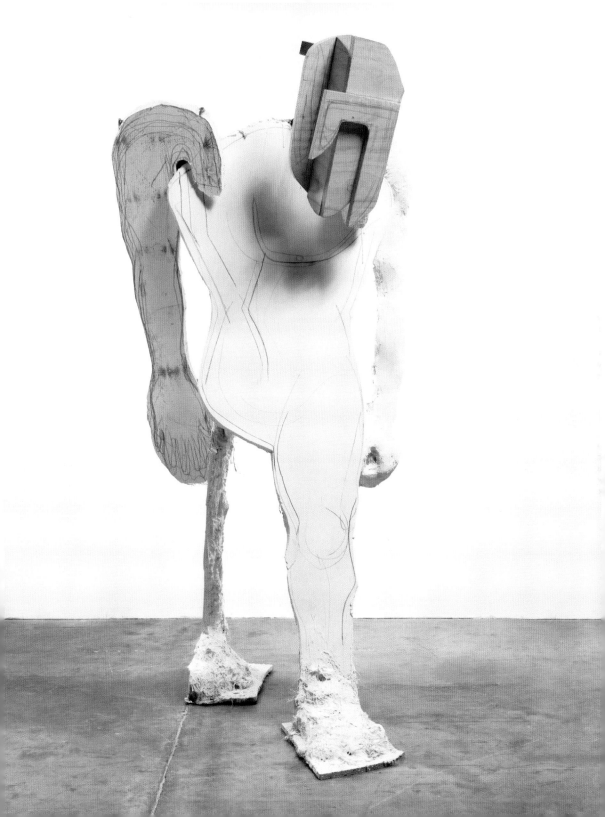

158

1 **Striding Giant**, 2008, Tuf-Cal, hemp, iron, graphite, 241 x 127 x 173 cm
2 **Snake**, 2007, Tuf-Cal, hemp, iron, graphite, 168 x 127 x 122 cm

3 **Untitled Striding Figure, 1**, 2007, bronze, 315 x 244 x 122 cm
4 **Untitled**, 2008, bronze, 249 x 175 x 200 cm

„Ich glaube, dass man Skulptur jedes Mal, wenn man damit beginnt, neu zum Leben erwecken muss."

« Je pense que chaque fois qu'on approche la sculpture, il faut entièrement la réinspirer. »

"I think that every time someone approaches sculpture, you have to completely re-breathe it."

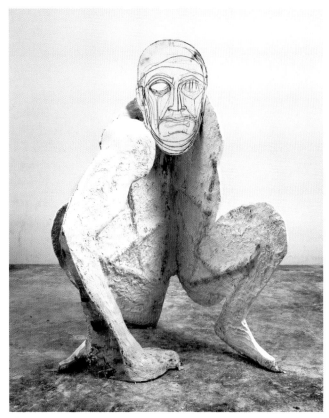

2

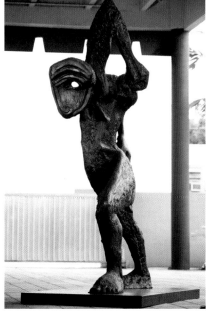

3

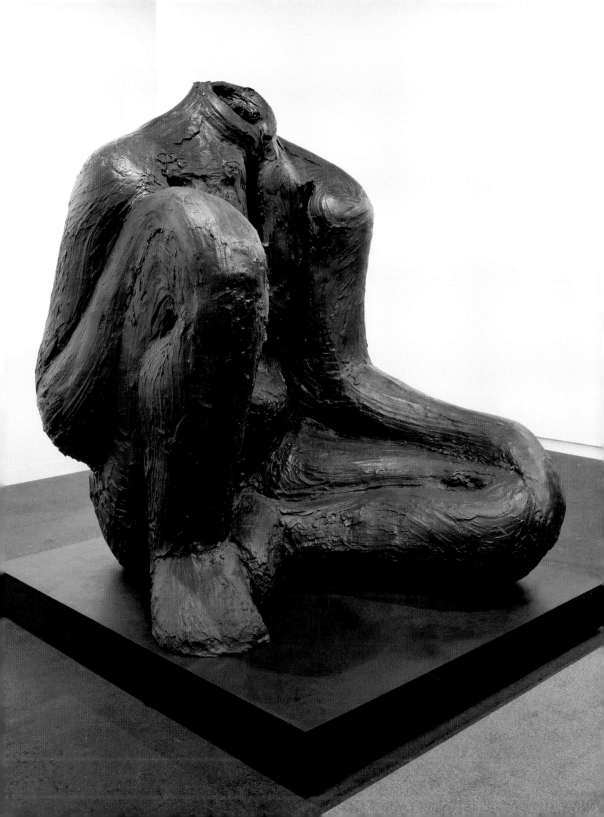

Emily Jacir

1970 born in Riyadh, Saudi Arabia, lives and works in Ramallah, Palestine, and New York (NY), USA

At the 2007 Venice Biennial, Emily Jacir presented *Material for a Film* (2005–), which deals with the violent death of Wael Zuaiter, a Palestinian intellectual living in Rome who was killed in 1972 by Israeli Mossad agents. Struck by twelve bullets outside his home for his alleged role in the attacks at the Munich Olympics, he was the first victim in a series of assassinations of Palestinian civilians living in Europe. Jacir took an unrealized film project about Zuaiter as the starting point for her research – this is the film referred to in the title. Using various available images and recordings, as well as conversations with Zuaiter's partner and friends, Jacir's work is a piece-by-piece reconstruction of the complexity of an individual fate representative of many others. Her survey operates with the usual means of presenting archival and documentary material, the more so as the title suggests that it is research for a film project. The purely documentary function of the material is repeatedly interrupted, however, for example when Jacir shows photographs of all pages of the copy of *One Thousand and One Nights* that was grazed by a highly symbolic 13th bullet when Zuaiter was assassinated. It was a book he had hoped to be the first to translate from Arabic into Italian. The smouldering conflict between Israel and Palestine is a central theme of Jacir's works, which she addresses using various artistic means. The photographic series *Entry Denied* (2003–06), for example, shows places and houses that laconically represent the state of being displaced – the impossibility of normality and a return to their own homeland for many Palestinians.

Auf der Biennale Venedig 2007 präsentierte Emily Jacir *Material for a Film* (2005–): Die Arbeit setzt sich mit dem gewaltsamen Tod von Wael Zuaiter auseinander, einem palästinensischen Intellektuellen, der 1972 in Folge der Münchner Olympiaanschläge als angeblicher Attentäter vom israelischen Geheimdienst Mossad mit 12 Kugeln vor seiner Haustür in Rom getötet wurde – das erste Opfer in einer Serie von Anschlägen auf palästinensische Zivilisten in Europa. Jacir nahm ein nicht realisiertes Filmprojekt über Zuaiter als Ausgangspunkt für ihre Recherchen – hierauf bezieht sich auch der Titel der Arbeit. Ihre Bestandsaufnahme rekonstruiert anhand von verschiedenem Bild- und Tonmaterial sowie Gesprächen mit Freunden und der Lebensgefährtin Zuaiters fragmentarisch die Komplexität eines Schicksals stellvertretend für viele. Die Arbeit spielt mit den üblichen Präsentationsformen für Archiv- und Dokumentationsmaterial, zumal ihr Titel suggeriert, dass es sich um Recherchen für ein Filmprojekt handelt. Die rein dokumentarische Funktion der Materialien wird jedoch immer wieder gebrochen, etwa wenn Jacir Fotos aller Seiten des Exemplars von *Tausend und eine Nacht* zeigt, das beim Anschlag auf Zuaiter von einer symbolträchtigen 13. Kugel berührt wurde – ein Buch übrigens, das Zuaiter als erster vom Arabischen ins Italienische zu übersetzen hoffte. Der seit Jahrzehnten schwelende Konflikt zwischen Israel und Palästina ist immer wieder zentrales Thema in Jacirs Arbeiten, das sie mit unterschiedlichen künstlerischen Mitteln angeht. Die Fotoserie *Entry Denied* (2003–06) etwa zeigt Orte und Häuser, die lakonisch für den Zustand der Deplazierung stehen – die Unmöglichkeit für viele Palästinenser, in die eigene Heimat und in die Normalität zurückzukehren.

Lors de la Biennale de Venise de 2007, Emily Jacir présentait *Material for a Film* (2005–), une œuvre qui abordait la mort violente de Wael Zuaiter, un intellectuel palestinien et auteur présumé de l'attentat des Jeux Olympiques de Munich qui fut tué de douze balles par le Mossad, le service secret israélien, en 1972 devant la porte de sa maison à Rome – devenant ainsi la première victime d'une série d'attentats commis contre des civils palestiniens en Europe. Comme point de départ pour ses recherches, Jacir avait pris un projet de film non réalisé sur Zuaiter, projet auquel se réfère le titre de l'œuvre. À l'appui de différents matériaux filmiques et sonores, mais aussi d'entretiens avec des amis de Zuaiter comme avec sa compagne, le constat dressé par Jacir reconstitue fragmentairement un destin complexe, représentatif de celui vécu par beaucoup d'autres. Avec un titre qui suggère qu'il s'agit de recherches autour d'un projet de film, l'œuvre joue des formes de présentation habituellement utilisées pour les documents et les matériaux d'archives. Mais la fonction purement documentaire des matériaux est sans cesse rompue, notamment quand Jacir présente des photos de toutes les pages de l'exemplaire des *Mille et Une Nuits* touché par une 13ᵉ balle lourdement symbolique lors de l'assassinat de Zuaiter, qui espérait être le premier à traduire cet ouvrage d'arabe en italien. Le conflit latent qui couve depuis des décennies entre Israël et la Palestine est un thème central et récurrent du travail de Jacir, qui l'aborde par le truchement de différents moyens artistiques. Ainsi, la série de photographies *Entry Denied* (2003–06) montre des lieux et des maisons qui représentent laconiquement la condition des déplacés – l'impossibilité pour de nombreux Palestiniens de revenir dans leur propre patrie et à une vie normale.

E. S.

SELECTED EXHIBITIONS →
2008 *Scènes du Sud II – Méditerranée Orientale*, Carré d'art de Nîmes **2007** *Emily Jacir*, Kunstmuseum St. Gallen; Galerien der Stadt Esslingen. *Think with the Senses – Feel with the Mind*, 52nd Venice Biennale, Venice **2006** *Zones of Contact*, 15th Biennale of Sydney. *Without Boundary: Seventeen Ways of Looking*, MoMA, New York. *Dark Places*, Santa Monica Museum of Art, Santa Monica

SELECTED PUBLICATIONS →
2008 *Emily Jacir*, Kunstmuseum St. Gallen; Galerien der Stadt Esslingen; Verlag für moderne Kunst, Nuremberg. *The Hugo Boss Prize 2008*, Guggenheim Museum, New York **2006** *Zones of Contact*, Biennale of Sydney, Sydney. *Without Boundary: Seventeen Ways of Looking*, MoMA, New York

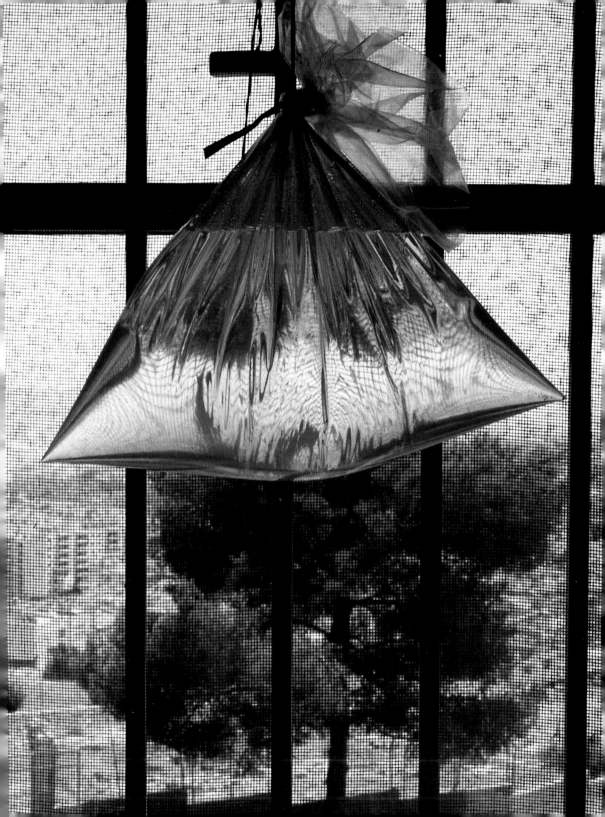

1 **Entry Denied: Outside the Malja**, 2003, C-print, 76 x 56.5 cm
2 **Entry Denied (a concert in Jerusalem)**, 2003, betacam video, 105 min. Documentation of a Marwan Abado concert which never happened

3 **Material for a Film** 2005–. Installation view, Italian Pavilion, 52. Biennale di Venezia, Venice
4 **Entry Denied: Nablus Eid**, 2006, C-print, 56.5 x 76 cm
5 **Entry Denied: Zuaiter House, Nablus**, 2006, C-print, 56.5 x 76 cm

„Es geht um Widerstand, Bewegung, Alltag, hinterlassene Spuren, Poesie, Schönheit, Untersuchungen, Eingriffe, unterdrückte Geschichtsschreibung und Nachforschungen. Es geht darum, Umsiedlungen, Ausweisungen und das Vergessen der Geschichte zu bekämpfen. Es geht darum, dass wir uns zu eigenen Bedingungen definieren."

« Il s'agit de résistance, de mouvement, de quotidien, de traces, de poésie, de beauté, d'investigations, d'interventions, de récits historiques réprimés et de recherches. Il s'agit de lutter contre les déplacements, les expulsions et l'oubli de l'histoire. Il s'agit de nous définir nous-mêmes selon nos propres critères. »

"It is about resistance, movement, everyday life, traces, poetry, beauty, investigations, interventions, repressed historical narratives and research. It's about fighting against displacement, expulsion and historical erasure. It's about defining ourselves on our own terms."

2

Mike Kelley

1954 born in Detroit (MI), lives and works in Los Angeles (CA), USA

Mike Kelley's installation *Kandors* (2007) is based on the comic series *Superman*. Kandor, Superman's hometown, was once shrunk to miniature scale by one of his adversaries and is now kept in a bottle by the superhero. Kelley has created resin models of the town based on its various depictions in the comic books; these are surrounded by videos of glass vials and bottles whose contents fester and bubble. In this way, he creates the impression of a futuristic laboratory. Kelley's exhibition *Educational Complex Onwards: 1995–2008* (2008) also takes architecture as its starting point. In 1995, Kelley exhibited a model representing every school he had ever attended. The exhibition develops a narrative around this model where the artist's works constitute the chapters, right up to his most recent creations. In this way, Kelley's engagement with the autobiographical is interwoven with other themes that characterize his performances, paintings and installations: he investigates the different ways in which mass culture and legends are created. They manifest supra-individual longings and fears, as for example in the legend of Lot's wife being turned to a pillar of salt, which he explores in his *Petting Zoo* (2007), which contains videos and a salt figure for the animals. Kelley incorporates into his artworks the explanations given by philosophy, psychology and science for popular forms of expression. He is particularly interested in how human perception and memory functions. So, for example, the different forms in which the city of Kandor appears symbolize the possible mental associations with which the brain calls up, saves, overlays or suppresses images, facts or experiences.

Mike Kelleys Installation *Kandors* (2007) basiert auf der Comicserie *Superman*, in der Kandor, Supermans Heimatstadt, einst von einem Widersacher auf Kleinstformat geschrumpft wurde und nun von ihm in einer Flasche aufbewahrt wird. Ausgehend von ihren unterschiedlichen Darstellungen im Comic hat Kelley Modelle der Stadt in Kunstharz erschaffen, umgeben von Videos mit Ampullen und Destillen, in denen es gärt und brodelt. Dadurch erzeugt er den Eindruck einer futuristischen Laborsituation. Kelleys Ausstellung *Educational Complex Onwards: 1995–2008* (2008) hat ebenfalls Architektur zum Ausgangspunkt: 1995 stellte Kelley zum ersten Mal ein Modell mit allen Schulen aus, die er besucht hatte. Um dieses Modell herum entwickelt die Ausstellung eine Geschichte, bei der die Arbeiten des Künstlers die Kapitel bilden, bis hin zu seinen neuesten Produktionen. Kelleys Beschäftigung mit dem Begriff des Autobiografischen verschränkt sich hierbei mit anderen Themen, die seine Performances, Gemälde und Installationen prägen: Er untersucht die verschiedenen Ausformungen von Massenkultur und Legenden. In ihnen manifestieren sich überindividuelle Sehnsüchte und Ängste, wie etwa in der Legende von Lots zur Salzsäule erstarrten Frau, die Kelley in seinem *Petting Zoo* (2007) untersucht, einem Streichelzoo mit Videos und einer Figur aus Salz für die Tiere. Kelley lässt seine Auseinandersetzung mit den Erklärungen, die Philosophie, Psychologie und Wissenschaft für populäre Ausdrucksformen geben, in seine Arbeiten einfließen. Sein besonderes Interesse gilt dabei der Funktionsweise von menschlicher Erkenntnis und Erinnerung. So symbolisieren etwa die verschiedenen Formen, in denen die Stadt Kandor erscheint, die möglichen Vorstellungen, mit denen das Gedächtnis Bilder, Fakten oder Erlebnisse aufruft, abspeichert, überlagert oder aber verdrängt.

L'installation de Mike Kelley *Kandors* (2007) est inspirée de la bande dessinée *Superman* : un ennemi de Kandor a réduit autrefois à une taille infime la ville natale de Superman qui la conserve à présent dans une bouteille. Partant des différentes représentations de Kandor dans la bande dessinée, Kelley en a créé des maquettes en résine synthétique entourées de vidéos où toutes sortes de liquides bouillonnent et fermentent dans des ampoules et des alambics, si bien que l'ensemble s'apparente à un laboratoire futuriste. L'exposition *Educational Complex Onwards : 1995–2008* (2008) a elle aussi pour point de départ l'architecture : en 1995, Kelley exposait pour la première fois une maquette montrant toutes les écoles qu'il avait fréquentées. Autour de cette maquette, l'exposition développe une histoire dont les chapitres sont ses œuvres, et ce jusqu'aux plus récentes. Dans le travail autobiographique de Kelley s'intercalent d'autres thèmes qui régissent ses performances, peintures et installations : Kelley étudie les différents avatars de la culture de masse et des légendes, dans lesquelles se manifestent des aspirations et des angoisses collectives. C'est par exemple le cas de la légende de Loth et de sa femme qui fut changée en statue de sel, légende que Kelley aborde dans *Petting Zoo* (2007), un zoo pour enfants comportant des vidéos et une statue de sel en guise d'animaux. Kelley fait entrer dans ses œuvres les explications que la philosophie, la psychologie et la science donnent des modes d'expression populaires. Il s'intéresse plus particulièrement aux modes de fonctionnement de la connaissance et de la mémoire humaines. C'est ainsi que les différentes formes sous lesquelles se présente la ville de Kandor symbolisent les configurations possibles sur la base desquelles la mémoire évoque, stratifie ou simplement refoule les images, les faits ou les expériences.

A. M.

SELECTED EXHIBITIONS →

2008 *Mike Kelley: Educational Complex Onwards: 1995–2008*, Wiels, Brussels **2007** *Sympathy for the Devil: Art and Rock and Roll since 1967*, Museum of Contemporary Art, Chicago. Skulptur Projekte Münster 07, Munster **2006** *Mike Kelley: Profondeurs Vertes*, Musée du Louvre, Paris. *The 80's: A Topology*, Museo Serralves, Porto. *Magritte and Contemporary Art: The Treachery of Images*, MOCA, Los Angeles. *Without Boundary: Seventeen Ways of Looking*, MoMA, New York **2005** *Translation*, Palais de Tokyo, Paris

SELECTED PUBLICATIONS →

2007 *Mike Kelley: Day Is Done*, Gagosian Gallery, New York; Yale University Press, New Haven. *Mike Kelley: Hermaphrodite Drawings (2005–2006)*, Gagosian Gallery, London. *Pop Art Is*, Gagosian Gallery, London **2005** *Mike Kelley: Interviews, Conversations, and Chit-Chat (1986–2004)*, Les presses du réel, Dijon; JRP Ringier, Zurich. *Mike Kelley: Memory Ware, Wood Grain, Carpet*, Galleria Emi Fontana, Milan

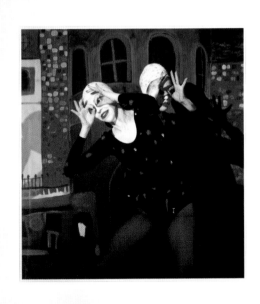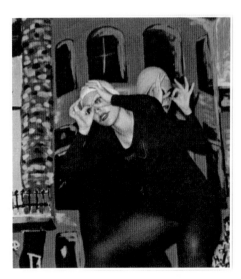

1 **Extracurricular Activity Projective Reconstruction #21 (Chicken Dance),** 2005, piezo print on rag paper (b/w) and C-print (colour), 76.2 x 70.1 cm (each)

2 Installation view, *Mike Kelley: Day Is Done,* Gagosian Gallery, New York, 2005
3 Installation view, *Mike Kelley: Kandors,* Jablonka Galerie, Berlin, 2007

„Ich finde meine Arbeiten schön. Sie sind schön, weil sie Begriffe und Grenzen zwischen den Begriffen durcheinander bringen, und so werden die Grenzen zwischen Kategorien durchlässig. Dadurch wirkt es für mich erhaben, oder aber humorvoll."

« Je pense que ce que je fais est beau. Je pense que c'est beau parce que les termes et les frontières entre les termes sont confus et que les frontières entre les catégories commencent à devenir glissantes. Cela produit ce que je considère comme un effet sublime, ou bien cela produit de l'humour. »

"I think what I make is beautiful. I think it's beautiful because terms, and divisions between terms, are confused and divisions between categories start to slip. That produces what I think of as a sublime effect, or it produces humour."

Terence Koh

1969 born in Beijing, China, lives and works in New York (NY), USA

In his monochromatic black or white objects, his environments and sound pieces, his handmade books, photographs and performances, Terence Koh references – and often comprises – gnomic rituals and cultish practices. His work additionally pays homage to the particularity of sexual subcultures and pillages the history of art. Lately, Koh's appropriations have taken his own past practice as their source. He restaged his infamous *The Whole Family* (2003) at Peres Projects in Los Angeles five years after the original show in the same location. *The Whole Family* (2008) thus reprised his otherworldly installation wholesale: the first floor of the gallery appeared empty save for a white desk lamp and a white styrofoam cup rimming the edge of a 3-inch hole in the floor. In the basement gallery below, a dense blanket of snowy powder covered and clung to viewers as well as to a motley assortment of objects, also white (e.g., figurines mounted upside down on shelves, a silk flag, a diminutive ladder), which were cast from bronze, aluminium and steel in a telling nod to the artist's meteoric ascent since his debut. Self-promotional from the start, Koh was formerly known as "asianpunkboy" thanks to his eponymous, still-extant website. He has since anointed himself the "Naomi Campbell of the art world". But while his public proclamations trumpet the artist's decadent narcissism, past works – some of which are perishable with constituents including lube, saliva, sperm and chocolate – might also suggest a poetics of loss more fragile than presumptive. Reversely, one could cite Koh's hubristic installation *God* (2007) and argue for his incipient self-deification.

Für seine monochromen schwarzen oder weißen Objekte, Environments und Klangstücke, seine handgemachten Bücher, Fotografien und Performances benutzt Terence Koh gnomische Rituale und kultische Praktiken als Bezugspunkt und Material. Seine Arbeiten sind außerdem eine Hommage an die Besonderheiten sexueller Subkulturen und plündern die Kunstgeschichte. In letzter Zeit hat Koh auch sein eigenes Werk als Fundus entdeckt. Er inszenierte sein berüchtigtes *The Whole Family* (2003) bei Peres Projects in Los Angeles fünf Jahre nach der Erstausstellung an derselben Stelle neu. *The Whole Family* (2008) gab also diese außergewöhnliche Installation komplett wieder: Das Erdgeschoss der Galerie schien leer bis auf eine weiße Schreibtischlampe und einen weißen Becher aus Styropor, der die Kante eines acht Zentimeter breiten Lochs im Boden umfasste. Im Keller darunter verschwanden die Besucher unter einer dichten Schicht schneeigen Puders, der an ihnen ebenso wie an einem Sammelsurium von weißen Gegenständen haften blieb (z.B. an von Regalbrettern kopfüber herabhängenden Figürchen, einer seidenen Flagge, einer winzigen Leiter), die diesmal in Bronze, Aluminium und Stahl gegossen waren, als Referenz auf den kometenhaften Aufstieg des Künstlers seit seinem Debut. Von Anfang an warb der Künstler, der dank seiner gleichnamigen noch immer existierenden Homepage als „asianpunkboy" bekannt war, geschickt für sich selbst und bezeichnete sich als „Naomi Campbell der Kunstwelt". Aber während Kohs öffentliche Proklamationen einen dekadenten Narzissmus verkünden, suggerieren seine früheren Arbeiten – von denen einige aus vergänglichem Material wie Vaseline, Speichel, Sperma und Schokolade bestehen –, vielleicht eher eine zerbrechliche als eine überhebliche Poetik des Verlusts. Umgekehrt könnte man Kohs anmaßende Installation *God* (2007) zitieren und den Beginn seiner Selbstvergöttlichung feststellen.

Dans ses objets monochromes noirs ou blancs, ses œuvres environnementales, ses pièces sonores, ses livres faits main, ses photos et ses performances, Terence Koh inclut et se réfère souvent à des rituels gnomiques et des pratiques cultuelles. Il rend en outre hommage aux minorités sexuelles et s'approprie l'histoire des arts. Il pousse ce phénomène d'appropriation jusqu'à réutiliser sa propre pratique passée. C'est ainsi qu'il a remis en scène son célèbre *The Whole Family* (2003) à Peres Projects (Los Angeles), cinq ans après la première installation dans ce même lieu. En 2008, *The Whole Family* reprenait l'ensemble de l'installation antérieure : la galerie semblait vide, à l'exception d'une lampe de bureau blanche et d'un gobelet en polystyrène blanc entourant un trou de 8 centimètres dans le sol. Un épais tapis de poudre blanche recouvrait le sous-sol de la galerie et s'accrochait aux visiteurs ainsi qu'à un assortiment hétéroclite d'objets blancs (parmi lesquels des figurines suspendues à l'envers à des étagères, un drapeau en soie, une échelle miniature) moulés dans du bronze, de l'aluminium ou de l'acier ; un clin d'oeil à l'ascension fulgurante de l'artiste. Assurant seul son auto-promotion, Koh se fait connaître sous le nom de « asianpunkboy », grâce à son site éponyme toujours en activité. Il s'est depuis sacré « Naomi Campbell du monde de l'art ». Alors que ses déclarations publiques revendiquent un narcissisme décadent, des œuvres passées – périssables en raison des matériaux utilisés comme le lubrifiant, la salive, le sperme ou le chocolat – pourraient suggérer une poétique de la perte plus fragile qu'elles ne le laisseraient croire. À l'inverse, sa prétentieuse installation *God* (2007) suggère les prémices d'une auto-déification.

S. H.

SELECTED EXHIBITIONS →
2008 *Terence Koh: Love for Eternity*, MUSAC, León. *Terence Koh: Captain Buddha*, Schirn Kunsthalle, Frankfurt am Main. *Expenditure*, Busan Biennale 2008, Busan Museum of Modern Art, Busan. *Eurasia – Geographic Cross-Overs in Art*, Museo di Arte Moderna e Contemporanea die Trento e Rovereto, Trento **2007** *Fractured Figure – Works from the Dakis Joannou Collection*, Deste Foundation, Athens **2006** *Terence Koh*, Kunsthalle Zürich; Whitney Museum of American Art, New York **2005** *Terence Koh*, Secession, Vienna

SELECTED PUBLICATIONS →
2008 *Terence Koh*, MUSAC, Leon, Hatje Cantz, Ostfildern. *Terence Koh: Captain Buddha*, Schirn Kunsthalle, Frankfurt am Main; Verlag der Buchhandlung Walther König, Cologne **2006** *Terence Koh*, Kunsthalle Zürich, Zürich, Whitney Museum of American Art, New York, Yale University Press, New Haven **2005** *Terence Koh*, Secession, Vienna

1 **God**, 2007, plaster, wood, wax, paint, Eros lube, artist's saliva, cum of the artist and others, 186 x 26 x 26 cm
2 **The World Is the Speed of Fire, Cry Tears But They Still Turn to Silver**, 2007, acrylic, charred enamel, plaster, Hermes perfume, the sweat of big and little men, 232 x 80 x 86 cm

3 **Judas Was Sad**, 2007, found skeleton, wood, paint, varnish, wax, artist's blood, secret message whispered to Judas, 135 x 70 x 65 cm
4 **Untitled 1 (Hole, Plant, Light Cup)**, 2008, bronze cup, steel string, aluminium lamp, bronze plant, bronze ladder, automative paint, dimensions variable, hole 8 cm. Installation view, Peres Project, Los Angeles

„Ich sehe in mir die klassische Sinnlichkeit eines alchimistischen Bildhauers. In meinen Werken geht es um reine Emotion, Liebe und Chemikalien."

« Je me considère comme quelqu'un qui est dans la sensualité classique du sculpteur alchimiste. Mon œuvre tourne autour de l'émotion pure, de l'amour et des produits chimiques. »

"I conceive of myself in the classical sensuality of the alchemist sculptor. My work is about pure emotion, love and chemicals."

2

Jeff Koons

1955 born in York (PA), lives and works in New York (NY), USA

The Museum of Contemporary Art in Chicago was the first one to dedicate a major solo show to Jeff Koons in 1988. Twenty years later, the museum hosted the most comprehensive American retrospective of Koons, arguably the artist who best incarnates our times with their mixture of vulgarity and elegance, the overproduced commodities and the delusions of grandeur. The exhibition gathered works from the beginning of his career in the late 1970s up to now. From his sarcophagi for vacuum cleaners to his porno paintings, from shiny sculptures to multilayered canvases, Koons has been composing a maddening encyclopedia of induced needs, where the inorganic may have more sex appeal than the human body. *Celebration*, one of his most renowned series, was begun in 1994 and includes sculptures and paintings that relate to celebratory moments in popular culture. The stainless steel sculptures combine the lightness of the shapes they take inspiration from – balloons, ornaments, children's toys – with a sense of monumentality achieved through a sophisticated polishing technique, which Koons has refined to truly obsessive ends. Among the recent additions to this series is *Cracked Egg* (1994–2006), a stainless steel egg with a fractured top, and *Hanging Heart (Red/Gold)* (1994–2006), which has become one of the most expensive artworks in the history of art. Lately, Koons has been working on large-scale paintings for the series *Hulk Elvis*. Playing with some of America's most famous heroes (*Triple Hulk Elvis*, 2007) and combining them with other symbols of American pop culture – as in *Liberty Bell* (2007) – Koons continues exploring the secret mechanisms that regulate our desires.

Das Museum of Contemporary Art in Chicago war das erste, das Jeff Koons 1988 eine große Einzelausstellung widmete. Zwanzig Jahre später veranstaltete das Museum die umfassendste amerikanische Retrospektive für Koons – vielleicht der Künstler, der unsere Zeit mit ihrer Mischung aus Vulgarität und Eleganz, ihren überproduzierten Waren und ihrem Größenwahn am besten verkörpert. Die Ausstellung versammelte Arbeiten vom Beginn seiner Karriere in den späten 1970ern bis heute. Von seinen Sarkophagen für Staubsauger über seine Pornobilder, von glänzenden Skulpturen zu vielschichtigen Leinwänden hat Koons eine verwirrende Enzyklopädie künstlich hervorgerufener Bedürfnisse geschaffen, wo anorganische Dinge mehr Sexappeal haben können als der menschliche Körper. *Celebration*, eine seiner bekanntesten Serien, wurde 1994 begonnen und umfasst Skulpturen und Gemälde, die sich mit den festlichen Momenten der populären Kultur befassen. Die Edelstahl-Skulpturen verbinden die Leichtigkeit der Formen, von der sie sich inspirieren lassen – Ballons, Ornamente, Kinderspielzeug – mit einem Sinn für Monumentalität, der durch die anspruchsvolle Kunst des Polierens erreicht wird, welche Koons bis zu einem obsessiven Grad verfeinert hat. Zu den jüngsten Stücken dieser Serie gehören *Cracked Egg* (1994–2006), ein aufgeklopftes Ei aus Edelstahl, und *Hanging Heart (Red/Gold)* (1994–2006), das zu einem der teuersten Werke in der Geschichte der Kunst geworden ist. Zuletzt hat Koons an großformatigen Gemälden für die Serie *Hulk Elvis* gearbeitet. Indem er mit den berühmtesten Helden Amerikas spielt (*Triple Hulk Elvis*, 2007) und sie mit anderen Symbolen der amerikanischen Popkultur kombiniert – wie in *Liberty Bell* (2007) –, fährt Koons fort, die geheimen Mechanismen zu erforschen, die unsere Begierden steuern.

Le Museum of Contemporary Art de Chicago a été le premier, en 1988, à consacrer une exposition personnelle majeure à Jeff Koons. Vingt ans plus tard, le musée accueillait la rétrospective américaine la plus complète de Koons ; sans doute l'artiste qui incarne le mieux notre époque, avec son mélange de vulgarité et d'élégance, de profusion de matières premières et de folie des grandeurs. L'exposition rassemblait des œuvres du début de sa carrière, entamée à la fin des années 1970, jusqu'à l'époque actuelle. De ses sarcophages pour aspirateurs à ses peintures porno, en passant par les sculptures brillantes et les toiles à plusieurs couches, Koons compose une exaspérante encyclopédie des besoins induits, où l'inorganique peut avoir plus de sex-appeal que le corps humain. *Celebration*, une de ses séries les plus remarquées amorcée en 1994, se compose de peintures et de sculptures qui sont en lien avec des moments de célébration dans la culture populaire. Les sculptures en inox associent monumentalité et légèreté des formes dont elles s'inspirent – ballons, décorations, jouets d'enfants –, grâce à une technique de polissage sophistiquée que Koons a affiné jusqu'à l'obsession. On trouve, parmi les récentes adjonctions à cette série, *Cracked Egg* (1994–2006), un œuf en acier inoxydable dont le haut est brisé et *Hanging Heart (Red/Gold)* (1994–2006) qui est devenue l'une des œuvres les plus chères de l'histoire de l'art. Koons travaille maintenant à des peintures grand format pour la série *Hulk Elvis*. Jouant avec les héros américains parmi les plus célèbres (*Triple Hulk Elvis*, 2007) et les associant à d'autres symboles de la culture pop américaine – comme dans *Liberty Bell* (2007) – Koons continue d'explorer les mécanismes secrets qui régulent nos désirs. C. A.

SELECTED EXHIBITIONS →
2008 *Jeff Koons*, Château de Versailles. *Jeff Koons: Kult des Künstlers*, Neue Nationalgalerie, Berlin. *Jeff Koons on the Roof*, The Metropolitan Museum of Art, New York. *Jeff Koons*, Museum of Contemporary Art, Chicago **2007** *Jeff Koons: Balloon Flower (Red)*, 7 World Trade Center, New York. *INSIGHT?*, Gagosian Gallery/Red October Chocolate Factory, Moscow. *Traum und Trauma*, MUMOK, Vienna **2006** *Jeff Koons: Diamond (Pink/Gold)*, Victoria and Albert Museum, London **2005** *Jeff Koons*, Lever House, New York

SELECTED PUBLICATIONS →
2008 Jeff Koons, Taschen, Cologne. *Jeff Koons*, Museum of Contemporary Art, Chicago **2007** *Re-Object: Marcel Duchamp, Damien Hirst, Jeff Koons, Gerhard Merz*, Kunsthaus Bregenz, Bregenz. *Traum und Trauma*, MUMOK, Vienna; Hatje Cantz, Ostfildern **2006** *Where Are We Going: Selections from the François Pinault Collection*, Skira, Milan **2005** *Blumenmythos: Van Gogh bis Jeff Koons*, Fondation Beyeler, Riehen/Basle; Edition Minerva, Wolfratshausen

1 **Landscape (Tree) II**, 2007, oil on canvas, 274.3 x 213.4 cm
2 **Moustache**, 2003, polychromed aluminium, wrought iron, coated steel chain, 260 x 53 x 192 cm
3 **Cracked Egg (Blue)**, 1994–2006, high chromium stainless steel with transparent colour coating, ca 198 x 158 x 305 cm
4 **Triple Hulk Elvis III**, 2005, oil on canvas, 274.3 x 371.2 cm
5 **Liberty Bell**, 2007, oil on canvas, 259.1 x 350.5 cm

„Ich glaube nicht, dass man Kunst einfach herstellen kann. Um zur Kunst zu kommen, musst du dir selbst vertrauen, die eigenen Themen verfolgen und dich absolut darauf konzentrieren. Das führt dich in einen metaphysischen Bereich."

« Je ne cois pas qu'on puisse créer de l'art. Mais je crois que ce qui mène à l'art, c'est d'avoir confiance en soi, de suivre et de se concentrer sur ce qui t'intéresse. Cela te fera parvenir à un état très métaphysique. »

"I don't believe that you can create art. But I believe what will lead you to art is to trust in yourself, follow your interests and focus on your interests. That will take you to a very metaphysical state."

2

3

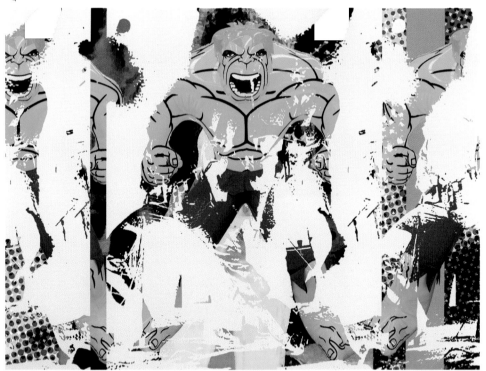

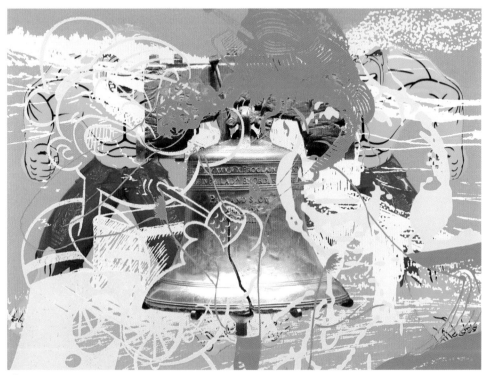

Won Ju Lim

1968 born in Kwangju, Korea, lives and works in Los Angeles (CA), USA

With her installation *Ruined Traces* (2007), Won Ju Lim transports the viewer into a wondrous winter garden, in which miniature landscapes covered by Plexiglas vitrines stand on high pedestals amidst real and artificial foliage plants. The landscapes are sliced in half like scientific preparations, thus revealing their material and method of construction. Video projections overlay the sculptural elements with images of lush vegetation or the Californian landscape. The interplay of light and space, together with artificial and natural materials, creates a landscape that, while recalling architectural and landscape models, also bears distinct traces of the fantastic. In her series *Broken Landscapes* (2007), Lim experimented with a new method: the works consist of found landscape paintings, which have been cut into pieces and then put back together, their individual parts attached with pins to a foam base so that they create a relief-like surface. But she is not concerned with accurate natural representations or engaging with art-historical genres, but rather with the fragmentation and fragility of perception and memory. *A Piece of Sun Valley* (2007) and *A Piece of Echo Park* (2007) are both models of mountainous landscapes presented under yellow Plexiglas, to which the artist adds an additional disturbing element: the alpine scenes are at odds with the titles, which refer to areas of Los Angeles. The works have a second view: from behind, colourful rubbery gels pour down the plaster frame. Lim's choice of material is always significant and never just the means to an end, but she employs materials in such a way that they are often pushed to their physical limits.

Mit ihrer Rauminstallation *Ruined Traces* (2007) versetzt Won Ju Lim die Betrachter in einen wunderlichen Wintergarten: Zwischen echten und artifiziellen Grünpflanzen stehen auf hohen Sockeln unter Plexiglasgehäusen Miniaturlandschaften, die wie aufgeschnittene Präparate ihre Konstruktion und ihr Material zur Schau stellen. Videoprojektionen überlagern die skulpturalen Elemente mit üppigen Vegetationen oder kalifornischer Landschaft. Das Zusammenspiel von Licht, Raum sowie künstlichen und natürlichen Materialien erzeugt eine Landschaft, die zwar an Architektur- und Landschaftsmodelle erinnert, jedoch deutliche Züge des Fantastischen trägt. In ihrer Serie *Broken Landscapes* (2007) erprobt Lim eine für sie neue Vorgehensweise: Die Arbeiten bestehen aus vorgefundenen Landschaftsmalereien, die zerschnitten und als Einzelteile mit Nadeln auf einen Untergrund gespießt werden, so dass sich eine reliefartige Oberfläche ergibt. Doch geht es ihr nicht um präzise Naturdarstellung oder die Auseinandersetzung mit einem kunsthistorischen Genre, sondern um den Verweis auf die Fragmentierung und Brüchigkeit von Wahrnehmung und Erinnerung. In Werken wie *A Piece of Sun Valley* (2007) oder *A Piece of Echo Park* (2007), ebenfalls Modelle bergiger Landschaften, präsentiert unter gelbem Plexiglas, führt die Künstlerin als zusätzlich irritierendes Moment einen Kontrast zwischen der alpin wirkenden Szenerie und den Titeln ein, die sich auf Stadtviertel in Los Angeles beziehen. Die Arbeiten haben zwei Ansichten, an ihrer Rückseite fließen zähe, farbige Gele über das Gipsgerippe. Das Material, das Lim für ihre Arbeiten wählt, ist nie einfach nur Mittel zum Zweck, sein Charakter bleibt stets bedeutsam und wird als solcher vorgeführt, wobei das Material oftmals bis an die Grenzen seiner physikalischen Eigenschaften genutzt wird.

Avec sa vaste installation *Ruined Traces* (2007), Won Ju Lim transporte le spectateur dans un étrange jardin d'hiver : au milieu de plantes vertes naturelles ou artificielles, des vitrines en plexiglas sont posées sur de hauts socles, dans lesquelles des paysages miniatures exhibent leur conformation et leur matériau comme des préparations laborantines vues en coupe. L'interaction entre la lumière, l'espace et les matériaux artificiels et naturels crée un paysage qui rappelle sans doute les maquettes d'architecture ou de paysages, mais qui présente manifestement des traits fantastiques. Dans sa série *Broken Landscapes* (2007), Lim s'essaie à une nouvelle manière de procéder : les œuvres sont constituées de découpages ou de parties de peintures paysagères existantes épinglées sur une base, de manière à produire des surfaces en relief. Cela dit, le propos de Lim n'est pas de donner une reconstitution précise de la nature ou de travailler sur un genre artistique passé, mais de renvoyer à la discontinuité et à la fragilité de la perception et de la mémoire. Dans des œuvres comme *A Piece of Sun Valley* (2007) ou *A Piece of Echo Park* (2007) – également des maquettes de paysages montagneux présentées ici sous plexiglas jaune –, l'artiste introduit une perturbation supplémentaire avec le contraste entre un décor alpestre et des titres évoquant des quartiers de Los Angeles. Les œuvres proposent deux vues : sur la face arrière, des gels colorés visqueux coulent le long de la structure en plâtre. Le matériau que Lim choisit pour ses œuvres n'est jamais un simple moyen justifiant une fin, son caractère reste toujours porteur de sens et est présenté comme tel, les matériaux étant souvent exploités jusqu'aux limites de leurs propriétés physiques.

A. M.

SELECTED EXHIBITIONS →
2008 *Won Ju Lim: 24 Seconds of Silence*, Ullens Center for Contemporary Art, Beijing. *All-inclusive. A Tourist World*, Schirn Kunsthalle, Frankfurt am Main **2007** *Won Ju Lim: Refraction/ Reflection*, Korean Cultural Center, Los Angeles **2006** *Idylle: Traum und Trugschluss*, National Gallery Prague; Domus Artium 2002, Salamanca; Phoenix Kulturstiftung/Sammlung Falckenberg, Hamburg. *Won Ju Lim: In Many Things to Come*, Honolulu Academy of Arts, Honolulu

SELECTED PUBLICATIONS →
2008 *All-inclusive. A Tourist World*, Schirn Kunsthalle, Frankfurt am Main; Snoeck Verlag, Cologne **2007** *Idylle: Traum und Trugschluss*, Phoenix Kulturstiftung/Sammlung Falckenberg, Hamburg; Hatje Cantz, Ostfildern **2006** *Carbonic Anhydride*, Galerie Max Hetzler, Berlin. *Lichtkunst aus Kunstlicht. Licht als Medium der Kunst im 20. und 21. Jahrhundert*, ZKM, Karlsruhe; Hatje Cantz, Ostfildern

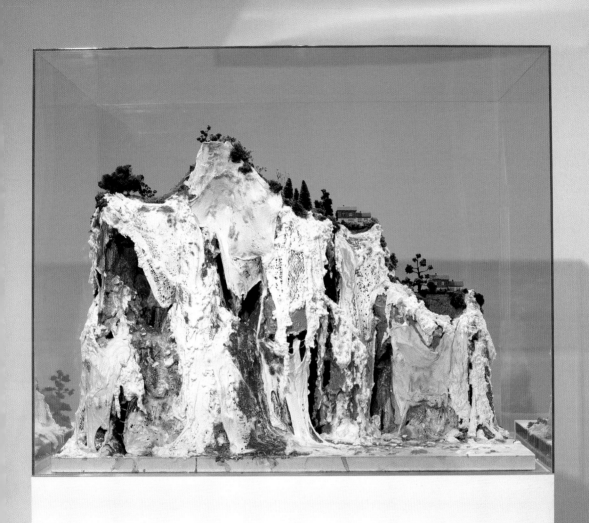

1 **A Piece of Sun Valley**, 2007, mixed media, Plexiglas, 97 x 114 x 97 cm
2 **Untitled (Pepto Bismol)**, 2007, mixed media, 34 x 97 x 91 cm
3 **Broken Landscape #2**, 2007, paint on canvas, silk pins, foam,
53 x 66 x 13 cm

4 **Ruined Traces**, 2007, mixed media sculpture, Plexiglas, artificial plants, live plants, video projections, dimensions variable

„Ich möchte, dass meine Arbeit sich auf viele Dinge gleichzeitig bezieht. Ich möchte auch, dass meine Arbeit von einer Referenz zur nächsten gleitet."

« Dans mon travail, ce qui m'intéresse est de me référer simultanément à des choses multiples, mais aussi de glisser d'une référence à une autre. »

"I am interested in my work referring to multiple things simultaneously. I am also interested in my work slipping from one reference to another."

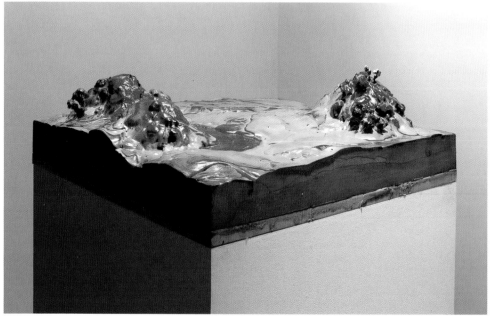

2

3

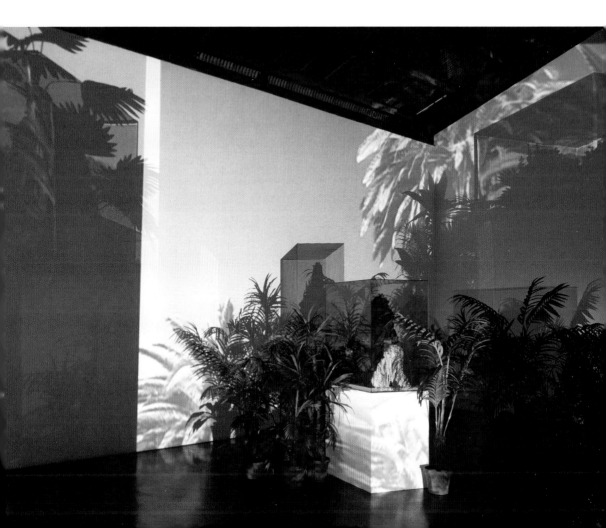

Marepe

1970 born as Marcos Reis Peixoto in Santo Antônio de Jesus, lives and works in Santo Antônio de Jesus, Brazil

To Marepe, displacement is an important matter. In *Veja Meu Bem* (2007), made to last only two days at Tate Modern's Turbine Hall, the artist recreated the ambiance of a Brazilian funfair, installing a fully functional carnival roundabout and adding to it a cascade of sugar-coated apples made available to the public as a signifier of abundance and desire. The installation was inspired by what he calls "beautiful and precarious Brazil" and was ultimately a way to bring a piece of his country and its contradictions to London – a displacement comparable to an earlier project, where the artist had brought a store wall from his native town to the São Paulo Biennial. With the transport of everyday objects into the art world, the artist honours the Duchampian gesture of the readymade, but he also extrapolates it, loading up concrete objects with new layers of meaning. Unlike most contemporary Brazilian artists who have elected Rio de Janeiro or São Paulo as their residence, Marepe lives in his native town at the southern outskirts of Salvador, a fact which deeply impacts his oeuvre. The Brazilian Northeastern way of life, its precarious material conditions and creative craftsmanship are his constant sources: a peddler's stall, low-income households, metal basins or the trunk of a cashew tree appear in his work in a changing context. As he straddles the different universes, Marepe creates a voice of alterity within the art world and his poetically shaped comments on colonialism, identity, social class, memory, family and the conflict between modern and traditional lifestyles have no pamphletary, regionalistic or naïve tones whatsoever.

Dislokation ist ein wichtiges Konzept in Marepes Kunst. In *Veja Meu Bem* (2007), das für nur zwei Tage in der Turbinenhalle der Tate Modern stand, stellte er ein brasilianisches Vergnügungsfest nach, indem er ein voll funktionsfähiges Karnevalskarussell aufbaute und ihm eine Fülle von kandierten Äpfeln – ein Zeichen für Überfluss und Verlangen – hinzufügte, die das Publikum mitnehmen konnte. Die Installation war von dem inspiriert, was Marepe das „wunderschöne und prekäre Brasilien" nennt, und war für ihn letzten Endes eine Gelegenheit, Brasilien und ein Stück seiner Widersprüche nach London zu bringen – ein Ortswechsel, der einem früheren Projekt vergleichbar ist, bei dem der Künstler die Wand eines Geschäfts seiner Geburtsstadt auf die Biennale in São Paulo brachte. Mit dem Versetzen von alltäglichen Gegenständen in die Welt der Kunst folgt Marepe Duchamp und seiner Geste des Readymades, aber er extrapoliert sie auch, indem er konkrete Gegenstände mit neuen Bedeutungen anreichert. Anders als die meisten zeitgenössischen brasilianischen Künstler, die in Rio de Janeiro oder São Paulo wohnen, lebt Marepe in seinem Geburtsort in den südlichen Vororten von Salvador, was sein Werk deutlich prägt. Das Leben im Nordosten Brasiliens, seine schwierigen Lebensbedingungen und die kreative Handwerkskunst dort sind seine Quellen: die Bude eines Händlers, die Haushalte der Armen, Blechbecken oder der Stamm eines Cashewbaums tauchen in seinem Werk in wechselnden Zusammenhängen auf. Indem er verschiedene Welten verbindet, gibt Marepe der Alterität innerhalb der Kunstwelt eine Stimme, und seine poetischen Kommentare zu Kolonialismus, Identität, sozialer Klasse, Erinnerung, Familie und dem Konflikt zwischen modernen und traditionellen Lebensstilen haben keinerlei pamphletartigen, regionalistischen oder naiven Ton an sich.

Pour Marepe, le déplacement est un sujet important. Avec *Veja Meu Bem* (2007), conçu pour ne durer que deux jours à l'intérieur du Turbine Hall de la Tate Modern à Londres, l'artiste recréait l'ambiance d'une fête foraine brésilienne, en y installant un manège forain opérationnel et en y ajoutant une cascade de pommes d'amour offertes au public, symbole d'abondance et de désir. L'installation, inspirée par ce qu'il nomme le « Brésil magnifique mais précaire », était un moyen de transporter à Londres une part de son pays et de ses contradictions – un déplacement comparable à un projet antérieur, où l'artiste avait exposé le mur d'une boutique de sa ville natale à la Biennale de São Paulo. Avec le transfert d'objets quotidiens dans le monde de l'art, l'artiste honore le geste Duchampien du ready-made, et le prolonge en chargeant des objets concrets d'un sens nouveau. Contrairement à la plupart des artistes contemporains brésiliens qui ont choisi de vivre à Rio de Janeiro ou à São Paulo, Marepe vit dans sa ville natale à la lisière sud du Salvador, ce qui a un impact significatif sur son œuvre. Le mode de vie dans le Nordeste brésilien, les conditions matérielles précaires et l'artisanat sont autant de sources d'inspiration : un éventaire de colporteur, des ménages pauvres, des cuvettes en métal ou un tronc d'anacardier apparaissent dans son œuvre dans un contexte transformé. En enjambant les différents univers, Marepe fait entendre une voix nouvelle dans le monde de l'art. Ses commentaires poétiques sur le colonialisme, l'identité, les classes sociales, la mémoire, la famille ou le conflit entre modes de vie moderne et traditionnel n'ont aucune tonalité pamphlétaire, régionaliste ou naïve.

R. M.

SELECTED EXHIBITIONS →
2007 *Marepe*, Museu de Arte Moderna de São Paulo. *Marepe: Veja Meu Bem*, Tate Modern, London **2006** *Alien Nation*, ICA, London; Manchester Art Gallery, Manchester; Sainsbury Centre for Visual Arts, Norwich. *How to live together*, 27th Bienal de São Paulo, Pavilhão Ciccillo Matarazzo, São Paulo. *Zones of Contact*, Biennale of Sydney 2006, Sydney **2005** *Marepe: Vermelho – Amarelo – Azul – Verde*, Centre Georges Pompidou, Paris. *Marepe*, Museu de Arte da Pampulha, Belo Horizonte.

SELECTED PUBLICATIONS →
2007 *Marepe*, Galerie Max Hetzler, Berlin; Galerie Luisa Strina São Paulo; Holzwarth Publications, Berlin. *100 Latin American Artists*, Exit Publicaciones, Olivares y Asociados, Madrid **2006** *Alien Nation*, ICA, London et al., Hatje Cantz, Ostfildern. *Carbonic Anhydride*, Galerie Max Hetzler, Berlin. *Zones of Contact*, Biennale of Sydney, Art Gallery of New South Wales, Sydney **2005** *Marepe*, Museu de Arte da Pampulha, Belo Horizonte.

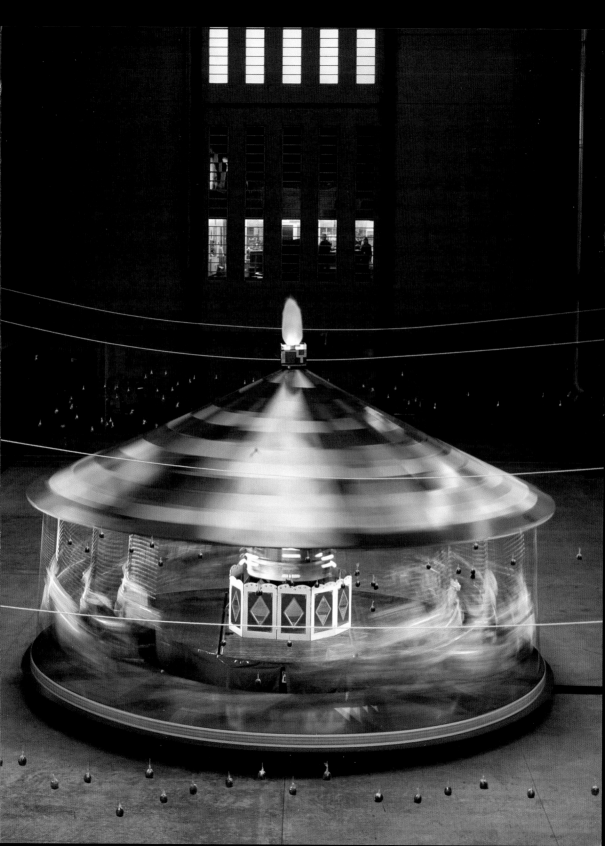

1 **Veja Meu Bem (Look, My Dear)**, 2007, carousel, lamps, toffee apples, acetate, cloth, dimensions variable. Installation view, *UBS Openings: The Long Weekend*, Tate Modern, London
2 **Periquitos**, 2005/07, mixed media, 41 x 53.5 x 30 cm

3 **Quatro Cadeiras Conversando (Four Chairs Talking)**, 2007, wood, steel wool, metal, ca 140 x 240 x 200 cm, dimensions variable
4 **Andador (Chair)**, 2005, metal, fabric, rubber, 323 x 259 x 288 cm

„In meiner Arbeit geht es um das, was mich umgibt, was ich sehe und fühle, den Alltag, den Wunsch nach einer gerechteren Welt, in der es weniger Gewalt gibt."

« Mon travail porte sur ce qui m'entoure, sur ce que je vois, sur le quotidien, le désir d'un monde plus juste et moins violent. »

"My work deals with what surrounds me, what I see, feel, the everyday, desires for a more equal world that is less violent."

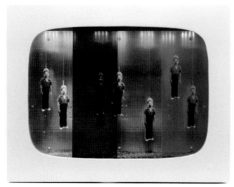

2

3

Paul McCarthy

1945 born in Salt Lake City (UT), lives and works in Altadena (CA), USA

Paul McCarthy, a contemporary master of the grotesque, began his artistic career in the 1960s with physical performances that could involve using his penis as a paintbrush. In the 1980s he began developing stage sets and incorporating video into his works. His sculptural cast includes politicians, pigs and Santa Clauses (to name just a few), who do their best to show the dark side of life in classically Freudian style. Sometimes all it takes is a nine-metre-tall inflatable ketchup bottle – when it goes by the name of *Daddies Ketchup* (2001) and evokes some nasty associations. Deliriously infantile and over the top, the work of this influential artist is often grotesque and always full of irreverent humour. McCarthy himself was influenced by Warhol and often employs the pop artist's blow-up method, although he attacks the incunabula of consumer society in a more playful manner. *Caribbean Pirates* (2001–05), his largest project to date, alludes to both the Disneyland ride and the Johnny Depp film. Realized in collaboration with Damon McCarthy, it comprises 20 video projections, a 70-foot frigate sculpture installation, a houseboat (used as a set), and numerous props from the original filming. Chaotic video sequences are collaged together to show the pirates' raucous debauchery and blood lust; not much remains of Disney's merry pirates. In his latest works McCarthy again shifts the ground beneath the viewer's feet – quite literally so in *Spinning Room* and *Mad House* (2008), which cast viewers into a disorientating world of rotation and reflection. McCarthy adjusts the parameters of how we perceive the world, setting up a Nightmare Factory opposite the Dream Factory of Hollywood.

Paul McCarthy, heute ein Meister des Grotesken, begann seine künstlerische Karriere in den 1960er-Jahren mit körperbetonten Performances, bei denen er auch mal seinen Penis als Pinsel einsetzte. Ab den 1980er-Jahren begann er, Bühnenaufbauten zu entwickeln und mit Video zu arbeiten. Sein Skulpturenpersonal enthält unter anderem Politiker, Schweine und Nikoläuse, die ihr Bestes geben, um freudianisch korrekt die dunkle Seite des Lebens zu zeigen. Manchmal reicht jedoch schon eine neun Meter hoch aufgeblasene Ketchup-Flasche, wenn sie *Daddies Ketchup* (2001) heißt und üble Assoziationen weckt. Delirierend infantil, großspurig im XXL-Format, grotesk und voll bösen Humors – so zeigt sich das Werk dieses einflussstarken Künstlers. Selbst beeinflusst von Warhol, greift er oft dessen Blow-up-Verfahren auf, wendet sich jedoch viel spielerischer als jener gegen Inkunabeln der Konsumgesellschaft. *Caribbean Pirates* (2001–05), zusammen mit seinem Sohn Damon realisiert, ist das bislang aufwändigste Projekt und bezieht sich auf den Disney-Themenpark sowie den Film mit Johnny Depp. Das Werk besteht aus 20 Video-Projektionen, einer Installation mit einer über 20 Meter langen Fregatte, einem Hausboot, das als Filmset benutzt wurde, und viele Requisiten der originalen Dreharbeiten. Chaotische Video-Sequenzen werden ineinander collagiert, sie zeigen die lärmenden Ausschweifungen und die Blutlust der Piraten – hier bleibt von Disneys fröhlichen Freibeutern nicht viel übrig. Auch bei seinen jüngsten Arbeiten geht es McCarthy darum, dem Betrachter den Boden unter den Füßen wegzuziehen. Das geschieht durchaus wörtlich bei *Spinning Room* und *Mad House* (2008), die den Betrachter in eine desorientierende Welt aus Rotationen und Spiegeln versetzen. McCarthy dreht an den Parametern unserer Weltwahrnehmung und setzt gegen Hollywoods Dream Factory eine Nightmare Factory in Gang.

Paul McCarthy, qui est aujourd'hui un maître du grotesque, a débuté sa carrière artistique dans les années 1960 avec des performances centrées autour du corps dans lesquelles il lui est arrivé d'utiliser son pénis comme un pinceau. À partir des années 1980, il commence à mettre au point des décors de scènes et à travailler avec la vidéo. Sa troupe de personnages-sculptures est notamment composée de politiciens, de porcs et de pères Noëls qui font tout pour mettre en évidence la face sombre de la vie selon le canon freudien. Une bouteille de ketchup gonflable de neuf mètres de haut intitulée *Daddies Ketchup* (2001) peut suffire à évoquer de fâcheuses associations. Empreinte de délire infantile, d'excès au format XXL, de grotesque et d'humour aigre – telle est l'œuvre de cet artiste influent. Lui-même influencé par Warhol, McCarthy utilise souvent le *blow up*, mais s'attaque de façon beaucoup plus ludique aux incunables de la société de consommation. *Caribbean Pirates* (2001–05), le projet le plus ambitieux réalisé à ce jour avec son fils Damon, se réfère au parc à thème de Disney et au film joué par Johnny Depp. L'œuvre est constituée de vingt projections vidéos et d'une installation avec une frégate de vingt mètres de long, un bateau-maison utilisé comme lieu de tournage et beaucoup d'accessoires utilisés lors du tournage original. Des séquences vidéos chaotiques ont été superposées, montrant les débauches tapageuses des pirates assoiffés de sang – mais des flibustiers joyeux de Disney il n'y a plus de traces. Dans ses toutes dernières œuvres, le propos de McCarthy est de faucher l'herbe sous le pied du spectateur, ce qui se produit presque littéralement avec *Spinning Room* et *Mad House* (2008), qui emportent le spectateur dans un monde déroutant de rotations et de miroirs. McCarthy manipule les paramètres de notre perception du monde et met en route une Nightmare Factory contre la Dream Factory de Hollywood. H. L.

SELECTED EXHIBITIONS →
2008 *Paul McCarthy: Central Symetrical Rotation Movement – Three Installations, Two Films*, Whitney Museum of American Art, New York. *Kult des Künstlers: Ich kann mir nicht jeden Tag ein Ohr abschnei-den*, Here Is Every. *Four Decades of Contemporary Art*, MoMA, New York **2007** *Paul McCarthy: Tokyo Santa 1996/2004*, The Essl Collection, Klosterneuburg **2006** *Into Me/Out Of Me*, P.S.1 Contemporary Art Center, Long Island City; KW Institute for Contemporary Art, Berlin

SELECTED PUBLICATIONS →
2008 *Paul McCarthy: Central Symmetrical Rotation Movement – Three Installations, Two Films*, Whitney Museum of American Art, New York. *Southern Exposure. Works from the Collection of the Museum of Contemporary Art San Diego*, MCA, Sydney. *Stations. 100 Meisterwerke zeitgenössischer Kunst*, DuMont, Cologne **2006** *Into Me/Out Of Me*, P.S.1 Contemporary Art Center, Long Island City; KW Institute for Contemporary Art, Berlin; Hatje Cantz, Ostfildern

1/4/5 **Caribbean Pirates**, 2001–05, in collaboration with Damon McCarthy, performance, video, installation, photographs
2 **Brancusi Tree (Gold)**, 2007, self inflatable Mylar fabric, 1 integrated fan, 190 x 95 cm

3 **Train, Pig Island**, 2007, foam, mixed media. Installation view, S.M.A.K. Stedelijk Museum voor Actuele Kunst, Gent

„Ich verwende Humor, um eine Reflexion über das Schreckliche zu ermöglichen."

« J'utilise l'humour pour permettre une réflexion sur l'horreur. »

"I use humour to facilitate a reflection on the horrendous."

2

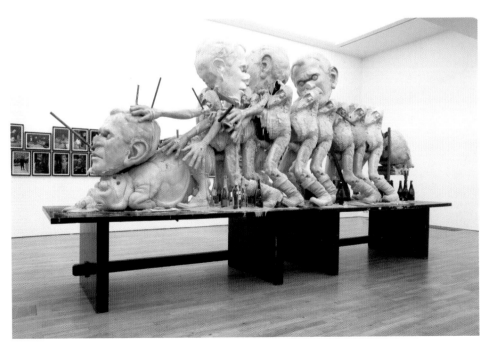

3

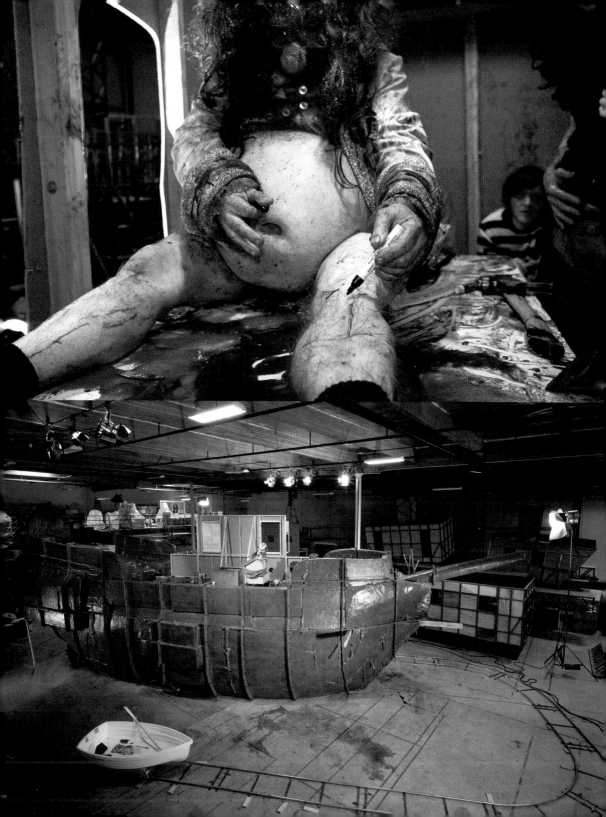

Beatriz Milhazes

1960 born in Rio de Janeiro, lives and works in Rio de Janeiro, Brazil

In her paintings and collages, Beatriz Milhazes has always revelled in the carnivalesque colour spectrum of her native Rio de Janeiro and in the decorative patterns of folk handicraft. Her works have consistently taken the form of vibrant, tropically hued canvases with an excessive and exuberant sampling of artisanal forms, baroque motifs and pop-cultural icons. An unabashed use of ornamental elements like flower petals and rosebuds, peace signs, strands of pearls, butterflies, lace doilies characterized her earliest paintings in the 1980s, since then, Milhazes' compositions have gradually become more explosive, with vivid bursts of concentric circles and exploding floral blooms, as well as an ever more psychedelic colour palette. Works like *Beleza Pura* (2006) have stretched into the scale of landscapes, with meandering organic tendrils and flourishes and overlapping circles drifting like balloons across the canvas. The overall effect is similar to the dizzying afterimage of dots that you see after staring directly at the sun. In contrast to this, Milhazes' collages are based on a loose structure of stripes or grids made of flattened candy wrappers, chocolate labels or shopping bags from stores around the world. She delights in the graphic design of these simple "throw-away" labels, making no distinction between the products of contemporary commercial marketing and of modernist abstraction. In the act of collecting fabric swatches, flattening out wrinkled labels and transferring plastic decals onto her pictures, Milhazes incorporates mass-produced products – while the works remain essentially handmade.

Mit ihren Gemälden und Collagen schwelgt Beatriz Milhazes schon immer im karnevalesken Farbenspektrum ihrer Heimatstadt Rio de Janeiro und in den dekorativen Mustern der Volkskunst. Ihre Arbeiten sind stets hoch lebendige Leinwände in tropischen Farben mit einer überbordenden Auswahl an künstlerischen Formen, barocken Motiven und Ikonen der Popkultur. Ihre unerschrockene Verwendung von ornamentalen Elementen wie Blütenblättern und Rosenknospen, Peace-Zeichen, Perlenketten, Schmetterlingen und Spitzendeckchen kennzeichneten schon ihre frühesten Bilder in den 1980ern. Seither sind Milhazes' Kompositionen schrittweise explosiver geworden, durch lebhafte Ausbrüche konzentrischer Kreise und explodierender Blumenblüten, wie auch durch eine immer psychedelischere Farbpalette. Arbeiten wie *Beleza Pura* (2006) haben sich auf die Größe von Landschaften ausgedehnt, mit mäandernden organischen Ranken und Schnörkeln und überlappenden Kreisen, die wie Ballons über die Leinwand gleiten. Der Gesamteindruck ist mit den schwankenden Punkten zu vergleichen, die man als Nachbild sieht, wenn man direkt in die Sonne geschaut hat. Im Gegensatz dazu basieren ihre Collagen auf losen Strukturen von Streifen oder Gittern, die aus geglätteten Keksverpackungen, Schokoladenetiketten oder Einkaufstüten aus aller Welt bestehen. Milhazes hat ihre Freude am Design dieser einfachen „Wegwerf"-Label, zwischen den Produkten des zeitgenössischen kommerziellen Marketings und denen der modernen Abstraktion unterscheidet sie nicht. Indem sie Stoffmuster sammelt, zerknitterte Etiketten glättet und Plastikfolien auf ihre Bilder setzt, baut sie massenproduzierte Produkte ein – und trotzdem bleibt ihre Arbeit komplett handgemacht.

Dans ses peintures et collages, Beatriz Milhazes joue constamment avec les couleurs du carnaval de sa ville natale, Rio de Janeiro, et avec les motifs décoratifs de l'artisanat populaire. Ses œuvres prennent invariablement la forme de toiles aux couleurs tropicales, vibrantes, avec un assemblage excessif et exubérant de formes artisanales, de thèmes baroques et d'icônes de la culture pop. Ses premiers travaux des années 1980 se caractérisaient par une utilisation sans bornes d'éléments ornementaux comme des pétales de fleurs et des boutons de roses, des symboles de paix, des rangs de perles, des papillons, des napperons de dentelle. Depuis, les compositions de Milhazes sont devenues plus explosives, avec des déploiements saisissants de cercles concentriques et de floraisons exubérantes, ainsi qu'une palette de couleurs de plus en plus psychédélique. Des œuvres telles que *Beleza Pura* (2006) prennent la dimension de paysages, avec de sinueuses vrilles, des fioritures organiques et des cercles entrecroisés, dérivant sur la toile à la manière de ballons. L'effet d'ensemble rappelle les étourdissantes taches lumineuses que l'on voit après avoir regardé le soleil à l'œil nu. D'autres tableaux récents sont composés à partir d'une structure lâche de rayures et de grilles faite de papiers de bonbons aplatis, d'étiquettes de chocolats ou de sacs à l'effigie des boutiques du monde entier. Milhazes se délecte du graphisme de ces identités visuelles simples et jetables, sans faire de distinction entre les produits du marketing commercial contemporain et ceux de l'abstraction moderniste. En collectant des échantillons de tissus, en aplatissant des étiquettes fripées et en transférant des décalcomanies sur ses tableaux, Milhazes incorpore des objets produits en masse à des œuvres faites à la main. CH. L.

SELECTED EXHIBITIONS →
2008 *Beatriz Milhazes: Pintura, Colagem*, Estação Pinacoteca, São Paulo. *Die Tropen*, Martin Gropius Bau, Berlin. *Prospect.1 New Orleans Biennial*, New Orleans **2007** *Um Sèculo de Arte Brasileira*, Coleção Gilberto Chateaubriand, Museu de Arte Moderna da Bahia, Salvador **2006** *Hyper Design*, 6th Shanghai Biennale, Shanghai **2005** *Beatriz Milhazes: Lagoa*, Museu de Arte da Pampulha, Belo Horizonte

SELECTED PUBLICATIONS →
2008 *Die Tropen*, Martin Gropius Bau, Berlin; Kerber Verlag, Bielefeld **2006** *Beatriz Milhazes: Color and 'Volupté'*, Barlèu Edições, Rio de Janeiro. *Hyper Design*, 6th Shanghai Biennale; Shanghai Fine Arts Publishers, Shanghai **2005** *Beatriz Milhazes*, Domain de Kerguéhennec, Centre d'Art Contemporain, Bignan. *The Cut-and-paste Tumulto of Collage (Populence)*, Blaffer Gallery, The Art Museum of the University of Houston. *Works on Paper*, Galerie Max Hetzler, Berlin

1 **Junior Mints**, 2006, collage on paper, 141 x 94 cm
2 **Beleza Pura**, 2006, acrylic on canvas, 200 x 402 cm

„Ich suche nach geometrischen Strukturen, aber mit der Freiheit der Form und Symbolik aus verschiedenen Welten."

« J'expérimente les structures géométriques, mais avec une liberté de la forme et une imagerie venue de différents univers. »

"I am seeking geometrical structures, but with freedom of form and imagery taken from different worlds."

2

Sarah Morris

1967 born in London, lives and works in London, United Kingdom, and New York (NY), USA

Sarah Morris' primary media are painting and film, which she uses in very different ways: while her paintings are geometric and abstract, her films are representational. They are mainly portraits of cities, or, more recently, of people. The common denominator of both media is an interest in urban structures, be they architectural or social. Morris sees her films as complementary to her painting; consequently, both films and painting series often share the same title, such as *Robert Towne* (2006). The film is about the scriptwriter and director Towne, starting from a panoramic view of his city, Los Angeles, then zooming in into an intimate portrait. After a series of smaller works with the same title, Morris realized *Robert Towne* in 2007 as a vast painting on the ceiling of the ground floor in Lever House, New York, taking the aesthetics of one city and grafting it onto the architecture of another. Cities are structured horizontally by networks of streets, and vertically by the facades of buildings. Morris addresses both: the street system of Beijing in the series *Rings* (2006/07), for example. Her most recent film, *1972* (2008), deals with the Olympic Games of that year in Munich. Her interview partner is Georg Sieber, a psychologist who worked with the security services at that event. Sieber developed a threat scenario that was subsequently delivered by reality, almost down to the last detail. Using montage, Morris supplements the interview with images of police checks, archive photographs of the Olympics and views of the site. The resulting image of the social structure of the city combines elements of terror, state control and architecture.

Sarah Morris arbeitet vor allem in den Medien Malerei und Film, die sie jedoch auf sehr unterschiedliche Weise nutzt: die Gemälde fallen geometrisch-abstrakt aus, die Filme hingegen sind gegenständlich. Meist liefern sie Porträts von Städten oder, seit kürzerem, auch von Personen. Der gemeinsame Nenner in beiden Medien ist das Interesse an urbanen Strukturen, seien sie architektonischer oder sozialer Art. Ihre Filme begreift sie dabei als Komplement der Malerei. Folgerichtig tragen Filme und Bildserien oft denselben Titel, wie bei *Robert Towne* (2006). Im Film geht es um den Drehbuchautor und Regisseur Towne; er beginnt mit einer Panorama-Ansicht der Stadt, in der Towne lebt, Los Angeles, zoomt dann näher und wird zu einem sehr intimen Porträt. Nach einer Serie mit kleineren Arbeiten mit demselben Titel realisierte Morris *Robert Towne* dann 2007 als riesiges Deckengemälde im Erdgeschoss des Lever Hause in New York – und übertrug so die Ästhetik einer Stadt auf die Architektur einer anderen. Städte sind horizontal geprägt von Straßennetzen und vertikal geprägt von Fassaden. Beidem widmet sich Morris stets von neuem, bei der Serie *Rings* (2006/07) etwa dem Straßensystem von Peking. Ihr jüngster Film, *1972* (2008), beschäftigt sich mit den Olympischen Spielen desselben Jahres in München. Ihr Interviewpartner ist Georg Sieber, Psychologe des Ordnungsdienstes bei der damaligen Olympiade. Er entwarf ein Bedrohungsszenario, das von der Realität fast punktgenau eingelöst worden ist. Per Montage reichert Morris das Interview mit Bildern von Polizeikontrollen, Archivfotografien der Spiele sowie Ansichten des Olympiaparks an. So entsteht ein Bild der sozialen Struktur der Stadt, das Momente des Terrors, des Kontrollstaates und der Architektur miteinander verknüpft.

Sarah Morris travaille surtout avec les médiums de la peinture et du cinéma, qu'elle utilise toutefois de manière très différente : si ses peintures sont abstraites et géométriques, ses films sont figuratifs. Ils présentent généralement des portraits de villes, mais dernièrement aussi des portraits de personnes. Le dénominateur commun de son utilisation des deux médiums réside dans l'intérêt pour les structures urbaines, qu'elles soient de nature architectonique ou sociale. Elle considère ses films comme complémentaires de la peinture. En conséquence de quoi, ses films et séries peintes portent souvent le même titre, comme *Robert Towne* (2006). Le film parle du scénariste et réalisateur Towne, et débute par une scène panoramique de sa ville de résidence : Los Angeles, pour se poursuivre en un plan rapproché, et dresser de lui un portrait intime. Après une série de petits travaux du même nom, Morris réalise en 2007 *Robert Towne*, une grande fresque au plafond du rez-de-chaussée de la maison Lever à New York et transpose ainsi l'esthétique d'une ville sur l'architecture d'une autre. Les villes sont marquées horizontalement par des réseaux de rues et verticalement par des façades. Morris revient toujours à ces deux aspects : dans la série *Rings* (2006/07), il s'agit du système de rues de Pékin. Son dernier film, *1972* (2008), parle des Jeux Olympiques de Munich de la même année. La personne interviewée est Georg Sieber, psychologue du service d'ordre des Jeux de 1972. Il avait élaboré un scénario que la réalité devait illustrer presque point par point. Le montage réalisé par Morris enrichit l'interview d'images de contrôles policiers, de photos d'archives et de vues du parc olympique. Il en résulte une image de la structure sociale de la ville qui relie entre eux des moments de terreur, d'État policier et d'architecture.

H. L.

SELECTED EXHIBITIONS →
2008 *Sarah Morris: Black Beetle*, Fondation Beyeler, Riehen/Basle. *Sarah Morris: 1972*, Lenbachhaus, Munich. *Art Is for the Spirit: Works from the UBS Art Collection*, Mori Art Museum, Tokyo **2007** *The Shapes of Space*, Solomon R. Guggenheim Museum, New York **2006** *Sarah Morris: Robert Towne*, Public Art Fund Project, Lever House Building, New York. *Sarah Morris: Artist in Focus*, 35th International Film Festival Rotterdam, Museum Boijmans van Beuningen, Rotterdam

SELECTED PUBLICATIONS →
2008 *Sarah Morris: 1972*, Verlag der Buchhandlung Walther König, Cologne. *Always There*, Galerie Max Hetzler, Berlin. *General Issue*, CGAC – Centro Galego de Arte Contemporánea, Santiago de Compostela **2006** *Carbonic Anhydride*, Galerie Max Hetzler, Berlin. *Without Boundary: Seventeen Ways of Looking*, MoMA, New York

1 **1952 (Rings)**, 2006, household gloss paint on canvas, 214 x 214 cm
2 **Robert Towne**, 2006, 35mm film, 34 min 25 sec

3 **1972**, 2008, 35mm film, 38 min 12 sec
4 **Weasel (Origami)**, 2007, household gloss paint on canvas, 289 x 289 cm

„Der rasche Wechsel zwischen verschiedenen Bereichen wie Politik, Architektur und Design ist für mich ein typisches Merkmal meiner Generation. Ich sehe auf die Wirklichkeit und beginne mit ihr zu spielen, schnell und riskant."

« À mon sens, ce qui caractérise ma génération est le passage rapide d'un domaine à l'autre – par exemple la politique, l'architecture ou le design. Je regarde la réalité et joue avec elle de manière rapide et légère. »

"Moving swiftly between different arenas like politics, architecture or commercial design is what I would consider defintive of my generation. I am looking at reality and playing fast and loose with it."

2

3

Ron Mueck

1958 born in Melbourne, Australia, lives and works in London, United Kingdom

As Aristotle noted in his *Poetics*, people take pleasure from the most faithful representations of things, which is why they persist with such replications. In the 1960s, Duane Hanson created sculptures that at first glance could easily be taken for actual people – they seemed so real. This distinctive, almost exaggerated realism led to the works being described as hyperrealist. Like Hanson, Ron Mueck works with fibreglass, polyester and latex, although his repertoire now includes the more flexible silicon. He then adds colour and features such as hair and clothing. Mueck acquired his skills in hyperrealism while working in special effects for film productions, and also with Jim Henson's team of puppet makers. Both of these aspects – special effects and puppet-like figures – still feature in his artworks, which either evince the shocking size of giants or a strange dwarfishness. This also applies to recent works such as *Wild Man* (2005), *Two Women* (2005) or *A Girl* (2006). What makes Mueck's sculptural figures unique is their scale, which deviates far from the norm. His exploration of monumental sculpture is particularly interesting: traditionally, the substantial enlargement of human scale has been reserved for the depiction of gods, heroes or rulers – size was a means of confirming the subject's status. Mueck's enormous figures, on the other hand, look fearful (*Wild Man*) or seem far removed from the point where they will be judged as deity, hero or ruler; often they are newborn babies (*A Girl*). In this way, Mueck subverts the heroic pathos of the monumental sculpture, revealing its mechanisms and at the same time posing the question as to how *size matters*.

Schon Aristoteles notierte in seiner *Poetik*, dass Menschen sich an möglichst getreuen Nachbildungen von Dingen erfreuen, weshalb sie solche auch immer wieder in Angriff nehmen. In den 1960er-Jahren schuf Duane Hanson Plastiken, die man auf den ersten Blick für tatsächliche Menschen halten konnte – so real wirkten sie. Aufgrund ihres ausgeprägten, geradezu übersteigert erscheinenden Realismus werden die Arbeiten als hyperrealistisch bezeichnet. Ron Mueck arbeitet wie Hanson vor allem mit Fiberglas, Polyester und Latex, seit Kurzem jedoch auch mit dem flexibleren Silikon. Hinzu kommen jeweils Farbe und Ausstattungsdetails wie Haare und Kleidung. Seine Fertigkeit im Hyperrealismus gewann Mueck bei der Arbeit für Special Effects im Film und bei Jim Hensons Team von Puppenbauern. Beides, Special Effects und Puppen, steckt noch in seinen Kunstwerken, die entweder die erschreckende Größe von Riesen oder eine merkwürdige Zwergenhaftigkeit aufweisen. Das gilt auch für seine neueren Arbeiten wie *Wild Man* (2005), *Two Women* (2005) und *A Girl* (2006). Die von der üblichen Norm abweichende Dimensionierung machen Muecks Menschenplastiken einzigartig. Interessant ist dabei vor allem seine Auseinandersetzung mit der Monumentalskulptur. Diese nutzt die erhebliche Vergrößerung der menschlichen Dimensionen meist für die Darstellung von Göttern, Helden und Herrschern. Nicht zuletzt durch die Größe wird dabei der Status der Dargestellten bestätigt. Muecks riesenhafte Figuren hingegen schauen angstvoll drein (*Wild Man*) oder stehen in ihrer Entwicklung noch lange vor der Bewertung, ob Gott, Held oder Herrscher – es sind immer wieder auch Neugeborene (*A Girl*). Solcherart unterläuft Mueck den heroischen Pathos der Monumentalskulptur, legt ihren Mechanismus offen, verbunden mit der Frage, inwiefern *size matters*.

Dans sa *Poétique*, Aristote notait déjà que les hommes se réjouissent à la vue de représentations fidèles des choses et ne cessent donc d'en produire. Dans les années 1960, Duane Hanson créait des sculptures que l'on pouvait prendre pour des personnes réelles tant elles étaient réalistes. Du fait de leur réalisme marqué, voire exacerbé, ces œuvres sont qualifiées d'hyperréalistes. Tout comme Hanson, Ron Mueck travaille surtout avec la fibre de verre, le polyester et le latex, et plus récemment avec de la silicone, matériau plus souple. À cela s'ajoutent la couleur et les accessoires tels cheveux et vêtements. Sa maestria dans l'hyperréalisme, Mueck l'a acquise en travaillant pour les effets spéciaux au cinéma et comme membre de l'équipe de fabricants de marionnettes de Jim Henson. Ces deux domaines transparaissent encore dans ses œuvres, qui présentent soit l'effrayante grandeur des géants, soit un étrange nanisme. La même chose vaut pour ses œuvres récentes comme *Wild Man* (2005), *Two Women* (2005) ou *A Girl* (2006). S'écartant de la norme habituelle, les dimensions de ses œuvres font le caractère unique de sa sculpture humaine. Dans ce contexte, un aspect intéressant est surtout sa confrontation avec la sculpture monumentale, qui utilise généralement le fort agrandissement de la taille humaine pour représenter les dieux, les héros et les princes. Si les dimensions de ces œuvres contribuent à confirmer le statut des personnages représentés, les immenses figures de Mueck ont pour leur part des regards apeurés (*Wild Man*), ou bien leur évolution les situe très en deçà de la question de savoir s'il faut les considérer comme des dieux, des héros ou des princes – il s'agit aussi régulièrement de nouveau-nés (*A Girl*). Mueck court-circuite ainsi le pathos héroïque de la sculpture monumentale, met à nu ses mécanismes – avec la question de savoir dans quelle mesure *size matters*. H. L.

SELECTED EXHIBITIONS →
2008 *Ron Mueck*, Kanazawa 21st Century Museum of Contemporary Art, Kanazawa. *Real Life: Guy Ben-Ner; Ron Mueck*, National Gallery of Canada, Ottawa **2007** *Ron Mueck*, The Andy Warhol Museum, Pittsburg. *Ron Mueck: A Girl*, CAC Málaga **2005** *Ron Mueck*, Fondation Cartier, Paris; Brooklyn Museum of Art, Brooklyn; Gallery of Canada, Ottawa; The Modern Art Museum of Fort Worth et al. *Melancholie – Genie und Wahnsinn in der Kunst*, Neue Nationalgalerie, Berlin

SELECTED PUBLICATIONS →
2008 *Ron Mueck*, Kanazawa 21st Century Museum of Contemporary Art, Kanazawa; Foil, Tokyo. *Real Life: Guy Ben-Ner; Ron Mueck*, National Gallery of Canada, Ottawa; ABC Art Books Canada, Montreal **2007** *Ron Mueck: A Girl*, CAC Málaga, Málaga **2006** *Ron Mueck: Catalogue raisonné*, Hatje Cantz, Ostfildern. *Ron Mueck*, Thames & Hudson, London **2005** *Ron Mueck*, Fondation Cartier, Paris; Brooklyn Museum of Art, Brooklyn; Gallery of Canada, Ottawa, The Modern Art Museum of Fort Worth et al.; Paris – Actes Sud, Paris

1 **Wild Man**, 2005, mixed media, 285 x 162 x 108 cm
2 **A Girl**, 2006/07, mixed media, 110 x 502 x 135 cm

3 **Two Women**, 2005, mixed media, 85 x 48 x 38 cm

„Ich habe nie lebensgroße Figuren gemacht, weil es mir nie interessant schien. Man trifft jeden Tag lebensgroße Menschen."

« Je n'ai jamais réalisé de figures grandeur nature parce que cela ne m'a jamais semblé intéressant. Des gens grandeur nature, nous en croisons à longueur de journée. »

"I never made life-size figures because it never seemed to be interesting. We meet life-size people every day."

2

Takashi Murakami

1962 born in Tokyo, lives and works in Tokyo, Japan, and New York (NY), USA

Takashi Murakami virtually embraces today's lack of distinction between high art and fashionable consumer goods. His 2007 retrospective at the LA MOCA included a merchandize shop for all the mass-produced objects and craftworks that bear his name, displayed behind glass, and even more controversially an exclusive Louis Vuitton boutique installed comfortably in the exhibition. There, amongst wall-to-wall white enamel display cases that evoked the "hush" that normally falls over those walking into a museum, visitors could purchase one of Murakami's signature Vuitton handbags. Unafraid of any potential confusion between his unique works and commercial products, he most likely has delighted in the flood of cheap knock-offs his handbags have spawned. Contrary to the romanticized idea of the solitary artist, Murakami is firmly in control of his own image or "brand". He oversees a fully-fledged enterprise, the Kaikai Kiki company, which operates partly as an artist's collective and partly as an industrial assembly line to produce the full gamut of his artistic output, from sculptures and paintings to key rings, toys and T-shirts. These products usually feature a cast of subversive characters in cartoon fantasylands reminiscent of video games, fusing Western pop and Japanese *manga* and *anime*. Mr. DOB, Murakami's most prominent character, was deliberately modelled after long-lived and popular cuddly creatures like Hello Kitty and Doraemon, which are ubiquitous in Japan. Like them, Murakami's inventions are now so widely recognized that they have become successful self-perpetuating promotional devices for the Murakami brand.

Takashi Murakami durchschaut die heute herrschende Unfähigkeit, zwischen hoher Kunst und modernen Konsumgütern zu unterscheiden. In seiner Retrospektive 2007 im LA MOCA gab es einen Merchandise-Shop hinter Glas für all die massenproduzierten Objekte und Kunstgegenstände, die seinen Namen tragen, und, noch umstrittener, eine exklusive Boutique von Louis Vuitton inmitten der Ausstellung. Dort, zwischen weißen, die ganze Wand ausfüllenden emaillierten Verkaufsvitrinen, welche die ehrfürchtige Stille hervorriefen, die normalerweise den Museumsbesucher befällt, konnte man einer der von ihm entworfenen Vuitton-Taschen erwerben. Furchtlos, was die mögliche Verwechslung von seinen Einzelstücken mit seinen kommerziellen Produkten angeht, hatte er wahrscheinlich an der Flut billiger Kopien, die seine Handtaschen bald hervorbrachten, selbst am meisten Spaß. Im Gegensatz zur romantisierten Vorstellung des einzelgängerischen Künstlers, hat Murakami sein eigenes Image und seinen „Markennamen" fest im Griff. Er steht einem ausgewachsenen Unternehmen vor, Kaikai Kiki, das teilweise wie ein Künstlerkollektiv und teilweise wie eine industrielle Maschinerie funktioniert, um die volle Skala seines künstlerischen Schaffens herzustellen: von Skulpturen und Gemälden bis Schlüsselanhängern, Spielsachen und T-Shirts. Auf diesen Produkten ist in der Regel eine Reihe von subversiven Figuren aus Cartoon-Fantasiewelten zu sehen, die an Videospiele erinnern und westlichen Pop mit japanischem Manga und Anime verbinden. Mr. DOB, Murakamis populärste Figur, wurde altbekannten und beliebten Schmusewesen frei nachgebildet, die in Japan allgegenwärtig sind, wie Hello Kitty und Doraemon. Auch Murakamis Schöpfungen sind inzwischen so bekannt, dass sie ein erfolgreiches selbstlaufendes Werbemittel für die Marke Murakami geworden sind.

Takashi Murakami se joue en quelque sorte de la confusion qui règne actuellement entre grand art et biens de consommation à la mode. Sa rétrospective de 2007 au MOCA de Los Angeles intégrait une boutique avec tous les objets industriels et artisanaux portant son nom, présentés derrière des vitrines et, plus controversée encore, une boutique Louis Vuitton en exclusivité, confortablement installée dans l'exposition. Parmi des vitrines murales vernies blanches, évoquant le silence pesant sur les visiteurs qui déambulent dans un musée, ces derniers pouvaient acheter l'un des sacs à main signés par l'artiste. Loin de redouter une éventuelle confusion entre ses pièces uniques et les produits commerciaux, il s'est très certainement délecté de l'avalanche d'imitations bon marché suscitées par ses sacs à main. À l'opposé de l'idée romantique de l'artiste solitaire, Murakami contrôle résolument sa propre image ou « marque ». Il supervise une entreprise à part entière, la société Kaikai Kiki, qui fonctionne à la fois comme un collectif d'artistes et une chaîne d'assemblage industrielle, chargée de produire toute la gamme de sa production artistique, depuis les sculptures et tableaux jusqu'aux porte-clés, jouets et T-shirts. Ces produits mettent généralement en scène un casting de personnages subversifs dans des univers imaginaires qui rappellent les jeux vidéos et mêlent culture pop occidentale d'une part et *mangas* et *animes* japonais d'autre part. C'est délibérément que Mr. DOB, figure la plus célèbre de Murakami, s'inspire des sympathiques Hello Kitty et Doraemon, des personnages populaires et d'une grande longévité, omniprésents au Japon. À l'instar de ces figures, les inventions de Murakami bénéficient aujourd'hui d'une telle notoriété qu'elles sont devenues pour la marque Murakami des outils promotionnels efficaces et capables de s'auto-générer.

CH. L.

SELECTED EXHIBITIONS →
2007 *Takashi Murakami: ©Murakami*, The Greffen Contemporary at MOCA, Los Angeles; Brooklyn Museum of Art, Brooklyn; MMK Frankfurt. *Takashi Murakami: Jellyfish Eyes*, MCA, Chicago. *INSIGHT?*, Gagosian Gallery/Red October Chocolate Factory, Moscow. *Red Hot: Contemporary Asian Art Rising*, Museum of Fine Arts, Houston. *Comic Abstraction*, MoMA, New York. **2006** *Get Ready, Land of the Rising Sun! Contemporary Japanese Art from Taikan Yokoyama to the Present*, Osaka City Museum of Modern Art, Osaka

SELECTED PUBLICATIONS →
2007 *Takashi Murakami: ©MURAKAMI*, Rizzoli, New York. *INSIGHT?*, Gagosian Gallery/Red October Chocolate Factory, Moscow
2005 *Takashi Murakami: Little Boy*, Kaikai Kiki Co. Ltd, New York. *Takashi Murakami: Summon Monsters? Open The Door? Heal? Or Die?*, Trucatriche, Chula Vista

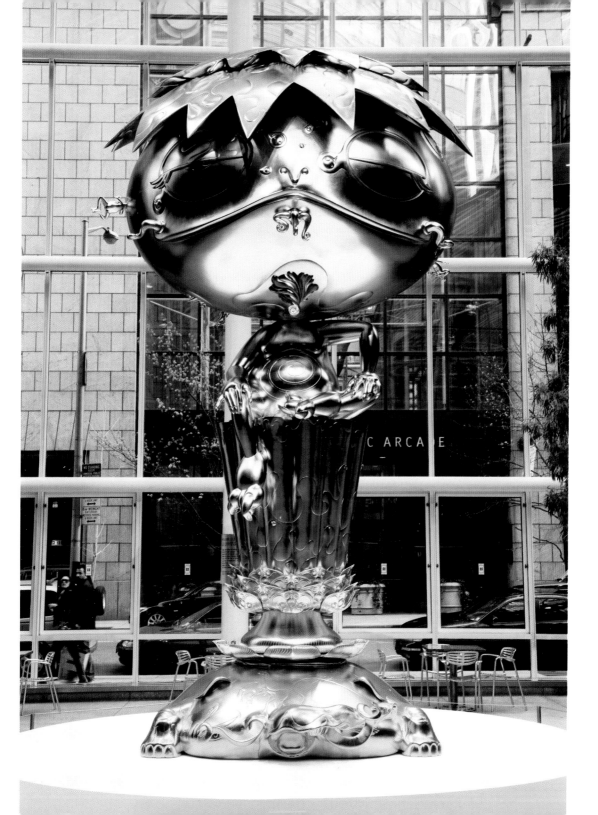

1 **Oval Buddha**, 2007, aluminium and platinum leaf, 568 x 318.9 x 311.5 cm. Photo: GION
2 **Flower Matango (b)**, 2001–06, **Kawaii! Vacances d'été**, 2002 (painting). **Cosmos**, 2003 (wallpaper). Installation view, © *Murakami*, Brooklyn Museum, New York, 2008. Photo: GION

3 **Second Mission Project ko² Advanced**, 1999–2007, oil, acrylic, fibreglass, iron, installation at the Brooklyn Museum, 2008
All artworks © 1999–2008 Takashi Murakami/Kaikai Kiki Co., Ltd. Photo: GION

„Wenn meine Arbeit ein Massenpublikum findet, dann bedeutet das, dass ich gut kommunizieren kann ... Ich will ein großes Publikum, damit meine Werke in der Zukunft weiterleben."

« Quand mes œuvres touchent un public de masse, cela signifie que je communique correctement... Je veux un large public, de manière à ce que que mes objets survivent dans le futur. »

"When my work reaches a mass audience, then it means I'm able to communicate well... I want a big audience so that my pieces can survive in the future."

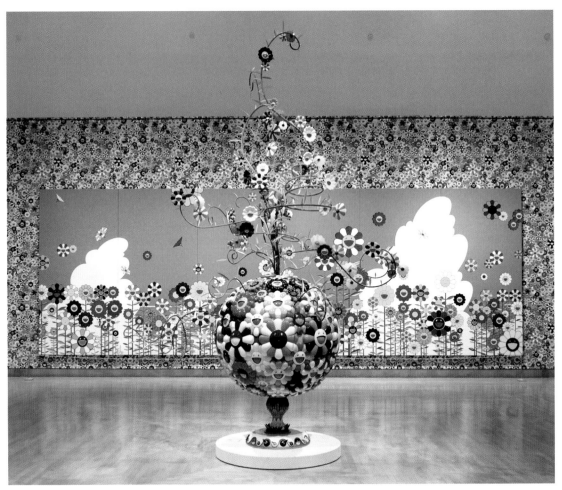

3

Ernesto Neto

1964 born in Rio de Janeiro, lives and works in Rio de Janeiro, Brazil

When Ernesto Neto installed *Léviathan Thot* (2006) at the Paris Panthéon, he created a sculpture that established one of the most prolific dialogues between art and architecture seen in recent times. The large sculpture, made from tulle and polystyrene, hung throughout the building's full central nave like a creature with soft, tube-like limbs. Its voluptuous organic forms created a baroque dialogue with the Panthéon's strict classicism. Neto's interest in a sculptural architecture is deeply layered with corporeal and sensory notions – a legacy of the sensuous geometry of Brazilian neo-concretism. Weight, mass, volume, but also tension, transparence and gravity are set against colonnades, ornaments and the building's profoundly republican sense, creating a permanent exchange between the inside and the outside, between individuality and collectivity. From his early beginnings, Neto has related the most classical issues of sculpture and composition to an idea of penetration, pregnancy and a presence of the spectator's body in the artwork. He has described his works as an exploration and a representation of the body's landscape from within, one which the viewer should interact with and physically experience by feeling, smelling and touching it. In *The Malmö Experience* (2006), a sculpture made of several sculptures, the artist offered such a landscape to be entered, travelled and experienced by the spectator: an organic labyrinth of fabrics, shapes and scented spices, the diverse topological elements inside destabilized the spectator's perception with olfactory and tactile sensations, with passages of light and labyrinthine pathways.

Als Ernesto Neto *Léviathan Thot* (2006) im Pariser Panthéon installierte, schuf er eine Skulptur, die einen der fruchtbarsten Dialoge zwischen Kunst und Architektur in den letzten Jahren anregte. Die große Skulptur aus Tüll und Styropor hing im Hauptschiff des Gebäudes wie ein Lebewesen mit weichen röhrenartigen Gliedern. Seine ausschweifenden organischen Formen schufen einen barocken Dialog mit dem strengen Klassizismus des Panthéon. Netos Interesse an skulpturaler Architektur ist tief mit Vorstellungen zu Körper und Wahrnehmung verbunden – ein Erbe der sinnlichen Geometrie des brasilianischen Neo-Konkretismus. Gewicht, Masse, Volumen, aber auch Spannung, Transparenz und Schwerkraft werden gegen die Kolonnaden, Ornamente und die tief republikanische Ausstrahlung des Gebäudes gesetzt. So schaffen sie einen permanenten Austausch zwischen Innen und Außen, Individuum und Kollektiv. Seit seinen Anfängen hat Neto die klassischen Fragen von Skulptur und Komposition in Zusammenhang gebracht mit einer Idee des Eindringens, der Schwangerschaft, der körperlichen Gegenwart des Betrachters im Kunstwerk. Er hat seine Arbeiten als eine Erkundung und eine Darstellung der Landschaft des Körpers von innen beschrieben, mit der der Betrachter interagieren und sie durch Fühlen, Riechen und Berühren physisch erfahren soll. Mit *The Malmö Experience* (2006), einer Skulptur aus mehreren Skulpturen, bot der Künstler dem Betrachter solch eine Landschaft zum Betreten, Durchreisen und Berühren: ein organisches Labyrinth aus Gewebe, Formen und duftenden Gewürzen, verschiedenen topologischen Elementen, die die Wahrnehmung des Betrachters mit Geruchs- und Tastempfindungen, mit Lichtdurchgängen und labyrinthischen Wegen ins Schwanken brachten.

Avec l'installation de *Léviathan Thot* (2006) au Panthéon à Paris, Ernesto Neto a établi l'un des dialogues les plus féconds de ces dernières années entre art et architecture. L'énorme sculpture, faite de tulle et de polystyrène, était suspendue à travers toute la nef centrale du bâtiment, telle une créature aux membres tubulaires souples. Ses formes organiques voluptueuses créaient un échange baroque avec le classicisme strict du Panthéon. L'intérêt de Neto pour une architecture sculpturale est fortement chargé de concepts corporels et sensoriels – un héritage de la géométrie sensuelle du néo-concrétisme brésilien. Poids, masse et volume, ainsi que tension, transparence et attraction, confrontés à un contexte de colonnades, d'ornements et du sens fortement républicain du bâtiment, créent un échange permanent entre l'intérieur et l'extérieur, entre l'individuel et le collectif. Neto a relié très tôt les points les plus classiques de la sculpture et de la composition à l'idée de pénétration, de grossesse et de présence du corps du spectateur dans l'œuvre d'art. Il a décrit ses œuvres comme une exploration et une représentation de l'intérieur du paysage humain, une représentation avec laquelle le spectateur doit dialoguer et qu'il doit éprouver physiquement par le toucher et l'odorat. Dans *The Malmö Experience* (2006), une sculpture composée de plusieurs sculptures, le spectateur devait pénétrer dans un paysage, y voyager, l'éprouver. Les différents éléments topologiques à l'intérieur de ce labyrinthe organique de textiles, de formes et de senteurs épicées, les corridors de lumière et les chemins dédaléens déstabilisaient la perception et les sens du spectateur – son toucher et son odorat.

R. M

SELECTED EXHIBITIONS →
2008 *Ernesto Neto: 1/3*, Fondazione Volume!, Roma. *Ernesto Neto: While Nothing Happens*, Museo d'Arte Contemporanea, Roma **2007** *Ernesto Neto*, Marugame Genichiro-Inokuma, Museum of Contemporary Art, Kagawa. *Ernesto Neto*, Museum of Contemporary Art San Diego. *To Be Continued...*, Magasin 3 Stockholm Konsthall, Stockholm **2006** *Ernesto Neto: The Malmö Experience*, Malmö Konsthall, Malmö. *Ernesto Neto: Léviathan Thot*, 35e Festival d'Automne, Panthéon, Paris. *Surprise Surprise*, ICA, London.

SELECTED PUBLICATIONS →
2008 *Ernesto Neto: From Sebastian to Olivia*, Galerie Max Hetzler; Holzwarth Publications, Berlin **2007** *Olaf Nicolai, Ernesto Neto, Rebecca Warren*, Parkett 78, Zürich. *Held Together with Water. Kunst der Sammlung Verbund*, Hatje Cantz, Ostfildern **2006** *Léviathan Thot*, Festival d'Automne, Paris. *The Malmö Experience*, Malmö Konsthall, Malmö. *Carbonic Anhydride*, Galerie Max Hetzler, Berlin.

1 **Léviathan Thot**, 2006, polyamide, styrofoam balls, 5300 x 6200 x 5600 cm. Installation view, Panthéon, Paris
2 **Meditation on Colour Vibration – Matter Colour**, 2007, cotton fabric, plastic rings, 240 x 277 cm
3 **The Creature, Malmö Experience**, 2006, cotton textile, polyamide, cotton cloth, polyurethane foam, plastic pipes (bones), sand, polypropylene,

glass beads, plastic spheres, polystyrene pellet, turmeric, clove, lavender, cumin, black pepper, 350 x 6500 x 2300 cm. Installation view, Malmö Konsthall, Malmö
4 **Now BTTA**, 2007, polyamide, cumin, clove, pepper, turmeric, 512 x 840 x 616 cm, dimensions variable. Installation view, Galerie Max Hetzler Temporary, OsramHöfe, Berlin

„Ich will nicht etwas schaffen, das einen sinnlichen Körper darstellt – ich will, dass es ein Körper ist, als Körper existiert oder wenigstens als Idee davon."

« Je ne veux pas faire une œuvre qui décrive un corps sensuel – je veux qu'elle soit un corps, qu'elle existe en tant que corps ou en tant qu'idée de ce corps. »

"I don't want to make work that depicts a sensual body – I want it to be a body, exist as a body or as an idea of it."

2

3

Tim Noble and Sue Webster

Tim Noble, 1966 born in Stroud, and Sue Webster, 1967 born in Leicester; live and work in London, United Kingdom

Artist duo Tim Noble & Sue Webster carved out a place for themselves in the British art scene of the 1990s – at the tail end of the Young British Artists movement – with work that falls somewhere between trashy punk-inspired art, light projections of shadow images and installations imbued with Las Vegas romanticism. They have become known above all for their ironic self-portraits made from household junk and dead animals, sometimes with a Neanderthal physiognomy. In their recent works Noble & Webster have cleaned up their materials and forms: the rubbish has been replaced by steel, for example (as in *The Glory Hole*, a group of sculptures from 2005). They haven't stopped working with light, however. The kinetic light sculpture *Sacrificial Heart* (2007) mixes Christian symbolism with biker iconography, and for their monumental *Electric Fountain* (2008), installed in front of New York's Rockefeller Center, they turned 3390 LED bulbs and 527 metres of neon tubing into a three-dimensional electric fountain. The colour and strength of the light changes according to the weather. In London's Freud Museum, on the other hand, Noble & Webster emphasized the shock factor. The installation *Scarlett* (2006), part of the project *Polymorphous Perverse*, shows a workbench on which bizarre mechanical devices – bastardized versions of children's toys – evoke sexual fantasies. This all relates to Freud, of course, who diagnosed a state of sexual chaos during childhood that is regarded as perverse from an adult perspective. Noble & Webster have ultimately remained true to themselves: they investigate the workings of consumerism, commerce and sexuality, all of which are core elements of modern market-economy-based society.

Das englische Künstlerpaar Tim Noble & Sue Webster hat sich in den 1990er-Jahren in der Folge der Young British Artists zwischen Trash Art mit Punk-Gestus, Lichtkunst mit Schattenbildern und Installationen mit Las-Vegas-Romantik positioniert. Vor allem ihre ironischen Selbstporträts, bestehend aus Haushaltsmüll und toten Tieren, zuweilen geformt in Neandertaler-Physiognomik, brachten ihnen erhöhte Aufmerksamkeit. Bei neueren Arbeiten räumen Noble & Webster mit ihrem Material- und Formenvokabular auf, der Müll etwa verschwindet zugunsten von Stahl (Skulpturengruppe *The Glory Hole*, 2005). Lichtwirkungen bleiben ihnen dabei weiterhin ein Anliegen. Sei es bei der kinetischen Leuchtskulptur *Sacrificial Heart* (2007), die christliche Symbolik mit Biker-Ikonografie mischt, oder sei es beim monumentalen *Electric Fountain* (2008) vor dem Rockefeller Center in New York. Noble & Webster verarbeiteten dafür 3390 LED-Glühbirnen und 527 Meter Neonschlauch, um einen elektrischen 3D-Springbrunnen herzustellen, dessen Farbe und Lichtstärke sich mit der Wettersituation ändert. Im Londoner Freud Museum hingegen frönten sie ihrer Lust am Schrecken. Die Installation *Scarlett* (2006) im Rahmen des Projekts *Polymorphous Perverse* zeigt eine Werkbank, auf der bizarre mechanische Geräte als bastardisierte Versionen von Kinderspielzeug sexuelle Phantasien inkludieren. Das Ganze geschieht mit Bezug zu Freud, welche bei der Kindesentwicklung einen Zustand sexueller Chaotik diagnostizierte, der aus Erwachsenenperspektive als pervers gewertet wird. Letztlich bleiben sich Noble & Webster somit treu: Sie untersuchen die Funktionsweise von Konsum, Kommerz und Sexualität, mithin Kernelemente dessen, was eine marktwirtschaftlich orientierte Gesellschaft ausmacht.

Pendant les années 1990, le couple d'artistes anglais Tim Noble & Sue Webster s'est inscrit dans le sillage des Young British Artists entre art trash avec attitude punk, projections lumineuses d'ombres et installations empreintes d'un romantisme de style Las Vegas. Ce sont surtout leurs autoportraits ironiques faits d'ordures ménagères et d'animaux morts, aux traits parfois néandertaliens, qui leur ont valu une forte notoriété. Les œuvres récentes de Noble & Webster font le ménage dans leur vocabulaire formel et leurs matériaux : les ordures disparaissent au profit de l'acier (groupe de sculptures *The Glory Hole*, 2005) tandis que les effets de lumière continuent de les intéresser, que ce soit avec la sculpture cinétique lumineuse *Sacrificial Heart* (2007), qui mêle symbolique chrétienne et iconographie des motards, ou avec la monumentale *Electric Fountain* (2008) réalisée au pied du Rockefeller Center à New York. Pour celle-ci, Noble & Webster ont utilisé 3390 ampoules à leds et 527 mètres de tube néon formant une fontaine électrique en 3D dont les couleurs et l'intensité lumineuse varient en fonction des conditions météo-rologiques. Au Freud Museum de Londres, ils ont en revanche donné libre cours à leur goût de l'horreur. L'installation *Scarlett* (2006) réalisée dans le cadre du projet *Polymorphous Perverse* montre un établi sur lequel d'étranges outils, versions bâtardes de jouets d'enfants, évoquent des fantasmes sexuels. Le tout est une référence à Freud et à la sexualité chaotique dans laquelle il avait vu une étape du développement de l'enfant et que les adultes considèrent comme une perversité. En définitive, Noble & Webster restent donc fidèles à eux-mêmes : ils étudient le mode fonctionnel de la consommation, du commerce et de la sexualité, éléments qui déterminent si souvent une société régie par l'économie de marché.

H. L.

SELECTED EXHIBITIONS →
2008 *Tim Noble & Sue Webster*, Goss-Michael Foundation, Dallas *Tim Noble & Sue Webster: Electric Fountain*, Rockefeller Center, New York. *True Romance*, Kunsthalle Wien, Vienna; Villa Stuck, Munich; Kunsthalle Kiel **2007** *Images of Man Today*, Arken Museum, Copenhagen **2006** *Tim Noble & Sue Webster: Polymorphous Perverse*, The Freud Museum, London. *Masquerade*, Museum of Contemporary Art, Sydney **2005** *Tim Noble & Sue Webster: The New Barbarians*, CAC Málaga

SELECTED PUBLICATIONS →
2008 *Tim Noble & Sue Webster: Polymorphous Perverse*, White Cube; Other Criteria, London **2007** *Traum und Trauma*, MUMOK, Vienna; Hatje Cantz, Ostfildern **2006** *Tim Noble & Sue Webster: Wasted Youth*, Rizzoli, New York **2005** *Tim Noble & Sue Webster: The New Barbarians*, CAC Málaga, Málaga

1 **Electric Fountain**, 2007, steel, 3390 LED bulbs, 52700 cm of neon tubing, 1067 x ø 914 cm. Installation view, Rockefeller Center, New York
2 **Spinning Heads**, 2005, painted bronze, Tim (black) 38 x 34 x 34 cm, Sue (white) 38 x 35 x 35 cm
3 **Black Narcissus**, 2006, black poly-sulphide rubber, wood, light projector, 38 x 72 x 60 cm

4 **Scarlett**, 2006, workbench table, studio detritus, taxidermy animals, mechanical assemblages, electric motors, urine, theatre blood, cooking oil, peanut butter, 185 x 189 x 144 cm. Installation view, Deitch Projects, New York, 2008

„Ein Mann wacht des Morgens auf, die Sonne scheint, die Vögel singen, es ist ein wunderschöner, optimistischer Tag. Er nimmt einen tiefen Luftzug, trommelt auf seine Brust und fühlt sich unbesiegbar … Der selbe Mann wacht am nächsten Tag auf, versteckt sich zitternd unter der Decke, hat zu viel Angst, um die Sicherheitszone des eigenen Betts zu verlassen … Der Himmel ist grau und düstere Gedanken treiben über seinem Kopf. Er fühlt sich überflüssig, verloren und verletzlich – völlig allein in der Welt … Das ist das Leben eines Künstlers."

« Un homme se réveille de bon matin, le soleil brille ; les oiseaux chantent, c'est une journée radieuse et pleine d'optimisme. Il respire profondément l'air frais, frappe sa poitrine et se sent invincible… Le même homme se réveille le lendemain, se recroqueville et frissonne sous ses draps, trop apeuré pour quitter la sécurité de son lit… Le ciel est gris, de sombres pensées flottent au-dessus de sa tête. Il se sent inutile, perdu et vulnérable – complètement seul au monde… Telle est la vie de l'artiste. »

"A man wakes up in the morning, the sun is shining, the birds are singing, it's a beautifully optimistic day. He takes a deep breath of fresh air, beats his chest and feels invincible… The same man wakes up the next day, he cowers and shivers beneath the sheets, too afraid to leave the safety of his own bed… The sky is grey and there are dark thoughts floating above his head. He feels redundant, lost and vulnerable – totally alone in the world… This is the life of an artist."

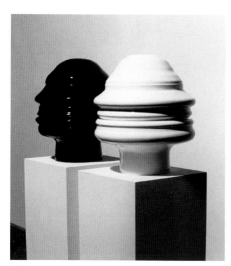

2

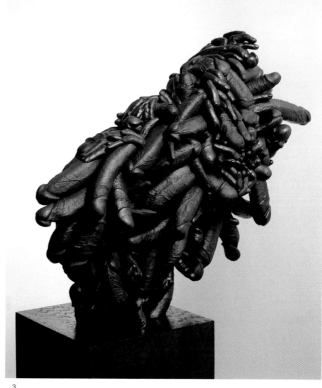

3

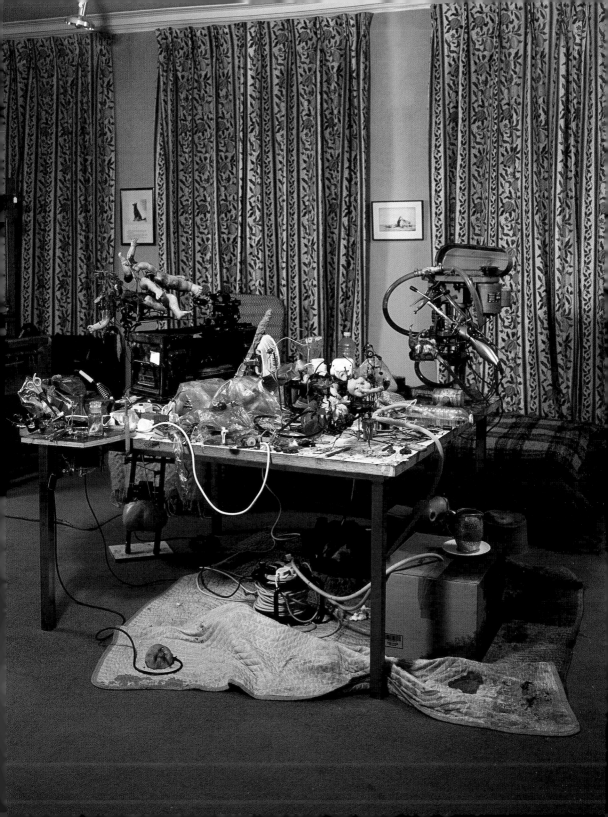

Albert Oehlen

1954 born in Krefeld, Germany, lives and works in Switzerland and Spain

After an early realization that the best way to critique painting is, in fact, to paint, Albert Oehlen, the good object of "bad" German painting, has wittily bastardized the medium's lofty pretensions for decades with a smorgasbord of figurative and non-objective offerings: "post-non-representational" abstract paintings, grey paintings, mirror paintings, computer paintings, posters and collages. Something of an aesthetic magpie, Oehlen has nonetheless – temporarily at least – alighted on rather luminous compositions, exhibited in his cheekily titled New York show, *Painter of Light*. Works including *(Durch die) rosa Brille* (2006) flaunt a spectrum of washes (pea green, goldenrod, the pink of the title) layered with arabesque ribbons and crossed with gooey drips. Fragmentary forms surface in other compositions, making clear the fact that Oehlen uses collage, albeit in a self-annihilating manner, as the basis for most paintings. Recent pieces such as *Hey* (2007) play image against word in an elaborate game of cat and mouse: the painting's text is obstructed by a nebulous grey blur and Lichtenstein-worthy explosion marks, all of which bursts beyond the confines of a frame within the frame which also contains an assortment of kitchen pots. These juxtapositions suggest a stream of consciousness that foregrounds the arbitrary nature of most signs and marks alike. Though he came of age at the peak of neo-expressionism, Oehlen was influenced by an interest in music and Gestalt theory as much as by the art of Jörg Immendorf and Sigmar Polke, and he might be thought of as a kind of latter-day surrealist pushing the limits of representation to exquisitely absurd failure.

Nachdem er früh erkannt hatte, dass der beste Weg, Bilder zu kritisieren, der ist, selbst welche zu malen, untergräbt Albert Oehlen, die gute Hauptfigur des deutschen „bad painting", seit Jahrzehnten absichtlich die hohen Ansprüche des Mediums mit einem Reichtum von figurativen und abstrakten Arbeiten: „post-ungegenständliche" abstrakte Gemälde, graue Gemälde, Spiegelbilder, Collagengemälde, Computergemälde und Poster. Oehlen, der so etwas wie eine ästhetische Elster ist, hat sich in letzter Zeit – zumindest vorübergehend – auf leuchtendere Kompositionen eingelassen, wie er sie in seiner hintergründig betitelten New Yorker Ausstellung *Painter of Light* zeigte. Arbeiten wie *(Durch die) rosa Brille* (2006) leuchten durch die Vielzahl von Farbtönen (Erbsengrün, Ocker und das namensgebende Rosa), die von arabesken Bändern und von zähen Tropfen überlagert werden. Fragmentarische Formen tauchen auch in anderen Kompositionen auf und unterstreichen die Tatsache, dass Oehlen heute die Collage, wenn auch in einer selbstzerstörerischen Weise, als Grundlage der meisten Bilder verwendet. In jüngsten Arbeiten wie *Hey* (2007) spielen Bild und Wort miteinander ein kunstvolles Katz- und Mausspiel: Der Text des Bildes wird von nebelhaften grauen Flecken und einer Explosion à la Lichtenstein verdeckt; diese sprengt die Grenzen eines Rahmens im Rahmen, in dem sich auch eine Reihe von Kochschüsseln befindet. Dieses Nebeneinander deutet einen Bewusstseinsstrom an, der die Zufälligkeit der meisten Zeichen in den Vordergrund stellt. Obwohl er in der Zeit des Neoexpressionismus groß wurde, ließ sich Oehlen ebenso von Musik und Gestalttheorie beeinflussen wie von Jörg Immendorf und Sigmar Polke; man könnte ihn eine Art modernen Surrealisten nennen, der die Grenzen der Darstellung hin zu einer erlesenen Form des absurden Scheiterns verschiebt.

Après s'être rendu compte très tôt que la meilleure façon de critiquer la peinture était encore de peindre, Albert Oehlen, le bon sujet de la « mauvaise » peinture allemande, a malmené avec esprit pendant des années les prétentions de ce moyen d'expression avec tout un assortiment d'offres non-figuratives : peintures abstraites « post non-figuratives », peintures grises, peintures de miroir, peintures générées par ordinateur, affiches et collages. En collectionneur de l'esthétique, Oehlen s'est néanmoins – du moins temporairement – arrêté à des compositions plus lumineuses, présentées avec insolence dans une exposition à New York intitulée *Painter of Light*. Des œuvres comme *(Durch die) rosa Brille* (2006) affichent des lavis (vert pomme, bouton d'or, rose éponyme) pourvus de rubans en arabesque et de coulures sirupeuses. D'autres compositions font apparaître des formes fragmentaires, dévoilant la technique du collage utilisée, quoique s'auto-anéantissant, comme base pour la plupart de ses peintures. Des pièces récentes, comme *Hey* (2007), jouent image contre mot dans un jeu complexe du chat et de la souris : le texte de la peinture est brouillé par un gris nébuleux et des traces d'explosion dignes de Lichtenstein. Le tout jaillit au-delà des limites d'un cadre dans le cadre contenant un assortiment de pots de cuisine. Ces juxtapositions suggèrent un état de conscience qui met en relief la nature arbitraire de la plupart des signes et des traces. Bien qu'arrivé à maturité à l'apogée du néo-expressionnisme, Oehlen a été influencé par la musique et la *Gestalt*, par les œuvres de Jörg Immendorf et de Sigmar Polke, et pourrait être considéré comme une sorte de surréaliste des temps modernes, poussant les limites de la représentation jusqu'à l'échec absurde.

S. H.

SELECTED EXHIBITIONS →
2008 *Bad Painting – Good Art*, MUMOK, Vienna **2007** *Klio: Eine kurze Geschichte der Kunst in Euramerika nach 1945*, ZKM, Karlsruhe **2006** *Albert Oehlen*, Whitechapel Art Gallery, London; Arnolfini, Bristol. *Albert Oehlen/Marc Goethals*, Museum Dhondt-Dhaenens, Deurle. *Die Götter im Exil: Salvador Dali, Albert Oehlen u.a.*, Kunsthaus Graz. **2005** *Albert Oehlen: I Know Whom You Showed Last Summer*, MOCA, North Miami. *Albert Oehlen: Selbstportrait mit 50millionenfacher Lichtgeschwindigkeit*, Kunsthalle Nürnberg, Nuremberg

SELECTED PUBLICATIONS →
2008 *Albert Oehlen*, Thomas Dane Gallery, London **2007** *Jon Kessler, Marilyn Minter and Albert Oehlen*, Parkett 79, Zürich **2006** *Albert Oehlen*, Galerie Max Hetzler, Berlin. *Albert Oehlen: I Will Always Champion Good Painting. I Will Always Champion Bad Painting*, Whitechapel Art Gallery, London; Arnolfini, Bristol. *Albert Oehlen: Mirror Paintings*, Galerie Max Hetzler; Holzwarth Publications, Berlin. *Albert Oehlen: The Painter of Light*, Luhring Augustine Gallery, New York **2004** *Albert Oehlen*, Secession, Vienna

1 **Das Grün**, 2007, oil, paper on canvas, 230 x 190 cm
2 **(Durch die) rosa Brille**, 2006, acrylic, oil on canvas, 280 x 340 cm

3 **Hey**, 2007, oil, acrylic, paper on canvas, 230 x 200 cm

„Als ich 15 war, gab es ein einfaches Rezept. Je härter oder komplizierter die Rockmusik war, um so mehr war sie gegen den Mainstream. Bei Kunst würde ich nicht von Härte sprechen, weil das blöd klingt. Meinen würde ich es aber trotzdem."

« Quand j'avais 15 ans, il y avait une recette toute simple. Plus la musique rock était dure ou compliquée, plus elle allait contre le courant dominant. Concernant l'art, je ne parlerais pas de dureté parce que ça a l'air débile. Mais c'est quand même ce que je penserais. »

"When I was 15, there was a simple recipe: the heavier or more complicated rock music was, the more it was against the mainstream. As far as art is concerned, I wouldn't say it's heavy, because that sounds stupid. But I still think that way."

2

Gabriel Orozco

1962 born in Jalapa, lives and works in Mexico City, Mexico, and New York (NY), USA

Gabriel Orozco's "drawing" *Dark Wave* (2006) is the artist's most spectacular work to date: the 14 metre long suspended skeleton of a Rorqual whale whose every knob, curve and crevice, tusky protrusion and flipper bone, is drawn over in black graphite in a concentric, geometric pattern, that leaves the creamy ivory surface visible in reverse. It is as if Orozco had mapped the beast not simply to acquaint himself with it, but to know how to orient himself in relationship to it. A curiosity for the topography of things, both the everyday and the out-of-the-ordinary, drives much of Orozco's art. Working across a range of traditional and new media, Orozco's is a tactile, rather than strictly ocular approach: seeing is absolutely not equivalent with knowing. The painting series *Dépliages* (2007), made from blobs of oil paint folded into small squares of paper, then unfolded, and his sculptures yielded from confronting his body mass with hunks of clay (e.g. *Pelvis*, 2007), seem born not so much from some age-old struggle between the artist and his materials, but from the simple positing of the question: "What if?" There is something deeply systematic and calculated about the exquisite play of red, white and blue tempera circles and gold-leaf of the *Samurai Tree* series (2006/07), the compositions of which are based in the principles of chess and the limits of a square, yet one still senses strong intuition at work in the seemingly organic multiplication of forms within the area of a quadrangle. With Orozco, the tension between the constraints of a system and his vital need for improvisation open up an extraordinarily fertile creative space.

Gabriel Orozcos „Zeichnung" *Dark Wave* (2006) ist die bislang bemerkenswerteste Arbeit dieses Künstlers: ein 14 Meter langes aufgehängtes Finnwalskelett, dessen Wülste, Bögen und Furchen, Rostrum und Flossen mit einem geometrischen, konzentrischen Muster in schwarzem Graphit überzogen sind, unter dem das cremige Elfenbeinweiß der Knochen hervorschimmert. Als hätte Orozco das Geschöpf kartografisch erfasst, um es zu erkunden und darüber hinaus die eigene Position in diesem Bezugssystem festzulegen. Viele seiner Werke entstehen aus einer Neugier für die Topografie sowohl gewöhnlicher als auch ungewöhnlicher Dinge. Orozco arbeitet in der Bandbreite traditioneller und neuer Medien und bedient sich einer eher taktilen als optischen Herangehensweise: Sehen und Verstehen sind nicht absolut äquivalent. Die Gemäldeserie *Dépliages* (2007), für die er kleine Papierquadrate mit Ölfarbe bekleckste, zusammen und wieder auseinander faltete, wie auch die Skulpturen, die aus seinem eigenen Körper aufgedrückten Tonklumpen entstanden (z.B. *Pelvis*, 2007), scheinen nicht so sehr aus dem uralten Ringen zwischen dem Künstler und seinem Material hervorgegangen zu sein, als vielmehr aus der einfachen Fragestellung: „Was wäre, wenn?" Strenge Systematik und Kalkül zeigen sich in dem exquisiten Zusammenspiel von roten, weißen und blauen Kreisen in Tempera und dem Blattgold in der Serie *Samurai Tree* (2006/07), deren Gestaltung auf den Prinzipien des Schachspiels und der Begrenzung eines Quadrats basiert, und doch spürt man noch die starken intuitiven Kräfte in der scheinbar organischen Multiplizierung der Formen innerhalb des Vierecks. Bei Orozco weitet sich die Spannung zwischen einschränkender Anordnung und vitalem Improvisationsdrang in einen ungemein fruchtbaren, schöpferischen Raum.

Le « dessin » de Gabriel Orozco intitulé *Dark Wave* (2006) est son œuvre la plus spectaculaire à ce jour : le squelette en suspension d'une baleine bleue de 14 mètres de long dont il a recouvert de graphite noir les moindres bosses, courbes, fissures, protubérances et os de nageoire d'un motif géométrique concentrique qui laisse transparaître la structure de couleur ivoire. C'est comme si Orozco avait cartographié l'animal, non seulement pour en faire sa connaissance, mais aussi pour entrer en relation avec lui. Une curiosité pour la topographie des choses, celles du quotidien comme celles sortant de l'ordinaire, sous-tend une grande partie de son œuvre. Travaillant avec une palette de techniques nouvelles et traditionnelles, Orozco a une approche plus tactile que visuelle dans son travail : la vue n'équivaut absolument pas à la connaissance. Sa série de peintures *Dépliages* (2007), composée de grosses gouttes de peinture à l'huile dans de petits carrés de papier pliés puis dépliés, ainsi que ses sculptures issues de la rencontre de la masse de son corps avec des blocs d'argile (par exemple *Pelvis*, 2007), semblent être nées non pas tant de la lutte ancestrale entre l'artiste et ses matériaux que de la simple question : « Et si ? » Il y a quelque chose de systématique et profondément calculé dans le jeu exquis des cercles à la feuille d'or et du rouge, blanc et bleu à la tempera de la série *Samurai Tree* (2006/07), dont l'agencement délimité par un carré est basé sur le principe de l'échiquier. L'on ressent pourtant une profonde intuition dans la multiplication, en apparence organique, de formes à l'intérieur d'un quadrilatère. Chez Orozco, la tension entre les contraintes d'un système et son besoin vital d'improvisation ouvre un champ créatif extraordinairement fertile.

V. R.

SELECTED EXHIBITIONS →
2008 *L'Argent*, FRAC Ile-de-France/Le Plateau, Paris. *The Implications of Image*, Museo Universitario de Ciencias y Arte, MUCA, Mexico City **2007** *Gabriel Orozco: Inner Circles of the Wall*, Dallas Museum of Art, Dallas. *Gabriel Orozco*, FRAC Picardie, Amiens. *What Is Painting?*, MoMA, New York. *The Shapes of Space*, Guggenheim Museum, New York **2006** *blueOrange Kunstpreis 2006. Gabriel Orozco*, Museum Ludwig, Cologne

SELECTED PUBLICATIONS →
2007 *Gabriel Orozco*, Museo del Palacio de Bellas Artes in Mexico City; Conaculta Publishers, Mexico City. *Gabriel Orozco: The Samurai Tree in Variants*, Verlag der Buchhandlung Walther König, Cologne **2005** *Gabriel Orozco: Catalogo De La Exposicion El Palacio De Cristal*, Madrid; Turner, Nashville **2004** *Gabriel Orozco: Trabajo 1992–2002*, Verlag der Buchhandlung Walther König, Cologne

1 **Samurai Tree 2H**, 2006, tempera, burnished gold leaf on cedar wood, 66.5 x 66.5 cm
2 **Dépliage, White 10**, 2007, oil on linen, 66 x 66 x 1.9 cm
3 **Pelvis**, 2007, bronze, 25.4 x 31.1 x 12.7 cm

4 **Dark Wave**, 2006, calcium carbonate, resin with graphite, 304 x 392 x 1375 cm
5 **Kytes Tree**, 2005, acrylic on linen, 200 x 200 cm

„Das Machen ist ein Teil des Resultats, des Ausgangs einer Geschichte. Und deshalb ist hier der Körper in Aktion, das Individuum in seiner Beziehung zum sozialen Raum, den sozialen Materialien und deren Ökonomie sehr wichtig."

« La réalisation fait partie du résultat final, elle fait partie de la fin de l'histoire. Et c'est pourquoi le corps en action, l'individu en action, en relation avec le champ social, les matériaux sociaux et leur économie sont très importants. »

"Making is part of the final result, is part of the final end of the story. And that's why the body in action, the individual in action, in relation with the social space, the social materials and economics of these is very important."

2

3

Raymond Pettibon

1957 born in Tucson (AZ), lives and works in Herosa Beach (CA), USA

Never one to mince words in his prolific ink and watercolour drawings, Raymond Pettibon nonetheless has recently employed language in the service of a surprisingly overt politics: a New York show in 2007, *Here's Your Irony Back (The Big Picture)*, featured the artist's name and show title scrawled in red, dripping down the chalky wall like B-movie blood; banners painted directly on the gallery wall drolly trumpeting "TWO CHEERS FOR THE RED WHITE AND BLUE" and equivocating Israel is "MORAL" with an insertion symbol wedging a "T" between the "R" and "A" to configure a reading of "MORTAL"; and a plethora of page-sized denunciations of the Iraq war, travesties of American foreign policy and failures of the regime of George W. Bush more generally. These aggregated drawings betray a deftness long associated with Pettibon's DIY, Los Angeles punk aesthetic – honed in the late 1970s and the 1980s while the artist was affiliated with SST Records and his brother's punk band Black Flag, designing their album covers, concert flyers and fanzines – though they point to more topical concerns than those explored in the past. Known for his musings on literary and philosophical sources as well as such quotidian mainstays as movies, music, sports, sex, Gumby and Superman, his incisive address of politics and social concerns becomes all the more compelling for its style. If Pettibon's installations assume the feel of a dorm room with a profusion of pasted images, his individual sketches suggest the work of a brilliant slacker rendering his ideas furiously into his notebook while slumped over his desk, who can only pretend to be too cool to care for so long.

Raymond Pettibon, der in seinen zahlreichen Tinten- und Aquarellzeichnungen nie ein Blatt vor den Mund nahm, hat sich in Werken jüngster Zeit dennoch überraschend offenkundig zur Politik geäußert. In der New Yorker Ausstellung *Here's Your Irony Back (The Big Picture)* (2007) waren der Name des Künstlers und der Ausstellungstitel mit roter Farbe wie in B-Movie-Blut an die weiße Wand gespritzt; direkt auf die Wand gemalte Tafeln schrien lustig „TWO CHEERS FOR THE RED WHITE AND BLUE" und ein zwischen „R" und „A" eingefügtes „T" hatte Israels „MORAL" zu „MORTAL" verändert. Hinzu kam eine Flut seitengroßer Blätter, auf denen der Irakkrieg angeprangert und die amerikanische Außenpolitik wie auch allgemeinere Fehler der Regierung Bush karikiert wurden. Obgleich diese Ansammlung von Zeichnungen im Vergleich zu früher eine konkretere Kritik darstellt, bleibt sie ganz im Sinne von Pettibons autodidaktischer Los Angeles Punk-Ästhetik – die ab Ende der 1970er und in den 1980ern eine Weiterentwicklung erfuhr, als der Künstler für das Label SST und die Punkband Black Flag seines Bruders Plattencover, Konzertflyer und Comichefte gestaltete. Ehemals bekannt dafür, dass er über literarische und philosophische Quellen sowie alltägliche Themen wie Film, Musik, Sport, Sex, Gumby und Superman sinnierte, wird seine scharfsinnige Beschäftigung mit politischen und sozialen Themen durch diesen Stil nun umso beeindruckender. Wenn Pettibon in seinen Installationen mit einer Überfülle aufgeklebter Bilder die Atmosphäre eines Internatsschlafsaals vermittelt, so deuten seine individuellen Skizzen auf die Arbeit eines hoch talentierten Slackers, der in zusammengesunkener Haltung über seinem Schreibtisch mit Verve seine Ideen in sein Notizbuch überträgt – einer, der seine Coolness offenbar nur vorgibt.

Ne mâchant déjà pas ses mots dans son abondante production de dessins à l'encre et à l'aquarelle, Raymond Pettibon met le langage au service d'idées politiques franchement affirmées : *Here's Your Irony Back (The Big Picture)*, son exposition new-yorkaise de 2007, étalait le nom de l'artiste et le titre de l'exposition au mur en lettres de sang dégoulinantes dignes d'un film de série B ; des banderoles peintes à même les murs de la galerie clironnant « TWO CHEERS FOR THE RED WHITE AND BLUE » et parlant de façon équivoque d'un Israël « MORAL », avec un signe intercalant un « T » entre le « R » et le « A » pour qu'on y lise « MORTAL » ; et une pléthore de petits dessins dénonçant la guerre en Irak, parodiant la politique étrangère américaine et faisant état, plus généralement, des échecs du régime de George W. Bush. Ces dessins regroupés révèlent une dextérité longtemps associée à l'esthétique bricolo-punk de Pettibon – aiguisée à Los Angeles à la fin des années 1970 et dans les années 1980, alors que l'artiste dessinait pochettes d'album, tracts de concerts et fanzines pour Black Flag, le groupe punk de son frère, et son label SST Records – même s'ils font état de préoccupations plus liées à l'actualité que par le passé. Connu pour ses songeries ayant pour fondements la littérature ou la philosophie mais aussi les films, la musique, le sport, le sexe, Gumby ou Superman, son discours incisif sur les questions politiques et sociales en devient d'autant plus convaincant de par son style. Si les installations de Pettibon empruntent à l'atmosphère d'un foyer d'étudiants avec sa profusion d'images collées, ses croquis suggèrent l'œuvre d'un fainéant de génie, affalé à son bureau, mais remplissant frénétiquement son carnet de ses idées, tout en faisant semblant d'être trop cool pour vraiment s'en soucier. S. H.

SELECTED EXHIBITIONS →
2008 *Raymond Pettibon: Thank You for Staying*, Riverside Art Museum, Riverside **2007** *Think with the Senses – Feel with the Mind*, 52nd Venice Biennale, Venice. *Raymond Pettibon*, Kestnergesellschaft, Hanover. *Imagination Becomes Reality*, ZKM, Karlsruhe **2006** *Raymond Pettibon*, CAC Malaga. *Into Me/Out Of Me*, P.S.1, Contemporary Art Center, Long Island City; KW Institute for Contemporary Art, Berlin **2005** *Raymond Pettibon*, Whitney Museum of American Art, New York.

SELECTED PUBLICATIONS →
2008 *The Pages Which Contain Truth Are Blank*, Museion, Bolzano; Skarabäus, Innsbruck. *Raymond Pettibon: The Books 1978–1998*, Distributed Art Publishers, New York **2007** *Raymond Pettibon*, Phaidon Press, London. *Raymond Pettibon: Whatever It Is Youre Looking For You Won't Find It Here*, Kunsthalle Wien, Vienna; Verlag für Moderne Kunst, Nuremberg

1 **No Title (Don't Make A)**, 2006, pen, ink on paper, 121.9 x 91.4 cm

2 Installation View, *Raymond Pettibon: Here's Your Irony Back (The Big Picture)*, David Zwirner, New York, 2007

„Wenn meine Arbeit gelungen ist … nun, eine meiner wenigen Richtlinien besteht darin, dass ich das Bild betrachte und mir sage, dass es auf der Welt keinen anderen gibt, der es hätte machen können."

« Je crois que quand mon travail est apprécié… eh bien, je me donne comme seul critère de regarder l'image et de me dire que personne d'autre que moi n'aurait pu le faire. »

"I think when my work is successful … well, one of the only standards I use is to look at the image and consider that this is something no one else in the world could have come up with."

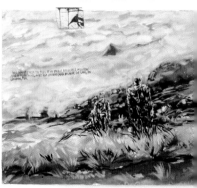

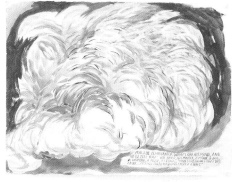

Elizabeth Peyton

1965 born in Danbury (CT), lives and works in New York (NY), USA

Since her 1993 debut at New York's Chelsea hotel, Elizabeth Peyton often has been characterized as a kind of fairy tale protagonist: with a beseeching kiss, she awakened the slumbering hero – portrait painting. Her thinly washed, colour-saturated, diminutively scaled paintings of gorgeously androgynous friends, celebrities and historical personages (Sid Vicious, Kurt Cobain and Susan Sontag brush shoulders with Napoleon, Marie Antoinette and Queen Elizabeth) evince neo-romantic longing, whether for the objects of her pictorial affections or the intensity of feeling in the representations as such. Through a diaristic approach reminiscent of David Hockney or Billy Sullivan, Peyton intimately chronicles moments of unadulterated narcissism, paying rapt attention to metonymic details of swoony, almost sentimental desire: popsicle-stained lips, webs of tattoos, attenuated limbs and halos of perfectly tussled hair. While some of her works take the likes of magazine photographs and record covers as their sources and train their gaze on the idle young, she has more recently turned to painting and drawing – noticeably older sitters or still lifes – from life or from her own snapshots, with an altogether more vulnerable affect. A picture of a stony, steel-jawed Matthew Barney, *Matthew* (2008), reveals deep circles under his eyes, which seem to gaze inward, avoiding the viewer. Even a casual view of downtown Manhattan, *NYC* (2008), feels like a poignant requiem despite its nervy urban intensity. In these and other new works, Peyton exhibits an interest in psychic intensity, supplanting the proverbial lightness of being for something heavier.

Seit ihrer ersten Ausstellung 1993 im Chelsea Hotel in New York ist Elizabeth Peyton immer wieder als Hauptdarstellerin einer Märchenwelt charakterisiert worden, deren inniger Kuss einem schlafenden Helden wieder Leben eingehaucht hat: der Porträtmalerei. Ihre dünn lasierten, farbenprächtigen, kleinformatigen Porträts glamouröser androgyner Freunde, Prominenter und historischer Persönlichkeiten (die Liste umfasst Namen wie Sid Vicious, Kurt Cobain, Susan Sontag, Napoleon, Marie Antoinette und Queen Elizabeth) zeigen neo-romantische Anklänge, in der Verehrung der Dargestellten durch Idealisierung wie auch in der dichten Bildatmosphäre. Durch eine tagebuchartige Vorgehensweise, die an David Hockney oder Billy Sullivan erinnert, gelingen Peyton intime Momentaufnahmen unverfälschter, narzisstischer Schönheit, die Symbole eines ohnmächtigen, fast sentimentalen Begehrens verbindet: scharlachrote Lippen, verschlungene Tattoos, langgezogene Gliedmaßen und zum Glorienschein stilisierte Haare. Während einige ihrer Arbeiten auf Zeitschriften oder Plattencovern entnommenen Fotografien basieren, die den Blick auf eine dekadente Jugend lenken, entstehen ihre neueren Zeichnungen und Gemälde mit merklich älteren Modellen oder Stillleben direkt nach dem Leben oder eigenen Schnappschüssen, was sie insgesamt noch zerbrechlicher wirken lässt. Ein Porträt des hart blickenden Matthew Barney, *Matthew* (2008), enthüllt die tiefen Ringe unter seinen Augen, die vom Betrachter weg, gleichsam nach innen gerichtet ist. Selbst eine flüchtige Ansicht von Downtown Manhattan wie *NYC* (2008) wird trotz ihrer nervenaufreibend urbanen Intensität ergreifend wie ein Requiem. In diesen und anderen neuen Bildern zeigt Peyton ein Interesse für psychologische Dichte, auf der Suche nach mehr Gewicht hinter der vermeintlichen Leichtigkeit des Seins.

Depuis ses débuts au Chelsea Hotel à New York en 1993, on a souvent perçu Elizabeth Peyton comme une sorte d'héroïne de conte de fée : d'un baiser implorant, elle réveillait le héros endormi : la peinture de portrait. Les petits portraits, à peine délavés, aux couleurs saturées, de ses amis superbement androgynes, de célébrités ou de personnages historiques (Sid Vicious, Kurt Cobain et Susan Sontag y côtoient Napoléon, Marie-Antoinette et la reine Elizabeth) dénotent une nostalgie néo-romantique, que ce soit pour les objets de son affection picturale ou pour l'intensité du sentiment dans les représentations en tant que telles. À travers une approche en forme de chronique qui rappelle David Hockney ou Billy Sullivan, Peyton relate de façon intime des moments de pur narcissisme, prêtant une attention considérable à des détails métonymiques de désir défaillant, voire sentimental : des lèvres maculées de glace à l'eau, des entrelacs de tatouages, des membres amincis et des auréoles de cheveux emmêlés à la perfection. Mais, alors que certaines de ses œuvres puisaient leur source dans les photos de magazines ou de pochettes de disques, et portaient leur regard sur une jeunesse oisive, elle s'est mise à peindre et à dessiner – des modèles nettement plus vieux ou des natures mortes – à partir du réel ou de ses propres photos, avec quelque chose de beaucoup plus vulnérable. *Matthew* (2008), le portrait d'un Matthew Barney, figé et mâchoires crispées, révèle des cernes profonds sous des yeux dont le regard introspectif évite le spectateur. Même *NYC* (2008), une vue ordinaire de Manhattan, s'apparente à un poignant requiem malgré sa nerveuse puissance urbaine. La plupart de ses œuvres exprime son intérêt pour une force psychique, évinçant la légèreté de l'être au profit de l'intensité. S. H.

SELECTED EXHIBITIONS →
2008 *Elizabeth Peyton: Live Forever*, New Museum, New York; Walker Art Center, Minneapolis; Whitechapel Art Gallery, London; Bonnefantenmuseum, Maastricht. *Elizabeth Peyton*, Aldrich Contemporary Art Museum, Ridgefield. *The Painting of Modern Life*, Castello di Rivoli, Turin **2007** *True Romance*, Kunsthalle Wien, Vienna. *Like Color in Pictures*, Aspen Art Museum, Aspen **2006** *Faster! Bigger! Better!*, ZKM, Karlsruhe. *Surprise, Surprise*, ICA, London. *Since 2000: Printmaking Now*, MoMA, New York

SELECTED PUBLICATIONS →
2008 *Elizabeth Peyton: Live Forever*, New Museum, New York; Phaidon Press, London. *Art & Today*, Phaidon Press, London **2007** *Collection Art Contemporain*, Centre Georges Pompidou, Paris **2006** *Faster! Bigger! Better!*, ZKM, Karlsruhe; Verlag der Buchhandlung Walther König, Cologne. **2005** *Elizabeth Peyton*, Rizzoli, New York

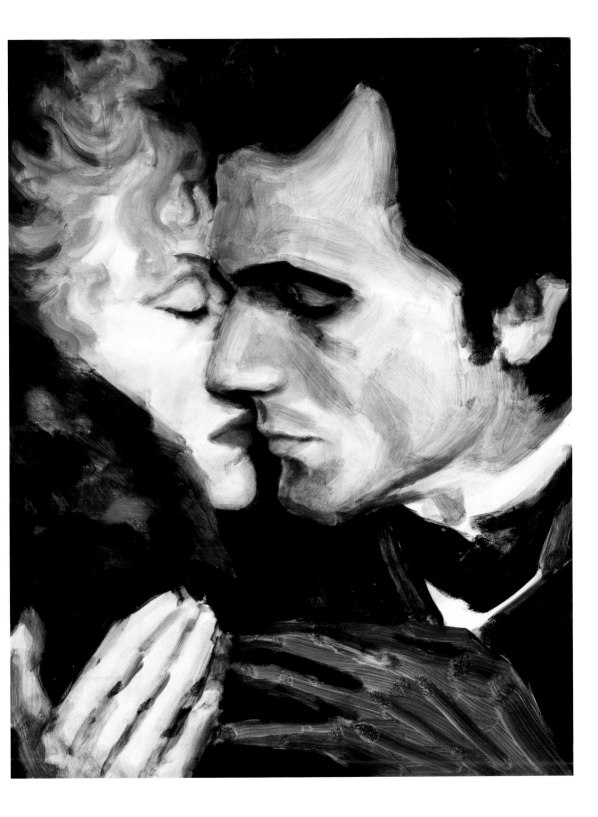

1 **The Age of Innocence**, 2007, oil on board, 36.2 x 25.4 cm
2 **Elizabeth and Georgia (Elizabeth Arden and Georgia O'Keefe 1936)**,
 2005, oil on board, 25.4 x 20.3 cm
3 **Matthew**, 2008, oil on board, 31.8 x 22.9 cm
4 **Flowers & Diaghilev**, 2008, oil on linen over board, 33 x 22.9 cm

„Für mich spielt sich alles in den Gesichtern ab. Sie sind wirklich Geschichte. Die vergeht und sie verändern sich, und das ist es."

« Je crois juste que tout est dans le visage des gens. Ce sont vraiment eux, l'histoire. Et elle passe et ils changent, et voilà. »

"I just think it's all in people's faces. They really are history. And it passes and they change, and that's it."

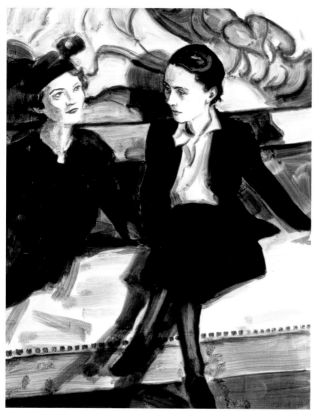

2

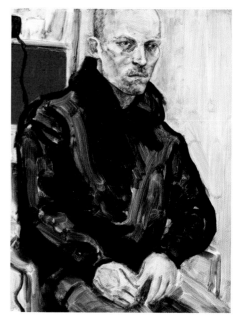

3

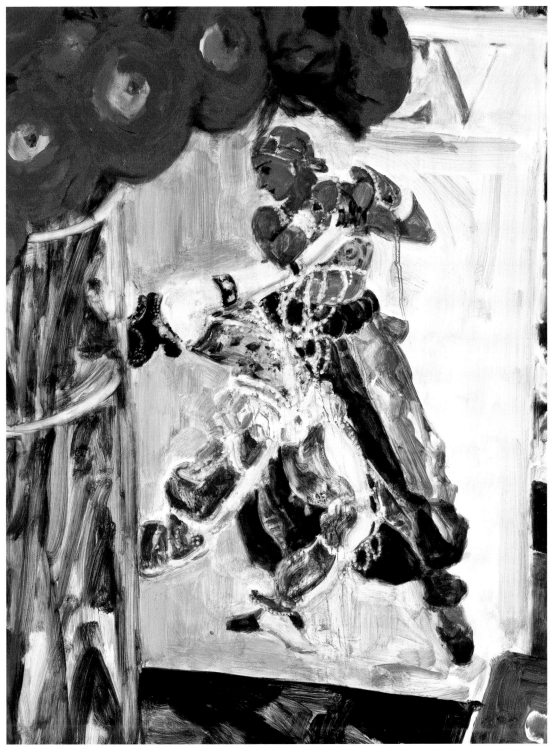

Richard Phillips

1962 born in Marblehead (MA), lives and works in New York (NY), USA

Hasn't everything there is to say on canvas already been said? Richard Phillips certainly doesn't think so. But rather than naively continue to paint away, he engages with this very question. Pop artists like Andy Warhol and Mel Ramos are his main points of reference, not just stylistically or thematically but because he, too, questions the status and function of images. The paintings in the exhibition *Michael Fried* (2006) initially present Phillips' typical motifs, derived from the spirit of pop art – aged soft porn images form the basis of many of his works. However, the way in which the exhibition is installed is central to his critical approach to painting. As in a chapel, the paintings are grouped together around an image of a completely different kind: a portrait of the influential art critic Michael Fried. Phillips thus incorporates a firm theoretical stance into his installation: Fried was of the opinion that art which prompts reflection upon how it is viewed loses its power to transport the viewer out of everyday life. Phillips places the authoritative portrait of Fried in a context that cunningly fulfils the critic's demand. With their affirmative means of depiction, the images do not seem to reflexively subvert the porn theme. In terms of subject matter, however, they are to be attributed to "low art" and a questionable form of absorption, which would hardly please Fried. Perhaps the painting *Herzausreisser* (2005), in which a femme fatale holds out a heart to the viewer, is also aimed at Fried? Phillips goes a step further with *Girl with Cigarette* (2008); its visual smoothness hinders reflection at the cost of vacuity – and is effective precisely for this reason. In this way painting lives on, ferocious and self-critical.

Ist auf der Leinwand schon alles gesagt? Richard Phillips ist keinesfalls dieser Ansicht. Er malt jedoch nicht naiv weiter, sondern setzt sich mit dieser Frage auseinander. Vor allem Pop-Art-Künstler wie Andy Warhol und Mel Ramos liefern ihm Bezugspunkte, nicht nur in stilistischer oder motivischer Hinsicht. Denn es geht ihm um die Frage nach dem Status und der Funktion von Bildern. Auf den ersten Blick bieten die Gemälde der Ausstellung *Michael Fried* (2006) jene für Phillips typischen Motive, die er aus dem Geiste der Pop Art holt: Zeitlich patinierte Softporno-Bilder liegen vielen seiner Arbeiten zugrunde. Zentral für das Verständnis seiner malereikritischen Vorgehensweise ist jedoch der installative Aufbau der Ausstellung. Wie in einer Kapelle sind die Bilder um ein gänzlich anders geartetes Bild gruppiert, ein Porträt des einflussreichen Kritikers Michael Fried. Phillips holt damit eine dezidierte Position in seine Installation hinein: Fried vertritt die Ansicht, dass Kunst, die eine Reflexion über ihr Betrachten auslöst, die Kraft, den Betrachter vom Alltag zu absorbieren, verlieren würde. Das autoritative Porträt Frieds stellt Phillips nun in einen Kontext, welcher die Forderung Frieds tückisch erfüllt. Die Bilder scheinen die Porno-Motivik mit ihrer affirmativen Darstellungsweise nicht reflexiv aufzubrechen, sind jedoch motivisch der Low Art und einem fragwürdigen Absorbieren zuzurechnen, was wiederum Frieds Herz kaum höher schlagen lassen dürfte. Vielleicht ist das Gemälde *Herzausreisser* (2005), bei dem eine Femme fatale dem Betrachter ein Herz entgegenhält, auch auf Fried gemünzt? Einen Schritt weiter geht Phillips mit *Girl with Cigarette* (2008). Dessen visuelle Glätte verhindert Reflexion bis um den Preis der Entleerung – und gerade dadurch wird sie thematisiert. So kann die Malerei weiterleben, bösartig und selbstkritisch.

Tout a-t-il déjà été dit en peinture ? Richard Phillips n'est nullement de cet avis. Il ne se contente pas de continuer de peindre de manière irréfléchie, mais travaille sur cette question. Ses références – pas seulement en termes de motif ou de style – sont surtout des artistes pop comme Andy Warhol et Mel Ramos. Pour Phillips, la question cruciale est en effet celle du statut et de la fonction de l'image. À première vue, les tableaux de l'exposition *Michael Fried* (2006) proposaient ses motifs habituels conçus dans l'esprit du Pop Art – nombre de ses œuvres reposent sur des images porno soft patinées par le temps. Mais un aspect central de sa critique picturale et de sa démarche était la présentation installative de l'exposition : ses tableaux étaient groupés comme dans une chapelle autour d'un tout autre tableau, un portrait du critique influent Michael Fried, qui introduisait une position nettement marquée dans l'installation. Fried prône l'idée que tout art qui induit une réflexion sur sa contemplation perd la capacité d'absorber le spectateur hors de sa vie quotidienne. Phillips place donc le portrait de Fried dans un environnement qui exauce de manière fallacieuse l'exigence du critique. Les tableaux ne semblent produire aucun démontage réflexif des sujets pornographiques et de leur mode affirmatif, mais doivent être associés au *low art* et à une forme d'absorption douteuse, ce qui ne saurait plaire davantage à Fried. Peut-être la peinture *Herzausreisser* (2005), dans laquelle une femme fatale tend un cœur au spectateur, vise-t-elle également Fried ? Phillips va plus loin avec *Girl with Cigarette* (2008), dont le « léché » visuel empêche toute réflexion jusqu'à l'inanité – thématisant ainsi, précisément, l'inanité. Sous ce signe, la peinture peut bien continuer d'exister, pernicieuse et autocritique.

H. L.

SELECTED EXHIBITIONS →
2008 *Blasted Allegories: Werke aus der Sammlung Ringier*, Kunstmuseum Luzern. *Out of Shape: Stylistic Distortions of the Human Form in Art*, The Frances Lehman Loeb Art Center, Poughkeepsie **2007** *INSIGHT?*, Gagosian Gallery/Red October Chocolate Factory, Moscow. *Timer01: Intimacy*, Triennale Bovisa, Milan **2006** *Dark Places*, Santa Monica Museum of Art, Santa Monica **2004** *Richard Phillips Paintings and Drawings*, Le Consortium, Dijon

SELECTED PUBLICATIONS →
2008 *Always There*, Galerie Max Hetzler, Berlin **2007** *Richard Phillips*, Gagosian Gallery, New York. *INSIGHT?*, Gagosian Gallery/Red October Chocolate Factory, Moscow. *Pop Art Is*, Gagosian Gallery, London **2006** *Richard Phillips: Early Works on Paper*, Galerie Max Hetzler, Berlin; Holzwarth Publications, Berlin. *Richard Phillips*, Le Consortium, Dijon; JRP Ringier, Zürich **2005** *Richard Phillips: Michael Fried*, White Cube, London; Friedrich Petzel, New York

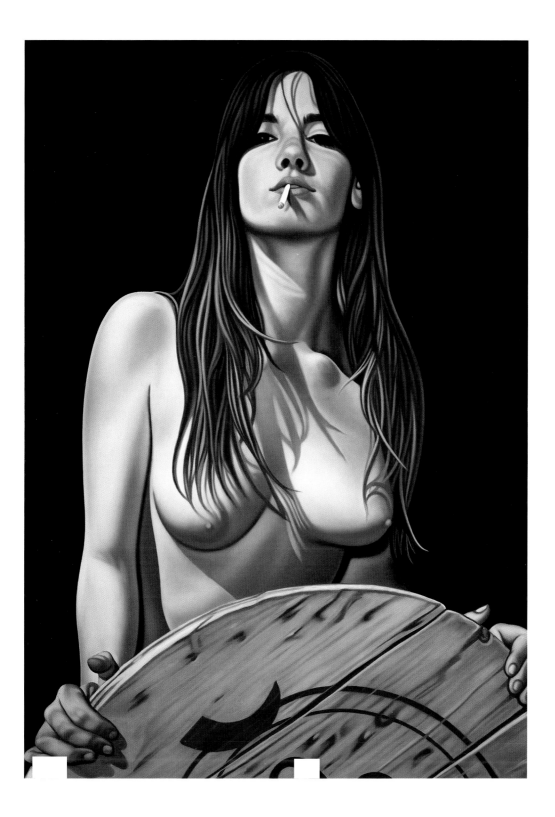

1 **Girl with Cigarette**, 2008, oil on canvas, 304.8 x 214.6 cm
2 **Free Base**, 2007, oil on canvas, 290 x 347.3 cm
3 **Herzausreisser**, 2005, oil on canvas, 218.4 x 162.6 cm

4 **Frieze**, 2007, charcoal, white chalk on grey toned paper, 37.5 x 50.2 cm
5 **Hell**, 2007, oil on canvas, 289.6 x 367.7 cm

„Meine Arbeit distanziert sich von sich selbst wie ein losgerissener Abschnitt aus einem Cadavre exquis. Wie beim grün-blauen Bein eines zerstückelten Drogenkuriers, das durch den Hafen von New York treibt, fragt man sich, ob unsere Kokainsucht sie hätte retten können."

« Mon œuvre se dissocie de lui-même comme le segment isolé d'un cadavre exquis. Comme la jambe bleu-vert d'un passeur de drogue démembré flottant dans le port de New York, on se demande si notre addiction à la coke aurait pu la sauver. »

"My work disassociates from itself like the torn off segment of an exquisite corpse. Like the blue green leg of a dismembered drug mule floating in New York harbour, one wonders if their coke habit could have saved her."

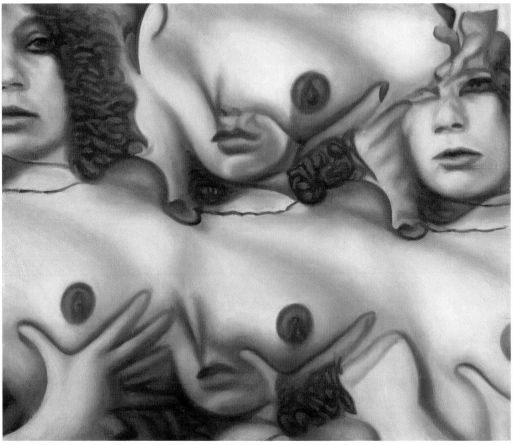

3

4

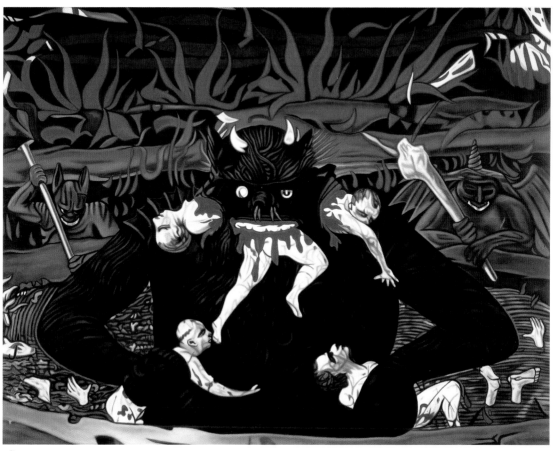

5

Richard Prince

1949 born in Panama Canal Zone, lives and works in New York (NY), USA

Appropriating everyday objects and bringing them into the realm of art has been a strategy of artists ever since Duchamp. In 1930, Louis Aragon linked this to a new definition of the artist: the artist was no longer someone who created original works, but someone who selected, and thus made conscious decisions. Richard Prince, a central figure of appropriation art, has made a number of such decisions, appropriating themes that are closely related to the American way of life, such as Marlboro cowboys, biker gangs or celebrities. Since the 1970s, he has reproduced and reworked these motifs in photographs and paintings, putting special emphasis on the darker side of society. His text/image paintings increasingly involve jokes on topics that are otherwise repressed, as well as soft-porn photographs, which he overpaints in the style of de Kooning. In his latest works he attempts to take appropriation art a step further by not only appropriating available images or de Kooning's painting style, or by venturing into product design and appropriating luxury goods as the "canvases" for his art. Prince collaborated with Marc Jacobs on the fashion designer's 2008 spring collection for Louis Vuitton, *After Dark* (2008). The artist traced monograms onto the bags or had them spray-painted with short jokes on his preferred themes of gender, race or poverty – fundamental issues of social coexistence that do not usually concern the average Louis Vuitton customer. In this way Prince cunningly appropriates platforms for his culturally critical works and turns Duchamp's approach back on itself by bringing art into the everyday.

Sich Dinge aus der Alltagswelt anzueignen, um sie in jene der Kunst zu holen, ist eine künstlerische Strategie, die seit Duchamp praktiziert wird. 1930 sah Louis Aragon damit eine Neudefinition des Künstlers verbunden. Dieser ist nicht länger Schöpfer eines originären Werkes, sondern jemand, der auswählt und damit gezielt Entscheidungen trifft. Richard Prince, zentrale Figur der Appropriation Art, hat eine Reihe solcher Entscheidungen getroffen und sich Motive angeeignet, wie etwa Marlboro-Cowboys, Biker-Gangs und Celebrities, die mit dem American Way of Life verknüpft sind. Diese Motive hat er seit den 1970er-Jahren fotografisch und malerisch reproduziert und bearbeitet, dabei legt er besonderen Wert auf die dunklen Seiten der Gesellschaft. Vor allem bei seinen neueren malerischen Bild-Text-Werken widmet er sich verstärkt Witzen, die Verdrängtes thematisieren, sowie Soft-Porno-Fotografien, die er im Stile de Koonings übermalt. Mit seinen neueren Werken versucht er, die Appropriation Art weiterzuführen. Sei es, indem er sich nicht nur bereits vorhandene Bilder aneignet, sondern zudem de Koonings Malstil. Sei es, indem er ausgreift in das Produktdesign und sich Waren als Träger seiner Kunst aneignet. Mit Marc Jacobs kooperierte er für die Frühjahrskollektion *After Dark* (2008) von Louis Vuitton. Prince versieht die Taschen mit nachgezeichneten Cartoons oder kurzen Witztexten. Sie drehen sich, typisch für Prince, um Geschlechter- und Rassenproblematik oder Geldmangel. Und damit um grundlegende Fragen des sozialen Miteinanders, mit denen die üblichen Louis-Vuitton-Kundinnen kaum je posieren würden. Auf subtile Weise eignet sich Prince so Flächen für seine kulturkritischen Arbeiten an und wendet Duchamps Ansatz: Er holt die Kunst in die Alltagswelt hinein.

S'approprier des objets du monde quotidien pour les faire entrer dans le monde de l'art est une stratégie pratiquée depuis Duchamp. En 1930, Aragon y voyait une nouvelle définition de l'artiste, qui n'est plus le créateur d'une œuvre inédite, mais quelqu'un qui choisit et prend des décisions ciblées. Richard Prince, figure centrale de l'appropriationnisme, a pris une série de décisions de ce genre et s'est approprié des motifs liés à l'*American way of life* comme les cow-boys Marlboro, les gangs de motards et les célébrités, qu'il a reproduits et travaillés en peinture et en photographie depuis les années 1970, détaillant ainsi les faces les plus sombres de la société. Dans ses peintures récentes, qui joignent le texte à l'image, il s'attache à des plaisanteries qui touchent souvent des aspects refoulés, mais aussi à des photographies porno soft peintes dans le style de de Kooning. Prince tente ainsi de pousser plus loin l'appropriationnisme. Il ne s'empare plus seulement des images existantes, mais fait sien le style pictural de de Kooning ou étend son champ pictural au design de produits et s'approprie des biens de consommation comme nouveaux supports pour son art. Prince a ainsi collaboré avec Marc Jacobs à la collection de printemps *After Dark* (2008) de Louis Vuitton. Il affuble les sacs de *cartoons* redessinés ou de courtes blagues écrites. Comme souvent chez Prince, ils tournent autour de problèmes sexuels et raciaux ou de manque d'argent, et problématisent des questions fondamentales sur la cohabitation sociale que les clientes habituelles de Louis Vuitton ne se poseraient sans cela jamais. Prince s'approprie ainsi subtilement de nouveaux supports pour sa critique culturelle et inverse la démarche de Duchamp en faisant entrer l'art dans le monde quotidien. H. L.

SELECTED EXHIBITIONS →
2008 *Richard Prince: Continuation*, Serpentine Gallery, London
2007 *Richard Prince: Spiritual America*, Solomon R. Guggenheim Museum, New York; Walker Art Center, Minneapolis; Serpentine Gallery, London. *Richard Prince: Panama Pavilion*, Venice. *Frieze Projects*, Frieze Art Fair, London **2006** *Richard Prince: Canaries in the Coal Mine*, Astrup Fearnley Museum, Oslo. *The 80's: A Topology*, Museo Serralves, Porto **2004** *Richard Prince*, Sammlung Goetz, Munich

SELECTED PUBLICATIONS →
2007 *Richard Prince*, Guggenheim Museum, New York; Hatje Cantz, Ostfildern. *Richard Prince: Canaries in the Coal Mine*, Astrup Fearnley Museet for Moderne Kunst, Oslo. INSIGHT?, Gagosian Gallery/Red October Chocolate Factory, Moscow. **2006** *Richard Prince: Jokes & Cartoons*, JRP Ringier, Zürich **2005** *Richard Prince: Hippie Drawings*, Sadie Coles HQ, London; Hatje Cantz, Ostfildern **2004** *Richard Prince: Man*, JRP Ringier, Zürich

1 **A Nurse Involved**, 2002, inkjet print, acrylic on canvas, 182.9 x 114.3 cm
2 **Big Foot**, 2004/05, cast polyurethane, 64 x 112 x 112 cm

3 **Untitled (cowboy)**, 2003, ektacolour photograph, 101.6 x 76.2 cm

„Für mich hat sich immer die Frage gestellt: ‚Was glaubst du, wer du bist?'
Der Wunsch ein Anderer zu sein, eine Rolle zu spielen, für eine andere
Persönlichkeit einzuspringen, ist entweder Zeichen von Unsicherheit oder
einer mächtigen Selbstgewissheit."

« La question a toujours été pour moi : "Pour qui te prends-tu ?" L'envie d'être
quelqu'un d'autre, de jouer un rôle, d'endosser un personnage, d'être une
doublure, est l'expression d'une insécurité ou d'un immense ego. »

"The question for me has always been, 'Who do you think you are?' The desire to be someone else, to play a part, take on a role, to be an understudy is either part of an insecurity or a huge ego."

2

Neo Rauch

1960 born in Leipzig, lives and works in Leipzig, Germany

With solo exhibitions at the Metropolitan Museum in New York (2007) and the Max Ernst Museum in Brühl (2008), Neo Rauch has truly arrived. The first confirmed his international reputation, the second contextualized his work and linked it to one of the leading exponents of surrealism. Attempting to characterize his pictorial worlds leads us to his working method: various points of reference, objects and stylistic elements are brought together like a collage. This often leads to a condensation of meanings and styles which is one of the most distinctive qualities of Rauch's art. It generates multiple tensions between utopian and nostalgic elements, idyll and horror, cartoon-like depiction and expressiveness, bold advertising and glittering pearls of meaning. Particularly characteristic of his paintings are combinations of several temporal strands. For example, *Das Gut* (2008) shows a car from the 1950s, a man wearing dandyish clothing from the 19th century and a cast of figures that appear twice, as in medieval simultaneous staging. The second man's body ends in a fishtail, representing a kind of siren figure. Mythology is evoked – and immediately transformed: Rauch paints the male siren involved in a fight. Although Rauch continues to stage the clash of symbols in his latest works, the fields of reference have shifted: above all, the 19th and 20th centuries now converge in combination with a mythological antiquity. Increasingly he is also focusing on his own activities: artists appear in front of canvases or sketchpads, usually pondering what to paint (*Parabel*, 2008). Rauch has certainly come into his own – and not just by making self-reflection his subject.

Neo Rauch ist doppelt angekommen: mit einer Soloausstellung im Metropolitan Museum in New York (2007) und im Max Ernst Museum in Brühl (2008). Die erste bestätigt seinen internationalen Rang, die zweite kontextualisiert seine Arbeiten und verbindet sie mit einer Hauptfigur des Surrealismus. Der Versuch, seine Bildwelten zu charakterisieren, führt zu seiner Vorgehensweise: collagenartig werden ganz verschiedene Bezugspunkte und Objekte, aber auch Stilelemente zusammengeführt. Das führt immer wieder zu Komprimierungen von Bedeutungen und Stilen, worin eine Qualität von Rauchs Arbeiten liegt. So entsteht ein mehrfaches Spannungsfeld von utopischen und nostalgischen Elementen, von Idylle und Horror, von Comicstil und Expressivität, von plakativer Werbung und schillernden Bedeutungsdiamanten. Besonders kennzeichnend für seine Bilder sind Kombinationen mehrerer Zeitzustände. So zeigt etwa *Das Gut* (2008) ein Automobil aus den 1950er-Jahren, eine Person trägt dandyhafte Kleidung aus dem 19. Jahrhundert und das gesamte Personal erscheint, wie in einem mittelalterlichen Simultanbild, zweimal. Der Körper des Mannes endet in einem Fischschwanz, solcherart eine Sirene darstellend. Mythologie wird aufgerufen – und sogleich gewandelt: Rauch malt eine männliche Sirene als Kämpfenden. In seinen jüngsten Werken inszeniert Rauch weiterhin den Zusammenprall von Zeichen, verschiebt jedoch die Referenzfelder: Vor allem 19. und 20. Jahrhundert treffen aufeinander, kombiniert mit mythologischer Antike. Und immer stärker thematisiert Rauch sein eigenes Tun: Künstler erscheinen vor Leinwänden oder Zeichenblöcken, meist mit der Frage befasst, was zu malen sei (*Parabel*, 2008). Rauch ist ganz bei sich angekommen, nicht nur in der Selbstreflexion als Sujet.

Avec une exposition personnelle au Metropolitan Museum de New York (2007) et une autre au Max Ernst Museum de Brühl (2008), Neo Rauch a été accueilli à juste titre: la première exposition confirme sa stature internationale, la seconde contextualise ses œuvres et les associe à une grande figure du surréalisme. Caractériser les univers iconiques de Rauch conduit à décrire sa manière de procéder : ses tableaux regroupent toutes sortes d'objets et de références, mais aussi d'éléments stylistiques à la manière d'un collage. Ceci produit des compressions de sens et de styles qui font la qualité de ses œuvres. De l'ensemble résulte un champ de tensions multiples composé d'éléments utopiques et nostalgiques, d'idylle et d'horreur, de bande dessinée et d'expressivité, de publicité criarde et de scintillants joyaux de sens. Un aspect caractéristique de ses tableaux est la combinaison de plusieurs états. Le tableau *Das Gut* (2008) montre une voiture des années 1950, une personne y est habillée en dandy du XIXᵉ siècle et tous les personnages apparaissent deux fois comme dans les scènes simultanées d'une peinture médiévale. Le corps de l'homme se termine en queue de poisson, la mythologie est invoquée et immédiatement transformée : Rauch peint un combattant sous forme de sirène masculine. Dans ses œuvres récentes, Rauch continue de mettre en scène le choc des signes mais déplace ses champs de références. Aujourd'hui se télescopent surtout les XIXᵉ et XXᵉ siècles associés à la mythologie antique. Rauch prend en outre de plus en plus souvent pour sujet sa propre activité : des artistes apparaissent devant des toiles ou des blocs de papier à dessin, généralement hantés par la question de savoir ce qui doit être peint (*Parabel*, 2008). Rauch s'est trové lui-même – et pas seulement à travers l'autoréflexion comme sujet.

H. L.

SELECTED EXHIBITIONS →
2008 Neo Rauch, Max Ernst Museum, Brühl. *Third Guangzhou Trianniel*, Guangdong Museum of Art, Guangzhou **2007** *Neo Rauch: Para*, Metropolitan Museum of Art, New York. *The Present – Acquisition Monique Zajfen*, Stedelijk Museum, Amsterdam **2006** *Neo Rauch, Musée d'art contemporain de Montreal. Neo Rauch: Neue Rollen. Bilder 1993 bis heute*, Kunstmuseum Wolfsburg. *Surprise, Surprise*, ICA, London **2005** Neo Rauch, CAC Málaga **2004** Neo Rauch, Albertina, Vienna

SELECTED PUBLICATIONS →
2008 Neo Rauch, David Zwirner, New York, Steidl, Göttingen. *Stations. Die Elisabethkapelle im Naumburger Dom mit den von Neo Rauch gestalteten Glasfenstern*, Imhof, Petersberg **2007** *Neo Rauch: Para*, Metropolitan Museum of Art, New York; DuMont, Cologne **2006** *Neo Rauch: Der Zeitraum*, DuMont, Cologne. *Neo Rauch, Musée d'art contemporain de Montreal. Neo Rauch: Neue Rollen. Bilder 1993–2006*, Kunstmuseum Wolfsburg; DuMont, Cologne

1 **Das Gut**, 2008, oil on canvas, 280 x 210 cm
2 **Vater**, 2007, oil on canvas, 200 x 150 cm
3 **Das Blaue**, 2006, oil on canvas, 300 x 420 cm

4 **Der Garten des Bildhauers**, 2008, oil on canvas, 300 x 420 cm
5 **Parabel**, 2008, oil on canvas, 300 x 210 cm

„Zumindest können wir davon ausgehen, dass die figurative Malerei eine ganze Reihe von Minen, von Fettnäpfchen, von Bananenschalen bereithält, mit denen man es zu tun bekommen kann, und das reizt mich."

« Nous pouvons du moins partir du principe que la peinture figurative recèle toute une série de mines, de bévues, de peaux de bananes auxquelles on peut avoir affaire, et c'est ce qui m'intéresse au plus haut point. »

"We can at least assume that figurative painting hides a whole series of booby traps, cowpats and banana skins that you have to deal with, and that's what excites me."

2

3

4

Anselm Reyle

1970 born in Tübingen, lives and works in Berlin, Germany

Anselm Reyle's works always look a bit like "modern art", but this is deliberate, as he works with stylistic quotations from abstract art that hang, slightly worse for wear, in our pictorial memory store. He is fascinated by the persuasiveness of the cliché, the formulaic in the form. His works are based on found objects, which can just as easily be stylistic formulae or things he has literally found. When he explores tachism or colourfield painting; when he reworks Art Informel sculpture; when he uses *objets trouvés* – painting a hay cart neon yellow, or combining paint with broken fragments and electrical scrap – he adapts the gestures of what was once advanced visual language, emptying them out while increasing their potency as surface and effect. "I'm interested in things that have the power to become a cliché," he says. "I try to get to the core and exaggerate it so much that it really does move you again." Reyle continues along this path, while the field of stylistic references has opened up and his combination of materials has become more experimental. Some works recall Vasarely, Armand or Manzoni. Materials and gestures are now used more drastically, for example in his *Black Earth* pictures (2007); in others he hits the precise spot where you don't know whether it reminds you of Art Informel or an arty calendar from a poster shop. He pushes the boundaries of taste and exaggeration, and, having already used neon paint "like a cranked-up electric guitar", he now makes use of striking textural pastes, ripple lacquer, steel frames, airbrush and LED light effects. "Part of my work is dealing with what is too much," Reyle says. "It's a balancing act that can end up hurting."

Arbeiten von Anselm Reyle sehen immer ein bisschen nach „moderner Kunst" aus. Das hat Methode, denn Reyle arbeitet mit Stilzitaten der Abstraktion, die heute ein wenig abgenutzt in unserem Bildgedächtnis hängen. Ihn fasziniert die Überzeugungskraft des Klischees, das Formelhafte an der Form. So basieren seine Arbeiten eigentlich auf Fundstücken, und das können ebenso gut Stilformeln wie gefundene Objekte sein: Wenn er Tachismus oder Colourfield Painting aufgreift, wenn er informelle Skulptur re-inszeniert, wenn er mit *objets trouvés* arbeitet, etwa einen Heuwagen mit gelber Neonfarbe überzieht oder in Materialbildern die Malerei mit Scherben und Elektroschrott verbindet – dann adaptiert er Gesten einst avancierter Bildsprachen, entleert sie, steigert aber zugleich ihre Wirksamkeit als Oberfläche und Effekt. „Mich interessiert etwas, das überhaupt die Qualität hat, ein Klischee zu sein", sagt er. „Ich versuche, den Kern zu erfassen und so zu überzeichnen, dass es einen schon wieder wirklich bewegt." Reyle hat das zuletzt noch fortgeführt, das Feld stilistischer Bezüge ist offener, die Materialkombination experimenteller geworden. Manche Arbeiten lassen an Vasarely, Armand oder Manzoni denken. Material und Geste werden drastischer verwendet, etwa in den neueren *Black-Earth*-Bildern (2007), in anderen trifft er perfekt den Tonfall, bei dem man nicht mehr weiß, ob das an Informel oder ans Kunstkalenderblatt aus der Postergalerie erinnert. Reyle reizt Grenzen zu geschmacklichem Tabu und Übertreibung aus, und hat er schon Neonfarben „wie eine stark aufgedrehte E-Gitarre" benutzt, setzt er inzwischen effektvolle Texturpasten und Reißlack, Stahlrahmen, Airbrush und LED-Lichteffekte ein. „Mit dem Zuviel umzugehen ist Teil meiner Arbeit", sagt Reyle, „das ist eine Gratwanderung, die durchaus wehtun kann."

Les œuvres d'Anselm Reyle ont toujours un côté « art moderne ». Reyle travaille méthodiquement avec des citations de styles de l'art abstrait quelque per usées, conservées dans notre mémoire iconique. Il est fasciné par la force de conviction du cliché, de la forme poussée jusqu'à la formule. Ses œuvres s'appuient sur des trouvailles qui peuvent être des formules stylistiques aussi bien que des objets trouvés. En faisant appel au tachisme ou au colourfield painting, en restaurant la sculpture informelle, en travaillant avec des objets trouvés comme une charrette de foin peinte en jaune fluo ou en combinant peinture, tessons et déchets électriques dans des tableaux d'assemblages – il adapte des langages iconiques naguère avant-gardistes, les vide de leur substance, mais intensifie en même temps l'efficacité des effets de surface. « Ce qui m'intéresse, c'est très généralement tout ce qui a la qualité d'être un cliché », dit-il. « Je cherche à cerner le noyau et à l'exacerber au point qu'il finit par vous toucher à nouveau. » Récemment, Reyle est allé encore plus loin : les références stylistiques sont plus vastes, les combinaisons de matériaux plus expérimentales. Certaines œuvres rappellent Vasarely, Armand ou Manzoni, matériau et position sont utilisés plus radicalement, comme dans les nouveaux tableaux de la série *Black-Earth* (2007). Dans d'autres, Reyle trouve le ton exact où l'on ne sait plus s'il faut y voir de l'informel ou un poster de calendrier d'art. Reyle joue des limites du tabou du bon goût et de l'exagération, et s'il se sert de couleurs fluo « comme d'une guitare électrique à pleine puissance », il introduit aujourd'hui des textures efficaces comme du vernis à craqueler, des cadres en acier, de la peinture au pistolet et des leds. « Travailler avec l'excès fait partie de mon travail », dit Reyle, « c'est une promenade sur le fil du rasoir qui peut parfois faire mal. »

J. A.

SELECTED EXHIBITIONS →
2008 *Vertrautes Terrain – Aktuelle Kunst in und über Deutschland*, ZKM, Karlsruhe. *abstrakt/abstract*, Museum Moderner Kunst Kärnten, Klagenfurt. **2007** *Anselm Reyle: The 5th Dream*, Modern Institute, Glasgow. *The Artist's Dining Room: Manfred Kuttner, Anselm Reyle, Thomas Scheibitz*, Tate Modern, London. *Ruinöse Abstraktion: Es gibt Dinge, die kann man nicht erklären*, Bonner Kunstverein, Bonn. *Sequence 1*, Palazzo Grassi, Venice. **2006** *Anselm Reyle: Ars Nova*, Kunsthalle Zürich.

SELECTED PUBLICATIONS →
2007 *Sequence 1*, Palazzo Grassi, Venice; Skira, Milan. *Minimalism and After*, Hatje Cantz, Ostfildern. **2006** *Anselm Reyle: Ars Nova*, Kunsthalle Zürich, Zürich. *Painting in Tongues*, MOCA, Los Angeles. **2005** *Etwas von etwas. Abstrakte Kunst*, Verlag der Buchhandlung Walther König, Cologne. **2004** *Anselm Reyle*, Galerie Giti Nourbakhsch, Berlin

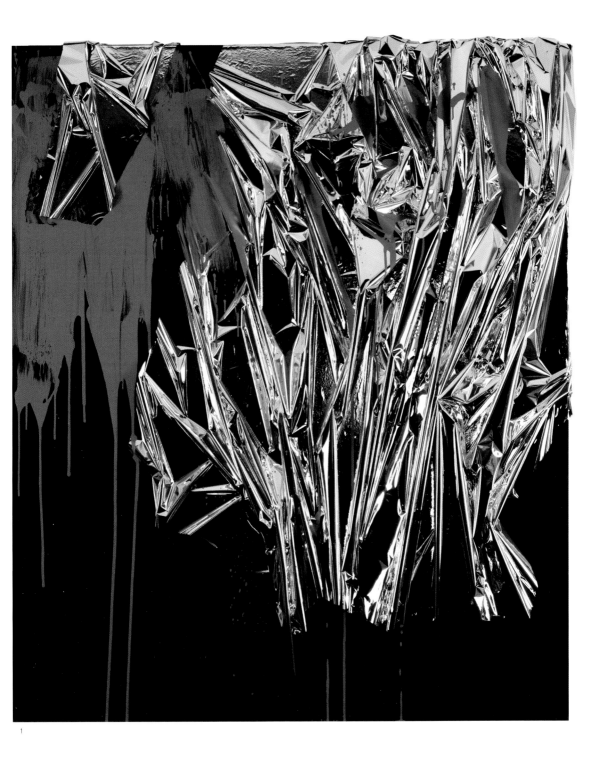

1 **Untitled**, 2006, mixed media on canvas, foil, acrylic glass,
 234 x 199 x 25 cm
2 **Untitled**, 2008, mixed media on canvas, found objects, crinkle lacquer,
 metal frame, 135 x 114 cm
3 **Harmony**, 2007, bronze, chrome, enamel varnish, veneer pedestal
 (makassa wood), 98 x 108 x 46 cm, pedestal 90 x 90 x 40 cm

4 Installation view, *Painting in Tongues*, The Museum of Contemporary Art,
 Los Angeles, 2006
5 **Heuwagen**, 2008, found object, wood, metal, neon-yellow lacquer, black
 light lamps, dimensions variable

„Mich interessieren vor allem die Sackgassen der Moderne." « Ce qui m'intéresse avant tout, ce sont les impasses de la modernité. »

"What interests me most are the dead ends of modernism."

2

3

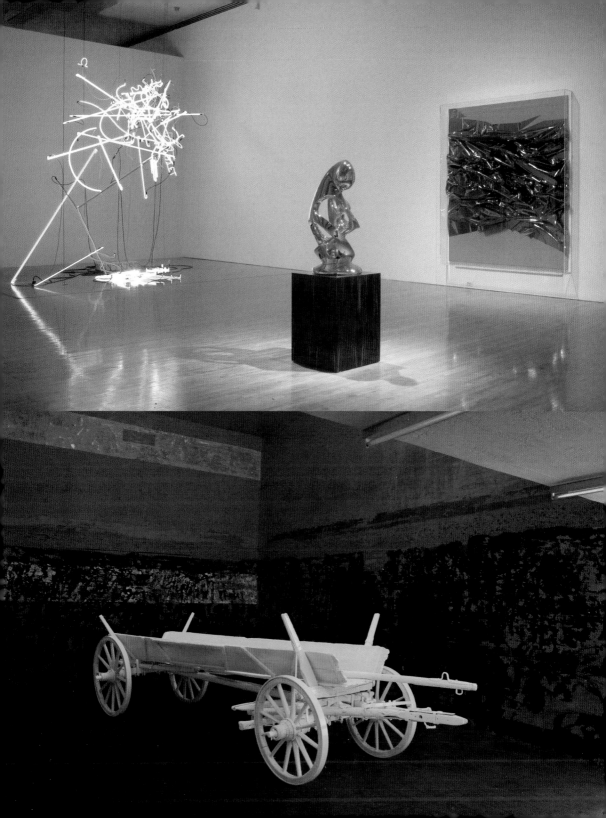

Wilhelm Sasnal

1972 born in Tarnów, lives and works in Tarnów and Warsaw, Poland

Wilhelm Sasnal is not just a passionate painter but also a versatile filmmaker. In both media he explores the potential of images to refer to things which have been seen or which once were. Despite the broad scope of his subject matter, a preoccupation with the history of his homeland is a recurrent theme in his work. Sasnal interprets Poland's political and cultural transformation since the 1960s with the aid of pop-cultural references such as book or record covers and images from the press or advertising. His main concern is to examine the collective memory of his own generation – a society trapped in its past but still looking to the future. While Sasnal's paintings have recently been moving away from specific source images, his films make increasing use of moving images that already exist. In *Let Me Tell You a Film* (2007), for example, he recorded the television broadcast of a Polish feature film with a video camera, cut it down into a ten-minute silent film, added text inserts and copied it back onto film. The original film tells the true story of two friends who sell methyl alcohol as vodka and through this act of negligence cause someone's death. Sasnal looks on this historical fragment – a tale of guilt and responsibility – as a story that has already been told and asks how it would look from a different angle – in terms of content as well as medium. A series of paintings are clustered thematically around the film, whereby their subject matter, spatial arrangement and coloration convey an almost physical feeling of unease, the sensation of a painful awakening – which in Sasnal's case can most certainly be understood in a broader sense.

Wilhelm Sasnal ist nicht nur ein leidenschaftlicher Maler, sondern auch ein umtriebiger Filmemacher. In beiden Medien erforscht er das Potenzial von Bildern, auf Gesehenes oder Gewesenes zu verweisen. Trotz der großen Bandbreite seiner Sujets zieht sich die Beschäftigung mit der Geschichte seines Heimatlandes wie ein roter Faden durch sein Werk. Er interpretiert die kulturelle und politische Transformation Polens seit den 1960er-Jahren, indem er unter anderem popkulturelle Referenzen wie Buch- und Plattencover sowie Bilder aus Presse und Werbung verarbeitet. Sein Fokus liegt dabei auf der Untersuchung des kollektiven Gedächtnisses seiner eigenen Generation – einer Gesellschaft, die in ihrer Vergangenheit gefangen ist und dabei trotzdem in die Zukunft blickt. In jüngster Zeit beruhen Sasnals Gemälde immer weniger auf konkreten Vorlagen, seine Filme dagegen immer mehr auf bereits existierenden bewegten Bildern. So hat Sasnal für *Let Me Tell You a Film* (2007) einen polnischen Spielfilm während seiner Ausstrahlung im Fernsehen per Videokamera aufgenommen, auf einen zehnminütigen Stummfilm zusammengeschnitten, mit Texteinschüben versehen und wieder auf Film rückkopiert. Der ursprüngliche Film erzählt die wahre Begebenheit zweier Freunde, die Methylalkohol als Wodka verkaufen und damit fahrlässig den Tod eines Menschen verursacht haben. Sasnal betrachtet dieses historische Fragment, diese Erzählung um Schuld und Verantwortung als bereits vermittelte Geschichte und fragt danach, wie eine erneute Betrachtung aussehen kann – auf der inhaltlichen wie der medialen Ebene. Um den Film schart sich thematisch eine Reihe von Gemälden, deren Themen, Raumgestaltung und Farbigkeit ein nahezu physisches Unbehagen vermitteln, das Gefühl eines schmerzhaften Erwachens – was bei Sasnal durchaus im übertragenen Sinne zu verstehen ist.

Wilhelm Sasnal n'est pas seulement un peintre passionné, mais aussi un cinéaste très actif. Dans ces deux médiums, il explore la propriété qu'ont les images à nous renvoyer à une chose vue ou à un événement passé. Malgré la grande diversité de ses sujets, le travail sur l'histoire de son pays natal parcourt son œuvre comme un fil conducteur. Sasnal interprète l'évolution culturelle et politique de la Pologne depuis les années 1960 en travaillant sur certaines références de la culture populaire – couvertures de livres et pochettes de disques, images de presse et publicités. Dans ce contexte, son intérêt porte principalement sur l'étude de la mémoire collective de sa génération, société prisonnière de son passé, mais néanmoins tournée vers l'avenir. Dans ses peintures récentes, Sasnal s'appuie de moins en moins sur des modèles existants, alors que ses films partent de plus en plus souvent d'images animées existantes. C'est ainsi que pour *Let Me Tell You a Film* (2007), il a réalisé l'enregistrement vidéo d'un film polonais lors de sa diffusion à la télévision, en a remonté une version muette réduite à dix minutes et l'a agrémentée d'insertions textuelles avant de la recopier au format cinématographique. Le film original racontait l'histoire vraie de deux amis qui avaient vendu du méthanol pour de la vodka, causant ainsi la mort d'un homme. Sasnal considère ce fragment d'histoire, ce récit autour de la faute et de la responsabilité, comme de l'histoire déjà transmise et se demande à quoi pourrait ressembler une nouvelle approche – sur les plans sémantique autant que médiatique. Autour du film viennent se grouper thématiquement toute une série de peintures dont les sujets, le traitement de l'espace et de la couleur communiquent un malaise presque physique, le sentiment d'un réveil douloureux – ce qui, chez Sasnal, doit être pris au sens figuré.

A. M.

SELECTED EXHIBITIONS →
2008 *Back to Black. Die Farbe Schwarz in der aktuellen Malerei*, Kestnergesellschaft, Hanover. *Peripheral Vision and Collective Body*, Museion, Bolzano **2007** *Wilhelm Sasnal, Years of Struggle*, Zacheta National Gallery of Art, Warsaw; Galleria Civica di Arte Contemporanea di Trento. *What Is Painting?*, MoMA, New York **2006** *Wilhelm Sasnal*, Van Abbemuseum, Eindhoven. *Wilhelm Sasnal: Ist das Leben nicht schön?*, Frankfurter Kunstverein, Frankfurt am Main

SELECTED PUBLICATIONS →
2007 *Wilhelm Sasnal, Years of Struggle*, Zacheta National Gallery of Art, Warsaw; Galleria Civica di Arte Contemporanea di Trento, Trento **2006** *The Vincent*, The Vincent van Gogh Biennial Award for Contemporary Art in Europe, Stedelijk Museum, Amsterdam; *Wilhelm Sasnal: Paintings & Films*, Van Abbemuseum, Eindhoven, Veenman Publishers, Rotterdam **2005** *The Triumph of Painting: The Saatchi Collection, Vol. 2*, Saatchi Gallery, London; Verlag der Buchhandlung Walther König, Cologne

1　**Magic Johnson**, 2006, oil on canvas, 40 x 35 cm
2　**Section through the Ground with Potatoes 1**, 2006, oil on canvas,
　 99.7 x 139.7 cm

3　**Section through a Fuselage**, 2006, oil on canvas, 190 x 190 cm

„Wenn ich jemanden male, erschaffe ich eine ganze Welt. Ich glaube, das ist wie beim Film – eine gewisse Festigkeit, eine Dichte des Mediums, wie Ölfarbe. Wie man es dann zeigt spielt auch eine Rolle – ein projiziertes Bild hat seine ganz besondere Qualität."

« Quand je peins quelqu'un, je crée une sorte d'univers. Je pense qu'un film a un effet analogue – une certaine solidité, une densité du médium, comme la peinture à l'huile. La présentation a elle aussi son importance – l'image projetée par un projecteur possède une qualité tout à fait unique. »

"When I paint someone, I create a kind of universe. I think film produces a similar effect – a certain solidness, a density of the medium, like oil paint. The way you show it also matters – the image thrown by the projector has its unique quality."

2

Cindy Sherman

1954 born in Glen Ridge (NJ), lives and works in New York (NY), USA

For over thirty years Cindy Sherman has masqueraded as everything from actresses and fashion victims to suburban housewives and decaying corpses in a form of photographic portraiture in which she is simultaneously director, photographer and actor. Her most recent untitled series of photographs features a comprehensive cast of middle-aged women fighting against encroaching age through fashion statements and exaggerated make-up. Shot against digitally manipulated, colour-saturated backgrounds – a recent development in Sherman's work – each tragic-comic image stages a withering critique of the standardized ideals of female beauty depicted by the mass media. This is in continuation with Sherman's artistic concerns from the beginning of her career: she gained critical acclaim as part of the "Pictures" generation of artists who emerged in the late 1970s with the discourses surrounding postmodernism and the media. Her re-enactments of female tropes from 1950s and 60s B-movies in the seminal series *Untitled Film Stills* (1977–80) unfolded as a perceptively staged succession of female stereotypes that unravelled these instantly recognizable tropes. Read as an ongoing narrative, Sherman's work has staged a specifically feminine form of aggressivity, from the vacant starlets of the *Untitled Film Stills* through the overtly sexualized and dismembered forms in the *Sex Pictures* (1992) to the eventual replacement of the body altogether in the series *Broken Dolls* (1999). Disappearing behind an endless cast of characters, Sherman's masked and made-up physical presence becomes a mirror in which the desires (and fears) of the viewers themselves are reflected.

Seit über dreißig Jahren verkleidet sich Cindy Sherman für ihre fotografischen Porträts, bei denen sie gleichzeitig Regisseurin, Fotografin und Darstellerin ist: als Schauspielerin und Fashion-Victim, als Vorstadthausfrau und als verwesender Körper. Ihre jüngste titellose Serie von Fotografien handelt von einer umfangreichen Gruppe von mittelalten Frauen, die mit Modestatements und übertriebenem Make-up gegen das herannahende Alter kämpft. Aufgenommen vor digital bearbeiteten, farbgesättigten Hintergründen – eine neue Entwicklung in Shermans Arbeiten der letzten Zeit –, stellt jedes dieser tragikomischen Bilder eine vernichtende Kritik an dem von den Massenmedien geprägten Standardideal weiblicher Schönheit dar. Dies bedeutet eine Kontinuität in Shermans künstlerischem Anliegen vom Beginn ihrer Karriere an: Sie verdiente sich den Beifall der Kritik als Teil der „Pictures Generation", die in den späten 1970er-Jahren mit den Diskursen um Postmoderne und Medien aufkam. Ihre Neuinszenierungen von weiblichen Geschlechterrollen aus B-Movies der 1950er- und 60er-Jahre in der bahnbrechenden Serie *Untitled Film Stills* (1977–80) war eine unverkennbar inszenierte Abfolge von weiblichen Stereotypen, die diese unmittelbar erkennbaren Tropen enträtselt. Als eine fortlaufende Erzählung gelesen, inszeniert Shermans Arbeit eine spezifisch weibliche Form von Aggressivität, von den ausdruckslosen Starlets der *Untitled Film Stills* über die übersexualisierten und zerlegten Formen in den *Sex Pictures* (1992) bis zum völligen Ersatz des Körpers in der Serie *Broken Dolls* (1999). Indem sie hinter einer endlosen Reihe von Charakteren verschwindet, wird Shermans maskierte und geschminkte körperliche Gegenwart zu einem Spiegel, in dem das Verlangen (und die Angst) der Betrachter reflektiert werden.

En plus de trente ans de carrière, Cindy Sherman s'est glissée dans toutes sortes d'identités, jouant l'actrice, la victime de la mode, la femme au foyer et jusqu'au corps en décomposition, dans des formes de portraits photographiques dont elle est tout à la fois le metteur en scène, la photographe et le modèle. Sa série de photographies la plus récente, non titrée, présente un ensemble représentatif de femmes âgées autour de la cinquantaine luttant contre les stigmates de l'âge à travers leurs choix vestimentaires et leur maquillage appuyé. Prises devant des arrière-plans traités numériquement, saturés de couleurs – un développement récent dans l'œuvre de Sherman – ces images tragi-comiques proposent une critique acerbe des idéaux standardisés de la beauté féminine véhiculés par les médias. Ce travail s'inscrit dans la lignée des préoccupations artistiques de Sherman depuis le début de sa carrière et le succès critique qu'elle remporta avec les autres artistes membres de la génération « Pictures » apparus à la fin des années 1970 dans le contexte des théories du postmodernisme et des médias. Ses reconstitutions des tropes féminins issus des films de série B des années 1950–1960 dans la série fondatrice *Untitled Film Stills* (1977–80) s'imposèrent comme une mise en scène subtile et une critique efficace des stéréotypes féminins en vigueur. Prise comme un ensemble narratif, l'œuvre de Sherman présente une forme spécifiquement féminine d'agressivité, depuis les starlettes vaporeuses des *Untitled Film Stills*, aux formes ouvertement sexuelles écartelées des *Sex Pictures* (1992), jusqu'à l'effacement ultime du corps dans la série des *Broken Dolls* (1999). Lorsqu'elle disparaît derrière un nombre infini de personnages, la présence physique de Sherman, sous ses masques et ses maquillages, devient un miroir dans lequel se reflètent les désirs comme les peurs des spectateurs.

A. B.

SELECTED EXHIBITIONS →
2008 *Female Trouble*, Pinakothek der Moderne, München. *Street & Studio*, Tate Modern, London; Museum Folkwang, Essen **2007** *Imagination Becomes Reality*, ZKM, Karlsruhe **2006** *Cindy Sherman: Rétrospective*, Jeu de Paume, Paris; Kunsthaus Bregenz; Louisiana Museum of Modern Art, Humlebaek; Martin Gropius Bau, Berlin. *Into Me/Out of Me*, PS1 Contemporary Art Center, Long Island City; KW Institute for Contemporary Art, Berlin

SELECTED PUBLICATIONS →
2007 *Cindy Sherman*, Thames & Hudson, London. *Cindy Sherman: A Play of Selves*, Metro Pictures, New York; Sprüth Magers, Cologne; Hatje Cantz, Ostfildern. *Cindy Sherman*, Mondadori, Milan. *Cindy Sherman*, MIT Press, Cambridge. *Cindy Sherman*, Jeu de Paume & Flammarion, Paris **2006** *The Cindy Shermans: Inszenierte Identitäten Fotogeschichten von 1840 bis 2005*, Böhlau, Cologne/Weimar

1 **Untitled**, 2007/08, colour photograph, 156.5 x 124.8 cm
2 **Untitled**, 2007/08, colour photograph, 155.1 x 104.5 cm

3 **Untitled**, 2007/08, colour photograph, 115.9 x 89.2 cm
4 **Untitled**, 2007/08, colour photograph, 198.8 x 150.2 cm

„Ich wollte keine ‚hohe' Kunst machen, ich hatte an Farbe kein Interesse, ich wollte etwas finden, zu dem sich jeder in Beziehung setzen kann, ohne etwas über zeitgenössische Kunst zu wissen."

« Je ne voulais pas faire de l'art avec un grand A, faire de la peinture ne m'intéressait pas, je voulais trouver une forme d'expression à laquelle quiconque puisse avoir accès sans connaître quoi que ce soit de l'art contemporain. ».

"I didn't want to make 'high' art, I had no interest in using paint, I wanted to find something that anyone could relate to without knowing about contemporary art."

2

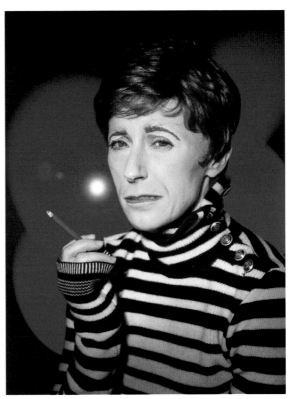

3

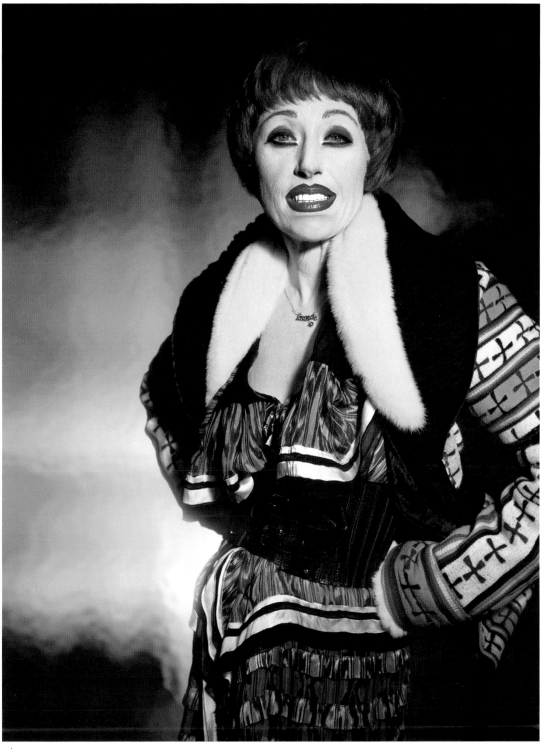

Dash Snow

1981 born in New York (NY), 2009 died in New York (NY), USA

Dash Snow made trashing hotel rooms – usually the preserve of rock stars – almost acceptable when he and Dan Colen exhibited one of his infamous hamster nests in a New York gallery. *Nest* (2007) was a sort of re-enactment with a happening-like feel. Previously, Snow often had to flee from hotels in the middle of the night after party-like events where he and friends such as Colen or the photographer Ryan McGinley had built a nest from shredded telephone books and bodily and other fluids. In the gallery, that now became a staged event. But Snow, who belonged to one of North America's most influential artistic dynasties, never originally planned to become an artist. He started his career in downtown Manhattan as a graffiti sprayer and self-declared shoplifter; he maintains that he only took Polaroids so as to remember next morning what had happened the night before. Snow transformed the Polaroids – a format he still uses – into art in his *Polaroid Wall* (2005), that seemed to reference Nan Goldin. For his collages he often used the yellowing pages of old books, on which he dissected words and pictures in a dadaist style. The result is like a collaboration between Hannah Höch and the Sex Pistols under the auspices of graffiti. Anarchy and nostalgia are never far apart in Snow's art, and are frequently paired with allusions to current social or political events – for example, in the caustic word collage *High School* (2006) or *The Government That Will Bring Paradise* (2007). For his Saddam Hussein series, Snow ejaculated onto the front pages of newspapers celebrating Hussein's death and strewed glitter over them as a commentary on American foreign policy and triumphalism.

Dash Snow hat die meist Rockstars vorbehaltene Tradition der „Hotelzimmer Trashings" salonfähig gemacht, als er zusammen mit Dan Colen eines seiner berüchtigten Hamsterneste in einer New Yorker Galerie ausstellte. *Nest* (2007) war eine Art Reenactment mit Happingcharakter. Früher musste Snow nachts aus Hotels flüchten, nachdem er mit Freunden wie Colen oder dem Fotografen Ryan McGinley aus zerfetzten Telefonbüchern, Körper- und sonstigen Flüssigkeiten in einer partyhaften Aktion ein Nest gebaut hatte. In der Galerie wurde dies zum inszenierten Ereignis. Dabei hatte es Snow, der aus einer der einflussreichsten Kunstdynastien Nordamerikas stammte, ursprünglich nicht darauf angelegt, Künstler zu werden. Er begann seine Karriere in Downtown Manhattan als Graffiti-Sprayer und bekennender Ladendieb und machte nach eigenen Angaben nur Polaroids, um sich hinterher an das erinnern zu können, was in den Nächten zuvor geschehen war. Snow überführte die Polaroids – ein Format, das er auch weiterhin nutzt – in seiner an Nan Goldin erinnernden *Polaroid Wall* (2005) in Kunst. Für seine Collagen verwendete er oft vergilbte Seiten alter Bücher, auf denen er Wort und Bild in dadaistischer Manier sezierte. Das Ergebnis gleicht einer Kollaboration von Hannah Höch mit den Sex Pistols unter den Vorzeichen von Graffiti. Anarchie und Nostalgie liegen hier nahe beieinander, häufig gepaart mit Anspielungen auf aktuelle gesellschaftliche oder politische Ereignisse, etwa in der bissigen Wortcollage *High School* (2006) oder in *The Government That Will Bring Paradise* (2007). Für seine Saddam Hussein-Serie ejakulierte er auf Titelseiten von Zeitungen, die den Tod Husseins feierten, und streute Glitter darüber, als Kommentar zur amerikanischen Außenpolitik und Siegesmentalität.

En exposant dans une galerie new-yorkaise un de ses nids de hamster tristement célèbres avec Dan Colen, Dash Snow a rendu convenable une tradition normalement réservée aux rock-stars : le « trashage de suite d'hôtels ». *Nest* (2007) a été une réactivation sous forme de happening. Autrefois, Snow devait quitter des hôtels en pleine nuit après avoir fait la « teuf » avec des amis comme Colen ou le photographe McGinley et y avoir construit un « nid » à partir de bottins déchirés et de fluides corporels ou autres. Dans la galerie, ceci devenait la mise en scène d'un événement. Issu d'une des plus influentes dynasties artistiques d'Amérique du Nord, Snow ne s'était pas destiné à cette carrière. Il avait débuté à Downtown Manhattan comme graffiteur et voleur à l'étalage déclaré ; il se contentait de réaliser des polaroïds pour se rappeler ce qui s'était passé les nuits précédentes. Snow a aussi fait passer ses polaroïds – format qu'il continue d'utiliser – dans le domaine de l'art avec son *Polaroid Wall* (2005), qui n'est pas sans rappeler le travail de Nan Goldin. Pour ses collages, il se servait souvent de feuilles jaunies d'anciens livres sur lesquelles il disséquait des mots et des images à la manière dadaïste. Le résultat tient d'une collaboration entre Hannah Höch et les Sex Pistols placée sous le signe du graffiti, dans laquelle se côtoient l'anarchie et la nostalgie, souvent parsemées d'allusions aux évènements de l'actualité sociale ou politique, comme le montrent le collage textuel caustique *High School* (2006) ou *The Government That Will Bring Paradise* (2007). Pour sa série sur Saddam Hussein, Snow devait éjaculer sur les unes de journaux qui célébraient la mort du dictateur avant de les saupoudrer de paillettes en guise de commentaire sur le caractère impérialiste de la politique étrangère américaine.　　　　E. S.

SELECTED EXHIBITIONS →
2008 *Babylon – Mythos und Wahrheit*, Pergamonmuseum, Berlin
2007 *Compulsive*, Magazine Jalouse, Palais de Tokyo, Paris
2006 *Defamation of Character*, PS1 Contemporary Art Center, Long Island City. *Day For Night*, Whitney Biennial 2006, Whitney Museum, New York

SELECTED PUBLICATIONS →
2008 *Nest: Dash Snow, Dan Colen*, Deitch Projects, New York
2007 *Dash Snow: The End of Living, The Beginning of Survival*, Verlag der Buchhandlung Walther König, Cologne **2006** *A Dash of Daring: Carmel Snow and Her Life in Fashion, Art and Letters*, Atria, Memphis

TARGET: Madonna

Legal bid to stop Madge's adoption

By TOM PETTIFOR

MADONNA'S adoption of African baby David Banda could be halted today by a new court action.

A Malawian human rights group has launched the proceedings claiming the 13-month-old's father Yohane, 32, did not understand what he was doing when he let his son go.

A high court judge in the capital Lilongwe will be asked to impose an injunction forcing Madonna, 48, and husband Guy Ritchie, 38, to return to face a full screening process in Africa.

Undule Mwakasungule, of the Centre for Human Rights and Rehabilitation in Malawi, expressed concern about the speed and secrecy of the interim adoption. He added: "The family is divided. Some feel that because the boy is with Madonna all their lives will change.

"Others are concerned at the way it's been done.

"What is not right is that the father still thinks the boy is his. He doesn't understand he is completely and forever going to be out of his custody."

Nick Glanville, of the Adoption Information Line said: "She has set a terrible example bypassing red tape in Britain."

Meanwhile, Madonna was yesterday targeted by "comedy terrorist" Aaron Barschak who gatecrashed Prince William's 21st birthday party in 2003.

As she left a London gym Barschak, 40, in a nappy yelled at her car: "Mummy adopt me, make me part of your family."

● *IF you adopted a Malawian child or were adopted from there, please contact us free on (000) 282 591.*

Why's Amy been told to stop boozing?

PAGES 12&13

FUZZY BEAR

HUNT officials got a tame bear drunk on vodka so it was easier for King Carlos of Spain to shoot on a visit to Vologda, Russia.

AT LEAST THEY DIED TOGETHER

1 **Untitled (At Least They Died Together)**, 2007, collage, 40 x 28.6 cm
2 **Untitled (Circles Psychedelic)**, 2007, collage, 45.1 x 60.3 cm
3 Installation view, *Dash Snow/Dan Colen: Nest*, Deitch Projects, New York, 2007
4 **Untitled (Cum in Mouth/Circles)**, 2007, collage, 20.3 x 12.7 cm
5 **Society for Cutting Up Men**, 2006/07, collage, 39 x 22.8 cm
6 **Untitled (Dirty Bomb Scare)**, 2007, collage, 59.7 x 24.6 cm
7 **Untitled (Saddam & Gomorrah)**, 2006, collage, 36 x 28.8 cm

2

3

Rudolf Stingel

1956 born in Merano, lives and works in Bolzano, Italy, and New York (NY), USA

The sheer beauty of Rudolf Stingel's paintings often distracts giddy viewers from the banality of the ready-made materials from which they are made. Whether abstract or photorealistic canvases, a carpet laid on a floor or hung on a wall or a room lined with silver insulation material, Stingel describes each work he makes as a painting. Playing with the essential ingredients of the medium – a culinary approach adopted in *Instructions* (1989), a step-by-step guide to making a "real Rudolph Stingel" painting – Stingel ruptures painting's autonomy, dislocating and unfolding its surfaces into architectural space with a knowing decorative appeal that collides spectacle and reality. A recurrent gesture sees Stingel lining entire rooms with reflective insulation panelling, creating an open invitation for viewers to leave marks or attach objects to its surfaces. Like the marks that accumulate on the carpets he installs on gallery floors or walls, or the surfaces of his Styrofoam pieces eaten away by footprints, Stingel's works record the presence of both artist and viewer and are at once activated and destroyed through the processes of viewing and making. His series of large-format photorealist self portraits based on photographs taken by his friend Sam Samore, or his recent *Untitled* (2007), a distorted remake of Francis Bacon's triptych *Study for Self-Portrait* (1985) copied from a black-and-white photographic reproduction, might at first suggest a return to more traditional values of image-making, yet they inevitably return our focus to their expertly rendered surfaces which mark that unstable threshold between the real and its manufactured image.

Die reine Schönheit der Bilder Rudolf Stingels lässt den hingerissenen Betrachter gar nicht sehen, aus was für einfachen, vorgefundenen Materialien sie gemacht sind. Für Stingel ist jedes seiner Werke ein Gemälde – abstrakte oder fotorealistische Bilder genauso wie ein auf dem Boden liegender oder an der Wand hängender Teppich oder ein mit silbernem Dämmmaterial verkleideter Raum. Im Spiel mit den essenziellen Bestandteilen des Mediums – in *Instructions* (1989) zeigt er nach Art eines Kochrezepts Schritt für Schritt, wie ein „echter Rudolph Stingel" zustande kommt – untergräbt Stingel die Autonomie des Gemäldes, indem er dessen Oberflächen verrückt und in architektonische Räume auffächert: Aus dem Zusammenprall zwischen Inszenierung und Realität entsteht so ein kluger dekorativer Reiz. Häufig kleidet Stingel auch ganze Räume mit reflektierender Isolierfolie aus – eine offene Einladung an die Betrachter, ihre Spuren zu hinterlassen oder Objekte an die Wandflächen zu heften. So wie die zahllosen Spuren auf den Teppichen auf Böden oder an Wänden von Galerien oder wie die unter Fußabdrücken wegbrechenden Flächen seiner Werke aus Styropor dokumentieren Stingels Arbeiten die Präsenz des Künstlers wie die des Betrachters: Durch die Prozesse des Sehens und Machens werden sie zugleich aktiviert und zerstört. Seine Serie großformatiger fotorealistischer Selbstporträts nach Aufnahmen seines Freundes Sam Samore oder sein neueres Werk *Untitled* (2007), ein verzerrtes Remake nach einer Schwarzweißkopie von Francis Bacons Triptychon *Study for Self-Portrait* (1985), könnten auf den ersten Blick eine Rückkehr zu traditionelleren Werten des Bildermachens vermuten lassen, doch zwangsläufig lenken sie unser Interesse erneut auf die meisterhafte Behandlung der Oberflächen, jene schwankende Grenze zwischen dem Realen und seinem künstlich produzierten Abbild.

Souvent, la pure beauté des peintures de Rudolf Stingel détourne les visiteurs ébahis des matériaux ordinaires dont elles sont composées. Qu'il s'agisse de toiles abstraites ou photoréalistes, d'un tapis jeté sur un plancher ou accroché à un mur, ou encore d'une chambre tapissée de matériau d'isolation argenté, Stingel décrit chacune de ses œuvres comme une peinture. Jouant avec les ingrédients essentiels de ce médium – une approche culinaire qu'il a adoptée dans *Instructions* (1989), un manuel pour réaliser une « vraie toile Rudolph Stingel » – Stingel fracture l'autonomie de la peinture, disloque et déplie sa surface dans l'espace architectural avec un sens de la décoration évident, où spectacle et réalité sont renvoyés dos à dos. Parmi les gestes récurrents dans l'œuvre de Stingel, il y a ces pièces tapissées de panneaux isolants et réfléchissants, où les spectateurs sont invités à laisser des traces ou à y accrocher des choses. Comme les marques qui s'accumulent sur les tapis étendus sur les sols ou les murs des galeries, ou à la surface de ses œuvres en polystyrène dégradées par les empreintes de pas, les œuvres de Stingel enregistrent la présence à la fois de l'artiste et du visiteur. Elles s'activent et sont détruites dans un même élan, à travers le processus de leur exposition et de leur fabrication. Sa série d'autoportraits photoréalistes en grand format réalisés à partir de photos prises par son ami Sam Samore, ou son récent *Untitled* (2007), nouvelle version distordue du triptyque de Francis Bacon, *Étude pour un autoportrait* (1985), que Stingel a élaborée à partir d'une reproduction en noir et blanc, pourraient laisser penser que l'artiste revient à des valeurs iconographiques plus traditionnelles ; cependant, là encore, ces œuvres dirigent le regard du spectateur principalement vers ces surfaces admirablement travaillées qui marquent le seuil instable entre le réel et son image fabriquée.

A. B.

SELECTED EXHIBITIONS →
2008 *Life on Mars – 55th Carnegie International*, Carnegie Museum of Art, Pittsburgh **2007** *Rudolf Stingel*, Whitney Museum, New York. *Rudolf Stingel*, MCA, Chicago. *Sequence 1 – Pittura e Scultura nella Collezione François Pinault*, Palazzo Grassi, Venice **2006** *Day for Night*, Whitney Biennial 2006, Whitney Museum, New York. *Infinite Painting – Contemporary Painting and Global Realism*, Villa Manin, Codroipo

SELECTED PUBLICATIONS →
2008 *Life on Mars – 55th Carnegie International*, Carnegie Museum of Art, Pittsburgh **2007** *Sequence 1 – Pittura e Scultura nella Collezione François Pinault*, Skira, Milan. *Rudolf Stingel: Painting, 1987-2007*, Yale University Press, New Haven **2006** *Rudolf Stingel – Louvre (after Sam)*, Inverleith House, Royal Botanic Garden, Edinburgh; Sadie Coles HQ, London. *Infinite Painting – Contemporary Painting and Global Realism*, Villa Manin, Codroipo

1 **Untitled**, 2006, oil, enamel on canvas, 210 x 170 cm
2 **Untitled**, 2007, oil on canvas, 38 x 52 cm
3 **Untitled**, 2007, acylic on canvas, triptych, 334 x 261 cm (each)

4 Installation view, Galleria Massimo De Carlo, Milan, 2006
5 Installation view, Whitney Museum, New York, 2007

„Wenn man die Dinge aus dem Zusammenhang reißt und den Maßstab verändert, werden sie ganz unheimlich. Aber geht es in der Kunst nicht genau darum? Um Verrückungen?"

« Les choses deviennent très inquiétantes lorsqu'on les sort de leur contexte ou qu'on en modifie l'échelle. Mais n'est-ce pas là l'objet même de l'art ? La dislocation ? »

"Things become very scary when you take them out of context and change the scale. But isn't that what art is about? Dislocation?"

2

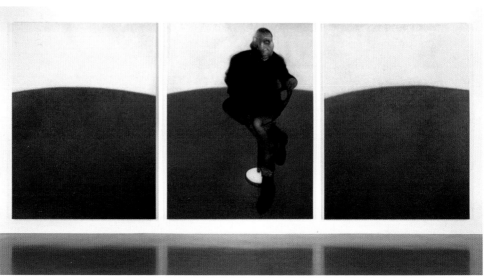

3

4

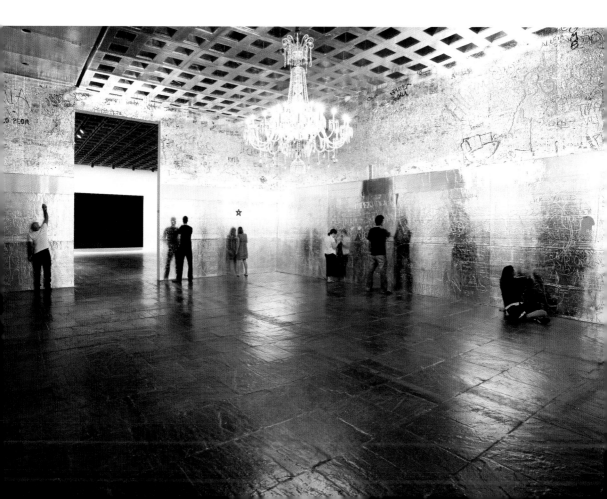

Thomas Struth

1954 born in Geldern, lives and works in Düsseldorf, Germany

It's no coincidence that Thomas Struth's most recent continuation of his series of "museum photographs" focuses on spectators at the Museo del Prado in front of Diego Velázquez's *Las Meninas*. The painting is famous for the complex construction of gazes, especially for the artist's inclusion of his self-portrait, which seems to confront the viewer directly. Struth's "museum photographs" – ongoing since 1989 – are exploring the relationship between the viewer and the artwork, they are multilayered studies of the ways we observe and understand art. In the images taken at the Museo del Prado (2005), the groups gathered around Velázquez's famous painting show a variety of different reactions: from concentrated viewers who listen attentively to a guide's explanations to elementary school students whose attentions are largely directed elsewhere – a playful contrast with the formal correspondence between their plaid uniform skirts and the elaborate skirts of the girls in the painting. A former student of Bernd and Hilla Becher at the Kunstakademie Düsseldorf, Struth's photographic approach reflects the influence of their objective view. Over the years Struth has captured every major genre explored by his medium's predecessor, painting. He has photographed land- and cityscapes that are eerily quiet, family portraits that are meticulously composed, and still lifes of dense green rainforests. But most of all his work is concerned with the social relations within the collective activity of viewing art. Struth, seeing through his camera, has made himself an intractable part of a complicated accumulation of looks and gazes, in which the camera is only one of many observers.

Dass Thomas Struth in der jüngsten Bildfolge seiner Serie von Museumsfotografien im Museo del Prado die Besucher vor dem Gemälde *Las Meninas* von Diego Velázquez ins Blickfeld rückt, ist kein Zufall. Das Werk ist bekannt für seine komplexen Beziehungen zwischen den Dargestellten, insbesondere für das Selbstporträt des Künstlers, das in direktem Blickkontakt mit dem Betrachter zu stehen scheint. Struths Museumsfotografien – mit denen er 1989 begann – untersuchen das Verhältnis zwischen Betrachter und Kunstwerk in vielschichtigen Studien über unsere Wahrnehmung und unser Verständnis von Kunst. Die Aufnahmen von Besuchergruppen vor dem Meisterwerk von Velázquez im Museo del Prado (2005) dokumentieren die vielfältige Bandbreite von Reaktionen: angefangen bei interessiert und konzentriert lauschenden Teilnehmern einer Führung bis hin zu Schulkindern, deren Aufmerksamkeit in alle Richtungen abgelenkt wird – in spielerischem Kontrast zu der formalen Korrespondenz zwischen den einheitlich buntkarierten Schuluniformröcken und den kunstvoll herausgearbeiteten Röcken der Mädchen auf dem Bild. Struths fotografische Vorgehensweise reflektiert den objektiven Blick seiner ehemaligen Lehrer Bernd und Hilla Becher an der Kunstakademie Düsseldorf. Über Jahre hinweg hat Struth jedes wichtige Genre der Malerei, des Vorgängermediums der Fotografie, fortgesetzt. Er fotografierte geisterhaft ruhige Landschaften und Stadträume, extrem durchkomponierte Familienporträts und Stillleben von dichtem, grünem Regenwald. Doch meistens thematisieren seine Werke die sozialen Interaktionen hinter der Gemeinschaftsaktivität Kunstbetrachtung. Struth wird als Beobachter durch die Linse selbst zu einem festen Teil der komplizierten Korrelation der Blickbeziehungen, in der die Kamera nur ein Betrachter unter vielen ist.

Ce n'est pas un hasard si la composante la plus récente de la série de « photographies de musée » de Thomas Struth se concentre sur les visiteurs du Museo del Prado regardant *Las Meninas* de Diego Velázquez. Ce tableau est célèbre pour le jeu de regards créé entre ses protagonistes, dont l'artiste lui-même à travers son autoportrait qui semble provoquer le spectateur. Les « photographies de musées », série qu'il poursuit depuis 1989, explorent la relation entre le spectateur et l'œuvre d'art. Il s'agit d'études à plusieurs niveaux des manières dont nous observons et comprenons l'art. Dans les photos prises au Prado (2005), les groupes assemblés autour de la fameuse toile de Velázquez livrent un éventail de réactions : certains, concentrés, écoutent les explications que dispense un guide, tandis que des élèves d'école primaire s'intéressent manifestement à autre chose – contraste amusant avec la correspondance formelle entre les jupes de plaid qui compose l'uniforme des enfants et celles sophistiquées des filles présentent sur la toile. L'influence de la vision objective chère au couple Becher, dont Struth a été l'élève à la Kunstakademie de Düsseldorf, se ressent clairement dans son approche photographique. Au fil des années, Struth a saisi tous les principaux genres explorés par le médium qui prévalait avant le sien, la peinture. Il a photographié des paysages et des villes mélancoliques, des portraits de famille méticuleusement composés et des natures mortes de denses forêts tropicales vertes. Mais la plus grande part de son travail s'attache aux relations sociales qui se nouent à travers l'activité collective de la contemplation de l'art. Struth, à travers son objectif, devient un élément intrinsèque de cette accumulation complexe de regards, dans laquelle l'appareil photo n'est qu'un observateur parmi beaucoup d'autres.

CH. L.

SELECTED EXHIBITIONS →
2008 *Thomas Struth*, Museo Madre, Museo d'Arte Contemporanea Donna Regina, Naples. *Thomas Struth: Familienleben*, SK Stiftung Kultur, Cologne. *Forgetting Velázquez. Las Meninas*, Museu Picasso, Barcelona **2007** *Thomas Struth: Making Time*, Museo Nacional del Prado, Madrid. *Private/Public*, Musem Boijmans van Beuningen, Rotterdam. *What Does the Jellyfish Want?* Museum Ludwig, Cologne **2006** *The 80's: A Topology*, Museo Serralves, Porto **2005** *Thomas Struth: Imágenes del Perú*, Museo de Arte Lima

SELECTED PUBLICATIONS →
2008 Hans Belting: *Writings on Thomas Struth*, Schirmer/Mosel, Munich. *Thomas Struth: Familienleben / Family Life*, SK Stiftung Kultur, Cologne; Schirmer/Mosel, Munich. Annette Emde: *Thomas Struth: Stadt- und Straßenbilder*, Jonas Verlag, Marburg. *Thomas Struth*, Mondadori, Milan **2007** *Thomas Struth: Making Time*, Museo Nacional del Prado, Madrid; Schirmer/Mosel, Munich **2005** *Thomas Struth: Museum Photographs*, Schirmer/Mosel, Munich

1 **Hermitage 5, St. Petersburg**, 2005, C-print, 114 x 144.8 cm
2 **Hermitage 2, St. Petersburg**, 2005, C-print, 114 x 144.8 cm
3 **The Felsenfeld/Gold Families, Philadelphia**, 2007, C-print, 179.2 x 217 cm
4 **Domingo Milella & Gabriella Accardo, New York**, 2007, C-print, 97 x 112 cm
5 **Paradiese 34, The Big Island (Hawaiian Islands)**, 2006, C-print, 178.1 x 219.4 cm

„Ein Kunstwerk stirbt, wenn es zum Fetisch wird." « Quand une œuvre d'art devient un fétiche, elle meurt. »

"When a work of art becomes fetishized, it dies."

4

5

Wolfgang Tillmans

1968 born in Remscheid, Germany, lives and works in London, United Kingdom, and Berlin, Germany

Ever since its invention, photography has been used as a tool to document and categorize. Wolfgang Tillmans photographs the people, places and objects of the world around him with the same desire to record and bring subjects to light, yet pursued with an innately democratic approach to image-making that rejects a categorizing impulse. From his emergence in the early 1990s, he assumed non-hierarchical methods to exhibiting his work, valuing with equal measure the white walls of the gallery, the carefully arranged pages of a book or the visually contested site of the magazine page. Dispelling any sense of linearity or imposed order, Tillmans' installations bring together old and new works, printed in different sizes or techniques, some framed others casually taped to the walls; while seemingly scattershot in their hang, each installation is a carefully choreographed interplay of form and narrative. In his ongoing project *Truth Study Center* (2005–) Tillmans photographs and displays newspaper and magazine cuttings alongside his own photographs displayed on low wooden glass-topped tables. Highlighting the propensity for those in the public sphere to impose claims for absolute truths, Tillmans' pseudo-scientific structure provides a literal and metaphorical framework within which these claims might be objectively examined. Tillmans' recent *Lighter* series (2006–) extends his investigations into the abstract image with additions of folds or creases that open them up into three-dimensional space. Representational in as much as they become objects that represent themselves, Tillmans' abstractions operate at the heart of his investigations into the politics of image making.

Seit ihrer Erfindung dient die Fotografie zur Dokumentation und Kategorisierung. Wolfgang Tillmans fotografiert die Menschen, Orte und Gegenstände der Welt um ihn herum mit genau diesem Verlangen, etwas festzuhalten und Objekte ans Licht zu bringen, aber seine persönliche, demokratische Herangehensweise an die Fotografie schließt eine Kategorisierung von Vornherein aus. Seit Beginn seiner Karriere in den frühen 1990ern präsentierte er seine Arbeiten ohne Rücksicht auf Hierarchien und maß den weißen Räumen der Galerie, der sorgfältig arrangierten Buchseite und der optisch anspruchsvollen Magazinseite denselben Wert bei. Da er jede Linearität oder erzwungene Ordnung ablehnt, bringen Tillmans' Ausstellungen alte und neue Arbeiten zusammen, in verschiedenen Größen und Techniken gedruckt, einige gerahmt, andere beiläufig an die Wand geklebt. Während ihre Hängung wahllos erscheint, ist jede Ausstellung ein sorgfältig choreografiertes Wechselspiel von Form und Erzählung. In seinem derzeitigen Projekt *Truth Study Center* (2005–) fotografiert und präsentiert Tillmans Ausschnitte aus Zeitungen und Magazinen neben seinen eigenen auf den Glasoberflächen niedriger hölzerner Tische ausgelegten Fotografien. Indem er den Anspruch von Personen des öffentlichen Lebens auf absolute Wahrheiten hervorhebt, bietet Tillmans' pseudo-wissenschaftliche Struktur einen wörtlichen und metaphorischen Rahmen, in dem diese Ansprüche objektiv geprüft werden können. Tillmans erweitert mit seiner jüngsten Serie *Lighter* (2006–) seine Untersuchungen am abstrakten Bild durch Falten oder Knicke, die das Bild ins Dreidimensionale öffnen. Seine Abstraktionen – die gegenständlich werden, insofern sie Objekte sind, die sich selbst darstellen – stehen im Zentrum seiner Erforschung der Politik des Bildermachens.

Dès son invention, la photographie a été utilisée comme un outil de documentation et de classification. Wolfgang Tillmans photographie ses sujets – les gens, les endroits et les objets du monde qui l'entoure – dans ce but précis de les mettre en lumière et de conserver leur trace, mais il est cependant animé d'une idée foncièrement démocratique de la production d'images et rejette tout dessein de classification. Dès son apparition sur la scène artistique au début des années 1990, il a mis en place des modes d'exposition non-hiérarchisés, investissant avec la même rigueur les murs blancs d'une galerie, la mise en page d'un livre ou l'espace visuellement enchevêtré du magazine. Repoussant toute impression de linéarité ou d'ordre préétabli, ses installations réunissent des œuvres à la fois récentes et anciennes, au format et au procédé différents, parfois encadrées, parfois simplement scotchées au mur. Malgré l'apparence aléatoire de l'accrochage, chaque installation résulte d'un va-et-vient soigneusement chorégraphié entre forme et narration. Avec son projet *Truth Study Center* (2005–), Tillmans photographie et expose dans des vitrines des images découpées dans des journaux ou des magazines aux côtés de ses propres photographies. Le dispositif pseudo-scientifique de Tillmans met en lumière la propension des acteurs de la sphère publique à revendiquer des vérités absolues, et fournit un cadre tant littéral que métaphorique au travers duquel ces prétentions peuvent être examinées avec objectivité. Avec la série *Lighter* (2006–) Tillmans développe sa recherche sur l'image abstraite en y ajoutant des plis ou des froissements qui invitent ces images dans l'espace à trois dimensions. Les abstractions de Tillmans, qu'on pourrait qualifier de représentationnelles dans la mesure où elles deviennent des objets qui se représentent eux-mêmes, sont au cœur de son exploration de la dimension politique de la production d'images. A. B.

SELECTED EXHIBITIONS →
2008 *Wolfgang Tillmans: Lighter*, Hamburger Bahnhof, Berlin
2007 *Wolfgang Tillmans: Faltung*, Camera Austria, Graz. *Wolfgang Tillmans: Bali*, Kestnergesellschaft, Hanover. *The Turner Prize: A Retrospective*, Tate Britain, London **2006** *Wolfgang Tillmans: Freedom From The Known*, P.S.1 Contemporary Art Center, Long Island City. *Wolfgang Tillmans*, Museum of Contemporary Art, Chicago; Hammer Museum, Los Angeles; Hirshhorn Museum and Sculpture Garden, Washington

SELECTED PUBLICATIONS →
2008 *Wolfgang Tillmans: Lighter*, Hamburger Bahnhof, Berlin; Hatje Cantz, Ostfildern **2007** *Wolfgang Tillmans: Manual*, Verlag der Buchhandlung Walther König, Cologne **2006** *Wolfgang Tillmans*, Yale University Press, New Haven **2005** *Wolfgang Tillmans: truth study center*, Taschen, Cologne

1 **Freischwimmer 20**, 2003, C-print, 237 x 181 cm
2 Installation view, Museum of Contemporary Art Chicago, 2006
3 **Cameron**, 2007, C-print, dimensions variable

4 **Truth Study Center (Table 25)**, 2007, C-prints, Xerox on wooden table, glass, 76 x 198 x 93 cm
5 **Lighter 69**, 2007, C-print, 61 x 50.8 cm

„Obwohl ich weiß, dass die Kamera lügt, halte ich doch fest an der Idee von einer fotografischen Wahrheit."

« Bien que je sache que la caméra ment, je m'accroche à l'idée d'une vérité photographique. »

"Even though I know that the camera lies, I still hold on to the idea of a photographical truth."

3

2

4

Luc Tuymans

1958 born in Mortsel, lives and works in Antwerp, Belgium

His sketchy, alternately vaporous or bleached-out paintings address the potential inadequacy and "belatedness" of the medium, as Luc Tuymans himself puts it. Still, Tuymans might be thought of as a deeply analytic postmodern history painter, working over the embers of painting as well as over the political and social subjects for which, once upon a time, painting was pressed gainfully into service. This time around though, "grand" style painting is whittled down in size and derived from photography, television and the movies; it is far from laboured over despite the fact that Tuymans' considered – even sober – surfaces hardly admit that he completes each painting in the course of a day, a habitual, not to say compulsive action (the traces of which linger mostly in the passages where one can see that the paint has been applied wet-into-wet). With subjects ranging from the Holocaust or Belgian Congo politics to such trifles as Christmas decorations, his wan portrayals exist in the gap between image and the event to which it is rendered ambiguously oblique. Even portraits like *The Secretary of State* (2005), a close-up of Condoleezza Rice, eyes squinty and lacquered lips pursed, are oddly unsettling in their aloofness for all their proximity. The most mute of objects can become equally sinister without us knowing why. Tuymans prefers to leave much outside the frame, such that titles come to play a critical role in securing meaning, but neither does Tuymans offer easy consolations even once references are known. Instead, his paintings are invitations to associations that make clear how circumstantial readings of pictures can be.

Seine skizzenhaften Gemälde – mal hingehaucht, mal ausgebleicht – thematisieren die potenzielle Unzulänglichkeit und „Verspätung" des Mediums, wie Luc Tuymans es selbst formuliert. Dennoch könnte man ihn als zutiefst analytischen, postmodernen Historienmaler sehen, der sich mit der Tradition der Malerei ebenso beschäftigt wie mit den politischen und gesellschaftlichen Themen, denen sie früher einmal nutzbringend zu Diensten zu sein hatte. Heutzutage jedoch wird die repräsentative Malerei im Format zurecht gestutzt, ihre Modelle kommen aus Fotografie, Fernsehen und Filmen; sie wird auch nicht bis zum sorgfältigen Finish immer wieder überarbeitet, selbst wenn Tuymans' durchdachte – sogar nüchterne – Oberflächen kaum erkennen lassen, dass er jedes Gemälde im Laufe eines Tages vollendet, eine gewohnheitsmäßige, um nicht zu sagen zwanghafte Praxis (deren Spuren hauptsächlich dort zu erkennen sind, wo die Farbe nass-in-nass aufgetragen wurde). Seine fahlen Darstellungen mit Sujets, die vom Holocaust oder belgischer Kongo-Politik bis zu Banalitäten wie Weihnachtsschmuck reichen, sind in der Lücke zwischen dem Bild und dem Ereignis angesiedelt, das es in schiefer Zweideutigkeit wiedergibt. Selbst Porträts wie *The Secretary of State* (2005), eine Nahaufnahme von Condoleezza Rice mit zusammengekniffenen Augen und grell geschminkten Lippen, wirken in ihrer Reserviertheit, die sie trotz aller Nähe haben, merkwürdig irritierend. Noch das stummste Objekt kann ebenso unheimlich werden, ohne dass wir wüssten, warum. Tuymans lässt gerne viel außerhalb des Bildfläche, so dass den Titeln eine wichtige Rolle als Bedeutungsträger zukommt, doch selbst wenn die Bezüge bekannt sind, verweigern sich seine Bilder einem allzu leichten Verständnis. Vielmehr laden sie zu Assoziationen ein, die das Willkürliche von Bildinterpretationen deutlich machen.

Les peintures aux allures d'esquisses, tantôt translucides, tantôt délavées, de Luc Tuymans traitent du caractère potentiellement inadapté ou « en retard » de la peinture, pour reprendre une de ses expressions. Toutefois, on peut considérer Tuymans comme un peintre profondément analytique de l'histoire postmoderne, qui travaille sur les braises encore chaudes de la peinture, et autour des sujets politiques et sociaux pour lesquels la peinture était autrefois brillamment convoquée. Cependant, chez lui, la « grande peinture » est réduite en taille et s'inspire de la photographie, de la télévision et du cinéma ; elle n'est pas extrêmement travaillée, même s'il est difficile de croire que ses toiles, même sobres, puissent être achevées en un jour. Elles le sont pourtant, grâce à une action permanente, pour ne pas dire compulsive comme en témoignent les endroits où la peinture a été appliquée sans attendre que la couche inférieure sèche. Avec des sujets qui vont de l'holocauste à des frivolités comme les décorations de Noël, en passant par la politique menée au Congo belge, ses représentations blêmes prennent vie dans l'intervalle entre l'image et l'événement dont elle rend compte de façon ambiguë, oblique. Mêmes les portraits comme *The Secretary of State* (2005), un gros plan montrant une Condoleezza Rice aux yeux bigles et aux lèvres laquées et pincées, dérangent par la distance que leur proximité brutale installe. Le plus muet des objets peut devenir tout aussi sinistre sans que nous comprenions pourquoi. Tuymans préfère laisser une grande partie du sens hors du cadre et les titres jouent un rôle crucial dans l'appréhension de ses œuvres. Mais connaître les influences et références de Tuymans ne rend pas son œuvre limpide pour autant. Ses peintures nous invitent plutôt à faire des associations qui montrent combien l'interprétation des images peut être contingente.

S. H.

SELECTED EXHIBITIONS →
2008 *Luc Tuymans: Come and See*, Zacheta National Gallery of Art, Warsaw; *Luc Tuymans: The Occupied Heart*, Vestfossen Kunstlaboratorium, Vestfossen; *Luc Tuymans: Wenn der Frühling kommt*, Haus der Kunst, Munich **2007** *Luc Tuymans: Retrospective*, Mücsarnok Kunsthalle, Budapest; Haus der Kunst, Munich; Zacheta National Gallery of Art, Warsaw; *Luc Tuymans: I Don't Get It*, MuHKA, Antwerp **2006** *Luc Tuymans: Dusk/Penumbra*, Museu Serralves, Porto

SELECTED PUBLICATIONS →
2008 *Stations. Hundert Meisterwerke zeitgenössischer Kunst*, DuMont, Cologne; *Art & Today*, Phaidon Press, London **2007** *Luc Tuymans: Retrospective*, Mücsarnok Kunsthalle, Budapest; Zacheta National Gallery of Art, Warsaw; *I Don't Get It*, Ludion, Ghent; *The Painting of Modern Life – 1960s to Now*, Hayward Publishing, London **2006** *Luc Tuymans: Dusk/Penumbra*, Museu Serralves, Porto

1 **W**, 2008, oil on canvas, 188 x 119.4 cm
2 **The Secretary of State**, 2005, oil on canvas, 45.5 x 61.5 cm

3 **Three Moons**, 2007, oil on canvas, 172.5 x 132.2 cm

„Sagen wir so: Manchmal überarbeite ich das Bild noch mal, klar, aber das sind dann wirklich nur kleine Details. Aber wenn das Bild nicht während des Tages fertig wird, dann kommt es nie zustande."

« Oui, bon, disons qu'il m'arrive de revenir sur une peinture, bien sûr, mais il s'agit vraiment toujours de tout petits détails ; je veux dire que si un tableau n'apparaît pas dans la journée, il n'apparaîtra jamais. »

"Well let's say that sometimes I come back at the painting, I surely do, but it is really very small details, I mean when the painting does not appear during the day it will never appear."

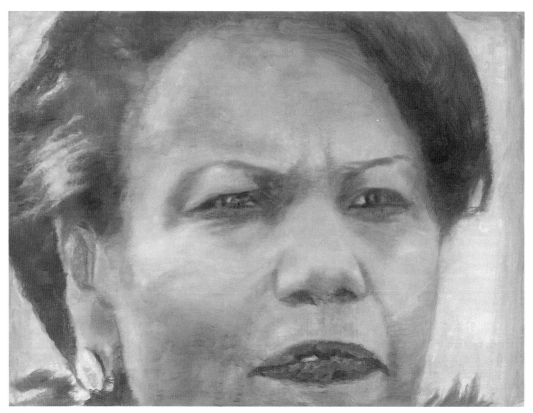

2

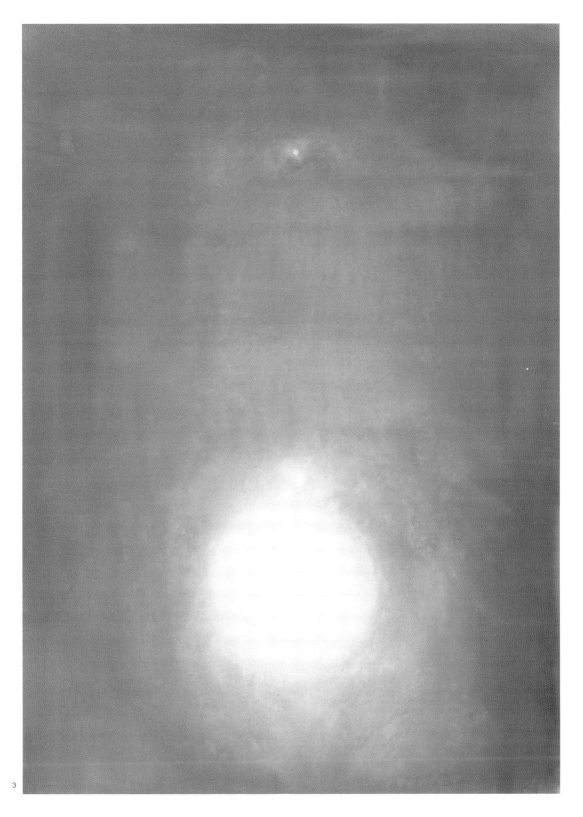

Piotr Uklański

1968 born in Warsaw, lives and works in Warsaw, Poland, and New York (NY), USA

The desire to look behind the signs into the mechanism of their coding is something that continually drives contemporary artists. Gaining insight into the encoding mechanism ultimately holds the promise of developing expertise in using the signs. In this context, clichés seem particularly suitable because of the density of sign-construction features they contain. In his work, Piotr Uklański repeatedly employs clichés, cleverly alluding to them, changing them and playing them out. This applies to his latest works, which he has brought together for an exhibition entitled *Biało-Czerwona* (*White-Red*, 2008), but also to other exhibitions such as *A Retrospective* (2007) and *Joy of Photography* (2007), as well as the western film *Summer Love* (2006). Many of the works in *Biało-Czerwona* allude to Polish symbols and colours, thereby addressing Uklański's own identities as an "international" artist and guest worker in New York, as well as his Polish roots. But in the same way as its propaganda gestures ultimately come to nothing, and in *Joy of Photography* the effectiveness of the eponymous handbook from the age of analogue photography is lost, in *Summer Love* not only the plot implodes but also the very genre of the Western. A sheriff points to an orange-coloured rock and asks his partners, "You know what that means?" before answering his own question: "Absolutely nothing. But you did not know that." Consequently, his posse mainly manages to injure only themselves in the manhunt and end up burying alive one of their own men. With a sure hand, Uklański evokes familiar elements of American and European westerns; however, he does not just play with clichés, he plays them out – to the bitter end. Because he has gained insight into their encoding mechanism.

Einen Blick hinter die Zeichen zu werfen, in das Uhrwerk ihrer Codierung, ist eine Sehnsucht, die zeitgenössische Künstler immer wieder umtreibt. Verspricht doch der Einblick in die Mechanismen der Codierung nicht zuletzt einen meisterhaften Umgang mit ihnen. Besonders geeignet erscheinen in diesem Zusammenhang Klischees, denn bei ihnen verdichten sich Merkmale der Zeichenkonstruktion. Piotr Uklański setzt bei seinen Arbeiten immer wieder auf Klischees, die er virtuos anspielt, wendet und ausspielt. Das gilt auch für seine neueren Arbeiten, die er unter dem Ausstellungstitel *Biało-Czerwona* (*Weiß-Rot*, 2008) zusammengefasst hat, aber ebenso für die Ausstellungen *A Retrospective* (2007) und *Joy of Photography* (2007) sowie den Western *Summer Love* (2006). Viele der Werke bei *Biało-Czerwona* nehmen Bezug auf polnische Symbole und Farben und thematisieren damit zugleich Uklańskis eigene Identität zwischen „internationalem" Künstler, Gastarbeiter in New York und polnischem Ursprung. Doch genauso, wie dabei Propagandagesten ins Leere laufen, bei *Joy of Photography* die Effektivität des gleichnamigen Handbuchs aus den Zeiten der analogen Fotografie verblasst, implodiert in *Summer Love* nicht nur die Handlung, sondern auch die Gattung des Westerns. So deutet der Sheriff auf einen orangefarbenen Felsen und fragt seine Mitstreiter: „You know what that means?" Und beantwortet es sich selbst: „Absolutely nothing. But you did not know that." Folgerichtig verletzt seine Truppe sich vor allem selbst bei der Menschenjagd und begräbt einen der ihren lebendig. Uklański ruft mit sicherer Hand gängige Elemente des amerikanischen und europäischen Westerns auf, aber er spielt nicht allein mit Klischees, er spielt sie aus. Bis ans Ende. Denn er hat in das Uhrwerk der Codierung geblickt.

Un désir qui anime régulièrement des artistes contemporains est de jeter un regard derrière les signes, dans l'horlogerie de leur codage. La compréhension des mécanismes qui régissent leur production promet en effet d'en tirer notamment un magistral maniement des codes eux-mêmes. Les clichés semblent particulièrement utiles à cette démarche car ils concentrent en eux certaines caractéristiques de l'élaboration des signes. Dans ses œuvres, Piotr Uklański mise régulièrement sur des clichés qu'il évoque, retourne et décline en virtuose. Ceci vaut également pour les œuvres récentes réunies sous le titre d'exposition *Biało-Czerwona* (*Blanc-Rouge*, 2008) aussi bien que pour les expositions *A Retrospective* (2007) et *Joy of Photography* (2007), ou encore pour le western *Summer Love* (2006). Nombre des œuvres de *Biało-Czerwona* se réfèrent à des couleurs et à des symboles polonais, thématisant ainsi l'identité d'Uklański entre « international », travailleur immigré à New York et origines polonaises. Mais de même que les positions propagandistes y tournent à vide, et de même que *Joy of Photography* fait pâlir l'efficacité du manuel homonyme paru à l'époque de la photographie analogique, de même *Summer Love* fait imploser non seulement l'action, mais aussi le genre cinématographique du western. Le shérif montre par exemple un rocher orangé et demande à ses adjoints : « You know what that means ? » avant de donner lui-même la réponse : « Absolutely nothing. But you did not know that. » Très logiquement, pendant la chasse à l'homme, sa troupe se blesse surtout elle-même et enterre vivant un de ses membres. Évoquant d'une main sûre des éléments courants du western américain et européen, Uklański ne se contente pas de jouer avec les clichés, il les pousse dans leurs derniers retranchements, car il a jeté un regard dans le mécanisme de leur codage.

H. L.

SELECTED EXHIBITIONS →
2008 *When Things Cast No Shadow*, 5th Berlin Biennial for Contemporary Art, Berlin; *The Hamsterwheel*, Malmö Konsthall, Malmö **2007** *Piotr Uklanski: A Retrospective*, Secession, Vienna; *Piotr Uklanski*, Whitney Museum of American Art, New York; *Piotr Uklanski*, Musée d'art moderne et contemporain, Strasbourg; *Piotr Uklanski: Summer Love*, Whitney Museum, New York; *INSIGHT?*, Gagosian Gallery/Red October Chocolate Factory, Moscow **2005** *Superstars*, Kunsthalle Wien; BA-CA Kunstforum, Vienna

SELECTED PUBLICATIONS →
2008 *Piotr Uklanski: Biało-Czerwona*, Gagosian Gallery, New York **2007** *Piotr Uklanski: The Joy of Photography*, Musée d'art moderne et contemporain, Strasbourg; Hatje Cantz, Ostfildern; *INSIGHT?*, Gagosian Gallery/Red October Chocolate Factory, Moscow

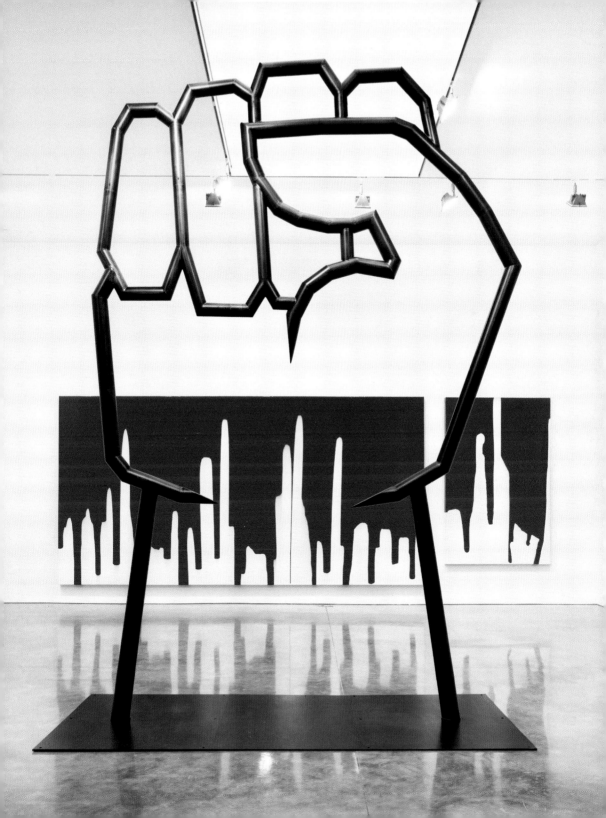

1 Installation view, Gagosian Gallery, New York, 2008, center:
 Untitled (The Fist), 2007, steel tube, varnish, 500 x 343 x 12 cm
2 **Untitled (Bullethole)**, 2007, gouache on Lanaquarelle paper collage, torn,
 pasted on plywood, 305 x 305 cm
3 **Untitled (Eagle, Polish)**, 2005, carved Styrofoam, 333 x 300 x 18 cm

4 **Summer Love**, 2006, 35mm film, colour, sound, 93 min. Promotional poster
 for Venezia 63rd Film Festival, offset print, 99 x 69 cm
5 **Untitled (Stephanie Seymour, the Supermodel)**, 2007, inkjet print on PVC,
 330 x 589 cm

„Wenn wir annehmen, dass Kunst oder eine andere kreative Aktivität in der
Lage ist, die Wahrheit über die menschliche Existenz zu reflektieren, sollte
sie diese Existenz nicht nachahmen, sondern eine künstliche Realität oder
Form schaffen."

« En admettant que l'art ou toute autre activité créatrice soit à même de
refléter la vérité de l'existence humaine, l'art ne devrait pas imiter cette
existence, mais créer une réalité ou forme artificielle. »

"If we accept that art or any other creative activity is able to reflect the truth of human existence, then it should not imitate this existence but instead create an artificial reality or form."

4

Kara Walker

1969 born in Stockton (CA), lives and works in New York (NY), USA

With her black-paper silhouettes, ochre gouaches, magic-lantern projections and video animations, Kara Walker has been exposing the heart of darkness of American culture, revealing its passion for violence and its inherent racism. 2007 saw Walker's first full-scale museum survey that toured internationally for nearly two years. The exhibition brought together recent works with seminal older pieces, such as *Gone: An Historical Romance of a Civil War as It Occurred between the Dusky Thighs of One Young Negress and Her Heart* (1994), the installation with which Walker polarized the New York art world on her debut at the Drawing Art Center. In her cut-out installations, Walker reinterprets a technique that echoes the genteel 18th-century art of paper silhouettes up to Lotte Reiniger's silhouette films, but forces it into a completely different direction, to tell stories of slavery and subjugation. Her large-scale tableaux, glued to the wall like dioramas, often start from references to the antebellum American South, with its cotton plantations, decadent landowners and mortified slaves. The representation of racial oppression is one of the central themes in Walker's work, but it is accompanied by a complex reflection on the seductive power of desire. Recently, Walker has been experimenting with film and shadow-puppets animation, as in the video installation *...calling to me from the angry surface of some grey and threatening sea. I was transported* (2007). This new body of works expands her research on racial stereotypes, while introducing more complex narrative structures that ark back to the tradition of the minstrel show and to the transmission of oral culture.

Mit ihren schwarzen Papiersilhouetten, ockergelben Gouachen, Laterna-Magica-Projektionen und Videoanimationen hat Kara Walker das Herz der Finsternis der amerikanischen Kultur freigelegt und ihre Gewalttätigkeit sowie den ihr innewohnenden Rassismus offenbart. 2007 wurde Walkers erste große Museumsretrospektive eröffnet, die fast zwei Jahre lang international zu sehen war. Neben neueren Arbeiten zeigte die Ausstellung auch wichtige ältere Werke wie *Gone: An Historical Romance of a Civil War as It Occurred between the Dusky Thighs of One Young Negress and Her Heart* (1994), jene Installation, mit der Walker die New Yorker Kunstwelt bei ihrem Debüt im Drawing Art Center polarisiert hatte. In ihren Scherenschnitten übernimmt Walker eine Technik, deren Tradition von der vornehmen Kunst des 18. Jahrhunderts bis hin zu Lotte Reinigers Silhouettenfilmen reicht, doch anstatt sie einfach nachzuahmen, gibt sie ihr eine völlig andere Richtung, um Geschichten von Sklaverei und Unterjochung zu erzählen. Ihre großformatigen Tableaus, die wie Dioramen auf die Wände geklebt werden, beginnen oft mit Szenen aus den amerikanischen Südstaaten vor dem Bürgerkrieg mit Baumwollplantagen, dekadenten Gutsherren und gedemütigten Sklaven. Die Darstellung von Rassenunterdrückung ist eins der zentralen Themen in Walkers Œuvre, doch es geht einher mit einer komplexen Reflexion über die verführerische Macht der Begierde. Seit Kurzem experimentiert Walker mit dem Medium Film und mit Schattenspielanimationen, etwa in der Videoinstallation *... calling to me from the angry surface of some grey and threatening sea. I was transported* (2007). Auch in diesen neueren Arbeiten werden rassische Stereotypen thematisiert, allerdings anhand komplexerer Erzählstrukturen, die auf die Tradition der Minstrelshows und die Überlieferung oraler Kultur zurückgehen.

Kara Walker expose avec ses silhouettes en papier noir, ses projections de lanternes magiques et ses animations vidéo le côté obscur de la culture américaine, en insistant sur sa passion de la violence et son racisme. En 2007, une première exposition d'envergure consacrée à Walker a été organisée, qui circula dans différents musées du monde pendant près de deux ans. L'exposition rassemblait des travaux récents et des pièces plus anciennes, comme *Gone* (sous-titrée « une romance en temps de guerre civile telle qu'elle se déroula entre les cuisses mates et le cœur d'une jeune négresse », 1994), installation qui polarisa le milieu artistique new-yorkais lorsqu'elle fut montrée pour la première fois au Drawing Art Center. Avec ses installations, Walker réinterprète une technique en vogue au XVIIIe siècle et utilisée jusque dans les films d'animation de Lotte Reiniger, mais en la poussant dans une direction nouvelle, pour raconter l'esclavage et l'assujettissement. Ses tableaux à grande échelle, collés au mur comme des dioramas, partent souvent de références au Sud américain d'avant la guerre de Sécession, avec ses plantations de coton, ses propriétaires terriens décadents et ses esclaves humiliés. La représentation de l'oppression raciale est un des thèmes centraux de l'œuvre de Walker, mais elle s'accompagne d'une réflexion complexe sur le pouvoir du désir. Walker expérimente depuis peu avec le film et l'animation en ombre chinoise, comme dans l'installation vidéo *...calling to me from the angry surface of some grey and threatening sea. I was transported* (2007). Ce nouvel ensemble d'œuvres est une prolongation de sa recherche sur les stéréotypes raciaux. Il lui permet d'introduire des structures narratives plus complexes qui font écho à la tradition de la chanson de geste et à la transmission de la culture orale.

C. A.

SELECTED EXHIBITIONS →
2008 *Kara Walker: The Black Road*, Centro de Arte Contemporáneo de Málaga. *Kara Walker*, Art Gallery of Ontario, Toronto **2007** *Kara Walker: My Complement, My Enemy, My Oppressor, My Love*, The Walker Art Center, Minneapolis; Musée d'Art moderne de la Ville de Paris; Hammer Museum, Los Angeles. *Kara Walker: Harper's Pictorial History of the Civil War (Annotated)*, Addison Gallery of American Art, Andover **2006** *Kara Walker at the Met: After the Deluge*, The Metropolitan Museum of Art, New York

SELECTED PUBLICATIONS →
2008 *Kara Walker: Bureau of Refugees*, Charta, Milan. *Waiting in New Orleans: A Reader* by Paul Chan, Creative Time, New York **2007** *Kara Walker: After the Deluge*, Rizzoli, New York. *Kara Walker: My Complement, My Enemy, My Oppressor, My Love*, Walker Art Center, Minneapolis; Hatje Cantz, Ostfildern. *Walker: Narratives of a Negress*, Rizzoli, New York **2004** Gwendolyn DuBois Shaw: *Seeing the Unspeakable: The Art of Kara Walker*, Duke University Press, Durham

ULYSSES S. GRANT.

THE LAST DELEGATION FROM MISSISSIPPI IN THE CONGRESS OF THE UNITED STATES.

1 **Untitled**, 2001–05, set of 9 collages on paper, 1 part 27.9 x 22.9 cm, 8 parts 40.6 x 28.6 cm (each)

2/3 **...calling to me from the angry surface of some grey and threatening sea. I was transported**, 2007, 5-channel video installation, colour, sound, 11 min, loop

4 **Hysteria! Savagery! Passions!**, 2006, gouache, paper collage on panels, 1 from a group of 11 parts, ca 45.7 x 50.8 cm (each)

5 **Authenticating the Artifact**, 2007, mixed media, cut paper, acrylic on gessoed panel, 152.7 x 213.4 x 5.1 cm

„Frühe amerikanische Spielarten von Scherenschnitten zu sehen, war für mich wie ein kathartisches Erlebnis. Was ich da erkannte – außer Erzählung, Historizität und Rassismus –, war dieser ganz physische Akt des Verlagerns: das Paradox, dass durch die Entfernung einer Form von einer leeren Fläche ein schwarzes Loch entsteht."

« J'ai vécu une catharsis en découvrant la grande variété d'anciennes silhouettes américaines en papier découpé. Ce que j'ai reconnu, au-delà des récits, du caractère historique et du racisme, c'est ce décalage très physique : le paradoxe résidant dans le geste de découper une forme dans une surface blanche pour créer un trou noir. »

"I had a catharsis looking at early American varieties of silhouette cuttings. What I recognized, besides narrative and historicity and racism, was this very physical displacement: the paradox of removing a form from a blank surface that in turn creates a black hole."

2

3

4

Rebecca Warren

1965 born in London, lives and works in London, United Kingdom

Appropriating, reinventing and otherwise exploiting the works of Degas, Rodin, Picasso, Boccioni and Fontana, Rebecca Warren is something of a bull in the china shop that is the Western sculptural tradition. She is best known for her anarchic unfired, untreated clay sculptures that query themes of gender and self-expression, and which are almost lovingly flecked with passages of muted colours and elsewhere marked by impressions left behind from her fingers modelling the pliant material. Breasts and buttocks, dancers and portrait busts that might suspiciously recall heads of cabbage, are often set atop white bases, although Warren has recently begun – à la Brancusi – to incorporate pedestals into her artworks. The wonderfully quirky MS 1 (2007) flaunts a base (and what rests upon it) further enclosed within a casket-like Plexiglas box, while other works employ the format of a wall-mounted vitrine, a receptacle for a canny array of quotidian detritus. This interest in installation follows upon Warren's earlier conceit of placing sculptures on studio trolleys – they cannot help but look like skateboards upon which the cumbersome figures ride, held safely in place by their leaden, oversized feet. The artist also works in with bronze – another venue for the exploration of form's disintegration in her practice. She models clay, sends it to the foundry, receives the broken clay original back and then revises it before sending it to the foundry – again – for recasting in a protracted back and forth that increasingly reveals mutations as the exigencies of process, an alchemy in which Warren translates raw matter into motion.

Die ungenierte Art, wie sich Rebecca Warren Werke von Degas, Rodin, Picasso, Boccioni oder Fontana aneignet, sie umdeutet oder anderweitig verwertet, macht sie gewissermaßen zum Elefanten im Porzellanladen der westlichen Bildhauertradition. Am bekanntesten ist sie für ihre anarchischen Skulpturen aus ungebranntem, unbehandeltem Ton, die Themen wie Geschlecht und Selbstdarstellung kritisch behandeln und die fast liebevoll mit gedämpften Farbtupfern besprenkelt oder durch Abdrücke ihrer modellierenden Finger anderweitig markiert sind. Brüste und Gesäßteile, Tänzer und Porträtbüsten, die verdächtig an Kohlköpfe erinnern, werden oft auf weiße Sockel gesetzt, obwohl Warren seit Kurzem auch Postamente – à la Brancusi – in ihre Kunstwerke integriert. Das wunderbar schrullige MS 1 (2007) prangt auf einem (Rest-)Sockel, der zusätzlich von einer schatullenartigen Plexiglas-Box umschlossen ist, während sich andere Werke im Format einer Wandvitrine präsentieren, eines Behälters für ein raffiniertes Aufgebot an alltäglichem Müll. Dieses Interesse für Installationen ergibt sich aus Warrens früherem Konzept, Skulpturen auf Rollwagen zu stellen, wie man sie im Atelier benutzt – sie sehen wie Skateboards aus, auf denen die klobigen Figuren fahren, die von ihren bleiernen, überdimensionierten Füßen im Gleichgewicht gehalten werden. Die Künstlerin verwendet auch Bronze – eine weitere Gelegenheit, in ihrer Praxis die Auflösung der Form zu erkunden. Sie modelliert Ton, schickt ihn zur Gießerei und bekommt das zerbrochene Original aus Ton zurück, das sie dann überarbeitet, bevor sie es erneut zur Gießerei schickt, um es in einem langwierigen Hin und Her umzugestalten: Mutationen erweisen sich immer mehr als Erfordernisse eines alchemistischen Prozesses, durch den Warren Rohmaterial in Bewegung umsetzt.

En s'appropriant, réinventant, ou du moins en exploitant les œuvres de Degas, Rodin, Picasso, Boccioni et Fontana, Rebecca Warren se conduit comme un éléphant dans le magasin de porcelaine qu'est la tradition de la sculpture européenne. Warren est principalement connue pour ses sculptures anarchiques en terre non cuite et non traitée qui touchent aux thèmes du genre et de l'expression personnelle, et sont presque amoureusement tachetées de couleurs pâles, ou marquées à d'autres endroits par la pression de ses doigts sur la terre encore meuble. Seins et fesses, danseurs et portraits en buste à têtes de chou, sont souvent placés sur des socles blancs, même si Warren commence depuis peu – à la manière de Brancusi – à incorporer les piédestaux à ses créations. Son MS 1 (2007) délicieusement excentrique exhibe ainsi un socle (et ce qui est posé dessus) lui-même inséré dans une sorte de boîte en Plexiglas aux allures de cercueil. D'autres œuvres prennent la forme de vitrines murales, qui servent de réceptacle à toute une collection de détritus quotidiens. Ce goût pour l'installation intervient après une période où Warren se contentait de présenter ses sculptures sur des chariots d'atelier – qui prenaient alors des allures de skateboards montés par des encombrants personnages, fermement campés sur leurs pieds lestés et surdimensionnés. L'artiste travaille aussi le bronze – une nouvelle occasion d'explorer la désintégration de la forme dans sa pratique. Elle modèle l'argile, envoie le modelage à la fonderie, récupère l'original en terre brisé et le retravaille avant de le retourner à la fonderie. Ce long procédé de va-et-vient révèle les transformations de l'œuvre et l'importance du processus, l'alchimie par laquelle Warren traduit la matière brute en mouvement.

S. H.

SELECTED EXHIBITIONS →
2008 The Vincent Award 2008, Stedelijk Museum, Amsterdam. Martian Museum of Terrestrial Art, Barbican Centre, London **2007** The Third Mind, Palais de Tokyo, Paris. Unmonumental: The Object in the 21st Century, New Museum, New York. No Room for the Groom, Herald St, London **2006** The Turner Prize, Tate Britain, London, Tate Triennial, Tate Britain, London.

SELECTED PUBLICATIONS →
2007 Ernesto Neto, Olaf Nicolai, Rebecca Warren, Parkett 78, Zürich **2006** Rebecca Warren, JRP Ringier, Zürich

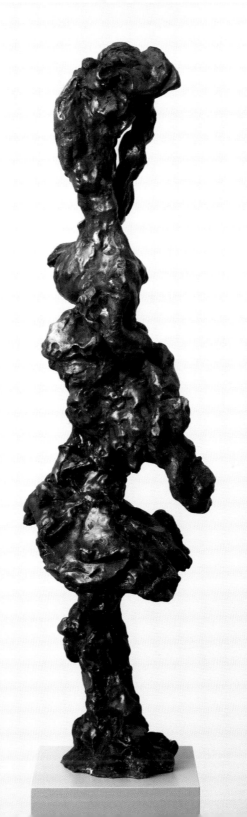

1 **Regine**, 2007, bronze, 125 x 35 x 40 cm, pedestal 57 x 28 x 28 cm
2 **The Living II**, 2007, mixed media wall mounted vitrine, 70 x 138 x 32 cm

3 Installation view, Turner Prize, Tate Britain, London, 2006

„Ich arbeite soweit es geht gegen die Vorschriften. Ton ist ein glitschiges Material und mein Umgang damit ist absichtlich voller Risiko. Das nötige Handwerkszeug ist auch Teil dieses Prozesses, nicht als Ziel, sondern als Mittel."

« J'évite de travailler de manière prédéfinie. La glaise est glissante et ma position à son égard est délibérément précaire. Les valeurs du savoir-faire et du métier sont soumises à ce processus, pas comme but mais comme moyen. »

"I try not to work in a prescribed way. Clay is slippery and my position within it is deliberately precarious. Skills and craft values are subsumed into this process, not as ends but as means."

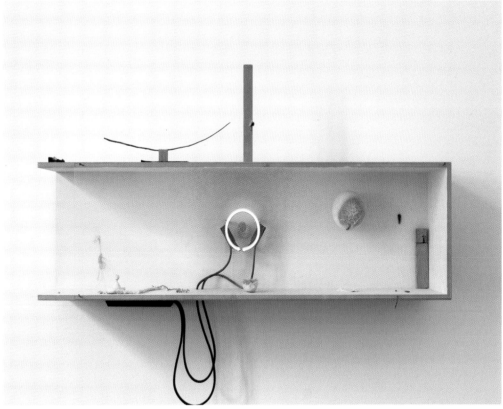

2

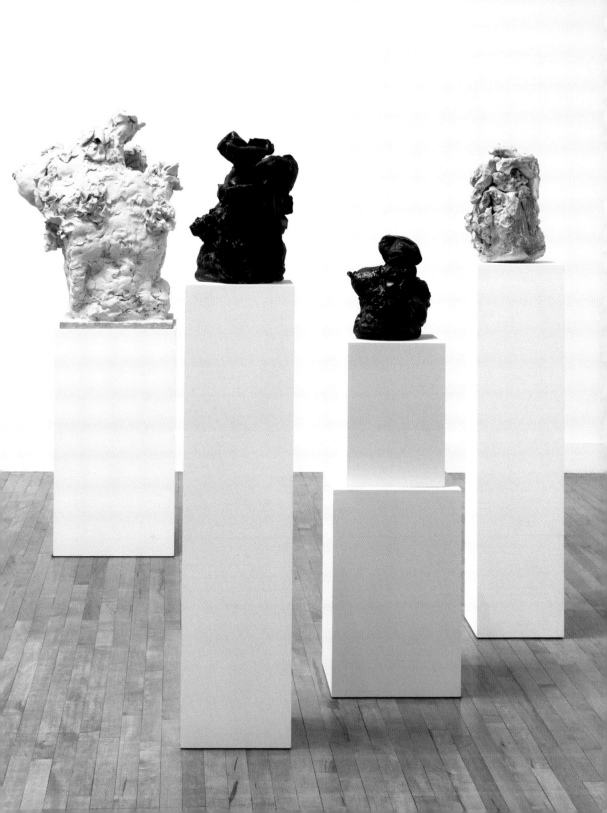

Franz West

1947 born in Vienna, lives and works in Vienna, Austria

"I believe that if neuroses were visible, they would look like this." When Franz West talks about his sculptures in this way, he means what he says: they embody something and, due to their very size and stature, represent a counterpart with whom we have to engage. It is no surprise that West has his roots in Vienna, the city of Freud and Nitsch. Originally influenced by Vienna actionism, and to this day characterized by a preference for archaic cultures, West's art addresses the relationship between object and body. This can be seen in his outdoor sculptures that hang around in parks or urban space, as well as in the *Passstücke* (adapters): the often bizarre appearance of these objects made of papier-mâché, plaster and polyester is disturbing to the gaze, which generally focuses on the body. Their meaning emerges through use; they are provocative prostheses of aesthetic experience which turn viewers into performers and force them to adopt an unusual stance. By the same logic, West is also interested in transitions between sculptures and utility objects: his tubular steel chairs covered in African batik fabrics, for example, are basically just furniture, but by putting them in performative situations he makes their use, however casual, sculpturally active. But West also creates autonomous sculptures that do not require use for their completion: the group of works around *Rachel Was Here* (2007), for example, not only upset the sculpture-plinth relationship with charming clumsiness, their atavism also expresses an obstinacy that is never merely illustrative, nor is it just formal; instead, with pointed recalcitrance, they confront the viewer with irony, ungainliness and high spirits: an abstract garden of brightly burgeoning neuroses.

„Ich behaupte, wenn man Neurosen sehen könnte, dann sähen sie so aus." Wenn Franz West so über seine Skulpturen spricht, ist das direkt gemeint: Sie verkörpern etwas, stellen schon der Statur nach ein Gegenüber dar, mit dem man es erstmal aufzunehmen hat. Nicht von ungefähr ist West in Wien, der Stadt von Freud und Nitsch verwurzelt. In seiner Kunst, ursprünglich geprägt vom Wiener Aktionismus und bis heute von der Vorliebe für archaische Kulturen getragen, ist die Beziehung von Objekt und Körper durchgängiges Thema. Das erweist sich an Wests lässig in Park oder Stadtraum herumlungernden Plastiken ebenso wie an den *Passstücken*: Das oft skurrile Erscheinungsbild dieser aus Pappmaché, Gips und Polyester geformten Objekte irritiert das Auge – weil es eigentlich in erster Linie auf den Körper zielt. Sie erschließen sich durch Verwendung, sind provozierende Prothesen ästhetischer Erfahrung, die Betrachter zu Performern machen und sie in ungewohnte Haltungen zwingen. In gleicher Logik interessieren West auch Übergänge zwischen Skulptur und Gebrauchsobjekt: Seine mit afrikanischen Wachsbatikstoffen behängten Stühle aus Stahlrohr etwa sind an sich bloß Mobiliar, doch indem er sie in performative Situationen stellt, macht er ihre, sei es noch so beiläufige, Verwendung skulptural aktiv. Daneben entwickelt er aber auch Skulpturen, die autonom und nicht erst qua Gebrauch komplett sind: Die Werkgruppe um *Rachel Was Here* (2007) zum Beispiel stellt in charmanter Grobklotzigkeit nicht bloß das Skulptur-Sockel-Verhältnis auf den Kopf. Ihr Atavismus prägt zudem Eigensinn aus, der nie illustrativ, aber eben auch nie bloß formal ist, sondern in pointierter Sprödigkeit die Betrachter ironisch, ungeschlacht und fröhlich konfrontiert: ein abstrakter Garten grell blühender Neurosen.

« Je prétends que si on pouvait voir les névroses, voilà à quoi elles ressembleraient. » Cette déclaration de Franz West à propos de ses sculptures est à prendre au pied de la lettre : elles incarnent quelque chose et leur seule stature en fait un vis-à-vis auquel le spectateur doit d'abord se mesurer. Ce n'est pas par hasard que West est installé à Vienne, la ville de Freud et de Nitsch. Dans son œuvre, qui fut d'abord influencé par l'actionnisme viennois et qui est aujourd'hui encore empreint d'une prédilection pour l'archaïque, le rapport entre l'objet et le corps est un thème constant. Ses objets « pour s'asseoir », ses immenses sculptures qui traînent négligemment dans l'espace public, ou encore ses *Passstücke* (pièces ajustées), objets souvent grotesques en papier mâché, en plâtre et en polyester, tous irritent le regard parce qu'ils s'adressent d'abord au corps. Ils s'apprivoisent par leur utilisation et sont des prothèses provocatrices d'expérience esthétique qui transforment le spectateur en performeur, l'obligeant à des attitudes inhabituelles. Dans la même logique, West s'intéresse aussi aux transitions entre sculpture et objet utilitaire : ses chaises en acier recouvertes de batiks africains cirés ne sont que du mobilier, mais dans des situations performatives, leur utilisation – même incidente – active leur caractère de sculpture. Mais West développe aussi des sculptures autonomes dont la raison d'être ne résulte pas de l'utilisation : avec leur charmante balourdise, les œuvres regroupées autour de *Rachel Was Here* (2007) ne se contentent pas d'inverser le rapport sculpture/socle. Leur atavisme dénote aussi un sens de l'entêtement qui n'est jamais seulement illustratif ou formel, mais dont la rudesse ciblée houspille le spectateur de manière ironique, grossière et joyeuse : un jardin abstrait où fleurissent des névroses hautes en couleurs.

J. A.

SELECTED EXHIBITIONS →
2008 *Franz West, To Build a House You Start with the Roof: Work, 1972–2008*, Baltimore Museum of Art, Baltimore. *Franz West: Sit on My Chair, Lay on My Bed*, Museum für angewandte Kunst, Vienna. *Leben? Biomorphe Formen in der Skulptur*, Kunsthaus Graz. *Games*, Kunsthalle Wien, Vienna. *Vertrautes Terrain – Aktuelle Kunst in und über Deutschland*, ZKM, Karlsruhe. *The Hamsterwheel*, Malmö Konsthall, Malmö **2007** *Strange Events Permit Themselves the Luxury of Occuring*, Camden Arts Center, London

SELECTED PUBLICATIONS →
2008 *Franz West, To Build a House You Start with the Roof: Work, 1972–2008*, Baltimore Museum of Art, Baltimore; The MIT Press, Cambridge. *Passstücke*, Gagosian Gallery, New York **2007** *Pop Art Is*, Gagosian Gallery, London **2006** *Franz West*, Friedrich Christian Flick Collection, Berlin; DuMont, Cologne **2004** *Franz West: Gesammelte Gespräche und Interviews*, Verlag der Buchhandlung Walther König, Cologne

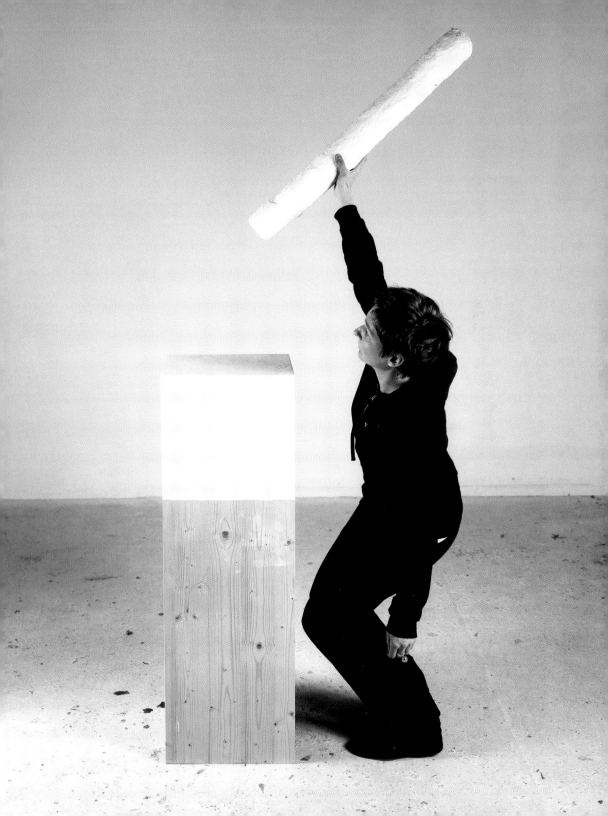

1 **Passstück**, 2007, papier-mâché, gauze, paint, plastic, 84 x 10 x 10 cm, pedestal (wood, paint) 111 x 37 x 33 cm
2 **Liege**, 2007, metal, air mattress, 90 x 150 x 73 cm
3 **Nullen / Zeros**, 2006, plaster, dispersion, foam, pedestal (wood, paint)

4 **Studienobjekt**, 2007, epoxy resin, metal, 320 x 420 x 200 cm
5 **Postexpression / Nachempfindung**, 2007, epoxy resin, ca 250 x 260 x 180 cm

„Ich habe gedacht, ja gehofft, meine Kunst wäre wie ein Schrei, aber im Gegenteil, sie war wie eine Blüte."

« J'avais pensé et même espéré que mon art était comme un cri, mais au contraire, il a été comme une floraison. »

"I had thought – and even hoped – that my art would be like a scream, but on the contrary, it was like a flower."

2

3

4

Pae White

1963 born in Pasadena (CA), lives and works in Los Angeles (CA), USA

Pae White relishes making artworks that shift before your eyes and play between arts, architecture, craft and design. Her delicate mobiles, made from humdrum materials, cut colour-aid paper and thread, take on multiple identities, each paper disc representing a splash of light, whether sparks from a Roman candle firework, the refraction of a waterfall or the glint of a peacock's feathers. The vertical stacks can take on more concrete form looking like the night-lighted windows of high-rise buildings or a city viewed from altitude. White is from Los Angeles, and for Skulptur Projekte Münster 07 she worked with the Kleimann Pastry Shop, situated in the heart of Münster, to make a selection of marzipan interpretations of East LA-style "taco trucks" (*my-fi*, 2007). The sweet mix of traditional confectionary and Californian fastfood culture was then displayed alongside more traditional candied souvenirs in the shop window. Also part of the project was a sound installation for the city centre, where carrillons played pop songs about love and bells stood in the parks, created after models by the side of roads that link the former Spanish missions in California. One of Pae's most recent works, the stage curtain for the newly inaugurated Norwegian National Opera in Oslo (2008), appears to be a massive sheet of crumpled tin foil (contrasting the clean lines of Snøhetta's design of the building). In reality, however, the curtain consists of digital images of aluminium foil which reflect and adopt the colours of the auditorium. As it lifts, it is revealed as computer woven curtaining — the first magic of the night.

Pae White produziert mit Vorliebe Kunstwerke, die sich vor unseren Augen verändern und sich zwischen Kunst, Architektur, Handwerk und Design bewegen. Ihre filigranen Mobiles aus einfachsten Materialien – farbiges Papier und Fäden – haben vielfältige Eigenschaften. Jede Papierscheibe ist wie ein Lichtreflex, es könnten Funken von einem Goldregen sein, die Brechung eines Wasserfalls oder das Schimmern von Pfauenfedern. Die vertikalen Elemente nehmen manchmal konkretere Formen an und sehen wie nächtlich beleuchtete Fenster von Hochhäusern oder wie eine Stadt aus der Vogelperspektive aus. White stammt aus Los Angeles – für die Skulptur Projekte Münster 07 arbeitete sie mit der im Stadtzentrum gelegenen Konditorei Kleimann zusammen und schuf Marzipanskulpturen von den für East L.A. typischen „Taco Trucks" (*my-fi*, 2007). Die süße Mischung aus traditionellem Konfekt und kalifornischer Fastfood-Kultur wurde dann neben eher herkömmlichen Süßigkeiten im Schaufenster der Konditorei gezeigt. Darüber hinaus entwickelte sie für die Münsteraner Innenstadt eine Klanginstallation, in der Glockenspiele Popsongs über das Thema Liebe spielten und Glocken, wie sie den Weg zwischen alten spanischen Missionen in Kalifornien säumen, in den Parks standen. Eines von Paes neuesten Werken, der Bühnenvorhang für die gerade eingeweihte Norwegische Nationaloper in Oslo (2008), wirkt wie ein riesiges Blatt aus zerknittertem Stanniol (im Kontrast zu den klaren Linien des von Snøhetta entworfenen Baus). In Wirklichkeit besteht der Vorhang jedoch aus digitalen Bildern von Alufolie, die sich den Farben des Auditoriums reflektierend anverwandeln. Beim Aufgehen offenbart sich dann der computergewirkte Vorhangstoff – der erste magische Moment des Abends.

Pae White éprouve un plaisir évident à produire des œuvres qui se balancent devant nos yeux et jouent avec l'art, l'architecture, l'artisanat et le design. Ses mobiles délicats réalisés à partir de matériaux ordinaires, nanciers en papier et fils de couleur, revêtent des identités multiples, chaque disque de papier représentant une éclaboussure de lumière différente : une étincelle de feu d'artifice, la réfraction d'une cascade, ou encore le chatoiement du panache d'un paon. Ses empilements verticaux prennent parfois des formes plus concrètes pour rappeler la vision nocturne des fenêtres éclairées d'un immeuble ou une ville vue du ciel. White vient de Los Angeles et pour Skulptur Projekte Münster 07, elle a travaillé avec la pâtisserie Kleimann située au cœur de Münster, pour produire une sélection de figurines en pâte d'amande représentant des « camionnettes à tacos » typiques des quartiers Est de Los Angeles (my-fi, 2007). Ce doux mélange de confection traditionnelle et de culture américaine du fast-food a ensuite été présenté au milieu d'autres friandises plus traditionnelles dans la vitrine de la boutique. White a également réalisé une installation sonore pour le centre-ville de Münster : des carillons jouaient des chansons d'amour pop et des cloches bordaient les chemins des parcs à la manière des anciennes routes des missions espagnoles en Californie. Une de ses créations les plus récentes, un rideau de scène pour le nouvel Opéra national de Norvège à Oslo (2008), apparaît comme une lourde feuille d'étain froissé (contrastant avec les lignes pures du bâtiment conçu par Snøhetta). En réalité, le rideau est constitué d'images numérisées de feuilles d'aluminium qui réfléchissent et s'approprient les couleurs de l'auditorium. Lorsque le rideau se lève, sa nature informatique est dévoilée – la première touche de magie de la soirée.

S. R.

SELECTED EXHIBITIONS →
2008 *Pae White: Lisa, Bright & Dark*, Scottsdale Museum of Contemporary Art, Scottsdale; Taubman Museum of Art, Roanoke. *Re-Reading the Future*, International Triennale of Contemporary Art, Prague. *Martian Museum of Terrestrial Art*, Barbican Centre, London **2007** *If Everybody had an Ocean: Brian Wilson, An Art Exhibition*, Tate St Ives; CAPC Musée d'art contemporain, Bordeaux. *Skulptur Projekte Münster 07*, Münster **2006** *Pae White: in no particular order*, Manchester Art Gallery, Manchester

SELECTED PUBLICATIONS →
2008 *Pae White: Lisa, Bright & Dark*, Scottsdale Museum of Contemporary Art, Scottsdale **2007** *Skulptur Projekte Münster 07*, Verlag der Buchhandlung Walther König, Cologne. *Idylle: Traum und Trugschluss*, Hatje Cantz, Ostfildern **2005** *Pae White: Ohms and Amps*, Centre d'art contemporain la Synagogue de Delme; Les presses du réel, Paris. *Brian Wilson: an Art Book*, Four Corners Books, London

1 **Scrap Tapestry 1**, 2006, collage, coloured cotton, weaved, 300 x 205 cm
2 **Ship o' Fools**, 2008, silver colour coated clay, bulbs, steel, cable,
 120 x 75 cm
3 **my-fi**, 2007, Majolica, steel pedestal, hanging, 3 parts, bell 80 x ø 90 cm
 (each). Installation view, Skulptur Projekte Münster 07

4 Installation view, *Pae White: In No Particular Order*, Milton Keynes Gallery,
 Milton Keynes, 2005
5 **Stage Curtain**, 2008. Installation view, Opera House, Oslo

„Mir gefällt die Idee, dass alles in der Welt das Potenzial hat, zum Kunstwerk zu werden, selbst wenn es nur ein Motiv ist."

« J'aime l'idée que tout dans le monde a les qualités pour être transformé en objet d'art, même si ce n'est qu'un motif. »

"I like the idea that everything in the world has the potential to be reintroduced as an art piece, even if it's just a motif."

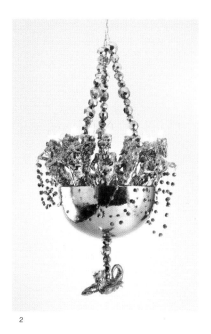

2

3

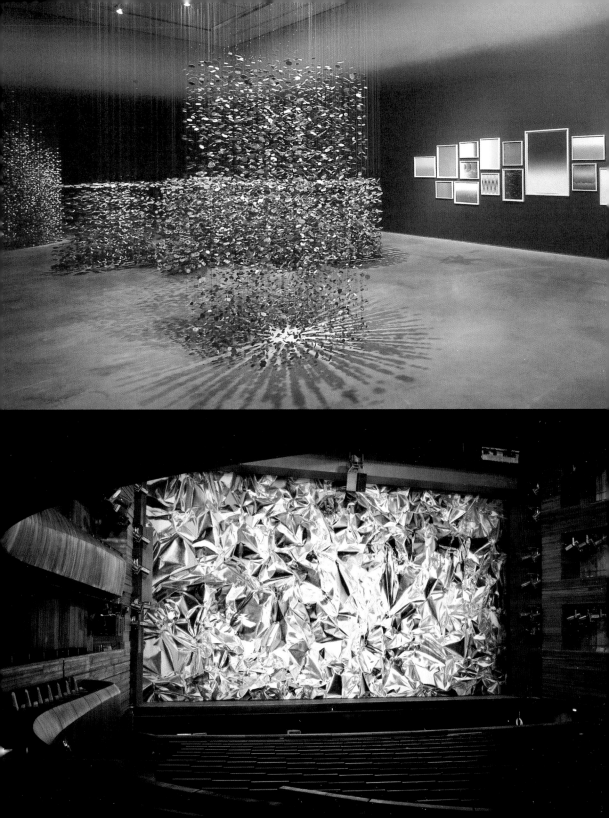

Kehinde Wiley

1977 born in Los Angeles (CA), lives and works in Brooklyn (NY), USA

In 2008, The Studio Museum in Harlem hosted Kehinde Wiley's one-man show *The World Stage: Africa, Lagos – Dakar*. In this exhibition Wiley took his passion for portraiture to a global scale by temporarily setting up studios in Lagos, Dakar and many other African cities. The show included paintings like *Three Wise Men Greeting Entry into Lagos* (2008), where three black males are posing as a traditional sculpture of post-colonial African art, and a group of more straightforward portraits such as *Mame Ngagne* (2007) in which young black men are depicted against a background of brightly coloured fabrics. Part of a wider project that had previously taken Wiley to China and will soon extend to India and Poland, *The World Stage* is an artistic enterprise that allows the artist to confront himself and his African roots with different cultures and traditions. Inspired by 19th century European portraiture, Wiley reinterprets the genre by weaving references to popular culture into it. His large-scale canvases, usually set in opulent frames, portray young urban black males proudly standing in front of highly decorated backgrounds. While the iconography might be reminiscent of a long gone aristocracy, the subjects are often connected to hip hop culture and its fascination with masculinity and power. In *Napoleon Leading the Army over the Alps* (2005), for example, Wiley reinterprets a Jacques-Louis David masterpiece by restaging it with a contemporary black rider dressed in camouflage and bandanna. Wiley investigates the perception of blackness and creates a contemporary hybrid Olympus in which tradition is invested with a new street credibility.

2008 präsentierte das Harlemer Studio Museum Kehinde Wiley mit *The World Stage: Africa, Lagos – Dakar*. In dieser Einzelausstellung globalisierte Wiley seine Leidenschaft fürs Porträt, indem er zeitweilig Ateliers in Lagos, Dakar und vielen anderen afrikanischen Städten einrichtete. Zu den Exponaten gehörten Gemälde wie *Three Wise Men Greeting Entry into Lagos* (2008), in dem drei farbige Männer als traditionelle Skulptur der postkolonialen Kunst Afrikas posieren, sowie eine Gruppe geradlinigerer Porträts wie *Mame Ngagne* (2007), in dem junge Schwarze vor einer hellfarbigen Textur dargestellt sind. *The World Stage* – Teil eines größeren Projekts, mit dem Wiley schon in China war und das demnächst auf Indien und Polen ausgedehnt werden soll – ist ein Unternehmen, das dem Künstler ermöglicht, sich selbst und seine afrikanischen Wurzeln mit anderen Kulturen und Traditionen zu konfrontieren. Angeregt von der europäischen Porträtmalerei des 19. Jahrhunderts interpretiert Wiley das Genre auf neue Weise, indem er es durch Bezüge zur Popkultur anreichert. Seine großformatigen, normalerweise opulent gerahmten Gemälde porträtieren junge farbige Städter, die stolz vor einem stark ornamentalen Hintergrund posieren. Die Ikonografie mag an eine längst untergegangene Aristokratie erinnern, doch die dargestellten Figuren haben oft einen Bezug zur Hip-Hop-Kultur mit ihrer Vorliebe für Maskulinität und Power. In *Napoleon Leading the Army over the Alps* (2005) deutet Wiley beispielsweise ein Meisterwerk von Jacques-Louis David um: Der Reiter ist hier ein Schwarzer unserer Tage, angetan mit Tarnkleidung und Stirnband. Wiley thematisiert die Wahrnehmung des Schwarzseins und schafft einen hybriden Olymp, in dem die Tradition eine neue aktuelle Glaubwürdigkeit erhält – die der Straßenszene.

En 2008, le Studio Museum de Harlem a accueilli l'exposition monographique de Kehinde Wiley, *The World Stage : Africa, Lagos – Dakar*. Il y déployait à une échelle mondiale sa passion pour le portrait, allant jusqu'à installer son studio tour à tour à Lagos, Dakar et dans de nombreuses autres villes africaines. L'exposition comprenait des tableaux comme *Three Wise Men Greeting Entry into Lagos* (2008), où trois hommes noirs posent à la manière d'une sculpture classique de l'art africain post-colonial, ou encore une série de portraits plus directs comme *Mame Ngagne* (2007), où de jeunes Noirs sont représentés devant des tissus aux couleurs vives. Nouvel épisode d'un projet de grande ampleur qui a déjà conduit Wiley en Chine et l'emmènera bientôt en Inde et en Pologne. *The World Stage* est une entreprise artistique qui permet à Wiley de se confronter, avec ses racines africaines, à différentes cultures et traditions. Inspiré par les portraitistes européens du XIXᵉ siècle, Wiley réinterprète le genre en y insérant des références à la culture populaire. Ses grandes toiles, généralement serties dans des cadres imposants, montrent de jeunes Noirs urbains qui posent fièrement devant des arrière-plans exagérément décoratifs. Si cette iconographie n'est pas sans évoquer une aristocratie depuis longtemps éteinte, les sujets sont souvent liés à la culture hip-hop et à sa fascination pour la virilité et le pouvoir. Dans *Napoleon Leading the Army over the Alps* (2005), Wiley réinterprète le chef-d'œuvre de Jacques-Louis David en remplaçant le personnage par un chevalier noir contemporain vêtu d'une tenue de camouflage et d'un bandeau. Wiley explore la perception de la négritude et crée un Olympe contemporain et hybride où la tradition est investie d'une nouvelle crédibilité venant de la rue.

C. A.

SELECTED EXHIBITIONS →
2008 *Kehinde Wiley, The World Stage: Africa Lagos – Dakar*, The Studio Museum in Harlem, New York. *Focus: Kehinde Wiley*, The Modern Art Museum of Fort Worth **2007** *Kehinde Wiley*, Portland Art Museum, Portland. *New York States of Mind*, Queens Museum of Art, New York; Haus der Kulturen der Welt, Berlin **2006** *Kehinde Wiley: Infinite Mobility*, Columbus Museum of Art, Columbus. *Black Alphabet – Contexts Of Contemporary African-American Art*, Zacheta National Gallery of Art, Warsaw

SELECTED PUBLICATIONS →
2008 *Kehinde Wiley, The World Stage: Africa Lagos – Dakar*, The Studio Museum in Harlem, New York **2007** *Kehinde Wiley: Columbus*, Roberts and Tilton, Los Angeles; The Columbus Museum of Art, Columbus. *The World Stage: China*, John Michael Kohler Arts Center, Sheboygen; Roberts and Tilton, Los Angeles **2006** *Neo Baroque!*, Byblos Art Gallery, Verona; Charta, Milan **2005** *Kehinde Wiley: Passing/Posing Paintings & Faux Chapel*, Brooklyn Museum of Art, Brooklyn; Earth Enterprise, New York

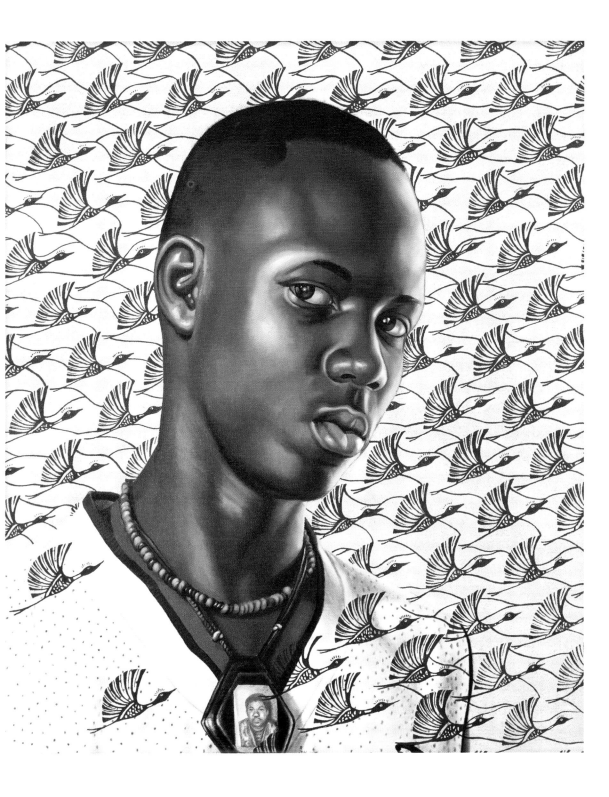

1 **Mame Ngagne**, 2008, oil on canvas, 66 x 55.9 cm
2 **Three Wise Men Greeting Entry into Lagos**, 2008, oil on canvas, 182.9 x 243.8 cm

3 **Napoleon Leading the Army over the Alps**, 2005, oil on canvas, 274.3 x 274.3 cm
4 **Louis Philippe Joseph, Duke of Orleans**, 2006, oil on canvas, 213.4 x 243.8 cm

„Das Wichtigste in meinem Werk ist für mich selbst folgende Tatsache: Die Geschichte der westeuropäischen Malerei ist die Geschichte westeuropäischer weißer Männer in Machtpositionen."

« Ce qui compte le plus dans mon travail, à mon avis, c'est que l'histoire de la peinture européenne occidentale est l'histoire de la domination des hommes blancs d'Europe occidentale. »

"What's most important in my work, to my own mind, is that the history of Western European painting is the history of Western European white men in positions of dominance."

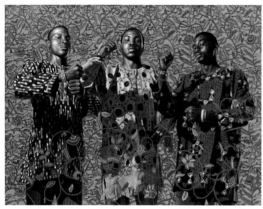

2

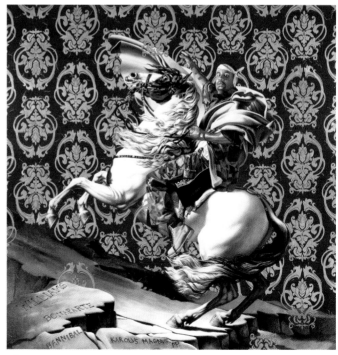

3

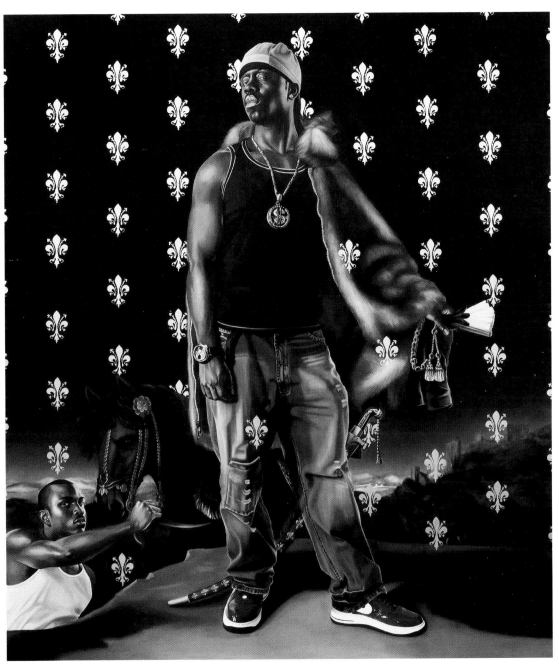

Christopher Wool

1955 born in Boston (MA), lives and works in New York (NY) and Marfa (TX), USA

The swooping lines and intermittent drips in Christopher Wool's recent large canvases and silkscreens might at first sight recall the imagery of a Jackson Pollock or Brice Marden, but more fundamentally they refer to the long history of the painterly gesture in general – the constant urge toward mark-making and a conflicting compulsion toward erasure. In his predominantly grey untitled paintings from recent years, Wool draws thin lines of black enamel paint with a spray gun, then he literally wipes them out with rags dipped in paint thinner until the complete surface is covered with the most subtly varied shades of grey. Wool doesn't attempt to make this eradicating gesture appear spontaneous or expressionistic, but rather deliberate in every aspect. In the horizontal and vertical swaths of paint and the upside-down drips you can tell that his canvas has been worked on, rotated, then re-worked. For his works on paper, Wool takes photographs of his paintings and collages them on the computer before making these new images into silkscreens, in which the grain of the reproduction process is patently visible. While Wool became known in the late 1980s for paintings he made with pattern rollers and his trademark word paintings, today his art influences a younger generation of abstractionists and mark-makers such as Kelley Walker, Seth Price, Josh Smith and Wade Guyton. Using every possible tool not usually associated with painting (rollers, rags, spray guns and the computer), Wool still manages to bring all the potentialities of the medium to the canvas, always stretching the limits while continuing to refine his painterly chops.

Wenn die geschwungenen Linien und unregelmäßigen Drips in Christopher Wools neuen Siebdrucken und großformatigen Leinwänden auf den ersten Blick an die Motivwelt eines Jackson Pollock oder Brice Marden denken lassen, verweisen sie doch viel grundsätzlicher auf die malerische Geste und ihre lange Tradition – das stete Verlangen, Zeichen zu setzen, und den entgegengesetzten Trieb zur Auslöschung. Für seine zumeist grauen, unbetitelten Gemälde der letzten Jahre zeichnet Wool mit einer Farbspritzpistole dünne Linien in Enamelfarbe, die er dann mit einem Lappen, den er mit Lösungsmittel getränkt hat, buchstäblich auswischt, bis die komplette Bildoberfläche mit fein abgestuften Grautönen bedeckt ist. Diese Geste des Auslöschens soll keineswegs spontan oder expressionistisch erscheinen, sie ist in jeder Hinsicht bewusst gesetzt. Die horizontalen und vertikalen Farbstreifen und die nach oben verlaufenden Tropfen verraten, wie an dieser Leinwand gearbeitet wurde, wie sie gedreht und wieder überarbeitet wurde. Für seine Papierarbeiten verarbeitet Wool Fotografien seiner Gemälde, die er am Computer collagiert, bevor er das neu entstandene Bild dann als Siebdruck produziert, in betont körniger Reproduktion. Wool wurde in den späten 1980er Jahren mit Gemälden, die er mit Musterwalzen machte, und seinen typischen Word Paintings bekannt, heute beeinflusst seine Kunst eine jüngere Generation abstrakter Künstler wie Kelley Walker, Seth Price, Josh Smith und Wade Guyton. Während er alle möglichen Werkzeuge benützt, die man normalerweise nicht mit Malerei in Verbindung bringt (Walzen, Lappen, Spritzpistolen und Computer), bringt Wool dennoch das ganze Potenzial des Mediums auf die Leinwand, immer auf dem Schritt über die Grenze, des Mediums Malerei an sich und der eigenen malerischen Möglichkeiten.

Si les lignes plongeantes et les coulures discontinues des dernières toiles et sérigraphies grand format de Christopher Wool peuvent, à première vue, rappeler la construction picturale d'un Jackson Pollock ou d'un Brice Marden, elles renvoient plus radicalement à la longue histoire du geste pictural – le perpétuel besoin de faire des marques et une compulsion contradictoire à l'effacement. Dans les peintures sans titre à prédominance grise de ces dernières années, Wool dessine au pictolet de minces arabesques noires qu'il efface ensuite avec des chiffons imbibés de diluant jusqu'à ce que la surface entière soit recouverte des plus subtiles nuances de gris. Wool n'essaie pas de faire apparaître ce geste de gommage comme spontané ou expressionniste, mais plutôt comme mûrement réfléchi. Ces gerbes de peinture horizontales et verticales, ces coulures signalent que la toile a été travaillée, tournée puis retravaillée. Pour ses œuvres sur papier, Wool prend des photos de ses peintures et en fait des collages sur ordinateur, avant de réaliser, à partir de ces nouvelles images, des sérigraphies sur lesquelles le grain du procédé de reproduction est nettement visible. Alors que Wool s'est fait connaître à la fin des années 1980 par des peintures réalisées avec des rouleaux tampons à motifs ou des peintures de mots, son art influence aujourd'hui une nouvelle génération d'abstractionnistes et de « faiseurs de marque » comme Kelley Walker, Seth Price, Josh Smith ou Wade Guyton. Se servant de tous les outils à disposition (rouleaux tampons, chiffons, pistolets et ordinateur), Wool arrive encore à porter sur la toile toutes les potentialités du moyen d'expression, à repousser les limites tout en continuant à affiner sa marque.

CH. L.

SELECTED EXHIBITIONS →
2008 *Christopher Wool*, Museo Serralves, Porto. *Oranges and Sardines: Conversations on Abstract Painting with Mark Grotjahn, Wade Guyton, Mary Heilmann, Amy Sillman, Charline von Heyl, and Christopher Wool*, Hammer Museum, Los Angeles. *Psychopts* (with Richard Hell), John McWhinnie@Glenn Horowitz Bookseller, New York **2007** *Camouflage*, Portland Art Museum, Portland. *Lines, Grids, Stains, Words*. MoMA, New York **2006** *Christopher Wool*, IVAM, Valencia; Musee d'art moderne et contemporain, Strasbourg

SELECTED PUBLICATIONS →
2008 *Christopher Wool*, Taschen, Cologne. Richard Hell, *Christopher Wool: Psychopts*, JMc & GHB Editions, New York **2007** *Christopher Wool*, Galerie Max Hetzler; Holzwarth Publications, Berlin. *Christopher Wool: Pattern Paintings 1987-2000*, Skarstedt Gallery; Luhring Augustine, New York **2006** *Christopher Wool*, IVAM, Valencia; Editions des Musees de Strasbourg, Strasbourg. *Christopher Wool*, Simon Lee Gallery, London. *Christopher Wool*, Gagosian Gallery, Los Angeles

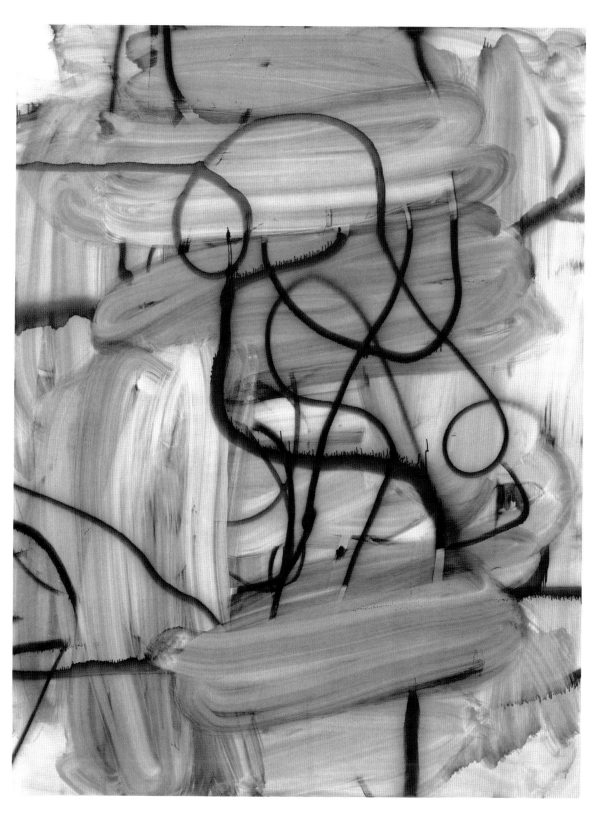

1 **Untitled**, 2007, enamel on linen, 320 x 243.8 cm
2 **Untitled**, 2007, silkscreen ink on paper, 182,9 x 140,3 cm

3 **Untitled**, 2007, enamel on linen, 320 x 243.8 cm

„Malerei ist wie ein Kampf zwischen Planung und Überraschung für mich. Die besten Gemälde kann man sich gar nicht vorstellen, bevor man damit begonnen hat … Das trifft natürlich auch auf die schlechtesten zu."

« Je conçois la peinture comme une lutte entre le programmé et l'imprévu. Les meilleures peintures sont celles que vous ne pouviez imaginer avant de commencer… Bien sûr, les pires se produisent aussi de la même façon. »

"Painting, for me, is often a struggle between the planned and the unforeseen. The best paintings are the ones that you could not have imagined before you began… Of course the worst paintings are created in this way as well."

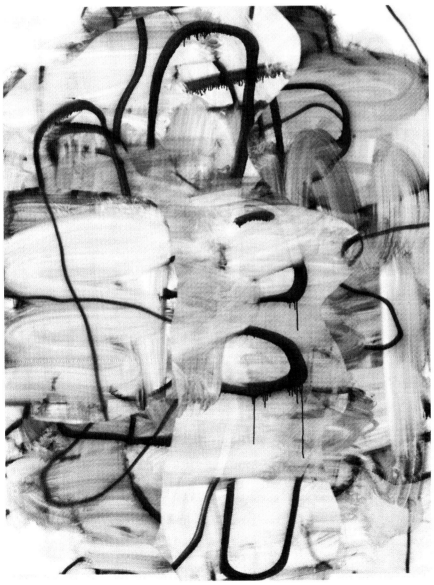

2

Thomas Zipp

1966 born in Heppenheim, lives and works in Berlin, Germany

For *Dwarf Nose* (2008) – one of Thomas Zipp's most recent installations – the artist turned the gallery into a deposit of gigantic missiles: Zipp took a number of decommissioned Patriot Missile warheads and reassembled them into an image of extraordinary power that evokes cold war nightmares of destruction but also childish memories of war games. A similar attraction to the rhetoric of power and the paranoia of history is evident in *Planet Caravan? Is There Life after Death? A Futuristic World Fair* (2007), a complex installation combining free-standing panels with paintings, collages and sculptures. With its evocative imagery populated by pictures of renowned astronomers, philosophers and scientists, the work merges religion, history, science and politics to exemplify the various systems of thoughts through which humanity has attempted to understand the world. Besides these large-scale installations, Zipp adopts a variety of media such as painting, drawing and photography. His work is often embedded with references to futurism and the avant-garde of the early 20th century. Unlike his predecessors though, Zipp sketches the future with a dark palette and tints it with bleak, apocalyptic overtones: in the painting *Black August* (2007), or in *A.B. Pusteblume* (2006), for example, Zipp depicts imaginary catastrophes and a mutant form of vegetation sprouted from some ecological disaster. Often Zipp combines different media in the same work, such as in *Uranlicht* (2006), a small portrait that is hung next to a large checkered painting. The two are connected by eight white lines that extend from the drawing into the canvas, sketching a desperate landscape of loneliness.

Für *Dwarf Nose* (2008) – eine von Thomas Zipps neuesten Installationen – verwandelte der Künstler die Galerie in ein Depot mit riesigen Raketen: Er nahm eine Reihe ausgemusterter Patriot-Missile-Sprengköpfe und fügte sie zu einem ungeheuer aussagekräftigen Bild zusammen, das die Zerstörungsalpträume des Kalten Kriegs heraufbeschwört, aber auch kindliche Erinnerungen an Kriegsspiele. Auf ähnliche Weise zeigen sich die Rhetorik der Macht und die Paranoia der Geschichte in *Planet Caravan? Is There Life after Death? A Futuristic World Fair* (2007), einer komplexen Installation aus frei stehenden Tafeln, Gemälden, Collagen und Skulpturen. In einer sinnträchtigen Bildwelt voller Porträts berühmter Astronomen, Philosophen und Wissenschaftler verschmelzen hier Religion, Geschichte, Wissenschaft und Politik miteinander und veranschaulichen die verschiedenen Denksysteme, durch die die Menschheit versucht hat, sich die Welt zu erklären. Neben diesen Rauminstallationen arbeitet Zipp auch mit einer Vielzahl an Medien wie Malerei, Zeichnung und Fotografie. Sein Œuvre enthält oft Verweise auf den Futurismus und die Avantgarde des frühen 20. Jahrhunderts. Doch anders als seine Vorgänger skizziert Zipp die Zukunft in dunkler Palette und färbt sie mit trostlosen, apokalyptischen Untertönen ein: In Gemälden wie *Black August* (2007) oder *A.B. Pusteblume* (2006) beschreibt er imaginäre Katastrophen und eine mutierende Form von Vegetation als Resultat eines ökologischen Desasters. Oft kombiniert Zipp verschiedene Medien in ein und demselben Werk, etwa in *Uranlicht* (2006), einem kleinen Porträt, das neben einem großen karierten Gemälde hängt. Beide sind durch acht weiße Linien miteinander verbunden, die sich von der Zeichnung bis in die Leinwand hinein erstrecken und eine trostlose Landschaft der Einsamkeit entstehen lassen.

Pour *Dwarf Nose* (2008) – une des installations les plus récentes de Thomas Zipp – l'artiste a transformé la galerie en dépôt pour missiles géants : il a assemblé un grand nombre de têtes de missiles Patriot désamorcés pour former une image d'une puissance extraordinaire, évoquant les cauchemars de destruction de la guerre froide ou des souvenirs de jeux d'enfants. Cette attirance pour la rhétorique du pouvoir et la paranoïa dans l'histoire se manifeste aussi dans *Planet Caravan? Is There Life after Death? A Futuristic World Fair* (2007), une installation complexe associant sculptures, collages et peintures accrochées sur panneaux. Avec une iconographie évocatrice peuplée de célèbres astronomes, philosophes et scientifiques, son travail intègre religion, histoire, science et politique pour illustrer les divers systèmes de pensée à travers lesquels l'humanité a tenté de comprendre le monde. Parallèlement à ce travail de grandes installations, Zipp utilise une grande diversité de médiums (peinture, dessin, photographie). Son travail s'inscrit dans l'héritage du futurisme et des avant-gardes du début du XXe siècle, mais contrairement à ses prédécesseurs, Zipp brosse l'avenir avec une palette sombre teintée de connotations sinistres et apocalyptiques. Ainsi les peintures *Black August* (2007) ou *A.B. Pusteblume* (2006) dépeignent une catastrophe imaginaire et une forme de végétation mutante qui serait née d'un désastre écologique. Zipp combine souvent différentes disciplines dans une même œuvre : dans *Uranlicht* (2006), un petit portrait est accroché à côté d'une grande peinture en damiers. Les deux cadres sont reliés par huit lignes blanches qui filent du dessin à la toile, esquissant un paysage solitaire et mélancolique.

C. A.

SELECTED EXHIBITIONS →
2008 Thomas Zipp: Planet Caravan? Is There Life after Death? A Futuristic World Fair, Museum Dhondt-Daehnens, Deurle **2007** Planet Caravan? Is there Life after Death? – A Futuristic World Fair, Kunsthalle Mannheim, Museum in der Alten Post, Mulheim. Kunstpreis der Böttcherstraße in Bremen 2007, Kunsthalle Bremen **2006** Rings of Saturn, Tate Modern, London. Of Mice and Men, 4th Berlin Biennial for Contemporary Art, Berlin **2005** Thomas Zipp: The Return of the Subreals, Oldenburger Kunstverein, Oldenburg

SELECTED PUBLICATIONS →
2008 Thomas Zipp: Black Pattex 78, Galeria Heinrich Ehrhardt, Madrid **2007** Thomas Zipp: Planet Caravan? Is There Life after Death? A Futuristic World Fair, Kunsthalle Mannheim; Kerber Verlag, Bielefeld. Thomas Zipp: Papers, Galerie Guido W. Baudach, Berlin; Galerie Krinzinger, Vienna. Kommando Friedrich Hölderlin Berlin, Galerie Max Hetzler, Berlin **2005** Thomas Zipp: Achtung! Vision: Samoa; The Family of Pills & The Return of the Subreals, Oldenburger Kunstverein, Oldenburg. Hatje Cantz, Ostfildern

302

Psychonaut A, 2008, diabase, silver, wood, 191 x 38 x 55 cm
2 **Crystal Meth**, 2007, mixed media, 3 parts, dimensions variable
3 Installation view, *Thomas Zipp: Planet Caravan? Is There Life after Death? A Futuristic World Fair*, Kunstmuseum Mannheim, 2007
4 **O.4**, 2006, mixed media, 6 parts, dimensions variable
5 **Achtung! Luther**, 2006, mixed media, 17 parts, dimensions variable
6 **Black August**, 2007, acryl, oil on canvas, 250 x 200 cm
7 **Loos**, 2006, mixed media on paper, 39 x 30 cm (framed)
8 Installation view, *Thomas Zipp: Dwarf Nose*, Harris Lieberman Gallery, New York, 2008

2

3

4

5

6

7

8

Glossary

ANIME → Japanese cartoon films, whose simply drawn figures and straightforward plots are based on Japanese manga comics. In the 1990s, anime and their extravagant soundtracks became famous outside Japan.

APPROPRIATION ART → In Appropriation Art, objects, images and texts are lifted from their cultural context and placed unchanged in a new one. They thus become charged with a new significance.

ARTE POVERA → Art movement which began in Italy in the 1960s. Artists used "humble" materials and the simplest design principles to reduce artworks to their barest essentials.

ASSEMBLAGE → A three-dimensional picture made of different materials, usually of everyday use.

BODY ART → Art that takes the body for its subject and makes it the object of performances, sculptures or videos.

CIBACHROME → A colour print (usually large format) made from a slide.

CODE → Sign system providing the basis for communication and conveying information.

COLLAGE → Work of art made up of a variety of unconnected objects or fragments that were not created by the artist.

COMPUTER ANIMATION → Apparently three-dimensional models produced on a computer which can be "walked through" or seen from different perspectives by the user; or virtual figures which move on the screen.

CONCEPTUAL ART → Conceptual Art emerged in the 1960s. It gives primacy to the basic idea of a work's content. This is often revealed in language alone, i.e. texts or notes. The actual execution of the work is considered secondary and may be totally lacking.

CONSTRUCTIVISM → Early 20th-century art movement that coined a mostly abstract formal language and sought to put modern art to everyday use.

C-PRINT → A colour print from a photographic negative.

CROSSOVER → Crossover refers to crossing the boundaries between art and popular culture and between different cultures; also to the inclusion of music, design and folklore etc in artistic work.

CURATOR → A curator decides what exhibitions are about, and selects the participating artists.

DADA → Revolutionary art movement at its peak in the 1920s, whose collages, performances and public readings of nonsense poetry called all existing cultural values into question.

DECONSTRUCTION → A means of interpretation that regards a work not as a closed entity but as an open and many-layered network of the most varied elements in form and content. These elements, their functions and contradictions, are revealed by deconstruction.

DIGITAL ART → Art that makes use of new digital media such as computers and the Internet.

DOCUMENTARY ART → This type of art concentrates on giving a more or less factual, uninterpreted account of social reality.

ECLECTICISM → A common resort of postmodernism, characterised by extensive quotation from largely historical styles and other artists' works.

ENTROPY → A concept derived from thermodynamics signifying the degree of disorder in closed systems. Total entropy would be reached when a system collapsed in chaos. By analogy, entropy indicates the informational value of news. The ultimate here would be a meaningless rushing noise.

ENVIRONMENT → An interior or exterior space entirely put together by the artist which integrates the viewer in the aesthetic experience.

FICTION → A picture or a story is a fiction when it is based on free invention.

FLUXUS → Radical experimental art movement embracing a variety of forms, including happenings, poetry, music and the plastic arts, whose ephemeral nature removed art from its accepted museum context.

FOLK ART → Traditional arts and crafts connected to particular regions – especially rural areas – or ways of life, which remain relatively unaffected by changes of style.

FUTURISM → Founded in Italy around 1910 by a group of writers and artists, the Futurist movement made a radical break with the past. It promoted a type of art reflecting life in the modern age, characterised by simultaneity, dynamism and speed.

GENDER SURFING → The confusing game with sexual roles whose point is to mix them up, to humorous effect.

GLOBALISATION → Globalisation means that economic or cultural processes increasingly have worldwide implications.

HAPPENING → An artistic action in front of a public that normally becomes involved in what happens.

HIGH AND LOW CULTURE → A complex of themes concerning the influence of trivial culture (low art) on modern art (high art). The concept derives from an exhibition assembled by Kirk Varnedoe in 1990 at the New York Museum of Modern Art.

HYBRID → Of many forms, mixed, incapable of single classification.

ICON → Image or person venerated by a cult.
ICONOGRAPHY → The language of images or forms that is typical of a particular cultural context; for example, the iconography of advertising, Western, postmodern architecture etc.
ICONOLOGY → The interpretation of the content of a work of art, based on its iconography.
INSTALLATION → A work of art that integrates the exhibition space as an aesthetic component.
INTERACTIVE ART → Works of art intended for the viewer's direct participation. Normally this participation is made possible by computer technology.

LOCATION → Site of an event or exhibition etc.

MAINSTREAM → Predominant style reflecting the taste of the general public.
MANGA → Comics and cartoon films, the most popular type of reading matter in Japan, where manga is produced and consumed in large quantities.
MEMENTO MORI → An event or object reminding one of death.
MINIMAL ART → Art trend of the 1960s that traces sculptures and pictures back to clear basic geometric forms and places them in a concrete relation to the space and the viewer.
MIXED MEDIA → Combination of different media, materials and techniques in the production of a work of art.
MONTAGE → Joining together pictorial elements or sequences in photography, film and video.
MULTIPLE → In the 1960s, the classical concept of a work of art came under fire. Instead of a single original, works of art were produced in longer runs, i. e. as "multiples". The idea was to take art out of museums and galleries and make it more available.

NARRATION → Telling a story in art, film or literature.

OBJECT ART → All works of art that contain already existing objects or materials, or are entirely composed of them. (cf. readymade)
OP ART → A type of 1960s Abstract Art that played with optical, rather than visual, effects on the eye.

PERFORMANCE → Artistic work performed in public as a (quasi-theatrical) action. The first performances took place during the 1960s in the context of the Fluxus movement, which tried to widen the concept of art.
PHOTOREALISM → Hyper-realistic painting and sculpture using exaggerated photographic sharpness to take a critical look at the details of reality.
POLITICAL CORRECTNESS → A socio-political attitude particularly influential in the USA. The purpose of Political Correctness is to change public language. The principal requirement is to refer to social "minorities" in a non-judgmental way.
POP ART → Artistic strategy of the 1960s which transformed the popular iconography of film, music and commerce into art.
POP CULTURE → Pop culture finds its expression in the mass circulation of items from areas such as fashion, music, sport and film. The world of pop culture entered art in the early 60s, through Pop Art.
POSTMODERNISM → Unlike modernism, Postmodernism starts from the assumption that grand utopias are impossible. It accepts that reality is fragmented and that personal identity is an unstable quantity transmitted by a variety of cultural factors. Postmodernism advocates an irreverent, playful treatment of one's own identity, and a liberal society.
POST-PRODUCTION → This term taken from the field of film describes, among other things, the post-processing of visual material.
PRODUCTION STILL → Photo of a scene from a film or of an actor in a film, taken on the set by a specialist photographer and used for publicity or documentary purposes.

READYMADE → A readymade is an everyday article which the artist declares to be an artwork and exhibits without major alterations. The idea derives from French artist Marcel Duchamp, who displayed the first readymades in New York in 1913, e. g. an ordinary urinal (Fountain) or a bottle drier.

SAMPLING → Arrangement of existing visual or audio material with the main intention of playing with the material's formal characteristics. Rather than quoting from the material, whose sources are often unclear, sampling aims to reformulate it.

SELF-REFERENTIAL ART → Art that refers exclusively to its own formal qualities and so rejects any idea of portrayal.
SEMANTICS → The study of the significance of linguistic signs, i. e. the meaning of words.
SETTING → An existing or specially created environment surrounding a work of art.
SITUATIONISM → The International Situationists are a group of artists who introduced the concept of "situation" in art in the mid-20th century. According to its practitioners, situationism means constructing temporary situations and transforming them to produce a higher level of passionate intensity.
STEREOTYPE → A standardised, non-individual image that has become generally accepted.
STRUCTURAL FILM → Expression commonly used since the 1960s in the USA to describe experimental films that reveal the material composition and the physical processes of film making.
STRUCTURALISM → Structuralism systematically examines the meaning of signs. The purpose of structuralism is to explore the rules of different sign systems. Languages and even cultural connections are seen and interpreted by structuralism as sign systems.
SURREALISM → Art movement formed in the 1920s around the writer André Breton and his followers, whose main interest was Automatism, or the suspension of conscious control in creating art.

TERROR → This artistic subject gained increasing popularity after "9/11".
TRANSCENDENCE → In philosophy and religion, transcendence is what is beyond normal human perception. In the extraordinary experience of transcendence, therefore, the boundaries of consciousness are crossed.
TRASH → The US word for "rubbish" aims at a level below accepted aesthetic and qualitative norms, with ironic intent.

URBANISM → City-planning and city-living considered as a concept.

VIDEO STILL → Still image taken by stopping a running videotape on screen or scanning a videotape.
VIENNESE ACTIONISM → Artform based around happenings of a ritualistic, bloodthirsty and apparently painful nature. Actionists often used sadomasochism and orgies for their systematic attack on the apparent moral and religious hypocrisy of Austrian society in the early 1960s.
VIRTUAL REALITY → An artificial world created on computer. (cf. computer animation)

WHITE CUBE → The neutral white exhibition room which in modern times has succeeded older forms of presenting art, e. g. hanging of pictures close to each other on coloured wallpaper. The white cube is supposed to facilitate the concentrated and undisturbed perception of the work of art.
WORK-IN-PROGRESS → Work which the artist does not attempt to complete, focusing instead on the actual creative process.

YOUNG BRITISH ARTISTS (YBA) → Group of British artists who since the beginning of the 1990s have created a furore with object and video art inspired by pop culture.

Ariane Beyn and Raimar Stange

Glossar

ANIME → Japanische Zeichentrickfilme, deren einfach gezeichnete Figuren und schlichte Handlungen auf den japanischen Manga-Comics basieren. In den neunziger Jahren wurden diese Filme und ihre aufwendigen Soundtracks auch über Japan hinaus bekannt.
APPROPRIATION ART → Bei der Appropriation Art werden Objekte, Bilder und Texte aus ihrem kulturellen Zusammenhang genommen und unverändert in einen neuen gestellt. Dadurch laden sie sich mit neuer Bedeutung auf.
ARTE POVERA → In den sechziger Jahren in Italien entstandene Kunstrichtung, die vor allem „ärmliche" Materialien und einfachste Gestaltungsprinzipien nutzte, um die Werke auf ihre ureigensten Qualitäten zu reduzieren.
ASSEMBLAGE → Dreidimensionales Bild aus verschiedenen, meist dem Alltag entnommenen Materialien.

BODY ART → Kunst, die den Körper thematisiert und zum Gegenstand von Performances, Skulpturen oder Videoarbeiten macht.

CIBACHROME → Ein meist großformatiger Farbpapierabzug von einem Dia.
COLLAGE → Ein künstlerisches Werk, das aus aneinandergefügten, vom Künstler nicht selbst angefertigten zusammenhanglosen Objekten beziehungsweise Objektteilen besteht.
COMPUTERANIMATION → Im Computer erzeugte, scheinbar dreidimensionale Modelle, die vom Benutzer „durchwandert" beziehungsweise von verschiedenen Perspektiven aus gesehen werden können; virtuelle Figuren, die sich auf dem Bildschirm bewegen.
C-PRINT → Ein „colour-print", der Farbpapierabzug eines Fotonegativs.
CROSSOVER → Beim Crossover werden die Grenzen zwischen Kunst und Populärkultur sowie zwischen verschiedenen Kulturen überschritten und Musik, Design, Folklore etc. in die künstlerische Arbeit einbezogen.

DADA → Revolutionäre Künstlerbewegung, die in den zwanziger Jahren des 20. Jahrhunderts vor allem mit ihren Collagen, Lautdichtungen und Performances sämtliche kulturellen Werte in Frage stellte.
DEKONSTRUKTION → Eine Interpretationsweise, die ein Werk nicht als geschlossene Einheit betrachtet, sondern als offenes und vielschichtiges Geflecht aus unterschiedlichsten formalen und inhaltlichen Elementen. Diese Elemente, ihre Funktionen und Widersprüche werden in der Dekonstruktion aufgedeckt.
DIGITALE KUNST → Kunst, die mit neuen Medien wie Computer oder Internet arbeitet.
DOKUMENTARISCHE KUNST → Diese Kunst konzentriert sich auf die mehr oder weniger sachliche, uninterpretierte Wiedergabe von gesellschaftlicher Wirklichkeit.

EKLEKTIZISMUS → In der Postmoderne übliches Verfahren, das durch das ausgiebige Zitieren von (historischen) Stilen und Werken anderer Künstler charakterisiert ist.
ENTROPIE → Der aus der Wärmelehre stammende Begriff benennt dort den Grad der Unordnung in geschlossenen Systemen. Vollständige Entropie wäre dann erreicht, wenn ein System sich im Chaos auflöst. Analog dazu zeigt die Entropie die Größe des Informationswertes einer Nachricht an. Der Endpunkt hier: ein bedeutungsloses Rauschen.
ENVIRONMENT → Komplett durchgestalteter Innen- oder Außenraum, der den Betrachter in das ästhetische Geschehen integriert.

FIKTION → Ein Bild oder eine Geschichte ist dann eine Fiktion, wenn sie auf freier Erfindung beruht.
FLUXUS → Radikal experimentelle Kunstströmung, die unterschiedliche Formen wie Happening, Poesie, Musik und bildende Kunst zusammenbringt. Das Flüchtige dieser Aktionen tritt an die Stelle von auratischer Musealität.
FOLK ART → Kunsthandwerkliche und volkstümliche Ästhetik, die an bestimmte Regionen oder Berufsstände, zum Beispiel das bäuerliche Milieu, gebunden ist und von Stilwandlungen relativ unberührt bleibt.
FOTOREALISMUS → Hyperrealistische Malerei und Skulptur, die mit überzogener fotografischer Schärfe Ausschnitte der Realität kritisch beleuchtet.
FUTURISMUS → Die um 1910 von Dichtern und bildenden Künstlern in Italien ausgerufene futuristische Bewegung vollzog einen radikalen Bruch mit der Vergangenheit. Sie forderte stattdessen eine den Lebensbedingungen der Moderne angemessene Kunst der Simultaneität, Dynamik und Geschwindigkeit.

GENDER SURFING → Das verwirrende Spiel mit den Geschlechterrollen, das auf die lustvolle Überschreitung ihrer Grenzen abzielt.
GLOBALISIERUNG → Globalisierung bedeutet, dass wirtschaftliche oder kulturelle Prozesse zunehmend weltweite Auswirkungen haben.

HAPPENING → Künstlerische Aktion in Anwesenheit des Publikums, das zumeist in das Geschehen einbezogen wird.

HIGH AND LOW CULTURE → Themenkomplex, der den Einfluss der Trivialkultur (Low Art) auf die moderne Kunst (High Art) beleuchtet. Der Begriff geht zurück auf eine von Kirk Varnedoe 1990 im New Yorker Museum of Modern Art konzipierte Ausstellung.
HYBRID → Vielgestaltig, gemischt, nicht eindeutig zuzuordnen.

IKONE → Bilder oder Personen, die kultisch verehrt werden.
IKONOGRAFIE → Bild- oder Formensprache, die für einen bestimmten kulturellen Zusammenhang typisch ist, zum Beispiel die Ikonografie der Werbung, des Westerns, der postmodernen Architektur etc.
IKONOLOGIE → Wissenschaft von der inhaltlichen Interpretation eines Kunstwerks, die auf seiner Ikonografie basiert.
INSTALLATION → Ein Kunstwerk, das den Ausstellungsraum als ästhetische Komponente mit einbezieht.
INTERAKTIVE KUNST → Kunstwerke, die die direkte Einflussnahme des Betrachters – meist durch computergestützte Technik – vorsehen.

KODE → Zeichensystem als Grundlage für Kommunikation und Informationsübermittlung.
KONSTRUKTIVISMUS → Künstlerische Richtung zu Beginn des 20. Jahrhunderts, die in Anlehnung an die moderne Technik eine zumeist abstrakte Formensprache und die alltägliche Anwendung moderner Kunst suchte.
KONZEPTKUNST → Die Konzeptkunst entstand in den sechziger Jahren und stellt die inhaltliche Konzeption eines Werkes in den Vordergrund. Diese wird oft nur durch Texte oder Notizen präsentiert, die tatsächliche Umsetzung eines Werkes wird für zweitrangig erklärt und bleibt manchmal auch aus.
KURATOR → Ein Kurator legt die inhaltlichen Schwerpunkte einer Ausstellung fest und trifft die Auswahl der beteiligten Künstler.

LOCATION → Ort einer Veranstaltung, Ausstellung etc.

MAINSTREAM → Bereits etablierte, dem Geschmack der breiten Masse entsprechende Stilrichtung.
MANGA → Comics und Zeichentrickfilme, die bevorzugte Populärliteratur Japans, die dort in großen Mengen produziert und konsumiert wird.
MEMENTO MORI → Ereignis oder Objekt, das an den Tod erinnert.
MINIMAL ART → Kunstströmung der sechziger Jahre, die Skulpturen und Bilder auf klare geometrische Grundformen zurückführte und in eine konkrete Beziehung zu Raum und Betrachter setzte.
MIXED MEDIA → Verbindung verschiedener Medien, Materialien und Techniken bei der Produktion eines Kunstwerks.
MONTAGE → Zusammenfügen von Bildelementen oder Bildfolgen in Fotografie, Film und Video.
MULTIPLE → In den sechziger Jahren entwickelte sich eine kritische Haltung gegenüber dem klassischen Werkbegriff: Anstelle eines einzelnen Originals wurden Kunstwerke in höherer Auflage, das heißt als Multiples, produziert. Kunst sollte auf diese Weise die Museen und Galerien verlassen können und mehr Menschen zugänglich gemacht werden.

NARRATION → Erzählung in Kunst, Film und Literatur.

OBJEKTKUNST → Kunstwerke, die bereits existierende Gegenstände oder Materialien beinhalten oder ganz aus ihnen bestehen. (vgl. Readymade)
OP ART → Kunstströmung der sechziger Jahre, deren Vertreter mit der visuellen Wirkung von Linien, Flächen und Farben experimentieren.

PERFORMANCE → Künstlerische Arbeit, die in Form einer (theatralischen) Aktion einem Publikum vorgeführt wird. Erste Performances fanden während der sechziger Jahre im Rahmen der Fluxus-Bewegung statt, die auf die Erweiterung des Kunstbegriffs abzielte.
POLITICAL CORRECTNESS → Eine engagierte Haltung, die besonders einflussreich in den USA vertreten wird. Ziel der Political Correctness ist es, die moralischen Standards des öffentlichen Lebens zu erhöhen. Gefordert wird vor allem ein gerechter Umgang mit sozialen Minderheiten.
POP ART → Eine künstlerische Strategie der sechziger Jahre, die populäre Ikonografien aus Film, Musik und Kommerz in die Kunst überführte.
POPKULTUR → Die Popkultur findet ihren Ausdruck in massenhaft verbreiteten Kulturgütern aus Bereichen wie Mode, Musik, Sport oder Film. Anfang der sechziger Jahre fand die Welt der Popkultur durch die Pop-Art Eingang in die Kunst.
POSTMODERNE → Die Postmoderne geht, im Gegensatz zur Moderne, von der Unmöglichkeit großer Utopien aus. Sie akzeptiert die Wirklichkeit als eine zersplitterte und die persönliche Identität als eine unstabile Größe, die durch eine Vielzahl kultureller Faktoren vermittelt wird. Die Postmoderne plädiert für einen ironisch-spielerischen Umgang mit der eigenen Identität sowie für eine liberale Gesellschaft.
POSTPRODUKTION → Ein aus dem Filmbereich übernommener Begriff, der die Nachbearbeitung von Bildmaterial u. ä. beschreibt.

PRODUCTION STILL → Foto von einer Filmszene oder von den Protagonisten eines Films, das am Filmset von einem speziellen Fotografen für die Werbung oder zu dokumentarischen Zwecken aufgenommen wird.

READYMADE → Ein Alltagsgegenstand, der ohne größere Veränderung durch den Künstler von diesem zum Kunstwerk erklärt und ausgestellt wird. Der Begriff geht auf den französischen Künstler Marcel Duchamp zurück, der 1913 in New York die ersten Readymades, zum Beispiel ein handelsübliches Pissoir (Fountain) oder einen Flaschentrockner, präsentierte.

SAMPLING → Arrangement von vorhandenem Bild- oder Tonmaterial, das vor allem mit den formalen Eigenschaften des verarbeiteten Materials spielt. Anders als das Zitieren zielt das Sampling dabei auf neue Formulierungen ab und lässt seine Quellen häufig im Unklaren.
SELBSTREFERENZIELLE KUNST → Kunst, die sich ausschließlich auf ihre eigenen formalen Eigenschaften bezieht und jeden Abbildcharakter zurückweist.
SEMANTIK → Lehre von der Bedeutung sprachlicher Zeichen.
SETTING → Eine vorgefundene oder inszenierte Umgebung, in die ein Werk kompositorisch eingebettet ist.
SITUATIONISMUS → Die Künstlergruppe der Internationalen Situationisten führte Mitte des 20. Jahrhunderts den Begriff der „Situation" in die Kunst ein. Die Situation ist demnach eine Konstruktion temporärer Lebensumgebungen und ihre Umgestaltung in eine höhere Qualität der Leidenschaft.
STEREOTYP → Klischeehafte Vorstellung, die sich allgemein eingebürgert hat.
STRUKTURALISMUS → Der Strukturalismus untersucht systematisch die Bedeutung von Zeichen. Ziel des Strukturalismus ist es, die Regeln verschiedener Zeichensysteme zu erforschen. Sprachen und auch kulturelle Zusammenhänge werden vom Strukturalismus als Zeichensysteme verstanden und interpretiert.
STRUKTURELLER FILM → In den USA geläufige Bezeichnung für Experimentalfilme seit den sechziger Jahren, die die materielle Beschaffenheit und die Wahrnehmungsbedingungen des Films offen legen.
SURREALISMUS → Kunstbewegung, die sich Mitte der zwanziger Jahren des 20. Jahrhunderts um den Literaten André Breton und seine Anhänger formierte und psychische Automatismen in den Mittelpunkt ihres Interesses stellte.

TERROR → Sujet, das nach „9/11" mehr und mehr an Attraktivität gewinnt.
TRANSZENDENZ → In Philosophie und Religion der Begriff für das, was außerhalb der normalen menschlichen Wahrnehmung liegt. In der Erfahrung der Transzendenz werden also die Grenzen des Bewusstseins überschritten.
TRASH → Trash – ursprünglich: „Abfall" – ist die ironische Unterbietung ästhetischer und qualitativer Normen.

URBANISMUS → Reflexionen über Städtebau und das Zusammenleben in Städten.

VIDEO STILL → Durch Anhalten des laufenden Videobandes auf dem Bildschirm erscheinendes oder aus den Zeilen eines Videobandes herausgerechnetes (Stand-)Bild.
VIRTUAL REALITY → Im Computer erzeugte künstliche Welt. (vgl. Computeranimation)

WHITE CUBE → Begriff für den neutralen weißen Ausstellungsraum, der in der Moderne ältere Formen der Präsentation von Kunst, zum Beispiel die dichte Hängung von Bildern auf farbigen Tapeten, ablöste. Der White Cube soll die konzentrierte und ungestörte Wahrnehmung eines Kunstwerks ermöglichen.
WIENER AKTIONISMUS → Blutig und schmerzhaft erscheinende Happening-Kunst rituellen Charakters, die mit oftmals sadomasochistischen Handlungen und Orgien systematisch die moralisch-religiöse Scheinheiligkeit der österreichischen Gesellschaft der frühen sechziger Jahre angreift.
WORK-IN-PROGRESS → Werk, das keine Abgeschlossenheit anstrebt, sondern seinen prozessualen Charakter betont.

YOUNG BRITISH ARTISTS (YBA) → Gruppe englischer Künstler, die seit Anfang der neunziger Jahre mit ihrer von der Popkultur inspirierten Objekt- und Videokunst Furore macht.

Ariane Beyn und Raimar Stange

Glossaire

ACTIONNISME VIENNOIS → Happening à caractère rituel, dont les manifestations sanglantes et douloureuses s'attaquent à la bigoterie morale et religieuse de la société autrichienne du début des années soixante, dans des actions et des orgies à caractère sadomasochiste.

ANIMATION → Module d'apparence tridimensionelle produit par ordinateur et pouvant être « parcouru » par le spectateur – en fait : pouvant être vu sous des points de vue changeants ; figures virtuelles qui se meuvent sur un écran.

ANIME → Dessins animés japonais dans lesquels le graphisme simple des figures et l'action sobre sont issus des mangas, les bandes dessinées japonaises. Depuis les années 90, ces films et leurs bandes-son très élaborées se sont aussi fait connaître au-delà des frontières japonaises.

APPROPRIATION ART → Des objets, des images, des textes sont extraits de leur contexte culturel pour être transplantés tels quels dans un nouveau contexte, où ils se chargent d'une nouvelle signification.

ART CONCEPTUEL → L'art conceptuel, qui a vu le jour dans les années 60, met au premier plan le contenu de l'œuvre, dont la conception n'est souvent présentée que par des textes ou des notes, la réalisation concrète étant déclarée secondaire, voire éludée.

ART DE L'OBJET → On peut y classer toutes les œuvres d'art entièrement composées ou comportant des objets ou des matériaux préexistants. (cf. Ready-made)

ART DIGITAL → Art s'appuyant sur les moyens offerts par les nouveaux médias tels que l'informatique ou l'internet.

ART DOCUMENTAIRE → Forme d'art qui se concentre sur la représentation plus ou moins objective de la réalité sociale sans ajout d'aucune interprétation.

ART INTERACTIF → Art qui prévoit une intervention directe du spectateur dans l'œuvre. Le plus souvent, cette intervention est rendue possible par des techniques s'appuyant sur l'informatique.

ARTE POVERA → Mouvement artistique né en Italie dans les années 1960, qui se servit surtout de matériaux et de principes de création « pauvres », en vue de réduire les œuvres à leurs qualités intrinsèques.

ASSEMBLAGE → Image en trois dimensions composée de matériaux divers issus le plus souvent de la vie courante.

AUTO-REFERENCE → Se dit d'un art qui renvoie exclusivement wà ses propres propriétés formelles et rejette ainsi tout caractère représentatif.

BODY ART → Art qui prend le corps pour thème et qui en fait l'objet central de performances, de sculptures ou d'œuvres vidéo.

CIBACHROME → Tirage papier d'une diapositive, le plus souvent en grand format.

CODE → Système de signes qui sous-tend la communication et la transmission d'informations.

COLLAGE → Œuvre d'art constituée d'objets ou de parties d'objets juxtaposés qui ne sont pas des productions personnelles de l'artiste.

COMMISSAIRE → Le commissaire d'une exposition fixe le contenu d'une présentation et procède au choix des artistes participants.

CONSTRUCTIVISME → Courant artistique du début du siècle dernier dont la recherche formelle, le plus souvent abstraite, s'appuie sur la technique moderne et vise à l'application de l'art dans la vie quotidienne.

C-PRINT → « Colour-print », tirage papier en couleurs à partir d'un négatif.

CROSSOVER → Dans le Crossover, les limites entre l'art et la culture populaire, ainsi qu'entre les différentes cultures, sont rendues perméables. La musique, le design, le folklore etc. sont intégrés dans le travail artistique.

CULTURE POP → La culture pop trouve son expression dans des biens culturels répandus en masse et issus de domaines tels que la mode, la musique, le sport ou le cinéma. Au début des années 1960, le monde de la culture pop devait entrer dans l'art par le biais du Pop Art.

DADA → Mouvement artistique révolutionnaire des années 1920 qui remit en question l'ensemble des valeurs culturelles, surtout dans des collages, des poèmes phonétiques et des performances.

DECONSTRUCTION → Mode d'interprétation qui ne considère pas l'œuvre comme une unité finie, mais comme un ensemble d'éléments formels et signifiants les plus divers, et qui met en évidence leurs fonctions et leurs contradictions.

ECLECTISME → Procédé courant dans l'art postmoderne qui se caractérise par la citation généreuse d'œuvres et de styles d'autres artistes.

ENTROPIE → Concept issu de la thermodynamique, où il désigne l'état de désordre dans les systèmes clos. L'entropie totale serait ainsi atteinte lorsqu'un système se dissout en chaos. Par analogie, l'entropie indique la valeur informative d'une nouvelle. L'entropie totale serait atteinte par un bruit de fond vide de sens.

ENVIRONNEMENT → Espace intérieur ou extérieur entièrement formé par l'artiste et intégrant le spectateur dans l'événement esthétique.

FICTION → Une image ou une histoire est une fiction lorsqu'elle repose sur l'invention libre.

FLUXUS → Courant artistique expérimental et radical qui réunit différentes formes d'art comme le happening, la poésie, la musique et les arts plastiques. Le caractère fugace de ces actions y remplace l'aura de la muséalité.

FOLK ART → Esthétique artisanale et folklorique liée à certaines régions ou à certains métiers – par exemple le monde rural –, et qui reste relativement à l'écart des évolutions stylistiques.

FUTURISME → Le mouvement futuriste, proclamé vers 1910 par des poètes et des plasticiens italiens, accomplit une rupture radicale avec le passé, dont il exigeait le remplacement par un art rendant compte des conditions de vie modernes, avec des moyens nouveaux comme la simultanéité, la dynamique et la vitesse.

GENDER SURFING → Jeu troublant sur les rôles des sexes, et qui vise à la voluptueuse transgression de leurs limites.

GLOBALISATION → La globalisation renvoie au fait que certains processus économiques ou culturels ont de plus en plus fréquemment des répercussions au niveau mondial.

HAPPENING → Action artistique menée en présence du public, qui est le plus souvent intégré à l'évènement.

HIGH AND LOW CULTURE → Complexe thématique dans lequel l'influence de la culture triviale (Low Art) éclaire l'art moderne (High Art). Ce concept remonte à une exposition organisée par Kirk Varnedoe en 1990 au Museum of Modern Art de New York.

HYBRIDE → Multiforme, mixte, qui ne peut être classé clairement.

ICONE → Image ou personne faisant l'objet d'une vénération ou d'un culte.

ICONOGRAPHIE → Vocabulaire d'images ou de formes caractéristiques d'un contexte culturel déterminé. Ex. : l'iconographie de la publicité, du western, de l'architecture postmoderne…

ICONOLOGIE → Science de l'interprétation du contenu d'une œuvre sur la base de son iconographie.

INSTALLATION → Œuvre d'art qui intègre l'espace d'exposition comme une composante esthétique.

LOCATION → Endroit où a lieu un évènement, une exposition etc.

MAINSTREAM → Tendance stylistique qui s'est imposée et qui correspond au goût de la masse.

MANGA → Bandes dessinées et dessins animés, littérature populaire du Japon, où elle est produite et consommée en grande quantité.

MEMENTO MORI → Evènement ou objet qui rappelle la mort.

MINIMAL ART → Courant artistique des années 1960 qui réduit les sculptures et les tableaux à des formes géométriques clairement définies et qui les place dans un rapport concret avec l'espace et le spectateur.

MIXED MEDIA → Mélange de différents médias, matériaux et techniques dans la production d'une œuvre d'art.

MONTAGE → Agencement d'éléments visuels ou de séquences d'images dans la photographie, le cinéma et la vidéo.

MULTIPLE → Au cours des années 1960 est apparue une attitude critique à l'égard de la notion classique d'œuvre : au lieu d'un original unique, les œuvres furent produites en tirages plus élevés (comme « multiples » précisément), ce qui devait permettre à l'art de quitter les musées et les galeries et d'être accessible à un plus grand nombre.

NARRATION → Récit dans l'art, le cinéma et la littérature.

OP ART → Courant artistique des années 1960 dont les représentants travaillent sur le jeu visuel des lignes, des surfaces et des couleurs. Ces artistes composent des motifs déterminés visant à produire des effets d'optique.

PERFORMANCE → Travail artistique présenté à un public sous la forme d'une action (théâtrale). Les premières performances furent présentées pendant les années 1960 dans le cadre du mouvement Fluxus, qui visait à l'élargissement du concept d'art.

PHOTO DE PLATEAU → Photo d'une scène de cinéma ou de protagonistes d'un film, prise pendant le tournage, à des fins publicitaires, par un photographe spécialisé. Les photos d'une documentation prises durant le tournage sont également appelées stills.

PHOTOREALISME → Peinture et sculpture hyperréaliste qui porte un regard critique sur des morceaux de réalité à travers une amplification extrême de la vision photographique.

POLITICAL CORRECTNESS → Attitude engagée particulièrement influente aux Etats-Unis, et qui se fixe pour but de relever les standards moraux de la vie publique. Une revendication majeure en est le traitement plus juste des minorités sociales.

POP ART → Stratégie artistique des années 1960 qui fit entrer dans l'art l'iconographie populaire du cinéma, de la musique et du commerce.

POSTMODERNISME → Par opposition à l'art moderne, le postmodernisme postule l'impossibilité des grandes utopies. Il accepte la réalité comme étant éclatée et l'identité personnelle comme une valeur instable fondée par un grand nombre de facteurs culturels. Le postmodernisme plaide en faveur d'un maniement ironique et ludique de l'identité personnelle et pour une société libérale.
POSTPRODUCTION → Terme emprunté à l'industrie du cinéma et qui désigne le traitement a posteriori d'un matériau visuel ou autre.

READY-MADE → Un objet quotidien déclaré œuvre d'art par l'artiste et exposé comme tel sans changement notoire. Le terme remonte à l'artiste français Marcel Duchamp, qui présente les premiers ready-mades – par exemple un urinoir du commerce (Fountain) ou un porte-bouteilles – en 1913 à New York.
REALITE VIRTUELLE → Monde artificiel généré par ordinateur. (cf. Animation)

SAMPLING → Arrangement de matériaux visuels ou sonores jouant essentiellement des caractéristiques formelles du matériau utilisé. Contrairement à la citation, le sampling vise à des formulations nouvelles et ne cite généralement pas ses sources.
SEMANTIQUE → Etude de la signification des signes linguistiques.
SETTING → Environnement existant ou mis en scène qui vient s'insérer dans la composition d'une œuvre.
SITUATIONNISME → Au milieu du siècle dernier, le groupe d'artistes de l'Internationale situationniste a introduit dans l'art le concept de situation, construction temporaire d'environnements de la vie et leur transformation en une intensité de passion.
STEREOTYPE → Idée qui a acquis droit de cité sous forme de cliché.
STRUCTURAL FILM → Depuis les années 1960, terme couramment employé aux Etats-Unis pour désigner des films d'art et d'essai qui mettent en évidence la conformation matérielle et les conditions de perception du cinéma.
STRUCTURALISME → Le structuralisme étudie systématiquement la signification des signes. Il a pour but d'étudier les facteurs qui régissent différents systèmes de signes. Les langues, mais aussi les contextes sociaux y sont compris et interprétés comme des systèmes de signes.
SURREALISME → Mouvement artistique formé au milieu des années 1920 autour du poète André Breton et de ses partisans, et qui plaça l'automatisme psychique au centre de ses préoccupations.

TERRORISME → Sujet qui gagne de plus en plus en attractivité depuis les attentats du 11 septembre 2001.
TRANSCENDANCE → En philosophie et en religion, terme employé pour désigner l'au-delà de la perception humaine ordinaire. Dans l'expérience inhabituelle de la transcendance, les limites de la conscience sont donc transgressées.
TRASH → Trash – à l'origine : « ordure, déchet » – est l'abaissement ironique des normes esthétiques et qualitatives.

URBANISME → Réflexions sur la construction des villes et la vie urbaine.

VIDEO STILL → Image (fixe) obtenue à l'écran par arrêt d'une bande vidéo ou calculée à partir des lignes d'une bande vidéo.

WHITE CUBE → Terme désignant la salle d'exposition blanche, neutre, qui dans l'art moderne remplace des formes plus anciennes de présentation, par exemple l'accrochage dense de tableaux sur des papiers peints de couleur. Le White Cube propose une perception concentrée et non troublée de l'œuvre d'art.
WORK-IN-PROGRESS → Œuvre qui ne recherche pas son achèvement, mais qui souligne au contraire son caractère processuel.

YOUNG BRITISH ARTISTS (YBA) → Groupe de artistes anglais qui, depuis les années 1990, fait parler de lui avec son art de l'objet et ses vidéos inspirés du Pop Art.

Ariane Beyn et Raimar Stange

Biographical notes on the authors — Kurzbiografien der Autoren — Les auteurs en bref

C. A. – CECILIA ALEMANI

Independent curator and art critic, frequently contributes to *artforum.com*, *Mousse Magazine* and *Domus*. Currently working on the exhibition *Italics: Italian Art between Tradition and Revolution, 1968–2008*, curated by Francesco Bonami.
Freischaffende Kuratorin und Kritikerin, regelmäßige Beiträge für *artforum.com*, *Mousse Magazine* und *Domus*. Arbeitet derzeit mit Kurator Francesco Bonami an der Ausstellung *Italics: Italian Art between Tradition and Revolution, 1968–2008*.
Critique et commissaire indépendante ; contributions fréquentes à *artforum.com*, *Mousse Magazine* et *Domus*. Travaille actuellement sur l'exposition *Italics: Italian Art between Tradition and Revolution, 1968–2008* organisée par Francesco Bonami.

J. A. – JENS ASTHOFF

Works as a freelance author and critic from Hamburg. Contributions to *Kunst-Bulletin*, *Kunstforum*, *Camera Austria* and *Kultur & Gespenster*, a.o. Recent essays for catalogues on Anselm Reyle, Janis Avotins and Annette Kelm.
Lebt als freier Autor und Kritiker in Hamburg. Schreibt u.a. für *Kunst-Bulletin*, *Kunstforum*, *Camera Austria* und *Kultur & Gespenster*. Zahlreiche Katalogbeiträge, zuletzt über Anselm Reyle, Janis Avotins und Annette Kelm.
Auteur et critique indépendant installé à Hambourg. Contribue entre autre à *Kunst-Bulletin*, *Kunstforum*, *Camera Austria* et *Kultur & Gespenster*. Essais récents pour les catalogues d'Anselm Reyle, Janis Avotins et Annette Kelm.

A. B. – ANDREW BONACINA

Studied at the Courtauld Institute and the Royal College of Art in London where he is based as a writer and curator. A Contributing Editor of *UOVO* magazine, he regularly writes for *Frieze* and *Untitled* and is a director of the independent imprint *Almanac*.
Studierte am Courtauld Institute und am Royal College of Art in London, wo er als Autor und Kurator lebt. Er ist Contributing Editor des *UOVO* Magazins, schreibt für *Frieze* und *Untitled* und ist Direktor des unabhängigen Verlags *Almanac*.
Études au Courtauld Institute et au Royal College of Art à Londres, où il vit et travaille comme auteur et commissaire. Co-rédacteur du magazine *UOVO*, écrit régulièrement pour *frieze* et *Untitled*, directeur de l'édition indépendante *Almanac*.

S. H. – SUZANNE HUDSON

New York-based critic and Assistant Professor of Modern Art at the University of Illinois. A regular contributor to *Artforum*, her writing has appeared in publications including *October*, *Art Journal* and *Parkett*.
In New York lebende Kritikerin und Assistant Professor of Modern Art an der University of Illinois. Neben regelmäßigen Beiträgen für *Artforum* schreibt sie außerdem für Publikationen wie *October*, *Art Journal* und *Parkett*.
Critique d'art installée à New York ; maître de conférences sur l'art moderne à l'Université d'Illinois. Collaborations régulières à *Artforum*, ses textes ont notamment été publiés dans *October*, *Art Journal* et *Parkett*.

CH. L. – CHRISTY LANGE

Berlin-based writer and Assistant Editor of *frieze*. She has written for *Afterall*, *Foam*, *frieze*, *Modern Painters*, *The Observer*, *Parkett* and *Tate Etc.* She is also a contributor to the recent monograph on Stephen Shore.
In Berlin lebende Autorin und Assistant Editor bei *frieze*. Sie schreibt für *Afterall*, *Foam*, *frieze*, *Modern Painters*, *The Observer*, *Parkett* und *Tate Etc.* Zuletzt hat sie zur aktuellen Monografie von Stephen Shore beigetragen.
Auteur et assistante éditoriale de *frieze* installée à Berlin. Écrit pour *Afterall*, *Foam*, *frieze*, *Modern Painters*, *The Observer*, *Parkett* et *Tate Etc.* A également contribué à la monographie publiée récemment sur Stephen Shore.

H. L. – HOLGER LUND

Art historian and curator. Since 2004, he is co-director of fluctuating images, a non-commercial media art space in Stuttgart. Regularly invited as a visiting lecturer to various institutes in Germany.
Kunsthistoriker und Kurator. Seit 2004 Kodirektor von fluctuating images, einem nicht-kommerziellen Medienkunstraum in Stuttgart. Unterrichtet regelmäßig an verschiedenen deutschen Hochschulen.
Historien de l'art et commissaire d'expositions. Depuis 2004, co-directeur de fluctuating images, espace d'art multimédia à but non lucratif basé à Stuttgart. Intervenant régulier dans différentes universités allemandes.

A. M. – ASTRID MANIA
Berlin-based independent writer and curator with a PhD in art history. She regularly contributes to *artnet.com*, *Art Review* and *Flash Art*, amongst others, and is the editor of the artist's book *David Hatcher: I Don't Must*.
Astrid Mania ist promovierte Kunsthistorikerin und lebt als freie Autorin und Kuratorin in Berlin. Sie schreibt u.a. für *artnet.com*, *Art Review* und *Flash Art* und ist Herausgeberin des Künstlerbuchs *David Hatcher: I Don't Must*.
Docteur en histoire de l'art, auteur et commissaire indépendante. Contribue régulièrement entre autre à *artnet.com*, *Art Review* et *Flash Art* ; directrice de publication du livre d'artiste *David Hatcher: I Don't Must*.

R. M. – RODRIGO MOURA
Curator, editor and art critic. Since 2004 he has held a position as curator at Inhotim Centro de Arte Contemporânea. He is a former curator of Museu de Arte da Pampulha (2003–06) in Belo Horizonte, the city where he lives.
Kurator, Herausgeber und Kunstkritiker. Seit 2004 ist er Kurator am Inhotim Centro de Arte Contemporânea. Außerdem war er 2003–06 Kurator am Museu de Arte da Pampulha in Belo Horizonte, seinem derzeitigen Wohnsitz.
Commissaire, éditeur et critique d'art. Occupe le poste de conservateur du Inhotim Centro de Arte Contemporânea depuis 2004. Ancien conservateur du Museu de Arte da Pampulha (2003–06) à Belo Horizonte, sa ville de résidence actuelle.

S. R. – SIMON REES
Curator at the Contemporary Art Centre (CAC) in Vilnius who writes regularly for international press and publications.
Kurator am Contemporary Art Centre (CAC) in Vilnius mit zahlreichen Veröffentlichungen in der internationalen Presse und in Katalogen.
Conservateur au Contemporary Art Centre (CAC) à Vilnius ; écrit régulièrement pour la presse internationale et d'autres publications d'art.

V. R. – VIVIAN REHBERG
Chair of Critical Studies and lecturer in art history at Parsons Paris School of Art & Design, and a founding editor of the *Journal of Visual Culture*. She is a frequent contributor to *frieze*, *Modern Painters* and other art publications.
Professorin für Critical Studies und Dozentin für Kunstgeschichte an der Parsons Paris School of Art & Design, sowie Gründungsherausgeberin des *Journal of Visual Culture*. Regelmäßige Beiträge u.a. zu *frieze* und *Modern Painters*.
Chaire d'études critiques et maître de conférences en histoire de l'art à la Parsons Paris School of Art & Design ; fondatrice et éditrice du *Journal of Visual Culture*. Contributions régulières à *frieze*, *Modern Painters* et d'autres publications d'art.

E. S. – EVA SCHARRER
Independent curator and critic, currently based in Basle. She has written various catalogue essays and is a regular contributor to *Artforum International*, *artforum.com*, *Modern Painters*, *Kunst-Bulletin*, *Spike Art*, and others.
Freischaffende Kuratorin und Kritikerin, lebt derzeit in Basel. Hat zahlreiche Katalogessays verfasst und schreibt regelmäßig Beiträge u.a. für *Artforum International*, *artforum.com*, *Modern Painters*, *Kunst-Bulletin* und *Spike Art*.
Commissaire et critique d'art indépendante installée à Bâle. A écrit plusieurs essais pour différents catalogues et contribue régulièrement à *Artforum International*, *artforum.com*, *Modern Painters*, *Kunst-Bulletin*, *Spike Art* et d'autres publications.

Photo credits — Fotonachweis — Crédits photographiques

We would like to thank all the individuals, galleries and institutions who placed photographs and information at our disposal for ART NOW 3.
Unser Dank gilt allen Personen, Galerien und Institutionen, die großzügig Bildmaterial und Informationen für ART NOW 3 zur Verfügung gestellt haben.
Nous remercions toutes les personnes, galeries et institutions qui ont mis gracieusement à la disposition de ART NOW 3 leurs documentations, images et informations.

Ackermann, Franz → © Franz Ackermann 1–3 Courtesy neugerriemschneider, Berlin **Ai Weiwei** → © Ai Weiwei 1 Courtesy Galerie Urs Meile, Beijing/Lucerne 2, 3 Courtesy Leister Foundation, Switzerland / Erlenmeyer Stiftung, Switzerland / Galerie Urs Meile, Beijing/Lucerne 4, 5 Courtesy Mary Boone Gallery, New York Portrait Frank Schinski **Aitken, Doug** → © Doug Aitken 1–6 Courtesy 303 Gallery, New York **Almond, Darren** → © Darren Almond 3 Courtesy Galerie Max Hetzler, Berlin / Photo Jörg von Bruchhausen 4 Courtesy Parasol Unit Foundation for Contemporary Art, London / Photo Hugo Glendinning Portrait Richard Dawson **Altmejd, David** → © David Altmejd 1–4 Courtesy Andrea Rosen Gallery, New York / Photo 1 Tom Powel / Photos 2–4 Ellen Page Wilson Portrait Ellen Page Wilson **Banksy** → Banksy 1, 2 Courtesy Pest Control Office, London **Barney, Matthew** → © Matthew Barney 1–4 Courtesy Gladstone Gallery, New York / Photo 1 Hugo Glendinning / Photos 2–4 Chris Winget **Bonin, Cosima von** → © Cosima von Bonin 1–5 Courtesy Friedrich Petzel Gallery, New York **Brown, Cecily** → © Cecily Brown 1, 2 Courtesy Gagosian Gallery, New York 3 Courtesy Contemporary Fine Arts, Berlin / Photo Jochen Littkemann Portrait Sidney B. Felsen **Brown, Glenn** → © Glenn Brown 1, 3, 4 Courtesy Galerie Max Hetzler, Berlin / Photos Jörg von Bruchhausen 2 Courtesy the artist Portrait Sex, 2003, oil on panel, 126 x 85 cm Courtesy Gagosian Gallery, New York **Butzer, André** → © André Butzer 1–5 Courtesy Galerie Max Hetzler, Berlin Portrait Thomas Biber **Cai Guo-Qiang** → © Cai Guo-Qiang 1–4 Courtesy Cai Studio / Photos 1, 3 Hiro Ihara / Photo 2 Tatsumi Masatoshi / Photo 4 Chen Shizhen Portrait Courtesy Cai Studio / Photo Ma Da **Cattelan, Maurizio** → © Maurizio Cattelan 1–3 Courtesy Galerie Emmanuel Perrotin, Paris/Miami / Photo 1 Axel Schneider / Photo 2 Wonge Bergmann / Photo 3 Zeno Zotti **Dean, Tacita** → © Tacita Dean 1–5 Courtesy the artist / Frith Street Gallery, London / Marian Goodman Gallery, New York/Paris / Photo 5 Alex Delfanne Portrait Nick MacRae **Dijkstra, Rineke** → © Rineke Dijkstra 1–6 Courtesy Galerie Max Hetzler, Berlin / Marian Goodman Gallery, New York/Paris **Djurberg, Natalie** → © Natalie Djurberg 1, 3 Courtesy the artist / Giò Marconi, Milan / Zach Feuer Gallery, New York 2, 4 Courtesy the artist / Fondazione Prada, Milan **Doig, Peter** → © Peter Doig 1–3 Courtesy Michael Werner Gallery, New York and Berlin / Photos Marcella Leith / David Clark: Tate Portrait Alex Smailes **Dumas, Marlene** © Marlene Dumas 1–4 Courtesy Zeno X Gallery, Antwerp / Photos Peter Cox Portrait Andre Vannoord **Dzama, Marcel** → © Marcel Dzama 1–5 Courtesy the artist / David Zwirner, New York Portrait Courtesy the artist / David Zwirner, New York / Photo Spike Jonze 2008 **Eliasson, Olafur** → © Olafur Eliasson 1–5 Courtesy neugerriemschneider, Berlin Portrait Jacob Jorgensen **Elmgreen & Dragset** → © Elmgreen & Dragset / VG Bild-Kunst, Bonn 2011 pages 10/11 Courtesy the artists / Photo Thorsten Arendt/artdoc.de **Fischer, Urs** → © Urs Fischer 1, 3 Courtesy Galerie Eva Presenhuber, Zürich / Sadie Coles HQ, London 2, 4 Courtesy Galerie Eva Presenhuber, Zürich / Photos Stefan Altenburger Photography, Zürich **Ford, Walton** → © Walton Ford 1–5 Courtesy Paul Kasmin Gallery, New York / Photos 2, 3 Christopher Burke Studio **Friedman, Tom** → © Tom Friedman 1–3 Courtesy Gagosian Gallery, New York Portrait Justin Kemp **Gallagher, Ellen** → © Ellen Gallagher 1, 4 Courtesy the artist / Hauser & Wirth, Zürich London / Photos Studio Ellen Gallagher 2 Courtesy the artist / Hauser & Wirth Collection, Switzerland / Photo Mike Bruce 3 Courtesy the artist / Hauser & Wirth, Zürich London / Tate, London / Photo Mike Bruce Portrait Edgar Cleijne **Gispert, Luis** → © Luis Gispert 1, 2 Courtesy Zach Feuer Gallery, New York / Mary Boone Gallery, New York 3–6 Courtesy Mary Boone Gallery, New York / Courtesy Zach Feuer Gallery, New York **Gober, Robert** → © Robert Gober 1–3 Courtesy Matthew Marks Gallery, New York Portrait Catherine Opie 2001 **Gordon, Douglas** → © Douglas Gordon 1 Courtesy the artist 2 Courtesy Inverleith House, Edinburgh 3 Courtesy Kunstmuseum Wolfsburg / Photo Matthias Langer 4 Courtesy Gagosian Gallery, New York Portrait Courtesy the artist **Grotjahn, Mark** → © Mark Grotjahn 1–4, front cover, endpapers Courtesy Gagosian Gallery, New York / Blum & Poe, Los Angeles / Anton Kern Gallery, New York / Shane Campbell Gallery, Chicago / Photo front cover, endpapers Joshua White **Gupta, Subodh** → © Subodh Gupta 1 Courtesy Galleria Continua, San Gimignano / Photo Aurélien Mole 2, 3 Courtesy Jack Shainman Gallery, New York / Photo 3 Shalendra Kumar **Gursky, Andreas** → © Andreas Gursky / VG Bild-Kunst, Bonn 2011 1–3 Courtesy Monika Sprüth Philomene Magers, Cologne/Munich/London Portrait Tom Lemke **Harrison, Rachel** → © Rachel Harrison 1–6 Courtesy Greene Naftali, New York / Photos 1–5 Jean Vong / Photo 6 Oren Slor **Hatoum, Mona** → © Mona Hatoum 1, 3, 4 Courtesy Galerie Max Hetzler, Berlin / Photo 3, 4 Jörg von Bruchhausen 2 Courtesy Alexander and Bonin, New York / Photo Bill Orcutt Portrait Courtesy Jay Jopling/White Cube, London / Photo Johnnie Shand Kydd **Havekost, Eberhard** → © Eberhard Havekost 1–5 Courtesy Galerie Gebr. Lehmann, Berlin/Dresden / Photos Werner Lieberknecht Portrait Wolfgang Stahr **Herrera, Arturo** → © Arturo Herrera 1 Courtesy Sikkema Jenkins & Co., New York 2–4 Courtesy Galerie Max Hetzler, Berlin Portrait Holger Niehaus **Heyl, Charline von** → © Charline von Heyl 1, 2 Courtesy Galerie Gisela Capitain, Cologne / Photos Lothar Schnepf 3, 4 Courtesy Friedrich Petzel Gallery, New York **Hirst, Damien** → © Damien Hirst / VG Bild-Kunst, Bonn 2011 1–3 Courtesy Jay Jopling/White Cube, London / Photos Prudence Cummings Associates Ltd. Portrait David Bailey **Houseago, Thomas** → © Thomas Houseago / VG Bild-Kunst, Bonn 2011 1–3 Courtesy David Kordansky Gallery, Los Angeles / Photos 1, 2 Fredrik Nilsen / Photo 3 Simon Hare Photography 4 Courtesy Xavier Hufkens, Brussels Portrait Amy Bessone **Jacir, Emily** → © Emily Jacir 1–5 Courtesy the artist / Alexander and Bonin, New York **Kelley, Mike** → © Mike Kelley 1, 2 Courtesy Gagosian Gallery, New York / Photos Robert McKeever 3 Courtesy Jablonka Galerie, Berlin Portrait Courtesy Walker Art Center, Minneapolis and Mike Kelley / Photo Cameron Wittig **Koh, Terence** → © Terence Koh 1 Courtesy Terence Koh / de Pury Luxembourg 2–4 Courtesy Terence Koh / Peres Projects, Berlin Los Angeles Portrait Courtesy Terence Koh / Peres Projects, Berlin Los Angeles **Koons, Jeff** → © Jeff Koons 1–5 Courtesy the artist Portrait Benedikt Taschen **Lim, Won Ju** → © Won Ju Lim 1–4 Courtesy Patrick Painter Inc., Los Angeles / Photos Fredrik Nilsen **Marepe** → © Marepe 1, back cover Courtesy Tate Modern, London / Photo Gary Weekes 2–4 Courtesy Galerie Max Hetzler, Berlin / Photo 3 Jörg von Bruchhausen **McCarthy, Paul** → © Paul McCarthy 1–5 Courtesy the artist / Hauser & Wirth, Zürich London / Photos 1, 3–5 Ann-Marie Rounkle / Photo 2 A. Burger Portrait Mara McCarthy **Milhazes, Beatriz** → © Beatriz Milhazes 1, 2 Courtesy the artist / Photos Fausto Fleury **Morris, Sarah** → © Sarah Morris 1–4 Courtesy the artist Portrait Ezra Petronio **Mueck, Ron** → © Ron Mueck 1 Courtesy Tate and National Galleries of Scotland, Edinburgh on behalf of the United Kingdom 2 Courtesy National Galleries of Scotland, Edinburgh 3 Courtesy Glenn Fuhrman Collection, New York Portrait Courtesy ART iT / Photo Satoshi Nagare **Murakami, Takashi** → 1 © 2008 Takashi Murakami/Kaikai Kiki Co., Ltd. All rights reserved / Courtesy Blum & Poe, Los Angeles 2 © 2001–2006 Takashi Murakami/Kaikai Kiki Co., Ltd. All rights reserved / Photo GION 3 © 1999–2007 Takashi Murakami/Kaikai Kiki Co., Ltd. All rights reserved / Photo GION Portrait Kenji Yagi **Neto, Ernesto** → © Ernesto Neto Photo 1 Marc Dornage, 2, 4 Courtesy Galerie Max Hetzler, Berlin / Photos Holger Niehaus Portrait Markus Wagner **Noble, Tim and Webster, Sue** → Tim Noble & Sue Webster 1–4 Courtesy Deitch Projects, New York **Oehlen, Albert** → © Albert Oehlen 1 Courtesy Galerie Max Hetzler, Berlin / Photo Schaub/Höffner, Cologne 2 Courtesy Luhring Augustine, New York 3 Courtesy Thomas Dane Gallery, London **Orozco, Gabriel** → © Gabriel Orozco 1 Courtesy the

Acknowledgements — Dank — Remerciements

303 Gallery, Simon Greenberg – Alexander and Bonin, Oliver Newton, Ariel Phillips – Darren Almond Studio, Connor Linskey, Kathleen Madden – Galerie Guido W. Baudach, Jasmin Scheckenbach, Heike Tosun – Blum & Poe, Heather Rasmussen, John Steele – Mary Boone Gallery, Ron Warren – Gavin Brown's enterprise, Alex Zachary – Glenn Brown Studio, Edgar Laguinia – Galerie Daniel Buchholz, Katharina Forero de Mund, Michael Kerkmann – Cai Guo-Qiang Studio, Bonnie Huie, Alicia Lu – Galerie Gisela Capitain, Wiebke Kayser, Sarah Moog, Dorothee Sorge – Galleria Massimo De Carlo, Anna Cappozzo – China Art Archives and Warehouse, Bonnie Huie – China Art Objects Galleries, Maeghan Reid – Christie's, Leonie Ashfield, Stella Calvert-Smith, Stephanie Manstein, Barbara Pusca, Milena Sales – Sadie Coles HQ, Rebecca Heald, Karimah Shofuneh, Chelsea Zaharczuk – Contemporary Fine Arts, Verena Hollank, Julia Rüther, Imke Wagener – Deitch Projects, Jasmine Levett – Design and Artists Copyright Society (DACS), Cassandra King, Joy Stanley – EIGEN + ART, Corinna Wolfien – Elmgreen & Dragset Studio, Sandra Stemmer, Elmar Vestner – Zach Feuer Gallery, Grace Evans – Frith Street Gallery, Dale McFarland – Gagosian Gallery, Ian Cooke, James McKee – Ellen Gallagher Studio – Barbara Gladstone Gallery, Jessie Greene, Eric Nylund – Marian Goodman Gallery – Douglas Gordon Studio, Martina Aschbacher, Bert Ross – Greene Naftali, Sam Pulitzer, Jay Sanders, Alexandra Tuttle – Mark Grotjahn Studio, Daniel Cummings, Laurel Lozzi – Andreas Gursky Studio, Annette Völker – Mona Hatoum Studio – Hauser & Wirth, Nicole Keller, Julia Lenz, Sabina Sarwa, Karin Seinsoth, Michael Stark – Arturo Herrera Studio – Galerie Max Hetzler, Wolfram Aue, Olivia Franke, Evke Rulffes, Tanja Wagner – Xavier Hufkens, Ann Hoste – Jablonka Galerie, Christian Schmidt – Jay Jopling/White Cube, Rowan Aust, Alex Bradley, Sophie Greig, Amy Houmoller, Susannah Hyman, Sara McDonald – Kaikai Kiki New York LLC, Marika Shishido – Paul Kasmin Gallery, Rebecca Siegel, Mark Markin – Mike Kelley Studio, Mary Clare Stevens – Anton Kern Gallery, Bridget Finn – Jeff Koons Studio, Lauran Rothstein – David Kordansky Gallery, Natascha Garcia-Lomas, Dwyer Kilcollin, Melissa Tolar – Galerie Gebr. Lehmann, Jörg Goedecke, Karola Matschke, Max Meyer-Abich – Luhring Augustine, Caroline Burghardt, Tiffany Edwards – Giò Marconi, Ylinka Barotto – Matthew Marks Gallery, Stephanie Dorsey, Caroline Gabrielli, Senem Oezdogan, Ben Thornborough – Urs Meile, Karin Seiz, René Stettler – Metro Pictures, Alexander J. Pall, James Woodward – Beatriz Milhazes Studio, Tereza Lyrio – Christian Nagel, Florian Baron, Andrea Zech – neugerriemschneider, Emilie Breyer, Valerie Chartrain, Claire Rose – Tim Noble & Sue Webster Studio, Andrew McLachlan – Albert Oehlen Studio – Anthony d'Offay, Hannah Barry – Patrick Painter Inc., Jacquelyn De Longe, Heather Harmon, Luis Zavala – Maureen Paley, Susanna Chisholm, Katie Guggenheim, Patrick Shier– Parallax, Julia Dault – Peres Projects, Nick Koenigsknecht, Victoria Sounthavong, Blair Taylor – Galerie Emmanuel Perrotin, Nathalie Brambilla – Pest Control Office, Holly Cushing – Friedrich Petzel Gallery, Colby Bird, Jason Murison, Andrea Teschke – Phillips de Pury & Company, Johanna Frydman, Cynthia Leung – Richard Phillips Studio – Fondazione Prada, Mario Mainetti – Galerie Eva Presenhuber, Gregor Staiger, Kerstin Weiss, Silja Wiederkehr – Richard Prince Studio, Betsy Biscone – Regen Projects, Tanya Brodsky, Brad Hudson – Anselm Reyle Studio, Alexander Fischer von Mollard – Andrea Rosen Gallery, Jeremy Lawson – Jack Shainman Gallery, Sabrina Vanderputt – Sikkema Jenkins & Co., Ellie Bronson – Sotheby's, Roxy Pennie, Lauren Pirrung – Monika Sprüth Philomene Magers, Franziska von Hasselbach – Galeria Luisa Strina, Camila Leme – Thomas Struth Studio, Sonja Ameglio – Tate Modern, Anna Ridley, Lucie Strnadova – Piotr Uklański Studio, Arianna Petrich, Malgorzata Bakalarz – Walker Art Center, Barbara Economon – Galerie Michael Werner, Jason Duval – Archiv Franz West, Michaela Obermaier, Andrea Überbacher – Kehinde Wiley Studio, Anthony Lanzilote, Carrie Mackin – Christopher Wool Studio – Zeno X Gallery, Roxane Baeyens, Koen van den Brande, Jelle Breynaert – Thomas Zipp Studio, Kai Erdmann – David Zwirner, Jessica Witkin

To stay informed about upcoming TASCHEN titles, please request our magazine at www.taschen.com/magazine or write to TASCHEN, Hohenzollernring 53, D-50672 Cologne, Germany; contact@taschen.com. We will be happy to send you a free copy of our magazine, which is filled with information about all of our books.

© 2012 TASCHEN GmbH
Hohenzollernring 53, D-50672 Köln
www.taschen.com

ART NOW Vol 3
Original edition © 2008 TASCHEN GmbH

Edited by Hans Werner Holzwarth

Chief editors: Cornelia Lund, Lutz Eitel

Texts: Cecilia Alemani, Jens Asthoff, Andrew Bonacina, Suzanne Hudson, Christy Lange, Holger Lund, Astrid Mania, Rodrigo Moura, Simon Rees, Vivian Rehberg, Eva Scharrer

English translation: Pauline Cumbers, Emily Speers Mears
German translation: Stefan Knödler, Gisela Sturm, Matthias Wolf
French translation: Wolf Fruhtrunk, Anthony Allen, Geneviève Bégou, Marie Gravey, Patrick Hersant, Blandine Pélissier, Alice Petillot

Editorial team: Kirsty Bell, Thomas Boutoux, Lucie Kostmann, Holger Lund, Jacqueline Todd, Miriam Wiesel
Coordination: Anna Stüler
Design: Hans Werner Holzwarth and Jan Blatt, based on the *ART NOW* design by Sense/Net Art Direction, Andy Disl and Birgit Eichwede
Cover: Sense/Net Art Direction, Andy Disl and Birgit Eichwede, Cologne, www.sense-net.net

Printed in South Korea
ISBN 978-3-8365-3618-9